The Face of Britain

The Face of Britain

A History of the Nation through Its Portraits

Simon Schama

OXFORD
UNIVERSITY PRESS

OXFORD
UNIVERSITY PRESS

Oxford University Press is a department of the University of Oxford. It furthers the University's objective of excellence in research, scholarship, and education by publishing worldwide. Oxford is a registered trade mark of Oxford University Press in the UK and certain other countries.

Published in the United States of America by Oxford University Press
198 Madison Avenue, New York, NY 10016, United States of America.

© Simon Schama 2016

Images copyright © National Portrait Gallery, London, 2015,
unless otherwise stated on pages 547–61
BBC and the BBC logo are trade marks of the British Broadcasting
Corporation and are used under licence. Logo © BBC 1996.

The moral right of the copyright holders has been asserted

The epigraph on page xi from Totality and Infinity by Emmanuel Levinas (1991)
is reprinted with the kind permission of Springer Science+Business Media.
Grateful acknowledgment is made to quote the lyrics on pages 239 and 240:
Written by John Lennon © Lenono Music. Used by permission.

First published in Great Britain by Viking Books.

Library of Congress Cataloging-in-Publication Data
Names: Schama, Simon, author.
Title: The face of Britain : A history of the nation through its portraits / Simon Schama.
Description: New York : Oxford University Press, 2016. | Includes
bibliographical references and index.
Identifiers: LCCN 2016005776 | ISBN 978-0-19-062187-2
Subjects: LCSH: Portraits, British. | Great Britain—Biography—Portraits.
Classification: LCC N7598 .S33 2016 | DDC 704.9/420941—dc23 LC record
available at http://lccn.loc.gov/2016005776

1 3 5 7 9 8 6 4 2

Printed by Sheridan Books, Inc., United States of America

For Jan Dalley
in love and friendship

Contents

Pre-Face

CONTENTS

CONTENTS

PART V
Faces of the People

About Face

539

'Is not the face given to vision?'

Emmanuel Levinas, 'Sensibility and the Face',
in *Totality and Infinity*

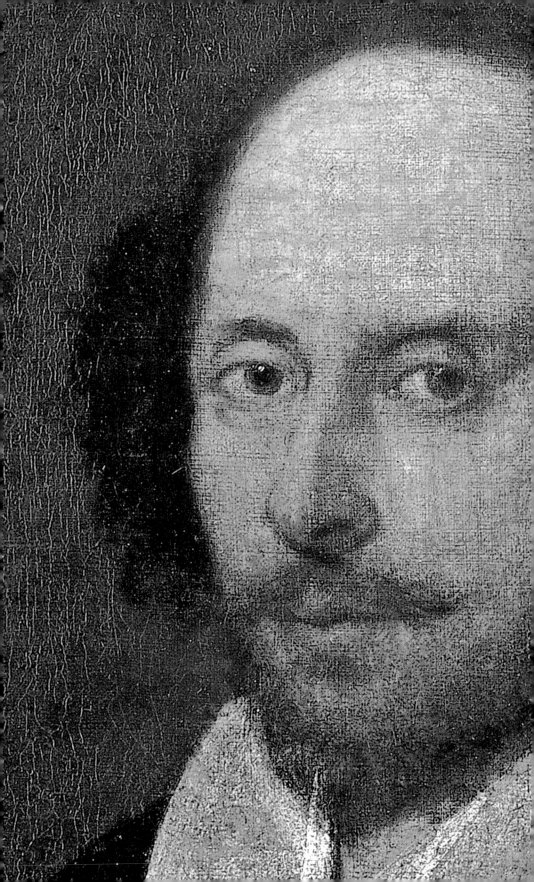

Pre-
Face

1. The Look

You spend a little time in front of a portrait and then you move on. But you have the odd feeling that the eyes of that painted face are tracking you round the gallery. It's a cliché, a joke, a fable, the kind of thing that has the guards rolling their eyes. But you are not altogether deluded. From somewhere deep in the temporal cortex of your brain has come, unbidden, the act which made you human in the first place: the locking of eyes.

Trust an artist to spot the one item of our anatomy which, our whole life long, never changes size. In his *Analysis of Beauty* William Hogarth noticed that 'though every feature grows larger and longer till the whole person has done growing, the sight of the eye still keeps its original size; I mean the pupil, with its iris or ring; for the diameter of this circle continues still the same . . . You may sometimes find this part of the eye in a new-born infant full as large as in a man of six foot, nay sometimes larger.'

He was right. We come into the world wide-eyed, ready to stare. And after we are done crying, eyes scrunched tight against the raw light, we start looking, which is the precise moment we begin to live in the company of humans. Nonsense, I was told; newborns can't see a thing; blind as a bat. Takes days, weeks, to make out anything. But I knew better.

*

A grim rain was falling on Boston in the early hours of 15 May 1983. The soundtrack for the birth of my daughter was Vivaldi and type-writer; a natural combo. No hospital staff wrote reports on computers at that time; every Caesarean section had to be documented. Vivaldi was the obstetrician's idea. As my wife was wheeled into the ward, up bounced the Jerry Garcia of obstetrics: flower shirt; jeans distressed but not as much as me. First words out of Jerry's mouth were: 'Music, man [I swear]; you brought music, right? Gotta have it. What'll it be?' Not 'Sugar Magnolia', sunshine, I thought; and definitely not 'Truckin''. Embarrassed even as the word left my mouth, I went lofty on him. 'Schubert?' Jerry's brow furrowed. 'We got Vivaldi, I think.' And typewriter.

But we also got daughter. Around 2 a.m., the rain hammering down on Brookline Avenue, a girl was lifted from the pond of blood, howling on cue, wiped clean of vernix and set in my trembling arms.

She stopped crying. A heavy sleep descended. But then after no more than ten minutes and possibly less, she opened her eyes, unnaturally enormous in a smooth, open face, unbruised by any jolting passage through the birth canal. Those pupils were fully operational, the irises a startling cobalt. We looked at each other through clouded vision – mine occluded with tears; hers doing the best it could with neonate optical musculature – giving each other the once-over. So much for the received wisdom. I knew my daughter was staring at me, and with an intensity that made it feel like a mute interview for fatherhood. She looked worried; we exchanged anxieties. I was not confident I had got the job. But I was sure we had made a connection; so sure that I moved my head a little to the right. Which is when it happened: the ocean-dark eyes with their big, black pupils followed the movement of my head. I took the experiment further, extending the range of my head movement; right and left, two or three times in each direction. Every time the baby's eyes tracked mine. This is not what one has been told, I said to myself. But this is undeniably happening. We were face to face. Hiya, darling.

*

Thirty years on, science has no doubts. The first thing newborns do, if all is well, is howl. Who can blame them? It's a rough ride. But when they open their eyes, they can make out, albeit in blurred forms, the bits of a face that count: eyes, nose, mouth, hairline; the contours of the head. Their engagement with that face is immediate and intense; the strong contrasts between light and shade help. Very quickly the attraction fastens to more than those contrasts. Presented with pictures of scrambled features or an upside-down face, the baby of but a few weeks loses interest, already deciding that this jumble of lines and shapes is somehow an unimportant distraction. A face with closed eyes will also leave her cold. Humans are the only primates to have so large an area of white sclera surrounding the darker iris and pupil, and this helps to attract the attention of the infant. Eyebrow movement animates and frames this mutual gaze. It is all that the baby wants to see.

Weeks turn to months. Focus pulls tighter, the clearest field of vision being precisely the six to twelve inches corresponding to breast-feeding or arm-cradling distance. By four months the baby can distinguish between different faces, establishing clear preferences for those most familiar. Smiles arrive in response to those repeatedly given by mother and father. Abrupt removal of the familiar face triggers distress. At this point, no later than six months, the baby has become an accomplished face reader, receiving messages from mouth, eyes and, most signally, eyebrows. She now knows the faces offering sustenance, protection and comfort: the faces which deliver happiness.

Astonishingly, the cerebral equipment at her command to process all this information has developed to the point at which its operations are as complete as they will be for the rest of her life. And this has been accomplished at a time when the infant is still incapable of differentiating other kinds of objects. Neurologists continue to debate whether this precocious scanning is acquired in response to habitual experience, or whether at birth the higher cortical region of the infant brain that specializes in face recognition is already, like the eye itself, fully developed and primed to spring into action. The most recent research seems to favour this latter view: that highly localized zones

of the brain situated along the ventral pathway have evolved expressly for the exchange of looks – for our very first and most important social act. Its satisfactory operation determines our most powerful impulses: expectations of joy; intimations of fear; yearnings for union; trust in protective authority; mistrust of the shifty look and the averted eye. Research at Princeton University has revealed that a reading of one tenth of a second is enough for us to decide whether we trust or mistrust a face, whether we want to engage or disengage from a countenance: a mere Tinder-swipe to settle our allegiance into a resolution no mere speech is likely to alter. Those face impressions we decide to retain are stored by the thousand, and the sophistication with which they are sorted dwarfs any other kind of mental data bank. It is, in the first instance, through face reading that we will navigate the world, anchor ourselves among the sympathetic, distance ourselves from the unsympathetic, decide which is which.

It is this elementary social wiring that makes portraiture at once the most basic and the least self-contained of all the genres of the visual arts. The earliest art manuals, such as the Dutchman Willem Goeree's *Introduction to the General Art of Drawing* of 1668, in line with Renaissance devotion to classical principles of beauty, assumed mastery of the figure to be the condition of making fine art. But before the torso, studied from antique statuary, came the most elementary form of all, the human face, the first that any pupil tackled: the egg-like oval which untutored children turn into a circle. The horizontal line bisecting the oval gives the correct positioning of the eyes, while the vertical line guides the disposition of nose and mouth. Thus the pupil repeats what he saw in the hours and days after his birth. Godlike, he remakes the aspect of humanity on his little sheet of paper.

But with duplication comes obligation, for portraiture is the least free of painterly genres. No rose will complain of excessive petal-droop in a still life; no cheese will take you to task over inaccurate veining. Landscapes may be entirely reimagined in the painter's vision and, from the very outset, in the fantastical encyclopaedic compositions of

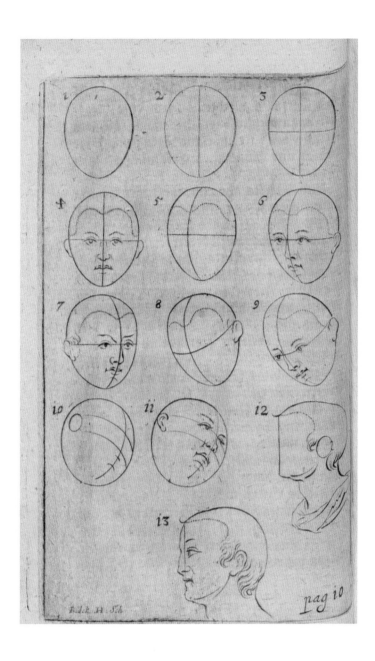

Introduction to the General Art of Drawing, by Willem Goeree, 1668

Joachim Patinir and Bruegel the Elder, alpine pinnacles occupying the same frame as Flemish huts and pastures, so indeed they were. Shocking liberties of scale were taken by the greatest Dutch masters, Jacob van Ruisdael especially, and no one called him out for the inventions; indeed, they may have been expected. But portraiture is answerable as no other speciality to something lying beyond the artist's creativity. That something is the sitter paying the bill. Inescapably, every portrait is the product of a three-way negotiation between what the subject imagines they look like, the artist's unstoppable urge to complicate that self-image, and the expectations of whoever ends up living with the result.

Which is the nub of it all. The most lifelike of early portraits, those made in the Roman-Egyptian mid-Nile region of Fayyum in the first to third centuries CE, were of the dead. Like almost every portrait that followed, they were made as an act of resistance to mortality. Their task was to perpetuate the presence of the mourned, long after their demise; to give them an afterlife. This had long been the point of painted mummification: to present the dead as not in any final sense gone but merely departed to a different realm; hence the obligation to provide provisions for the journey. But most of those classical mummies were heavily stylized. The families and friends of the deceased who commissioned the later Fayyum funerary portraits wanted an image to the *life*, as animated as if the subject were present in the room; as if they had never gone at all.

Portraits have always been made with an eye to posterity, to recreate a presence where there is, for whatever reason, absence. Erasmus of Rotterdam sent the picture of himself made by one friend, Hans Holbein, to another, Thomas More, that he might be remembered *vividly*, which is to say as if still alive and nearby.

A portrait must offer a good likeness, so the truism holds. But this begs an enormous issue: a likeness of what, exactly? Which of the innumerable faces we put on for as many occasions, some public, some private, or those that just arrive unbidden? Do subjects want artists to agree with their assumption that the best-looking version of

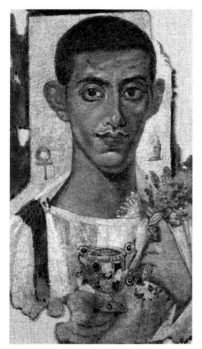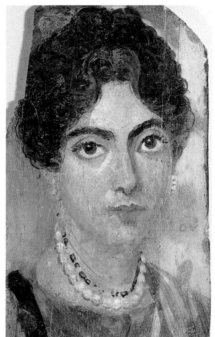

A Young Woman and a Young Man from Al Fayyum, Egypt, first to third centuries CE

themselves also happens to be the most truthful? In any case, the artist has a different priority: vitality – which may or may not be delivered by an accurate map of features. Animation is registered in the eyes, or the mouth or the turn of the head, and this is a tall order, since almost all artists require immobility from their subjects, often for hours on end. The challenge for any artist trying to capture the *life*likeness of the subject is that, in such circumstances, a face may freeze into a mask and this may be what is transcribed on to the canvas. The greatest of all portraitists – a Rembrandt or a Goya – caught their subjects as if temporarily halted between a before and an after: an interruption of the flux of life rather than a becalmed pose.

The petrified face only reinforces the second obligation of the artist: to crack it and get at the essential character lying beneath the mask, the person, which is always more than an inventory of features. The eighteenth-century art critic and (mediocre) painter Jonathan Richardson described this task as capturing the 'history' of the subject and thought it the main point of all portraits, if they wanted to be considered in the same class of art as depictions of exemplary scenes from antiquity or scripture. But suppose there is no essence to unearth from beneath a variety of the appearances we assume as the day demands: the office face, the party face, the teaching face, the flirting face? Or that one of those faces, shadowed with introspection, may be as much the authentic picture as its exuberant, outward-facing opposite?

When it's a Gainsborough or a Lucian Freud who has pictured an otherwise unknown and private person, we take it on trust that, as elusive as an essential *them* might be, the portrait has managed to nail the qualities that made them *them*. (Freud was notorious for taking his subjects hostage until he was confident he did have that defining knowledge and then taking as long as he needed to flesh it out in the density of his paint.) But when the 'history' of the sitter is portrayed for the history of the world – or the country – he inhabits and must somehow be both exemplary and individual, the challenge becomes daunting. For the painter is now answering not just to the self-image

of the sitter, nor to the creatively disruptive urges of his muse, but to a third party that must be satisfied: public expectation.

Those expectations were institutionalized in the founding of the National Portrait Gallery in 1856, the first such gallery in the world (though France had established its pantheon for its *grands hommes* (*sans femmes, cela va sans dire*); and Poets' Corner in Westminster Abbey had done much the same in tomb sculpture, which even today surprises in some cases by a jolt of unfunereal animation). The impulse behind it was to tell the British who they were, via a procession of two-dimensional heroes. For all the self-assurance of the Victorians, it was not accidental that the question was put at a time of sudden imperial uncertainty in India and the Crimea. What was wanted, then as now, was a gathering of characters who 'stood for' Britain yet were not waxwork ciphers of a nation, rather, a gathering of individuals still alive enough in their painted incarnations for us to feel at home in their company.

Such an ambition may fail. Walls may be covered with figures frozen in the postures of importance imagined by either the subjects or their portrayers; pictures in which the public persona has all but choked out of the countenance the spark of their long-gone vitality. Yet against the odds, in the hands of a sympathetic painter these figures come to life. Thomas Lawrence captures William Wilberforce, his pose bent not by the artist's instructions but by the dreadful iron contraption his deformed spine was obliged to endure. In the painting, left unfinished at Lawrence's death, the face of the hero is lit by the sweet animation almost everyone acknowledged. Likewise, the sublimely crazed Laurence Sterne is caught in a twist of his torqueing mind by Joshua Reynolds. The eyes of Harold Wilson, painted by Ruskin Spear, glance sideways through the curling pipe smoke as if there is something, or someone, the sitter ought not to miss.

These moments when actual people emerge from the paint are all the more impressive because, if we know one thing about the British, it is their perennial suspicion of the self-preening of the Great and the

Good. So what the gallery documents, and what comprises the true subject of this book, is not a parade of the grand but the struggle to magic from the triangular collision of wills between sitter, artist and public the palpable presence of a remarkable Briton.

Yet there are times when the three-cornered contest tears the subject apart and all that is left are lamented remains. One of those times was the autumn of 1954.

I
The Face of Power

1. The Face of Britain

'How will you paint me?' said the Prime Minister to the artist, immediately narrowing the alternatives: 'the bulldog or the cherub?'

'That depends entirely on what you show me ... sir,' replied the painter, trying not to be intimidated.

The signs were not promising. On this first visit he had been made to wait in Churchill's book-lined study before a nose appeared around the corner of the door. Just a nose, in advance of the famous face. In due course the rest of Churchill followed: rounder, pinker, flakier, wispier, jowlier than most people, including the artist, imagined. A softly cushioned hand was extended. A tiny starburst of merriment lit the old boy's eyes. Graham Sutherland tried to put himself at ease; to concentrate his attention on the matter at hand. It was not easy.

Sutherland had driven down to Kent in his Hillman Minx that September morning of 1954 anxious about what he had taken on. He could hardly have refused. It was a plum job; anyone in their right mind would have killed for it: to paint the portrait that would represent Parliament's gift to the most famous Briton alive or dead, on his eightieth birthday. There would be a televised ceremony in Westminster Hall. The eyes of the country – of the whole world – would be on Sutherland and his work. And as successful as Graham Sutherland had become, there was a large piece of him that craved the benediction of the mighty.

He had come out of Deep Britain, from some minor tier of what George Orwell, describing his own background, had called the upper-lower-middle class. Epsom College, not Eton College, had been his school. Denied the fashionable Slade for his art school, he had gone to the then more marginal Goldsmiths. But Graham Sutherland had a lot going for him. He was strikingly handsome, personable, urbane, and there was no question of his gift with the brushes. There was in him, in addition, a streak of the social romantic, almost obligatory for

artists coming of age in the 1930s. (He never told Churchill that he was a Labour voter.) When he left school he had taken a job in the locomotive works at Derby, his lunchbox slimy with engine grease. And as well as a budding sense of knowing a world beyond the twill and tweed of his class, Sutherland felt himself embedded in the English landscape. It was the subject of the etchings which made up his earliest work, alongside the commercial graphic designs he produced to put bread on the table.

His work was good enough to attract the attention of the grandees of the British modern-art scene: those who supplied prospects, connections and gallery space for shows. Hans Juda, a Jewish refugee from Nazi Germany, transferred his affection and his taste from his old, barbarized home to his new asylum, and patronized those whom he thought represented the best of contemporary British painting – in his view, John Piper and Graham Sutherland. The young director of the National Gallery, Kenneth Clark, was also among those admirers and, come the war, it was Clark, busy storing masterpieces in safe havens in Wales, who told Sutherland that he could best serve his country by joining the ranks of official war artists, a team which also included Stanley Spencer and Henry Moore. It was nothing to do with avoiding the war itself. Clark told the war artists that the country needed their work to record what it was going through and, for that matter, as a way to keep its collective chin up, and he was not wrong about that. Every so often their work was exhibited at the National Gallery. So Sutherland went off from his home in Kent to Do His Bit in Cornish tin mines and Welsh steelyards, but it was when he went to London during the Blitz that his modernism suddenly and spontaneously married up with his patriotism.

Like almost everyone in his generation, his vision, his working hand, his life, his sense of what art was supposed to do had been irrevocably changed by Picasso. It was especially the Picasso of the 1930s, when both the artist's sculpture and his painting heaped up tangled and broken forms, which imprinted itself on Sutherland as fitting for a time of destructive havoc. He was, in any case, drawn towards matter

that was both anciently eroded and brutally contemporary: tree stumps and half-extruded bones; the armoury of nature: thorns and pinnacles; claws and plumes: the roadkill of the modern world. There were times when the good-looking Englishman with the lively brush and the smooth talk was all ganglia and viscera, spikes and splinters. He didn't have to look far for inspiration. In London during the last months of the Blitz he was struck by 'the silence; the absolute dead silence, except now and then a thin tinkle of falling glass'. Amidst the flattened, smouldering, soot-fouled City streets and alleys about the miraculously still-standing structure of St Paul's Cathedral, he would, he said, 'start to make perfunctory drawings here and there and gradually it was borne in on me amid all the destruction how singularly one shape would impinge on another. A lift shaft, for instance, the only thing left from what had obviously been a very tall building . . . suggested a wounded tiger in a painting by Delacroix.' In the East End some houses had been sliced clean through: 'All floors had gone, but the staircase remained. And there were machines, their entrails hanging through the floors, but looking extraordinarily beautiful at the same time . . .' Disfigurement was all around him: a torn-up metropolis, the flayed skins of London pride.

A London *Guernica* was beyond him (though he venerated that painting). It was beyond anyone. What British modernists were doing instead – especially when they saw, as Sutherland did, in 1945, the first photographs to come out of the liberated concentration camps – were crucifixions: Passions of Christ. The nonpareil of these, *Three Studies for Figures at the Base of a Crucifixion*, was by Sutherland's friend Francis Bacon, to whom twisted torment came naturally. Sutherland, too, was commissioned to do a crucifixion, for a church in Northampton, and produced something using the language of traditional Christian devotional art – the collapsed ribcage; the spray of crowning thorns (bleached in Sutherland's image) – and frontally posed but overlaid with a patina of modernist gestures: a painfully hard ice-blue for a background.

It's impossible not to feel that Sutherland was looking over his

shoulder at the feverish brutality of Bacon as he did this; indeed, the two would stalk each other for many years until Bacon became dismayed by (or conceivably jealous of) Graham's co-option into the world of Clarkian connoisseurs and collectors. Whether or not he aimed for it, Sutherland emerged from the war years, despite all those shards and fractures, a painter of a user-friendly version of British modernism: brownish, lukewarm and a little diluted, like the ubiquitous cup of tea which, as far as the patriarchs of the London art world in its years of recuperation were concerned, he rather was. He was not as cerebrally abstract as Victor Pasmore or Ben Nicholson; he was not a clotted, mortary expressionist like Frank Auerbach and Leon Kossoff; not as playful as the loud boys of the Independent Group in Whitechapel, Eduardo Paolozzi and Richard Hamilton (godfathers to a genuinely new British art). It wasn't that Sutherland aimed to be safe. If the work called for jagged and torn, like a crucifixion, he would do it. It was rather that he saw no special virtue in confrontational obscurity.

Along with his startlingly beautiful wife, Kathleen Barry, Sutherland was an accomplished social animal, giving off waves of easy charm, smartly articulate; just the ticket for Kenneth Clark, who, along with Juda, helped organize his first shows in London. It may have been that Sutherland at this point felt almost smothered by Clarkian benevolence. When Graham told 'KC' he was thinking of going to the Côte d'Azur, Clark frowned on the idea: 'You can't imagine Constable on the Riviera.' But Sutherland had no wish to be a latter-day Constable. Francis Bacon was there, and hardly seemed to have suffered painter's block. Sutherland's gods and heroes – Picasso, Matisse, Braque and Léger – all worked in drenching light. (He would get to meet the first three.) Off he went with Kathleen, staying first in a hotel, then moving to a villa owned by the mother of one of his well-heeled Chelsea friends. Clark may have tut-tutted about Sutherland losing his edge amidst the basking geckos, but he nonetheless supplied him with introductions to the Great and the Good.

Among them was the grand old man-monster of British letters 'Willie' Somerset Maugham, padding around in a silk dressing gown among

4

the gold buddhas of his Villa Mauresque. Maugham knew all about Graham Sutherland and liked the sound of him. A lunch invitation arrived; and since Graham and Kathleen were now established in Villa Fiorina, they could return the favour without too much embarrassment. At some point – according to one source – Sutherland is said to have remarked while looking at the picturesque ruin of Maugham's face that, were he ever to turn to portraits, the author was the sort of subject he would love to paint. This got back to Maugham, who then took him up on the notion. At that point Sutherland had had no experience of portraiture whatsoever, though when Kathleen drew some feature of Maugham on a napkin, he is said to have corrected it. It wasn't really his thing at all, he told Maugham, but when the writer persisted, Sutherland relented, on the strict condition that the work was to be treated as an 'experiment'. Either party was free to hate and reject the result.

It turned out to be the most powerful thing Sutherland had yet done. On the broad acres of Maugham's face he had caught an air of monumental self-satisfaction; a curl of the lip just short of a sneer. Asked about his style of portraiture, Sutherland observed that two approaches were possible. The first was Picasso's, which was to make a free 'paraphrase' of the subject, in which, nonetheless, some likeness had been preserved; the other was just to paint what was before one. His own way was the simpler one: 'to make as clear a presentation as one's efforts allow for what one sees in front of one's own face'. 'But,' he added, 'I think if one does that, sometimes the thing comes full circle, because if the thing is intense enough in itself it becomes a kind of paraphrase.'

'The first time I saw it,' Maugham said, 'I was shocked. Really stunned. Could this face really be mine? And then I began to realize that here was far more of me than I ever saw myself.' Then came the accolade that every portrait painter wants to hear: 'There is no doubt that Graham has painted me with an expression I have sometimes seen without being aware of it.'

Had Sutherland nailed something about the sitter that was more

'real' than any mechanically descriptive likeness could convey? Plenty of people who counted in the art world of the 1950s thought so, especially when the painting went on view in London. New offers came the artist's way, including a summons from one of Maugham's neighbours on the Côte d'Azur: the Canadian newspaper mega-tycoon Lord Beaverbrook. He was installed in true tycoon style at Cap d'Ail, where his old wartime boss Winston Churchill would often come and settle down with straw hat, easel, brushes and paint. Sutherland gave Beaverbrook the same unsparing attention – many sittings, careful sketches with both pencil and brush, elaborately gridded transfers from those studies to the canvas. The sitter, in his inimitable way, was happy. When Beaverbrook set eyes on the result he gave Kathleen one of his lizard grins. 'It's an outrage,' was his comment, 'but it's also a masterpiece.' The art critic Quentin Bell resorted to amphibian rather than reptilian analogies. Sutherland, he wrote, had managed to make Beaverbrook look like a 'diseased toad in methylated spirits'. It was high praise.

Maugham advised Sutherland that now he had painted him and Beaverbrook he had best not chance his arm. Best give it up, dear boy. That was not going to happen. In the early 1950s Sutherland rode a wave of giddy fame. There were shows at the Venice Biennale, in London and New York; commissions to design costumes for Frederick Ashton's Royal Ballet and prints for Hans Juda textiles; a massively opaque work supposedly evoking *The Origins of the Land* for the Festival of Britain in 1951. He was now firmly enthroned among the mighty of British modernism; mentioned in the same breath as Henry Moore, Jacob Epstein, John Piper, Barbara Hepworth and the *enfant terrible* Francis Bacon.

So Graham Sutherland was perfect for the Churchill commission: forthright but not brutal; figurative but not fuddy-duddy. When one of his friends, the Labour MP Jennie Lee, sounded him out on behalf of the all-party Parliamentary committee handling Churchill's birthday celebrations, he could hardly back away. He had been a war artist; he had done his best for the Festival of Britain. This was another task

to be tackled for the country, as much as anything else, as the painting would end up, after Churchill's death, on permanent display somewhere in the House of Commons. Duty called. Also fame. So why could he not shake off the mixed feelings?

Sitting in Churchill's study at Chartwell, Sutherland saw what he would be up against. To bring the picture off there had to be a shared understanding. Churchill had to have an open mind about the result; Sutherland had to paint with confidence just what was in front of him, without being cramped or paralysed by the weight of National Expectations. But he could not escape the sense that all of Britain was wanting an image that would embody everything that Churchill had meant during the war: the national saviour without whose resolve they would have ended up like France, crushed by shame and occupation. The portrait Parliament and the people wanted was not just a likeness of a man, it was supposed to be an apotheosis of Britain itself: the finest hour in the form of the finest man. When this sank in, Sutherland knew he could not live up to this cult of national salvation. All he could do, he kept on telling himself, was paint what he saw. Then the bigger thing – the 'paraphrase' – would happen. Or not.

Being taken around the House of Commons to explore where the picture might eventually hang did not lighten this sense of burden. Nor did Churchill's well-intentioned efforts to give Sutherland the best possible working space, namely his own studio; for this already implied some sort of deference not just to the Great Man but to Churchill, fellow artist! In a letter setting the date for the first sitting, Churchill laid out all the advantages of his studio: blinds to control the intake of light; the low dais on which he would sit. It was kindly done but, as Sutherland followed Churchill down the garden path and came into the studio, lined with Churchill's own paintings, he realized with a rising sense of panic that the old boy evidently thought of the whole project as a collaboration between peers and equals. (Much taken with Kathleen – everyone was – Churchill offered to paint her portrait in return.)

There is no question that Graham Sutherland, even with just a few

portraits under his belt, had already an exceptional talent for the genre. Later portraits – a brilliantly droll profile of his mentor Kenneth Clark, a study in beaky self-contentment; a gloriously lurid Helena Rubinstein; and the abundantly fulsome frame of Arnold Goodman – are some of the best of the post-war years. But for this particular assignment, technical talent was not enough; he also needed a grasp of the national psychology of the occasion: what it was bound to mean not just to Churchill and Parliament but to the whole country, for whom the televised ceremony would function as an act of collective gratitude. It would be a moment of national bonding in an uncertain time, akin to the coronation of the young Queen which had taken place just the year before. In these circumstances, Sutherland's purist insistence that he would paint 'just what he saw in front of him' was arrogantly naive. None of the great portraitists – not Titian, not Rubens, not Rembrandt, not Goya, not Reynolds, not David, not Sargent – ever painted their subjects as if there were no history attached to them; or without some consideration of where the picture would end up. The adhesion of history (as Jonathan Richardson had explained) was not something to be avoided: it *was* the sitter; it had shaped them mentally and physically. Sutherland could not simply stare at Churchill and trace this feature and that as if he were a figure arbitrarily plopped down in front of him that autumn of 1954. It was not a question of choosing between the man and the icon. By this stage they were indivisible. In fact, there never had been a time when the public, political Churchill was separated from the private, personal Winston, certainly not at this particular moment.

In medieval thought on monarchy a distinction was made between 'the king's two bodies'. The body natural endured all the ills and indignities that time visited upon it; the body politic, on the other hand, for the sake of the state, had to be imagined as immune to infirmity. Something like this was very much on Churchill's mind as he approached the sittings with Graham Sutherland. In July 1953, during the course of a dinner for the Italian Prime Minister in which Churchill's exuberance (on the subject of Caesar) had been in full play, he had suffered a major stroke. The disaster was kept secret from the country

and, to the happy astonishment of his inner circle, Churchill made a recovery so swift, and apparently so complete, that there seemed to be no reason why it should ever be made known. But Charles Moran, Churchill's doctor, was now always on hand and, to him, the Prime Minister admitted that he thought he had lost a little of his mental sharpness. It was, in fact, hard to judge how much the old man's faculties had been damaged since well before the stroke (even, if the critical diaries of Alan Brooke is to be believed, during the later stages of the war); Churchillian alertness was already suffering from daily dosages of cognac and Havanas. Those who looked carefully at the famous face, whether in cherubic or bulldoggian mode, might have seen in a slightly closed left eye the physiognomic trace of the attack.

It was not vanity that was making Churchill nervous about the portrait (though what politician has ever been entirely free of that?), but history. His famous quip that he knew history would be kind to him because he would write it himself came home to him when he contemplated what the story of his last years would look like to those who would chronicle it after he was gone. He himself was at work writing the later volumes of his *History of the English-speaking Peoples*. After the brutal shock of rejection by the electorate in 1945, his second prime ministership, beginning in 1951, came as vindication. It also had come at a time when the terrors of the Cold War, and Britain's uneasy position between the United States and the Soviet Union, had become unsettling. Though Churchill had resigned himself to the hard fact that, henceforth, America would be very much the senior partner in the alliance, he fervently believed that there was no one in British political life – certainly not his likely successor, Anthony Eden – who could navigate a course between the superpowers with as much authority and experienced wisdom as himself. So when a new and even more apocalyptic weapon, the hydrogen bomb, was tested, Churchill saw himself as indispensable to the fate of his country and, indeed, the peace of the world.

He needed to be seen as such, he thought; not as some doddery old duffer in a siren suit, nodding off over a snifter. While he acknowledged that he must at some point go, he was determined that he should

not be hustled out of the door by colleagues in his own Cabinet and party. Much turned on the timing of Churchill's resignation, since the next General Election could be no later than 1956. It seemed reasonable to many in the Cabinet – R. A. Butler and Harold Macmillan, as well as Anthony Eden – that Conservative prospects would be better served by Churchill going sooner rather than later. That way, Eden would have time to stamp his independent authority on government and the country, and the party would be in better fighting shape at the polls. By the spring of 1954 there had been warning signs against allowing the old man to soldier on. He had faced a storm of barracking and shouts of 'Resign!' from the Labour benches when he attempted to put a brave face on the chilling fact that, notwithstanding his friendship with President Eisenhower, the Americans were not going to permit joint control over the H Bomb. It was not so much the government's position about this which made the Tory front bench uncomfortable as the unaccustomed sight of Churchill failing to defend himself with his usual feisty counter-attacks. Instead of giving as good as he got, delivering the odd growly-chuckly one-liner, he ploughed relentlessly on with his dim speech, shuffling the pages as the din rose to uproar. The hyenas could smell blood and were beginning to laugh.

Churchill was not so obtusely self-obsessed that he could not see the force of the 'sooner rather than later' argument, though at one point he complained to Moran that Eden was not exactly a spry young thing himself and kept sending him 3,000-word memos containing 'nothing'. But he often reverted to his conviction that, with the international crises at hand – the fate of the Suez Canal, where the Egyptian government was beginning to make noises about nationalization, and the nuclear-armed Cold War – the party would be better off moving into election mode under his continued leadership. It all depended which Churchill greeted him in the morning mirror: the pink-faced, merry-minded, assertive leader or the exhausted old man.

Churchill procrastinated. He informed his colleagues that 18 September 1954 would be the day of his resignation. Then, over the course of an exacting trip to the United States, he thought better of it. Who

else could deal with John Foster Dulles, or Ike, or for that matter the post-Stalin Soviet leadership?

For all these reasons, the face that would appear in the portrait assumed a significance well beyond that of a birthday present. It had to be an image of his body politic: 'the rock', as he told the painter when he started to sketch. Sutherland later remembered that Churchill repeatedly – and indiscreetly – told him about the manoeuvres against him in the Cabinet and his party and the ill-advised efforts to get him out of the way; affronts he took personally as well as politically. In fact, Churchill grumbled constantly to Sutherland during their sittings about the attempts to push him out of Number Ten. Churchill may well have thought to himself, He's a clever man; he will understand what is needed here. But the painter had a political tin ear. He just carried on sketching. That the portrait had now become a crucial weapon in Churchill's resistance to his own demise didn't occur to him until after the disaster had unfolded. The stakes now could not have been higher. Churchill did not want his eightieth birthday to be some sort of ceremonial farewell, still less for the painting at the centre of it all to have a valetudinarian quality to it. What he evidently wanted was something akin to the photograph by Karsh taken in 1941 by which he was best known around the world: the picture called *The Roaring Lion*.

And authoritative dignity – he wanted that, too, especially since the presentation was to take place in the vast theatrical space of Westminster Hall, the common possession of Parliament and nation, beneath the hammer-beam roof commissioned by Richard II. So he told Sutherland that he ought to paint him in the robes of a Knight of the Garter; even though the Parliamentary Committee had specified that he should be commemorated as he had always been seen in the Commons: spotted bow tie, striped trousers, waistcoat and jacket. When Sutherland pointed this out, Churchill pouted through his cigar, shrugged and consented.

Though Sutherland later said (of Churchill's opening remark) that all he got was the bulldog, the back and forth between the two of them during the sittings was not combative. Churchill, the painter said, was

charming and often very kind. For her part, Clemmie, Lady Churchill, fiercely loyal and nervous lest the painting displease her beloved Winston, was almost girlishly taken with the artist. On 1 September she wrote to her daughter Mary that 'Mr Graham Sutherland is a "Wow". He really is a most attractive man and one can hardly believe that the savage and cruel designs which he exhibits come from his brush. Papa has given him three sittings and no one has seen the beginnings of the portrait except Papa & he is struck by the power of his drawings.'

None of this meant that the sittings were going to be easy. Churchill frequently arrived late, shifted his bulk about, fidgeted and, after lunch with the usual libations, could slump into drowsy torpor. 'A little more of the old lion,' Sutherland would say, as tactfully as he could. As the sittings went on, the painter became concerned that the truncated sessions would not give him the complement of studies he needed for the painting. So he supplemented his sketches and oil studies with photographs taken, first by the *Picture Post* journalist Felix Man, and then by Elsbeth Juda, the wife of his friend and patron Hans Juda. Her contact sheets have survived and are a rich document for recreating what those momentous sessions in autumn 1954 were actually like. Some were reassuring: Churchill walks around the garden, gallantly escorting Kathleen and Graham, smiling. But then, in greater number, he is seen brooding grimly as if the black dog of depression, or possibly the yapping Eden, could not be shaken off. But the low angle at which Elsbeth Juda's photographs were taken, after instruction from Sutherland, make it clear that, while the painter claimed to be painting just what he saw, he had a very decided idea in his head. He later said that he wanted to paint Churchill 'as a rock'. But he ended up turning him into a man-mountain: weathered, glacial and steep. Churchill's face, with the right eye oddly half closed, peered down, rather than addressing the viewer front on at eye level as in the pose Sutherland had set for Maugham and Beaverbrook. At that angle, Sutherland must have known it was difficult, if not impossible, for Churchill not to appear forbidding. On 17 October Winston's daughter-in-law, June, saw the progressing portrait and pronounced it 'brilliant, quite alarmingly like

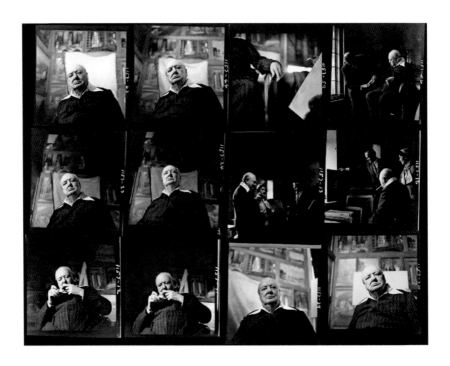

Winston Churchill, Kathleen Sutherland and Graham Sutherland, by Elsbeth Juda, 1954

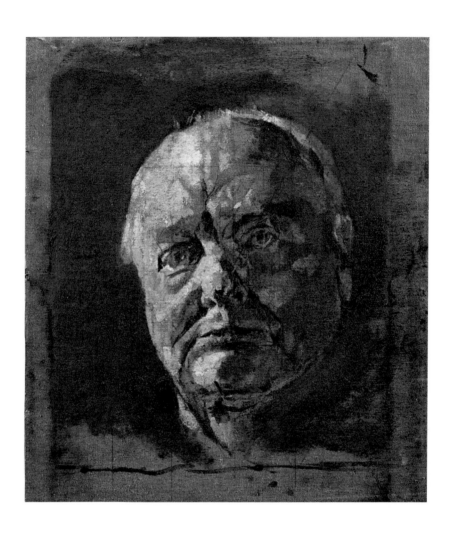

Winston Churchill, by Graham Sutherland, 1954

him . . . so alive one feels he might suddenly change position and say something. But something pretty beastly, I should think. I wish he didn't have to look quite so cross, although I know he often does.'

The portrait was already getting mixed responses. On first seeing the work in progress at Saltwood Castle, his home, Kenneth Clark declared it was like a 'late Rembrandt'. Two weeks later, at the end of October, comparisons with the Masters had faded. Clark was worryingly tight-lipped, allowing only that it was the best portrait Sutherland had yet made. Winston's son, Randolph, as blunt as his father, took one look and said right away that his mother was not going to like it. On 13 November Sutherland and Kathleen drove to Chequers for a lunch party. He had given Churchill the distinct impression that he would bring the painting with him for a first look. When this turned out not to be the case, Churchill took umbrage with the man whom he had come to believe was comrade-in-brushes and personal friend. When he asked Sutherland what the painting was like, the artist misleadingly told him that he was seated with his 'head looking up'.

The moment of truth was at hand. On 20 November, just ten days before the presentation (and far too late to make any significant alterations), Clemmie was to see the painting. Sutherland was beside himself with nerves, and shipped in Somerset Maugham to warm her up. Generously, Maugham volunteered to accompany her for the initial viewing and then signal if all was well. The light was green, so it seemed. 'I can't thank you enough,' she said to Sutherland through tears; though what those tears signified was another matter entirely. At any rate, Clemmie liked the painting enough to ask Sutherland for a photograph which she could take to Winston. It was duly given.

The response from the subject was not long coming. The next afternoon a driver delivered it. Handwritten, it was politely shattering.

My dear Graham Sutherland. Thank you for sending me the photograph.

Personally, I am quite content that any impression of me by you should be on record. I feel, however, that there will be an

acute difference of opinion about this portrait and that it will bring an element of controversy into a function that was intended to be a matter of general agreement between the Members of the House of Commons, where I have lived my life. Therefore I am of the opinion that this painting, however masterly in execution, is not suitable as a presentation from both Houses of Parliament.

It was sad, he added, that there would be no portrait at the Westminster Hall ceremony, though he knew that a 'beautiful book' was going to be presented. It had been 'a great pleasure' meeting Sutherland and at some time hence, 'when the pressure has abated', perhaps they might talk over the picture together?

'It was,' said Kathleen, 'the worst day of our life.'

Panic broke out. Sutherland phoned the secretary of the commissioning committee, Charles Doughty, who drove straight away to Chartwell to persuade Churchill or, if need be, lay down the law. There could be no question of the painting not being presented as planned, as it was Parliament's gift, paid for by the Members. Whatever Churchill thought of it (and it seems that Doughty quite liked it), he must stifle his dismay to make the occasion the one that the whole country was expecting. He must not poison the well of gratitude. Churchill accepted he had no choice in the matter but was bitterly unreconciled, feeling that he was about to be humiliated before the biggest public imaginable. 'It makes me look half-witted, which I ain't,' he grumbled to Doughty. 'How do they paint today? Sitting on the lavatory?'

For the next week, as the painting moved to Downing Street and then to the Ministry of Works and was framed in preparation for the great day, Churchill made sure to let everyone who would listen know how much he hated the picture. It was probably hardest on Clemmie, who was distraught to see her husband feel so angry and wounded by a depiction that had turned him into a 'gross and cruel monster'. Her distress was such that she was determined that, following the birthday moment and the painting's delivery to Chartwell, no one, especially

not Winston, would ever have to look at it again. She would commit pictocide. For Winston; for Britain.

Came the day of reckoning: a packed Westminster Hall, the BBC cameras rolling. Sutherland, tight-lipped, resigned to the ordeal, was seated behind Churchill. The painting, like a condemned prisoner, all five feet by four of it, sat shrouded on an easel. There could hardly have been a greater sense of national occasion. Churchill was heralded by a military drumroll beating out 'V' for Victory in Morse code. As the Prime Minister descended the steps to his allotted place in the front row, Charles Moran was aghast to see his right leg shooting out in front of him, though miraculously not landing in such a way as to cause him to fall. There was a flowery, gracious, full-hearted speech from Clement Attlee, the Leader of the Opposition, who made the most of Churchill's defiant resolution at the testing moment of the war, remarks perhaps thoughtfully calculated to chime with the expression that Sutherland had given him in the portrait. Churchill rose; the mischievous cherub rather than the grim hound on his round countenance. He was, when all was said and done, the birthday boy. He began to speak: 'I doubt whether any of the modern democracies abroad has shown such a degree of kindness and generosity to a party politician who has not yet retired and may at any time be involved in controversy.' The pauses were mercilessly brilliant theatre. Then came the studied moment of revenge, even more lethal for being thinly disguised as good fun. 'The portrait is a remarkable example of *modern* art. It certainly combines force and candour. These are qualities no member of the House can do without or should fear to meet.'

A gale of uproarious hilarity swept through the hall. For very many people, 'modern art' was anathema: bewilderingly ugly; incomprehensibly, perversely displeasing. Here was another example of its excesses, perpetrated on the greatest Briton that had ever lived. Trapped in his seat, Kathleen beside him, the hapless Sutherland was mortified; a figure of sudden ridicule. With the laughter ringing in his ears, he attempted a sporting smile. Kathleen did not. A minute later the BBC camera caught Sutherland's eyes rolled upwards in true torment.

Somehow, on a day that was meant to have been a triumph for both of them, artist and subject had become the walking wounded. Both would get over it; neither would ever forget or forgive.

Not everyone felt this way. Nye Bevan and Jennie Lee thought the portrait a masterpiece and, in general, the Labour ranks liked it, just as many (though not all) of the Tories hated it, thus confirming Churchill's prediction that the painting would cause contention rather than unity. Lord Hailsham told the papers that he thought it should be thrown in the Thames, while the tabloids competed in howls of execration and proposals for destruction. Disgruntled members of the public made their voice heard in the letters columns. For a while the doomed object went to the Churchills' town house at Hyde Park Gate, where some of the great figures in British art, among them Ben Nicholson and William Coldstream, got to see it; and were almost all struck by its power.

Something had been lost in all the shouting: the possibility of seeing the portrait on its own terms rather than how far it might, or might not, have corresponded to the public image of Churchill as both exuberantly humane and politically formidable: the warrior who saved Britain with rousing good humour as well as unshakable resolve.

That, to be sure, was not the Churchill Sutherland had delivered. But he had never seen his task that way. Of course he knew the difference Churchill had made to British history; that he was one of, if not the greatest of all Britons. Yet he could not concoct an icon which summed all that up, the 'history of a man' that the Richardson formula called for. He could only paint what he saw, he kept telling himself. But this was not quite honest either, for he had witnessed plenty of the old man's magical charm, as much as his obstreperousness and bat-flights of grim melancholy. What he produced instead was a study in adamant.

And yet, what a study it was! All that we have left to judge its quality by is a transparency, since the Churchills' loyal private secretary, Grace Hamblin, took matters into her own hands and burned the original on a bonfire lit in her brother's back garden several miles away from Chartwell. But the surviving image is enough to make it painfully clear what was lost in the fires of Lady Churchill's sorrow and anger.

Winston Churchill, by Graham Sutherland, 1954

With the exception perhaps of the paintings of the Duke of Welling-ton by Goya and Thomas Lawrence, Sutherland accomplished the most powerful image of a Great Briton ever executed. It is not an ingratiating portrait. The bright colour of the Churchillian personality did not reg-ister in its tone. Colour, as his critics, such as Patrick Heron, pointed out, was not Sutherland's forte. A sour yellow ochre predominates, stained with a still-less-cheerful umber. Churchill is enthroned, but the majesty summoned in the picture is not the Henry V of the Prime Min-ister's speech allusions to the 'few' but rather Lear, albeit the truculent rather than the unhinged monarch. But the reason that the painting did find admirers during the brief time it had in the public view was that the bulk of Churchill, the set quality to the jaw, the expression of obdurate resolution, all added up to the immovable force Britain had most needed during the war. The picture had majesty; what it did not have was warmth: the warmth that came from the great love Churchill had for his country, for its Parliament, for the entirety of its history. It was as though none of that was of the least relevance or concern to the painter. Art, the unclouded eye, must, apparently, override sentiment.

Charles Moran, who was one of those full of mixed feelings, neither infuriated nor especially appreciative, and who knew better than any-one the state and degree of Churchill's decaying old body, thought Sutherland had not *looked* hard enough. Or, rather, he had looked and, despite professing purely to transcribe what he saw, selected according to the concept of the old lion/ eroded-rock notion which had become an *idée fixe*. The result was a kind of petrification. The physician's eye, habituated as it was to looking his patient over, now proceeded to dissect, anatomically as well as psychologically, just what was wrong with Sutherland's vision:

There is, to be sure, plenty of power and vigour and defiance – the coarse features that Graham Sutherland has drawn – but they do not belong to Winston Churchill. Look again at him as he is in life. Take your eye away from the fleshy folds of the jowl and look again at the bony structure of the lower jaw. It is delicate, almost

feminine, in its contours; where there is massive moulding in the brow and skull the artist has given us only an eggshell. The lips, too, though they often pout, are delicately moulded; in short, the coarseness and the force in the portrait are only part of the artist's romantic conception of a man of wrath struggling with destiny. It is not Winston Churchill.

Who was to say, though, what the look, the aspect, of the 'real' Churchill was? Licking his wounds, Sutherland later brooded that perhaps he should not have taken on a work that could never meet the expectations of the whole country (who, much as they cherished him for the war leadership, were not necessarily united in unqualified adoration). Sculpture was perhaps the easier medium. Almost exactly a year after the debacle, Oscar Nemon's statue for the City of London was unveiled at the Guildhall, where it was to stand. Everyone loved it, especially Churchill himself, who, in glaring, obvious contrast to the dire event of the previous year, went out of his way in his acceptance speech to say how much he admired it because it was 'a good likeness'. Laughter again. Everyone remembered.

Sutherland went on to become one of the great portraitists of modern British painting, but none of his studies ever had the raw, uncompromising truth of the Churchill. It was as though, deeply scarred by the disaster, Sutherland had decided to study not just what he saw in front of him in terms of folds and creases of skin but the inner perception his sitters had of their own presence. If he could meet them at least halfway to that perception, his integrity would be undamaged. It was as though his handsome paintings of Kenneth Clark, Helena Rubinstein and Arnold Goodman were the result of cordial conversations. Churchill had in fact thought that this was the way things had gone between him and Sutherland, but all the painter saw was growling bulldoggery.

But then, perhaps the commission had been, from the very start, a poisoned chalice. After all, how do you paint a saviour?

2. Saviours

Arthur Lindley discovered the Saviour underneath the wallpaper in 1953. He stood frontally, the right hand making the two-fingered blessing, the left holding the orb surmounted with a cross: *Salvator Mundi*, Christ himself in supreme majesty.

Lindley owned and ran a service garage situated next door to a row of cottages, set back a little from the lane. That end of Hertfordshire had had a busy war, what with the de Havilland aircraft works at Welwyn. There had been some sprawl; Londoners coming out to Knebworth (my parents among them), Letchworth and St Albans. But Piccotts End had stayed much the same: fields and hedgerows; All Saints Church; a couple of timbered pubs. There were still barns, and the odd farm, and dozy cattle up to their knees in cow parsley and nettles. And there was that line of old, gabled houses which everyone knew were 'historic', though not for the reasons as yet slumbering beneath the wallpaper. Local historians liked to say, with whatever nuance, that Piccotts End was where the National Health Service had really begun. What they meant was that it had been the home of Britain's first cottage hospital, back in the early nineteenth century. In 1827 the squire, Sir Astley Cooper, had set it up to offer, entirely *gratis*, the services of an infirmary and an occasional surgeon to repair broken bones or extract dangerous growths. Every so often someone came across a claw-hooked instrument or a small saw amidst the dust and fallen plaster. Moved by the traces of benevolence, Arthur Lindley began collecting old medical instruments and opened a little museum.

Lindley's business had done well enough for him to be able to buy the cottages, since it now occurred to him that, together with the Georgian house at the other end from his garage, he might make them into a nice terraced row. He would take one of the houses; the rest might be sold to some party coming and going from a City job via Hemel Hempstead station. After he bought the row he began to look

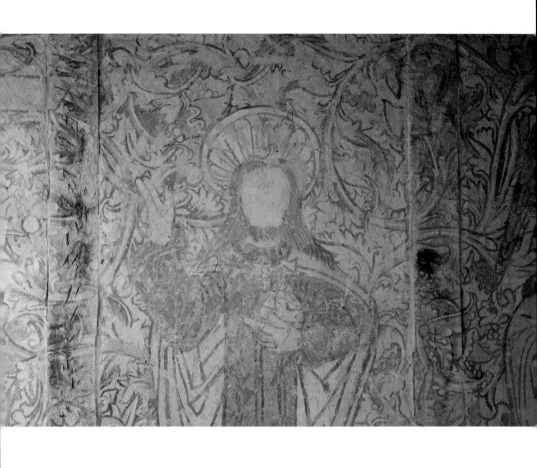

Piccotts End Wall Painting, late fifteenth century

at the condition of the cottages, starting with the one at the eastern end. It was, as he thought, in a bad way, but when he peeled back the thick layer of linen- and canvas-laid wallpaper, discoloured by the elements through years of abandonment, Arthur Lindley saw timbers, which, keen amateur historian as he was, he thought looked a lot older than eighteenth century: dark, a little worm-holed here and there, but anciently stout. There was something under there; something interesting to the likes of him.

So before he had exposed the whole underwall in that first cottage, Arthur Lindley went along to the next in the row, beginning on the upper floor, where, in the time of Sir Astley Cooper, there had been hospital beds. Working with a fine-edged chisel, he peeled away the skins of many layers of paper. Sodden flakes of it fell to the floor. Beneath the paper was a layer of plaster, cracked here and there, and underneath that some old boarding. As that, too, was picked away, earwigs scuttling down the surface, the Saviour appeared, his robe the bright red of freshly shed blood. All around him was a profusion of ferny vegetation, as though the Lord's death had made the ground fruitful: the abundant botany of salvation – coils and tendrils, vines and flowers, roses and lilies, acanthus and gillyflowers, and blooms entirely fantastic. The Christ was set between wooden divisions but the painted decoration continued over them and seemed to travel right through the floor, which made Arthur wonder whether or not, at the time of the painting, the chamber had been two storeys or one.

When Arthur uncovered the ground-floor wall he saw that his guess had been correct. Originally, the room had been a single undivided space all the way to the timbered vault ceiling. And he saw much else besides: a great unified spectacle of Christian piety. Down below, pictures of two female saints appeared. St Catherine he recognized from the wheel on which her body remained unbroken and the sword that finished her off. The other woman turned out to be St Margaret; both were set in the burgeoning decorative garden.

The British Museum was called in, though, before he did that, Arthur Lindley uncovered the rest of the vivid imagery that had lain

for centuries beneath the boarding and plaster: a Baptism of Christ, with St John wearing a camel's-hair coat (though not the kind you could buy at Austin Reed). This was the prototype, with actual dromedary attached, the big-eyed face of the animal trailing the ground, looking permanently surprised. There was a winged archangel holding the robe of Jesus; two saints, St Peter and St Clement, each wearing the triple tiara of the Pope. And there was a pietà, the Virgin costumed in the same Piccotts End uniform of red ochre, rather than the usual blue. The body of her son, whom she was holding in her arms, showed puncture wounds, spurting, as was the style, little sprays of blood. Standing back, Arthur tried to take in the full force of the revelation. But this was hard, because, with the exception of the baptized Christ, eyes closed, summarily delineated, every sacred countenance had been de-faced.

It was not difficult to reconstruct when this obliteration had taken place. The 'pedimented' or 'gabled' headdress of the two female saints dated the painting firmly in the early Tudor period, most likely late fifteenth century. The last decades of Catholic England witnessed a great flowering of Christian imagery at exactly the moment when it was beginning to be attacked by reforming iconoclasts condemning its 'idolatry'. But most of this imagery – in sculpture and stained glass as well as in painting – decorated churches. Piccotts End was evidence that the appetite for sacred imagery had spilled over into non-ecclesiastical buildings as well. Not that it was separated from the world of Christian piety. The village lay between two pilgrimage sites: that of the first English martyr, St Alban, at the town bearing his name, just six miles off; and, ten miles in the opposite direction at Ashridge, a priory of the Boni Homines, monks who practised the severe rule of St Augustine and who had in their custody a relic of the Sacred Blood of Christ.

This had been given to them in the thirteenth century by a nephew of King Henry III, Edmund, 2nd Earl of Cornwall. In 1247 the King had processed through the streets of London bearing relics which had been passed to him by the Patriarch of Jerusalem in an ultimately

unsuccessful attempt to persuade Henry to participate in a new crusade. The relics had been divided into three: one remained in Westminster Abbey (the redesign of which became the consuming project of the King's life); another went to the Cistercian Hailes Abbey in Gloucestershire; and the third to Ashridge, where it became the focus of a fervent east Hertfordshire cult. The cottage at Piccotts End became a lodging house for pilgrims travelling between the two holy sites. The great murals were painted over a thin layer of limewash which covered a wattle-and-daub wall and they looked down on the company of pilgrims as they ate and said their graces and complines.

This was enough to attract the hostility of the reformers of the 1530s, who were busy liquidating monasteries, especially those holding the relics they scorned as profane trickery, maintained to deceive and enslave the credulous. Using the attack on images written by the Strasbourg reformer Martin Bucer, Hugh Latimer, newly appointed Bishop of Worcester, and Thomas Cranmer, Archbishop of Canterbury, launched a ferocious onslaught on such images around 1536. Henry VIII's separation from Rome and his elevation to the head of a Church of England meant that this became royal policy. In order to avoid the excesses of destruction that had taken place in Europe, the Ten Articles setting out the core doctrine of the Church of England allowed for the preservation of some images, always provided they were not objects of worship and veneration. The nice distinction proved difficult to uphold, especially in the face of reforming zeal. The gaze of Christ, the Virgin and the saints, simultaneously the look of forgiveness and justice, and the association, at least in the popular mind, of those faces with the working of miracles and intercession for sins, were especially suspect. Beginning in 1536, Thomas Cromwell instigated a campaign against objects and images said to be sacrilegious. Egregious relics such as those of the Holy Blood at Hailes Abbey and the Rood of Boxley, which had movable eyes lit by candles, were prime targets. A propaganda ballad made fun of the rood: 'He was made to jogle/ His eyes would goggle/ He would bend his eyebrowes and frowne/ With his head he would nod/ Like a young god.'

The figures of the Piccotts End lodging house would almost certainly have been de-faced at some point in this initial attack on pilgrim cults. And it may be that, of all the faces, only that of the baptized Christ was spared, precisely because the Saviour's eyes are shown closed and thus make no direct engagement with the beholder. Because Henry VIII's conservatism put the brakes on the most radical destruction of the Reformation, the images, with their de-facings, might have stayed in sight. Without the custom of pilgrims, the lodging house had lost its *raison d'être*, but it could have survived for a while as a wayside hostelry. It seems likely that the boarding and plastering which sealed up the paintings would have taken place in the second great wave of reform, under Edward VI around 1548, when any surviving images were subject to a more militant iconoclasm. Out came the brushes and the limewash, the plaster and the planks, and one of the great spectacles of pre-Reformation Christian England disappeared into its four-hundred-year sleep.

At exactly the same time that the look of this Christ in Majesty was being de-faced, another look was being devised for English majesty, this time for the monarch who was now God's deputy in his kingdom. There was a direct connection between these two events. As the de-facings were taking place, Hans Holbein the Younger was commissioned to produce charismatic images of the godlike royal presence. Holbein had been to England before, staying between 1526 and 1528, and had brought his beautiful profile of the learned Erasmus of Rotterdam as a gift for their common friend Thomas More. Holbein's accomplishments – a supreme talent for rendering the tactile quality of fabrics and the vitality of the human face, and an unerring ability to set figures in dramatic space – were enough to acquire him an important circle of patrons and sitters in London, ranging from the German steelyard merchants among whom he lived to high members of the clergy and, most significantly, the Comptroller of the Royal Household, Henry Guildford, and his wife.

None of this, however, was enough to put him on the royal payroll, and he returned, restively, to Switzerland. When he came back to

England in 1532, his old circle of patrons had been whittled away by death, or (in More's case) by suspicion. Holbein's alertness to changes in political wind direction did not fail him. A portrait head of Thomas Cromwell, posed in the same three-quarter profile he had used for More but facing left, while his adversary had faced right, was executed in 1534, while Cromwell was Chancellor of the Exchequer and Master of the King's Jewel House but before he had become Henry's Principal Secretary. The painting is a study in beady-eyed vigilance; Cromwell's face set in watchful severity. His left elbow leans on a table on which a handsomely bound book and a letter from Henry VIII rest. His dress, though richly fur-collared, is calculated to speak of modest simplicity. No massive chain of office lies upon his coat, as it had on More's. He is the very picture of duty.

Holbein was given the prize of the woodcut title page for Miles Coverdale's English Bible, the first complete translation of both Old and New Testaments. (William Tyndale's translation, which had been condemned to the flames by Thomas More, had encompassed only the Gospels and half of the Hebrew Bible.) Knowing the Coverdale Bible was as important politically as it was theologically, Holbein made the most of its comprehensiveness, setting images from the Old Testament to the left of the title, while placing those of the New to its right. Thus, Adam and Eve on the left line up with the Resurrected Christ (the Fall with Salvation) on the right; Moses' tablets of the 'old' law on the left with Christ preaching the new, superceding, gospel on the right. Most significantly of all, however, is the image of the enthroned Henry VIII at the foot of the page, handing the book – this very book – to a trio of mitred, kneeling bishops: the unquestionably supreme head of both Church and state.

While the Dissolution of the Monasteries was under way, Holbein was employed in the most spectacular of all Henrician paintings, a vast celebration of the Tudor dynasty, designed for the Privy Chamber at Whitehall Palace. After Cardinal Wolsey's fall the King had appropriated the sprawling palace and set about remodelling it as a house of royal business and ceremony. It was so designed that the person of

the King should be made as inaccessible as possible, except to the chosen few, so that when ambassadors were finally admitted to an inner sanctum they would be properly awed by the royal presence. The figure of Christ in Majesty currently being erased from churches and lodgings like that at Piccotts End, whether shown standing or enthroned, combined divine authority with the knowledge of compassionate sacrifice, embodied, literally, in the tormented and broken person of the crucified Saviour. Henry VIII's body, as presented by Holbein, was bull-like and Jovian, the King's legs lengthened, his chest expanded by shoulder-extending, padded costume, to project an aura of massive invincibility.

The painting was lost in the fire which consumed Whitehall Palace in 1698 and is known in its entirety only from a copy made by Remigius van Leemput, commissioned by Charles II in 1667. It shows that, beyond anything else, the painting was meant as a statement of Tudor legitimacy and perpetuation. Behind the King and Queen Jane Seymour, who provided the male heir Henry had been desperately seeking, are depicted his father, Henry VII, and that monarch's queen, Elizabeth of York: the union which ended the long English civil wars. The portrait of Henry VII was largely recycled from the version painted by an unknown Netherlandish artist in 1505: he looks lean-cheeked, watchful and vaguely learned. But that was a half-length, as were nearly all portraits of English kings when they were not mere head and shoulders (with the exception of Richard II, whose enthroned godlike presence was stationed for a while in Westminster Abbey).

But the beauty of the portrayed Richard II lay in his slender Gothic elegance; angelically ethereal. Holbein's Henry VIII, known from the artist's preparatory drawing, or cartoon, is the opposite: a hulking, meaty mass of physical force, posed in a manner completely unprecedented for a king or an emperor. There had been other famous standing figures: Titian's of the Habsburg Emperor Charles V, for example, – but it was self-contained in its dignity. Henry's pose was theatrically demonstrative, facing the spectator down, hands on his hips as if threatening an oncoming adversary who might wish him or

his realm ill. In this guise he marshalled one of the parental looks to which all children respond: the immovable sturdiness of fatherly protection.

At this particular moment Henry was indeed a father. He was well into his forties, already corpulent, and had taken a bad spill in the tiltyard earlier in 1536 from which neither his gait nor his general health had quite recovered. But Holbein made him the image of virile power and, above all, an unstoppable engine of dynastic generation. The King's left hand grasps a dagger but, otherwise, none of the customary symbols of royal authority – sword, helmet, sceptre – are there. Instead there is something incomparably mightier: the royal codpiece, imposing and indefatigable, clothing the organ which had produced a prince. The whole composition, in fact, may have been painted to celebrate either the birth of Edward or else the advanced pregnancy of Queen Jane, whose homely, chinless features Holbein had also painted but who seems here to shrink beside the alarming bulk of her husband.

The cartoon shows the King's face, with its small eyes and withering gaze, in Holbein's favourite three-quarter profile. But the van Leemput copy of the finished composition has Henry front-facing, and it has been suggested that the change was made in deference to the King's own wishes, for he took an exacting interest in every aspect of the rebuilding and redecoration of his palaces. There could be no question of anything other than full-face power: the kind of look that would reduce incoming ambassadors and courtiers to a trembling jelly, and which even in the days of the informal and mostly affable Charles II would still send a shiver down the spine of all those entering the Privy Chamber. It was the kind of look which all by itself could decapitate your courage. Behold my codpiece and prepare to die.

The codpiece turned out to be optimistic. None of the three children who succeeded Henry managed to produce heirs. His son Edward VI, whose arrival Holbein's 'Greate Peece' at Whitehall celebrated, died at fifteen, before he could marry and beget a successor. Edward's elder half-sister Mary, who turned England back to Roman obedience,

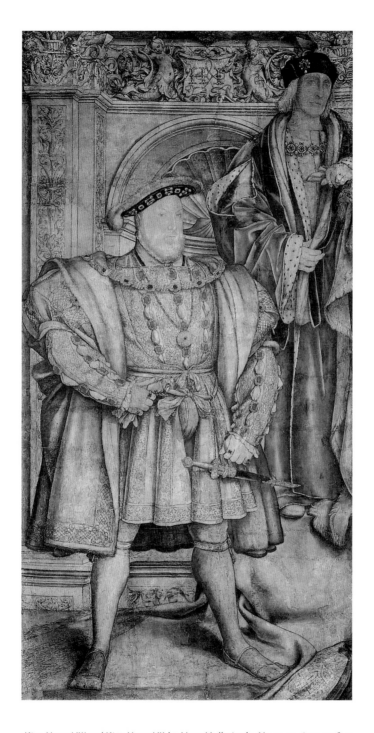

King Henry VIII and King Henry VII, by Hans Holbein the Younger, circa 1536–7

married Philip II of Spain, but had no children. Although, in the interests of political order and even survival, Philip attempted to contain the more ferociously punitive aspects of Mary's Counter-Reformation, she pressed on relentlessly with trials, burnings and the restoration of the old cults and images. Devotion to the Virgin Mary, she could not help but believe, would somehow by association make Queen Mary more sympathetic to subjects who were still alienated from her Romanized church. In fact, it served only to mark the contrast between the Madonna's compassion and merciful intercession for sin and the Queen's intractable asperity.

On her accession in 1558, Mary's half-sister, Elizabeth, found herself in the middle of a war of images: between the radical enemies of 'idolatry' who had purged the country of pictures in the reign of Edward, and those whose devotion to them had been rekindled by the Marian Counter-Reformation. But one of the many remarkable qualities of the new Queen was her understanding of the psychological need for images by people who did not consider themselves Catholic. In this shrewd attention to image-fascination (rather than veneration), Elizabeth was the truest heir of her father's conservative pragmatism. As a result, she took her time proscribing the old mystery plays, which, in some places, went on into the 1570s. It was only when an alternative cult – that of herself, the Virgin Queen – had been firmly established in the popular mind as a kind of national religion that she could afford to stamp out the older practices entirely.

Two salient dates in Elizabeth's life quickly assumed the status of cult festivals: 17 November (her Accession Day) and 7 September (her birthday). The latter was particularly contentious for devotees of the old Catholic calendar, because it coincided with the eve of the celebration of the Virgin's Ascension, and they suspected, quite rightly, that the Virgin Queen had established the celebration both to pre-empt and absorb the old piety.

Elizabeth, and her alter ego, the indispensable William Cecil, recognized very early on, and with strikingly modern acumen, that portrayal was political, and that control of the royal image was

critical to the effectiveness of government. In 1563 Cecil drafted a proclamation which is the first explicit acknowledgement of the importance of managing the image of the Queen, and not allowing it simply to become generated in the public realm, either by devotees or enemies. It had been barely thirty years since Holbein, Cromwell and the King had designed his image, on the assumption that it would stay inaccessible to most of his subjects, at least in its original form. Now, the wording of the proclamation recognized the demand by 'all sorts of people both noble and mean' for a likeness of the Queen, both painted and (most significantly) 'graved' and thus available for mass circulation. But they must restrain their commendable enthusiasm 'until some special person that shall by her be allowed, shall first have finished a portraiture thereof, after which finished her Majesty will be content that all other painters and gravers . . . shall and may at their pleasure follow the said pattern or first portraiture'.

There was, as yet, no single Elizabethan Holbein to supply such an agreed template, certainly not the Flemish artist Hans Eworth, who had served Mary and managed to survive the abrupt change of regime to continue as a portraitist and designer of court masques and allegories. As long as the Queen – and her anxious councillors – were invested in seeking for her a suitable marriage partner, the control of her image insisted on by Cecil did not preclude a natural likeness, for Elizabeth, in her strong-featured way – the slightly hawkish nose inherited from her grandfather; the lustrous copper tresses – was beautiful, at least to any potential suitor not seeking features of demure submission. A few paintings from this period survive, like the full-length 'Hampden portrait' from around 1564 attributed to Steven van Herwijck, one of the many Flemish artists working in London at the time, which, in that Netherlandish style, turns the young Queen into a fashion plate, almost swallowed up by sumptuous lengths of scarlet cloth (the best possible advertisement for Flemish dyed textiles), with a drop of crystals and a rope of pearls descending from her high-collared throat, down through her stomacher and almost to the hem of her skirt. Van Herwijck and the unknown but probably foreign painter who

produced the last portrait recording the natural features of the Queen (ropes of pearls about her bodice and a costume of gold and white), both had to navigate the tricky passage between nubile woman and royal mannequin. But they were up against that face, with its uncompromising, angular severity; lips pursed in an attitude legible either as royal pride or merely the irritable impatience the Queen was known to have for sittings (and much else).

Nicholas Hilliard, the miniaturist who, with his pupil Isaac Oliver, was to come closest to establishing an Elizabethan iconography, described with wonderful vividness the nerve-racking experience of a first encounter with the Queen. Like Churchill long after, Elizabeth was an opinionated sitter but, unlike him, she was not going to leave anything on trust, especially to a twenty-something miniature painter (however well commended). Before he got his pencil out, Elizabeth made it categorically clear she didn't care for chiaroscuro, for exaggerated lights and darks:

> [A]fter showing me how she noticed great difference of shadowing in the works and diversity of drawers of sundry nations and that the Italians, who had the name to be cunningest and to draw best, shadowed not, requiring of me the reason of it, seeing that best to show oneself needeth no shadow of place, but rather the open light. To which I granted . . . Here her Majesty . . . chose her place to sit in for the purpose in the open alley of a goodly garden, where no tree was near, nor any shadow at all, save that as the Heaven is lighter than the earth . . .

Elizabeth's 'curious demand', Hilliard added, 'hath greatly bettered my judgement'. Why, to be sure! But he did in fact produce miniatures of dazzling, jewel-like clarity and brilliance, and this is not surprising, since his background was that of a goldsmith. As for the Queen herself and Cecil, Mary's Counter-Reformation had been painful for the Protestant Hilliards. Young Nicholas had been sent to Geneva, returning only in 1559, when Elizabeth succeeded to the throne. So he was one

English artist who would celebrate Accession Day every year with wholehearted sincerity. In London, Hilliard was apprenticed to Robert Brandon, the royal goldsmith, and worked in the neighbourhood of their company. Miniatures – watercolour on vellum, applied with the finest squirrel-hair brushes – were beginning to be popular among the aristocracy. But miniatures of the Queen painted in the 1570s, along with medallions, had special value as expressions of loving loyalty that could be pocketed, worn and displayed wherever the owner went. The year 1570 saw a Bull of excommunication issued against Elizabeth by the militant Counter-Reformation Pope Pius V. Henceforth, all true sons and daughters of Rome were released from allegiance. This meant not only that they could, but that they ought to become rebels against the heretic Queen. Were a party to bring about her death, he would find special favour in the eyes of the Church. In the circumstances, with the Queen's very life in hazard, her likenesses on medals and miniatures – or, best of all, both, combined in cunningly articulated small objects – became a personal statement of defiant allegiance; a passion taken to the point of true love. And she was termagant on Tuesday, flirt on Wednesday, warrior on Thursday, goddess on Friday, so very easy to love. A portrait of the courtier Sir Christopher Hatton by an unknown artist shows him with a cameo of the Queen wound about his hand and wrist.

The proliferation of Elizabethan portraits from the 1570s onwards coincided with the receding of any realistic prospect of her marrying (though the hopes of the Duc d'Anjou staggered on until 1582). The image-makers – Hilliard, Oliver and the Flemish artists Lucas de Heere and Marcus Gheeraerts the Younger – responded, together with the poets, by making the best of what they had: the Virgin Queen who had professed early in her reign she would be content to stay that way. Thus she became, in the words of her motto, *semper eadem*, always the same, unchanged by fleshly union; married only to her people (though actually it had been Mary who, when confronted by the unpopularity of her Spanish union, insisted with a show of a ring that her 'first marriage' was to her subjects alone). Now the body politic took over

35

entirely from the body natural; indeed, the latter had been sacrificed to the former. One of the formal, mask-like paintings included a pelican, which, by tearing its breast to feed its young, demonstrated the sacrifice of the body. This was but one of the emblems taken from the sacred iconography of the Virgin Mary: others recycled for the Virgin Queen were the rose, the pearl, lilies, moons and stars.

Face painting depended on the painting of the face. Though Elizabeth's naked face was increasingly concealed behind her Mask of Beauty, heavy cosmetics were still applied to sustain its perfection: potions and lotions to cleanse the complexion and disguise freckling – asses' milk, cherries and berries, honey and rosewater; and, to achieve the absolute whiteness needed by the Queen as she became old, terrifying, multilayered concoctions of chalky pastes that could take hours to apply before she could be revealed to the court.

Elizabeth was on her way to becoming England's first national fetish: face disappeared inside its formulaic mask; a body encrusted both with gems and symbolic meanings; the whole persona giving off an aura of potent magic: the sovereign as sorceress of Albion. The face of the fetish was as pale as the moon and, like all deities, impervious to the ravages of time. At its most artful, Renaissance portraiture – in the faces painted by Lorenzo Lotto, Giambattista Moroni or indeed Hans Holbein – was all about tangible presence; the uncanny detail: a curl of hair hanging over a brow; the catchlight in a pair of eyes; the set of a mouth – cumulatively giving the viewer the feeling that they were sharing the room with such and such a person, or even that the looking face was on the point of speaking. But Elizabeth's portraits were meant to create distance, an unapproachable remoteness, the veil of mystery which, on selective occasions, could be parted to reveal tantalizing glimpses of the actual woman. Thus her body politic, if not her body natural, lived in a sacred space positioned somewhere between womanly warmth and lunar frost.

For most of her reign the Queen kept herself very much to herself, retreating within the inner sanctum of Hampton Court, Whitehall, Greenwich or, towards the end, Hatfield House, the residence of Robert

Cecil. But remoteness was calculated to make her public appearances, when they happened, correspondingly more exciting and precious. There she was at the Tilts on her Accession Day; there again on St George's Day, when the Knights of the Garter processed in public, admired by throngs of spectators. Most adventurous and carefully stage-managed were the periodic progresses around the country (within a reasonable radius), expressly orchestrated for the goddess-monarch to show herself to her subjects. Her features would have been known from engraved versions and from the frontispieces to books, including the Bishops' Bible. But when Elizabeth appeared in person the effect could be stupefying. In a famous encounter in the summer of 1572, at Warwick, the larynx of the local dignitary assigned to welcome the Queen seized up in terror, and in one account Elizabeth took the opportunity to exercise the common touch, her aspect as tender-hearted mother of the 'loving people', as she called the English in her speeches. 'Come hither, Little Recorder,' she was reported to have said. 'It was told me you would be afraid to look upon me or speak so boldly, but you are not so afraid of me as I was of you and I thank you for putting me in mind of my duty and that should be in me.'

For all her hatred of shadow, Elizabeth could not stop the advancing dimness of age. But her portraits compensated by showing her as the regal source of light. The 'Ditchley portrait', where she appears as the banisher of stormy darkness, probably painted by Marcus Gheeraerts the Younger, commemorated an elaborate entertainment laid on for the Queen at the estate of Sir Henry Lee near Oxford. Lee had been the Queen's Champion at the Accession Day Tilts, an occasion he himself had devised, but retired from the office in 1590 at the age of fifty-seven. For his retirement pageant, John Dowland set to music a poem by George Peele, 'His Golden Locks Time Hath to Silver Turned'. The poetic conceit was that Lee had retired 'hermit-like' to Ditchley, but, unlike a hermit, he openly lived with his mistress, Anne Vavasour, by whom he had an illegitimate child. The Queen, increasingly prim in her own advancing years, was said to be displeased, and it may have

been to restore himself to her favour, if not to the court's, that Lee staged his entertainment. The scale was so lavish and spectacular that the cost nearly ruined him, and he became the butt of the sneerers when he declined to repeat it some years later. The picture, however, remained unprecedented in its union of monarchy and geography, for Elizabeth's reign also saw the production of detailed maps of the kingdom. Elizabeth stands with her feet planted on Ditchley, the giantess-goddess of her dominions, the personification of England. Behind her left shoulder a tempest rages, struck by bolts of lightning. But the storm loses force in her majestic presence. Over her right shoulder sunlit clouds are parting and the sky is coloured the cerulean blue of peace. An inscription acclaims her as the 'Prince of Light'.

The theme of royal radiance gets its consummation in the prodigious 'Rainbow portrait', possibly painted by Isaac Oliver for Robert Cecil and still in his spectacular mannerist palace of Hatfield House. Elizabeth has become sun as well as moon. Her hair (or rather her wig) is brilliant with the red-gold of its benign rays, which form themselves into the streaming tresses falling over her shoulders. The colour is repeated on the silk lining of her cape, and on her skirts. The rainbow she grasps is the sacred sign of hope and peace, the promise of a second golden age. But without the sun-queen, there is no peace and no light. *Non sine sole iris.*

But this is just the principal element in the stupendous visual encyclopaedia of symbols swarming over the picture without, somehow, choking it to death. Can an old girl (in her sixties) have too many pearls? Not this one. They drop from her throat over the bosom exposed by the deep décolletage fashionable around 1600 and from which all signs of crêpey wrinkling were of course banished. No visible body part is left unpearled. Ropes of them hang about both wrists; they glow from the trim of her robes; festoon the edging of the gossamer outer ruff encircling her head; a pearly threesome depends from her left ear; a circlet of them sits atop her hair with two monster pearls set apart by a square-cut diamond; they climb all the way to the top

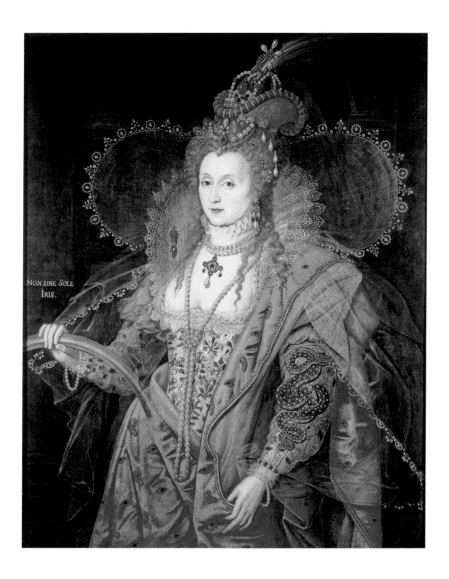

Queen Elizabeth I, 'The Rainbow Portrait', attributed to Isaac Oliver, circa 1600

Queen Elizabeth I, 'The Rainbow Portrait': detail

of her fantastical headpiece, curved like the horns of an ibex, and further still again, up to its very pinnacle.

Radiance nourishes everything: the field of spring wild flowers – pansies, carnations and roses – that riot on her bodice. On her left arm the serpent of wisdom catches a heart-shaped ruby. The queen-goddess's heart is ruled by her head. And her coat is covered with an astonishing pattern of eyes and ears, signifying her omniscient attention to the care of her subjects (not least by the institution of an intelligence service). But less noticed by commentators are open mouths clustered near the base of her rope of pearls, as well as on the opened left side of her golden coat. These are the organs of renown; a fame seen, attended to, spoken of, the wide world over.

And yet there was, for some of her subjects at least, a craving for

simplicity. For someone around 1600 commissioned a copy of the first portrait of Elizabeth as Queen, painted at the time of her coronation in 1559, and to celebrate it. It is quite obviously an adaptation of the large portrait of Richard II displayed in Westminster Abbey. Elizabeth, like Richard, is depicted frontally, ceremoniously; like him, enthroned and holding as he does the orb in one hand and the sceptre in the other. Her undressed locks proclaim her virginity. They are scarcely grown up, these two: the lad-king and the maiden queen. But one knew how to inhabit the body politic with ruthless understanding, and one did not. 'Know ye not that I am Richard II?' an angry Elizabeth is supposed to have said after hearing that the rebellious Earl of Essex had staged a performance of Shakespeare's play of deposition as a morale booster for his comrades. But the truth is she was not. Beneath the mask operated one of the most formidable political intelligences ever to have ruled in England. She knew what power lay with the royal stare. But she also knew that image was not everything.

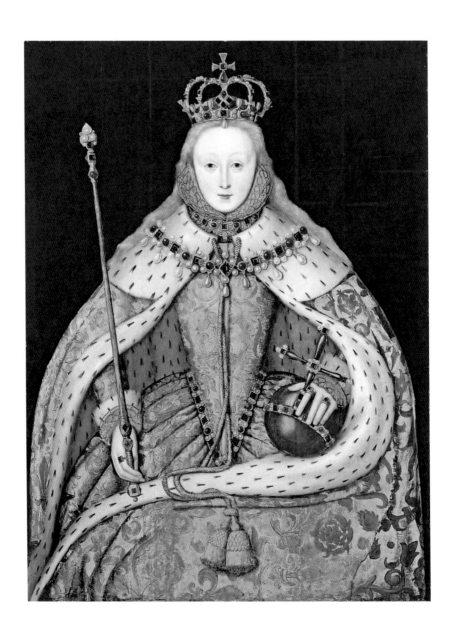

Queen Elizabeth I, by unknown English artist, circa 1600

3. Reins of Power

The King sits high on his horse on a traffic island at the south side of Trafalgar Square. Mount and rider clip-clop towards Whitehall and the Banqueting House, where, on 30 January 1649, the monarch's head was severed from his body. The eyes are impassive rather than shadowed by the melancholy Van Dyck was said to impart to them, but then what bronze eyes are not impassive? The sculptor, Hubert Le Sueur, did his best, but he was no Bernini. Alas for him, he was not even the peer of Pietro Tacca, the foreman of Giambologna's workshop in Florence, where Le Sueur had worked. It had been Tacca who, after his master's death, had been given the work of completing the equestrian statue of the murdered King Henri IV as a memorial on the Pont Neuf. That great horse had been realized in motion, trotting along as the King held the rein with one hand alone, the other tightly gripping the baton of command. Somehow, prince and steed felt alive, loftily surveying the city swarm. People had already begun the custom of doffing their hats to the bronze horseman as they walked over the bridge.

Le Sueur had helped complete the sculpture for the Pont Neuf and, evidently, he wanted to make something as imposing for Charles I, who, like his father, James I, had styled himself King of 'Magna Britannia' – Great Britain. When Inigo Jones, James's master builder, came through Paris and suggested that Le Sueur (a Protestant) travel to England, the sculptor crossed the Channel, arriving in 1625, the same year as Charles's French Queen, Henrietta Maria, a time when London artists were still overwhelmingly a foreign colony: Flemings, Dutchmen, Italians and a few French. Under Elizabeth, there had been little call for monumental sculpture, but the Stuarts, with their grandly European taste, changed that. Le Sueur was hired to produce frieze figures for the bier of James I, designed by Jones, and for the late King's tomb in Westminster Abbey. Charles, an avid collector and

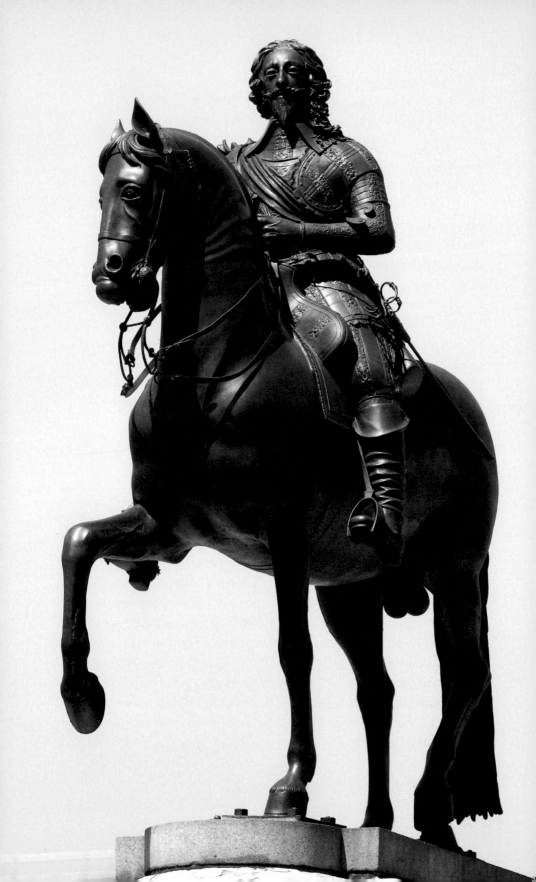

connoisseur, wanted his own copies of famous classical statuary – the *Spinario* of a boy pulling a thorn from his foot and the recently excavated *Gladiator* (actually a swordsman) in the Borghese collection, so Le Sueur was sent to Rome to take moulds from which casts could be made back in England.

But until the commission for the King on horseback came along, Le Sueur was struggling to be seen as more than a useful journeyman. All through the 1630s he was haunted by the shadow of Bernini, whom he must have encountered in Rome. Van Dyck would make a triple portrait of the head and shoulders of Charles I from which Bernini could fashion a bust. It may be that the court was wanting something more impressive than the three marble busts Le Sueur had already made. One of them had Charles wearing a helmet in the antique style, surmounted by a tiny dragon, an allusion to the King's pretensions to be the latter-day St George; the whole effect unintentionally comical, as if the King were trying on a masquer's party hat, one size too small.

The commission for Charles on horseback was Le Sueur's great opportunity to be taken seriously in his own right. But the sculpture was not intended for the kind of public space where it now stands. It was the Lord High Treasurer, Sir Richard Weston, soon to be 1st Earl of Portland, who wanted the statue for his garden at Mortlake Park in Roehampton, then being designed by Charles I's major-domo of art, Balthazar Gerbier. The enclosure in a private park is telling. Weston, whose self-important face was given the full treatment by Anthony van Dyck, was not popular, at least not in Parliament, for as Chancellor of the Exchequer he was also the enabler of the King's personal rule: his decision to govern without the inconvenience of having to seek revenue from Parliament. Weston, who had been an M P himself, had risen on the strength of diplomacy: funding a war with France which did not go down well in the country, and then delivering a peace with Spain which went down even less well. Now, in the 1630s, he supplied the wherewithal for royal extra-parliamentary rule while attracting attention for a personally indulgent, aristocratic manner of living at Mortlake Park.

Charles I, by Hubert Le Sueur, 1633 45

A royal statue tucked away from all but friends of court and government – the very opposite of the king on the Pont Neuf – was, however, an opportunity for Le Sueur to display his prowess without risking public criticism. Even shut away, it would still be an event: the very first bronze equestrian statue of any kind in Britain. Since Gerbier was supervising both the casting of the statue and its installation at Mortlake Park, it surely would not be long before Charles came to admire himself set high above the parterre plantings. Charles made no secret of wanting to be seen on a par with the great prince-patrons of the ruling houses of Europe. Sovereign horsemen were everywhere: Andrea del Verrocchio's great mounted *condottiere* Bartolomeo Colleoni reared above the Campo Santi Giovanni e Paolo in Venice. While in Spain, unsuccessfully courting an infanta, Charles, then Prince of Wales, would have seen Titian's great portrait of the Emperor Charles V in his gilt-trimmed armour at the Battle of Mühlberg, the epitome of the *miles Christianus*, the Christian knight. He might even have known of work under way by Philip IV's court artist Diego Velázquez to decorate a Hall of Honour with equestrian portraits, both of the King and his father, Philip III, firmly seated while their mounts reared up on their haunches: the levade, meant to intimidate, or at least impress, both the enemy and one's own soldiers.

The prototype of all these equestrian works was the statue of Marcus Aurelius, displayed on the terrace of the Campidoglio in Rome in a setting redesigned by Michelangelo: an obligatory stop for all cultural tourists, and doubtless Le Sueur himself. The posture of the philosophical ruler – one hand only on the rein, the other extended – was held to be the very embodiment of imperial power: stoical self-control while the vigorous mount, one hoof raised, was in motion. The extended arm generated imaginative speculation. Was it a gesture of clemency to a prisoner thrown beneath the horse's hoof, or an imperial acknowledgement of saluting crowds? Titian's aim had been to recast Charles V as the new Aurelius; and all those who followed in his wake wanted to emulate or surpass the Mühlberg painting. It was certainly in Rubens's mind when he painted Philip III's favourite, the Duke of

Lerma. More controversially, Rubens borrowed the royal-imperial rearing levade for his bravura painting of George Villiers, the Duke of Buckingham. The young, good-looking Villiers had been so favoured by James I that tongues wagged, and one of the offices the King showered on him was Master of the Horse. The spectacular painting was finished in 1625, the year of Charles's accession and Buckingham's botched campaign in France.

It was important then, that a Buckingham equestrian portrait be eclipsed by even greater paintings of the new King. The logical – the only possible – choice for this was Anthony van Dyck, since he could rise to a double challenge: making the image of the new King surpass that of the favourite; and his own painting surpass that of his mentor and master: Rubens. Van Dyck arrived in London in April 1632, at the height of his powers and the summit of his fame. He, too, had been introduced to the itinerant talent-spotting Earl of Arundel, in Antwerp, and had been pointed out as Rubens's best pupil. He was brought to London by Arundel to do some work for James I around 1620–21, though exactly what he did seems unknown. In the mid-1620s he had spent time in Italy, and in Genoa, where Rubens's dazzling full-length portraits of the local nobility were prized and praised even beyond Titian's. Rubens's precocious pupil was not shy of competing with his master, not least by painting two eye-popping equestrian portraits, both on the Lerma format, with figures mounted on a white steed advancing towards the viewer.

In England the art-loving King treated his new acquisition as a human treasure, discarding Daniel Mytens, who until then had been his court painter. Had he not been doomed to suffer comparison with Van Dyck, Mytens might be seen as a better than competent artist, though his stage sense, indispensable in the baroque, where all the arts were to some degree or other a form of poetic performance, was nil. Mytens posed the five-foot-four King in High Renaissance space, into which he disappeared. His portrait sitters are largely devoid of the breath of life. Cruelly, he was the one to organize the living arrangements for the man who supplanted him. Van Dyck was lodged

at the King's expense, initially with the miniaturist Edward Norgate, and then given a house at Blackfriars (where all the Flemish and Dutch artists congregated) with a studio large enough for the enormous paintings he was immediately commissioned to execute for specific spaces at the end of long galleries: one in Whitehall, the other at St James's. The house came with a garden, and the King had a new causeway and steps put in so that he could make regular visits to Van Dyck's studio to inspect his pictures and the progress of royal works. In case all this was not enough, he knighted Van Dyck towards the end of the year, instantly elevating him as a peer of Rubens, who had been knighted two years earlier.

The first 'Greate Peece' destined for Whitehall was a family portrait of the King and Queen and their two children, Charles and Mary. By Van Dyck's standards, it suffers from formal awkwardness, although it is already apparent that no one could paint children, even royal ones, like the Flemish master. The second enormous canvas was to fit a particular niched space in a gallery at St James's Palace where incoming ambassadors would walk past Titian's and Giulio Romano's pictures of Roman emperors. It was only fitting, then, that Van Dyck should paint the King riding through a classical arch, the traditional action of a Roman triumph, Charles's own quasi-imperial coat of arms propped against its masonry. The King is wearing his ribbon of the Order of the Garter; a telling detail since, in keeping with the Stuart withdrawal of public ceremonies from the public eye, Charles had moved the annual procession of the Garter on St George's Day from Whitehall to Windsor. He is mounted on the same Rubensian white horse, probably a thin-coated Spanish-Arab grey stallion, the better to set off the dignity of his regal posture. For the first time, Van Dyck had invested the royal face with that poetic sobriety romantic generations would later read as full of melancholy foreknowledge of his fate. Like Rubens, Van Dyck had refreshed the formula with landscape backgrounds and the mutable skies of northern Europe, and here the King – Prince of Peace notwithstanding, fully armoured – rides towards us against a background of sunny Elizabethan sky. There are

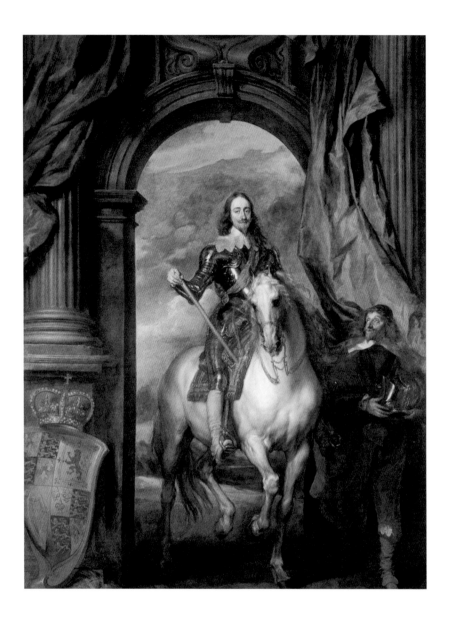

Charles I with M. de St Antoine, by Sir Anthony van Dyck, 1633

wonderful details: the foreshortened foot firmly engaged in the stirrup; Charles's baton of command pressed against his sumptuous saddle-cloth. No one could compete with Van Dyck's rendering of textiles (his father was a merchant of silk and linen); and the green silk drapes billow with animation as if blown by an English springtime zephyr. The scarlet-clad equerry and Master of the Horse, M. de St Antoine, hastens forward in time with the animal but with a glance of adoring duty cast the way of his royal master. The pace of his own march syncopated with the animal's is one of the great passages of dynamic painting in all of seventeenth-century art, comparable to the foreground figures in Rembrandt's *Night Watch*.

As much as Titian and Rubens, Van Dyck understood how the figure of a mounted prince, in firm command of an enormous and noble steed, could project an image of imperial power like no other pose. The degree to which English artists had fallen short of this challenge was embarrassingly evident in Robert Peake's two-dimensional attempt to represent Charles's older brother, Henry, Prince of Wales, in an allegorical composition which included Father Time. Henry was celebrated in court and country as the coming royal knight gallant (in contrast to his father), and it was to the young prince that the French King Henri IV had in 1603 sent a gift of six high-pedigree horses, together with the Master of the Horse de St Antoine, who stayed in that position in the Royal Mews through two reigns. On Henry's premature death in 1612, the smaller, self-conscious Charles had inherited the horses and de St Antoine, as well as his older brother's armour and title. Somehow everything, including his own sense of royal authority, had to be sized up to fit his dead brother's place.

Everyone involved in the royal horse-show – Charles, Maître de St Antoine, Van Dyck – would have read the classic manual written by Louis XIII's riding master Antoine de Pluvinel, 'L'Instruction du Roy en l'exercice de monter à cheval'. But on his own account Van Dyck studied everything he could about the musculature of the horse, and preparatory drawings in black chalk he made for the two great Caroline equestrian paintings show a perfect translation from anatomical

knowledge to pure painterly flamboyance. Van Dyck rides his pencil as if he were to the saddle born, and the tricky bits – the folds of flesh between the legs, for example; the big eyes that give the animal its heroic animation; the deep chest and massive hind quarters – are all rendered with a vital exactness of which Leonardo would not have been ashamed. Completed, the extraordinary picture went into its allotted space so that, on entering the long gallery, visitors were taken sharply aback by the illusion of the mounted monarch trotting ominously towards them out of the candle-lit darkness.

At the same time as Van Dyck was working on his masterpiece, the pedestrian Hubert Le Sueur was doing what he could with the equestrian statue for Lord High Treasurer Weston. Both of them were obliged to take liberties with Charles's stature, lest the King be dwarfed by his mount. Le Sueur was expressly instructed to make 'a horse in Brasse bigger than a greate Horse by a foot; and the figure of his Maj King Charles proportionable, full six foot, which the aforesaid Hubert Le Sueur is to perform with all the skill and workmanship as lieth in his power'. But while Van Dyck magnified both horse and rider to equal scale, Le Sueur did not get the proportions quite right. Seen from some angles, it looks as though a tall king is taking a chubby pony for a trot. Likewise, Charles's face, copied from his marble bust, is solemnly expressionless. There is a sturdy dignity to the piece. Le Sueur's father was an armourer, and the half-armour worn by the King is well rendered, along with the Garter sash, as are the long riding boots, persuasively creased. The piece was at any rate good enough for Gerbier and Weston, since the statue was cast, not far from where Le Sueur was living in Drury Lane, on a plot of land close to Covent Garden where Henry Peacham, the author of *The Compleat Gentleman*, saw it 'well nigh finished'. But even though Weston did not die until 1635, thus sparing him impeachment by the Long Parliament, the statue never seems to have been installed, as planned, at Mortlake Park.

Not surprisingly, the coming of civil war was a disaster for both artists. Two of Van Dyck's great patrons, William Laud, Archbishop of Canterbury, and Thomas Wentworth, Earl of Strafford, were

indicted by the Long Parliament as enemies of the Puritan 'right religion' and the liberties of the English people. Strafford was tried and executed in 1641; Laud four years later. Van Dyck himself died in 1641, aged just forty-two. Le Sueur was almost as compromised. He had made standing figures of the King and Queen for Laud in Oxford and, by 1643, a sense of prudence and the evaporation of work persuaded him to return to France, where in 1651 he was still known as *Sculpteur du Roi*.

Charles's art collection, of unprecedented magnificence, was sold off. At some point, someone, possibly the Earl of Portland's son, looking at Le Sueur's royal horseman, took pre-emptive action. In 1650 the Commonwealth Council of State instructed local authorities to 'throw down and break into pieces' any such statues. A search was instituted for the equestrian piece, but in vain. Stories about its fate during the Interregnum told by antiquarians such as George Vertue and Horace Walpole abounded in the following century. One of them claims that bronze horse and rider were dismantled and hidden somewhere in the vicinity of Covent Garden, possibly even in the crypt of Inigo Jones's church of St Paul's. Under the Protectorate the search was resumed, not least because the Lord Protector himself, Oliver Cromwell, had adopted the classic equestrian pose in his Great Seal, designed by the prolific and ingenious medallist and official Engraver of Coin Thomas Simon. Simon posed Cromwell in statuesque profile, general's baton in his right hand, the reins firmly grasped in the left, with London Bridge and the Thames in the background, all exquisitely miniaturized.

In 1655 the bronze horseman was at last discovered in Covent Garden and, following seizure, it was given to a brazier aptly named John Rivet, or Revet, living near Holborn Conduit, who was then charged with destroying it and melting down the parts. Rather than obey his orders, Rivet buried the disassembled statue beneath the garden of St Paul's churchyard, while, according to the eighteenth-century story, making money from selling cutlery and knick-knacks purportedly made from it, to secret royalists. Come the Restoration in 1660, Charles II wanted the unearthed statue erected at Charing Cross, where the

biggest medieval Eleanor Cross had been vandalized as idolatrous at the height of the Puritan iconoclasm. But now, Weston's son, the 2nd Earl of Portland, claimed it as his family's property.

If John Rivet was actually Jean Revet, he may have been one of the many London Huguenot metalworkers and thus a friend of the equally Huguenot Le Sueur. It is not inconceivable that the brazier's overriding aim in hiding the statue was less a devotion to Charles than a commitment to preserving the work of the artist, a goal not incompatible with making money from its conservation and eventual sale. At any rate, Rivet clung to the statue so tenaciously that, following Portland's petition to the House of Lords, an order of seizure had to be issued for forcible repossession. Even this was not enough to have King and horse erected at Roehampton before the 2nd Earl died in 1663. Rivet was not yet done with the piece. Perhaps through the romance of the statue, he became 'King's Brasier' and doubtless let people know all about his story, even though the statue seemed to be haunted by ill fortune. Grimly tenacious in his insistence on recompense, Rivet fell sick with the palsy and went to Bath to take the water cure. In 1674 he declared himself well again. But the optimism may have been premature for, whatever ailed him, it was, one way or another, lethal. The following year he killed himself.

The tug of war over the statue went on. In the year of Rivet's suicide, Charles II finally agreed to the extortionate price the Earl of Portland's resolute widow was demanding for the statue: sixteen hundred pounds. It was then handed over to the freshly knighted Sir Christopher Wren, Surveyor of the King's Works. Just who determined that the site of the Eleanor Cross, known as Charing Cross, but originally between the Strand and Whitehall – where the statue still stands today – should be its final resting place is less clear. But Charing Cross, aside from being right in the centre of one of the most populous areas of London – more so before the arrival of Trafalgar Square – was a place of expiation. Surviving regicides were executed where the Eleanor Cross had stood.

Wren was paid to come up with plans for a fitting pedestal.

Typically, he produced two. One was an elegant baroque setting, complete with water basin. But after his plans to rebuild St Paul's Cathedral as a Greek cross had met with dug-in resistance, Wren was under no illusions about English taste, so he also drew another, plainer, plinth and base. He was probably not surprised that the second, duller, design was declared by the King to be more suitable. Purbeck stone was expensively acquired and the mason William Marshall employed to provide the elaborate heraldic ornamentation incorporating the inevitable toothy lion and rampant unicorn. Andrew Marvell, who now served the Restoration monarchy as avidly as he had done Cromwell's Protectorate, supplied a poem for the statue while complaining Britishly of the delays in completion and its invisibility behind scaffolding. Finally, with railings set around it, the statue appeared on public view in 1676. It became the custom every year on the anniversary of Charles's execution in front of his palace at Whitehall for oak boughs to be placed at the foot of the plinth; and you will sometimes find them there. As it is, encircled by the thrum of buses, taxis and lorries, the King still rides his horse towards his end. But if he could trot a little further down Whitehall he would come to Parliament Square – and there he would encounter, standing on his own two feet, his nemesis, Oliver Cromwell.

Hamo Thornycroft's statue of Cromwell, Bible in one hand, sword in the other, was unveiled in 1899 in front of the House of Commons to commemorate the tercentenary of the birth of 'God's Englishman'. Understandably, Irish MPs (other than Unionists) were furious about it, but Liberals, who had been badly defeated in the 1895 election, wanted to use Cromwellian memory to bring Nonconformist voters back to the fold. Lord Rosebery, the last Liberal Prime Minister until 1905, paid for the statue and in a flight of atypical oratory extolled Cromwell as the bringer of free speech and religious toleration to Britain. Up to a point, Lord Rosebery; and perhaps the credit should have gone to his secretary, Milton. As for the Lord Protector, he was also, as a commentator crisply reminded fellow Liberals, the man 'who cut the throat of the Commonwealth'.

King Charles I, by Wenceslaus Hollar, mid-17th century

Cromwell himself was of two minds about how he should like to be seen. That he ought to be represented in likenesses of all kinds – formal portraits, coins and medals and, not least, the Great Seal – was never in question. Any residual Puritan distaste for images was confined to their veneration in church. Portraits which personalized allegiance to the great cause for which the civil wars had been fought and the Commonwealth established were not just desirable but essential. Whatever else had been overthrown with the end of monarchy, visual propaganda remained indispensable for the work of binding the people to the new regime. The cult of kingship had to be replaced by a new national iconography.

So there was no collapse in demand for portraits, nor any shortage of artists prepared to supply them. Nor was there any loyalty test applied to ensure that only the politically pure would be employed on such work. Balthazar Gerbier, who had been personally close to both the King and Van Dyck, had no difficulty at all in switching allegiance to Parliament in 1642 when he saw which way the wind was blowing. He did this so publicly that, during the Restoration, he was reduced to working anonymously. But after the monarchy had been abolished a question arose for the art directors of the new regime. What was English Republican style? Should the Van Dyck manner be maintained for the leaders and generals of the Commonwealth, or should the satiny extravagance and flashing light Van Dyck had brought to his portraits of aristocrats and poets be seen now as politically indecent and yield to a more sombre style? The question was never really pressed hard, since so many prominent Parliamentarian warriors came from the same class of nobility and gentry as those on the opposing side. Robert Walker painted a portrait of Henry Ireton, and one of Cromwell himself, the style of which was indistinguishable from Van Dyck's manner, except for the fact that he wasn't Van Dyck's equal. But time and art history have been a little hard on Robert Walker. His three-quarter-length of Cromwell, fully armoured, has the general standing beneath an English sky as dour as his expression, the intense martial severity set off only by a stooping page tying on his sash of

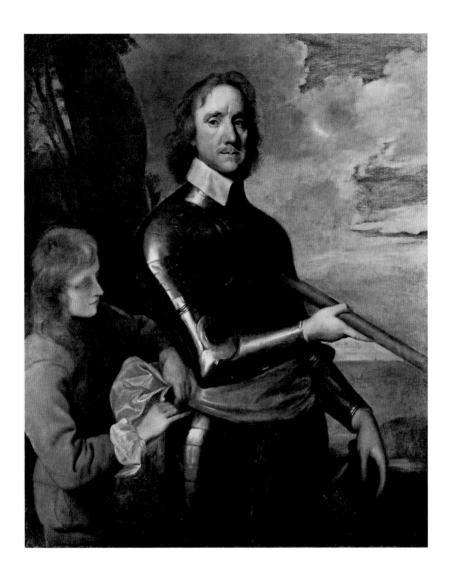

Oliver Cromwell, by Robert Walker, circa 1649

command. It is in fact a wonderful portrait, copied many times and engraved as serviceable propaganda. Cromwell stares back at us with a look just this side of exasperation, a quality all who encountered him vividly described. Walker has lit the picture Van-Dyckishly but without a trace of courtly ingratiation. The light shines dully on the great man's dark armour and from a faint glow of sweat on his brow. This is portraiture as no nonsense, and it makes the beholder nervous, as Cromwell unfailingly liked to do.

When Cromwell assumed the title of Lord Protector, one might expect him to have embraced a more obviously courtly style, not least because there was talk of an elevation to the throne. Slavishly adulatory poems praised his virtues to high heaven, much as they had the Stuarts'. But something surprising then took place, which for a brief time had the potential to revolutionize political portraiture. That something was the rise of Samuel Cooper.

Had Cooper not been a miniaturist, his skill at rendering the natural presence of a figure would be seen as fully the equal of the very greatest European painters of his time. Comparisons with Velázquez, Jusepe de Ribera and Frans Hals are not altogether laughable. But, aside from specialists in miniatures, Cooper has not even been adequately honoured in his own country as the inventor of a radically new naturalism, but rather seen as simply the heir of Hilliard and Isaac Oliver. Apart from the fact that they worked in the same genre, Hilliard and Cooper could not have been more different. Hilliard was in the business of making brilliantly stagey images of players in the theatre of Elizabethan court life, beginning with the full-on, total-cosmetic goddess-Queen herself. As per Elizabeth's instructions, Hilliard eschewed shadow. Everything and everyone was bathed in even light, as though, in Elizabeth's England, it was always noontide in the month of May. Cooper, on the other hand, was the master of moody shadow, and no one – least of all Oliver Cromwell, who sat for him many times – was going to argue him out of it. When Charles II sat for one of the sketches to be the model for a coin, Cooper had him do it at night and had John Evelyn, the diarist and man of science and letters,

hold the candle while Charles, a good sport, prattled away to fellow connoisseurs on matters artistic.

The contrasts with Van Dyck are telling. The Flemish artist used the whole repertoire of flash and dash in the service of poetic idealism, and wanted them to work on the eyes, life-size or bigger. The results were, in every sense, spectacular. Cooper, on the other hand, works optically, eyeball scale; with unoccluded vision, a chaste palette for his watercolours, everything so stripped down and concentrated that its realism is luminously distilled on the pale vellum that was his surface. On those small pieces of parchment, wonders were wrought; faces fix us – Cromwell, Thomas Hobbes, Cooper himself, looking guardedly over his shoulder – and establish themselves in our presence with uncanny immediacy. Van Dyck's mistress, Margaret Lemon, so tempestuous that in a fit of jealousy she tried to bite his thumb off to end his career, looks at us, dressed in a man's clothes. From under her high hat, she's a one-woman weather forecast, and the news isn't good. Storms in the offing.

Every handicap you would expect from a miniaturist 'limner' is overturned by Samuel Cooper. Instead of the human presence being diminished by the scale, it seems magnified and intensified. Instead of the paint handling needed for such a small scale (and in watercolours) turning the finished result into something gem-like and artificial, Cooper managed to work his squirrel-hair brushes with such licked freedom that they rendered skin and flesh and bone more, not less, natural. And, with incredibly fine motor control at his command, Cooper, even when he was working with the powerful, simply ignored the traditional obligation to idealize the faces he was looking at, to remove any blemishes or disfigurements. Painting Queen Henrietta Maria's teeth as they actually were, protruding so badly that, in the words of one unkind observer, they resembled 'guns sticking out from the side of a fort', was out of the question for the Court Painter of Charles I. But, famously, Oliver Cromwell at some point decided to overturn all these conventions of classical decorum, so that the body natural should *be* the body politic. In the famous anecdote related by George Vertue in the eighteenth century, Cromwell tells Peter

Margaret Lemon, by Samuel Cooper, circa 1635
John Maitland, Duke of Lauderdale, by Samuel Cooper, 1664

Lely: 'Mr Lilly I desire you would use all your skill to paint my picture truly like me and not Flatter me at all but remark all these ruffness, pimples, warts & everything as you see me.' The story has a provenance good enough not to dismiss it as spurious, or as the early-eighteenth-century idea of Cromwell as the honest flayer of idle vanity and fashion (though he was that, too). Vertue heard it from the gentleman architect Captain William Winde, who, in turn, got it from the Duke of Buckingham, for whom he worked.

Typically, Cromwell was making a point about his authority being rooted in Christian honesty and simplicity, even as he was establishing his own kind of court. Since Lely, who would come to specialize in painting the half-dressed, raspberry-nippled mistresses of Charles II, was already known as a painter of society, Cromwell's corrective instruction sounds plausible. Nonetheless, it may not have been Lely who received the order for visual candour. Many years ago David Piper, author of *The English Face* and Director of the National Portrait Gallery, pointed out that Lely's head of Cromwell, which is certainly warty, was almost identical to that painted by Samuel Cooper, and especially to one of the preparatory sketches Cooper was in the habit of making during the many sittings he required of any subject. Piper observed that it was inconceivable that two heads so similar could have been produced from two separate sittings. For that matter, the Lord Protector's day was never short of urgent business. It was much more likely that one portrait was a copy of the other, and Piper concluded that it was Lely who had copied Cooper. Why? Because Piper, after doing a wart-count, noticed that Lely, while remaining faithful to the instruction of candour, had fallen one short. He had, in fact, overlooked one of the most expressive of the little growths, nesting just above Cromwell's right eyelid and close to the bridge of his nose. That Cooper would *add* this as a gratuitous tribute to Cromwell's lack of vanity can be ruled out.

So it is Cooper's which is the real Oliverian face and head and, once one has accepted this, other details in Cooper's likeness become marvels of observation; touching grace notes of unattractive homeliness: for example, the glimpse of bald skull exposed beneath Cromwell's

inadequate comb-over. But it is, in the end, those warts which are the most painterly: ungainly little soldiers standing to attention on the Cromwellian face, so lovingly rendered that they cast their own individual shadows, from the pimply one at the crease of the brow to the majestic King Wart beneath his lower lip, incompletely concealed by a small beard; the one which defied anybody in the general's presence *not* to stare and stare and stare. Everything else is done with Rembrandtian perfection: the deep-set eyes; the blue irises beneath heavy lids; the element of thought coexisting with a face so lit that it belongs to the man of action.

In profile, the Cromwell face, with its virtuous blemishes, became if anything even more dramatic and the detail more uncompromisingly true to nature. The picture made Cooper, as well as Oliver, famous throughout Europe. Queen Christina, the cross-dressing Swedish monarch, ordered a Cromwell from the hand of the artist, since there were innumerable unsatisfactory copies circulating, many of which still survive.

Governments came and went, but Cooper never went out of style or wanted for work. Despite (or possibly because of) the fame of the Cromwell miniature, Charles II could hardly wait to sit for him.

Within ten days of the King's Restoration, Cooper was summoned for the nocturnal sketching session. The resulting profile gives a better idea of the unvarnished King than any other: the handsome features already relaxed into a kind of easy indolence. As Royal Limner with a salary of two hundred pounds a year, Cooper could afford to live in comfortable, if not lavish, style in his house on Henrietta Street in Covent Garden, where, between portraying politicians and the likes of Samuel Pepys's wife, he played the lute and entertained his friends. When he died, in 1672, one of his pupils, Susannah-Penelope Rosse, took over his house and studio, where she became accomplished enough for some of her work to be mistaken for Cooper's. She could hardly escape a destiny as miniaturist, since she was also the daughter of 'Little Dick' Gibson, who was not only a miniaturist but was himself miniature, measuring three foot ten inches, and who, though no Cooper, made a respectable living from his work.

Piece by piece, Charles I's art collection – though by no means all of it – came back to England and to the Crown. Some of it had never left. The great *Charles I on Horseback* – another Van Dyck of the King mounted beneath a spreading English oak, looking thoughtfully into the distance – was restored to the space at the end of the gallery in Hampton Court for which Van Dyck had painted it. The earlier painting with de St Antoine came back to St James's. For a while, Charles II, and even his fatally grandiose brother, James, avoided the imperial-equestrian pose, preferring to project majesty by standing in coronation robes or armoured against a martial background. Ironically, it was left to William III – already established as a military hero in the Dutch Republic – to revive the Prince on Horseback; first with Jan van Wyck, whom he brought from the Netherlands, then with the immense canvas painted by Godfrey Kneller for the Presence Chamber at Hampton Court, complete with extravagant allegorical allusions to Hercules, Virgil's *Aeneid* and the return of the Age of Gold.

Most of William and Mary's subjects, though, consumed their history in illustrated chronicles, the engravings adapted from large-format prints

originally made by the master of history-images, Romeyn de Hooghe. The great tableaux – William's landing at Torbay, the Battle of the Boyne, the double coronation – were widely available and bound into the history books defending the Glorious Revolution: a founding scripture, in images as well as words, for the new constitutional monarchy. As the wars against Louis XIV toiled on into the next century, there were occasions to depict their martial heroes – for example, Prince Eugene of Savoy – on their commanding mounts. Kneller, who fell out of favour with Queen Anne, transferred his painted eulogies to the Duke of Marlborough, and worked on a picture of the duke meant to go in Blenheim, and comparable in imperial pretensions to that of William. Palace and painting and Marlborough's ego were all considered a little too rich for Hanoverian Britain. Though George II went to battle on a fine mount, the pictorial tradition of the imperial prince on his charger as the British royal style had gone.

But the horses hadn't. In the eighteenth century they galloped back and, this time, as the subjects of portraits themselves. We have no idea what the name of Charles I's Great Horse was, if indeed he had one. But in one of the most surprising rooms in Britain, at Althorp House in Northamptonshire, we are introduced to 'Brisk', 'Sore Heels', 'Craftsman', and many other beauties. The octagonal room, brilliantly lit from high windows, is called 'The Wootton Hall', after the horse or 'sporting' painter who decorated it for Charles, Fifth Earl of Sutherland, between 1730 and 1740. John Wootton, along with two contemporaries – James Seymour and Peter Tillemans – has understandably been eclipsed by the greatest horse painter of all: George Stubbs. Stubbs's equine nudes – like *Whistlejacket*, riderless and saddle-less, posed against an abstracted plain background without any kind of landscape – are some of the most extraordinary images ever set on canvas, embodying the purity of classical sculpture: great animals caught in space. Wootton was hired to do something more workaday: paint not just the favourite hunters of the aristocracy but the hunts themselves, complete with hounds, grooms – the entire tally-hoing scene.

This is enough to document the change in power that had taken place in England since the Revolution of 1688. Social and political

Viscount Weymouth's Hunt: The Hon. John Spencer beside a Hunter Held by a Young Boy, by John Wootton, 1733–6

authority – the source of assurance, continuity and prosperity – had passed from the royal father to a league of uncles, the landed aristocracy, and had settled down in the country. The patriarch had been replaced by patronage, especially in the counties around their great estates. Local governance – the magistracy; the lord-lieutenancies; the nomination of Members of Parliament – was all contained within the orbit of this landed power. And the expression of this new lordship – which conducted itself as if it had always been there – was the county meet: the hunt. In France, the only hunt that mattered was the royal one, because the absolute monarch had corralled the potentially dangerous nobility into his park and palace at Versailles. Politically neutered, their self-importance was defined by attendance on the sovereign in his daily rituals. Courtiers high and low fulfilled the requirements of his body politic: master of the shaving bowl; lord of the linen closet; and so on. In England, where close personal attendance on the royal body had once been the key to power, Grooms of the Stool were no longer men to be reckoned with. Country had come to displace court and no one coveted paintings of Hanoverians on horseback.

Instead, John Wootton supplied pictures of the Spencer estate, over which his handsomely muscled horses galloped in pursuit of fox and stag. Althorp, like others of the great houses built or rebuilt in the late seventeenth century – Chatsworth for the Cavendishes; Woburn for the Russells – was a power unto itself. Hampton Court, Whitehall and St James's no longer had a monopoly on long galleries designed to proclaim the continuity of dynastic power. Like their peers, the Spencers moved their own full-length ancestral portraits out of bedchambers and into their own gallery, where they made a statement of dynastic grandeur. In Althorp's case, the martial Spencers, scabbards and boots, were hung on the high walls of the great entrance hall, while the astounding long gallery was wall-to-wall royal pin-ups, mistresses and women courtiers of Charles II and James II. Lely and the glamour team did what they were hired to do: flounce, lipgloss and peekaboo nipples, one after the other; a relentless beauty parade of the fish-eyed and the flirty. Robert Spencer, 2nd Earl of Sunderland, the presiding genius of Althorp, himself designed

a newly ornate type of frame to hold those portraits. Hanging them all in the gallery, the earl became, in effect, the master of the seraglio, though definitely not a eunuch. In an age of fungible allegiances, no one quite surpassed Sunderland for breathtaking opportunism. Having encouraged and directed the pro-Catholic policies which brought James II down, he lost no time in switching allegiance to William III. Instead of holding Sunderland in contempt or prison, the new King came to Althorp in 1691 to seek his advice. For that matter, William matched Sunderland in any pragmatism contest and understood very well that the Spencers ran things in the East Midlands; office, treasure and ecclesiastical livings were theirs to command. Entertained in imperial magnificence in the long gallery, looked down on by the court floozies, William must have wondered just who was paying homage to whom.

Sunderland overreached. When his power was more secure, William dispensed with him as a political player and he sank into insignificance, which at least was better than the fate of Nicolas Fouquet, who had, similarly, paid the penalty for entertaining Louis XIV at Vaux-le-Vicomte in greater style than the King himself could afford and ended up dying in prison. Sunderland's heirs did the prudent thing and became party-line loyal defenders of the Revolutionary settlement. And why would they not? There were no more cavaliers. A monarchy restrained by Parliament was entirely in their interest; a revolution made for them, rather than against aristocratic landed power: a gift which kept on giving. They became entrenched in Northamptonshire; a landed fortune flowed back into the burgeoning City and made them still richer, able to survive the wild weather of mercantile and financial speculation on the Exchange. A London house almost as grand as the country house was built. And, at Althorp, the Spencers built the ultimate emblem of how they were seated in Hanoverian Britain: a stable block. Theirs, designed by Roger Morris in 1732, the same year Wootton got to work on the horse paintings, was, in every sense, a classic, complete with giant-order Tuscan columns. Brisk and Sore Heels and Craftsman, glossy with perpetual grooming, were themselves the new nobility. Bloodstock was everything. Pedigree ruled in Albion.

4. Bigwigs

Power had a face in town as well as in the country. London's painter to court and Quality was Godfrey Kneller: born in Lübeck but trained in Amsterdam with Rembrandt's sometime pupil Ferdinand Bol, something of a society portraitist himself. After Peter Lely died in 1680 Kneller had flourished as a court artist to Charles II and his long-nosed, doomed successor, James II. His work pleased them well enough for Kneller to be granted a knighthood, though he was scarcely a Sir Peter Paul Rubens, much less a Sir Anthony van Dyck. But he was asked to be visually grandiloquent and that was well within his powers. Kneller could do you full length; he could do you half length; he could do you in antique costume; he could do you *à la* Lely, vaguely emparked and pastoral, your iron-curled lady posing as a classical nymph, a length of silk slipping down her shoulders. With a shrewd eye to custom, Sir Godfrey Kneller avoided giving offence. Occasionally, when the 'essence' of the man meant more than the sum of outward features, when he was painting someone marked by wit or intellectual exertion, Kneller would bestir himself to engage more deeply. The strokes of his brush landed with a touch more freedom. He would light his subject with a little theatrical flair so that they would materialize as something more than Renown Illustrated. In 1689, two years after the publication of his *Principia Mathematica*, Isaac Newton appears with naked face, unwigged, his expression liberated from the cramp of pose; lost in obscure revolutions of thought. Thirteen years later, Kneller painted Newton again, the scientist now Master of the Mint. The full Augustan wig is planted a little too tightly on the skull, the elbow and forearm parallel to the picture plane in a standard Kneller pose and the grimace of distaste wonderfully written on Newton's face. It was the older Dryden, appealingly dishevelled, unwigged, a touch of coarseness on his features, which was the one the mezzotint engravers preferred. In all of these portraits, the sitter's

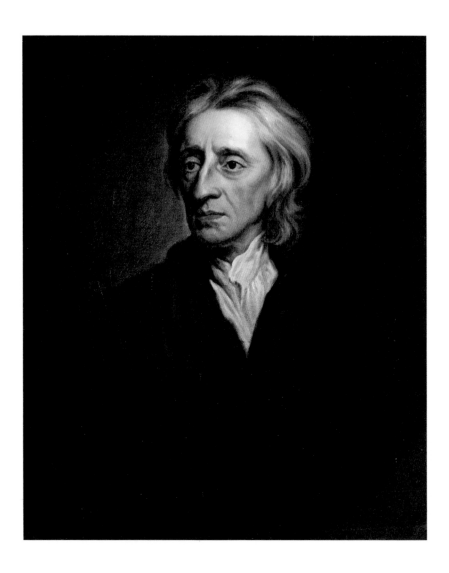

John Locke, after Sir Godfrey Kneller, 1670–99

gaze is somewhere else than on the intruding beholder. Most distant of all from ingratiation is John Locke, the most powerfully moving of all Kneller's pictures: the beaky nose, knitted brows and careworn bags beneath the eyes; the very image of a modern Cicero, exhausted with disappointment.

But Kneller could not support his social ambitions with a gallery of Genius. As well as a handsome town house in London, he kept a grand country villa at Twickenham, adorned with terraced gardens back and front, a stable of coaches and a large household of servants. Courtiers, aristocrats, solid gentry, potentates of the Exchange were his stock in trade. Wanting it himself, he went where the money was, investing in land, urban real estate, mining and the manufacture of mining equipment. Servicing the vanity of the moneyed, he imitated their acumen, creating a non-stop workshop that was as much a business as a house of art. Kneller would make sketches from live sittings and then the inevitable team of assistants would work up the finished painting, though anecdotes of assembly-line division of labour – wig men handing over to arms-and-hands men handing over to velvet-coat men – are apocryphal. But Kneller did streamline his work so as to be able to take at least ten, and on one occasion *fourteen*, sitters in a single day. In they filed, one after another, coaches lined up along the street. A very good morning; please be seated, there in the light, just so; excellent; thank you thank you, now if you will be so good as to hold quite still for a time, I would be most obliged; yes, quite like, excellent i'faith, very handsome indeed, so kind. Mr such and such will be sure to let you know when the likeness is done. Truly most obliged. Good day to you. Next, I believe? Ah yes, Lady so and so. Pray, do come in.

Not everyone in London society wanted to be painted solo. At the turn of the century, a new genre had arrived, as Dutch as the Protestant King, and that was group portraiture. It fitted its political moment. Power in England had become pluralized. Where once it had been concentrated in the peerless person of the sovereign, now it was dispersed among a class of the like-minded and the comparably propertied whose servant (though he dare not be described as such) the monarch

now was. Court had withered away, and in its place came Connection. Those connections were first those of social rank, power rooted in landed estate; then of political party; and, finally, and uniquely to England, of culture. The parties – Whig and Tory – were divided by attitudes towards the Revolutionary Settlement of 1688–9, and its implications for foreign policy. Whigs defended restrictions on royal executive power, frequent parliaments, the rights of Nonconformist dissenters, and were eager to go to war against the threatening absolutism of Louis XIV and his allies, who were hosts to the ejected James II and his heirs. The Tories, by contrast, championed a more expansive view of royal power, the high Church of England, and were leery of foreign adventures and the revenues required to fight them, since they would most likely impose on the country classes they claimed to represent. The Tories also suspected the institutions of the City of London: the Bank of England and the mercantile companies, which, on pretence of furthering the national interest, were feathering the nests of Whig grandees and their legions of toadies and placemen.

Once the issue of the Protestant Succession had been settled in 1701 and its designated monarch, George of Hanover, had arrived, the Whigs, who were both the engineers and beneficiaries of the order, embarked on ruthless purges of Tories, with the result that they more or less monopolized government for the next half-century. But before that happened, a new kind of portraiture came to be in demand: the picturing of sociability. What the county hunt meant to the lords of horse and hound, the club meant to the Quality of the town (sometimes the same people): an easy-going gathering of the like-minded; sharing common civility, 'politeness' and cultivation. Like-minded fellowship could be, and often was, political; there were Whig and Tory clubs, though some members were known to switch allegiance. The same pattern of loyalty extended to other places of socializing. The tavern was the incubator of male friendship and connection. The coffee house might admit some women of decent reputation, but it was the brand-new institution of the afternoon or evening tea party, socially limited for the moment by the high cost of the brew, where

women hostesses in handsome town houses set the tone. The English domestic salon already sipped dishes of China tea, not cups of coffee or chocolate. Each type of entertainment had its painters.

In the last decade of the seventeenth century, Dutch group portraiture – high-class 'merry companies' adapted to English circumstances – began to be favoured by the clubbable. The subject now was not the isolated individual but the life of a gathering. This posed compositional challenges, if the effect was not to be that of a chaotic crowd or a dull line-up pictured in a shallow space and extended right across the breadth of the canvas. These challenges were not always met. Sometimes the scenes were little more than depictions of boozy drinking societies, but ones in which each individual was clearly identified. In more polite circles, like the extended banking family of the Wollastons, painted by the young Hogarth in 1730, the gatherings, often over tea and including games of whist (hence little tables of twosomes scattered along the picture plane, left to right), could include as many as twenty figures; bonneted women as conspicuous as velvet-coated men.

These 'conversation pieces' were evidently beneath Kneller's customary scale of remuneration. But in the first decade of the eighteenth century an opportunity had arisen for him to do a different style of club painting: portraits that were, at the same time, likenesses of powerful and influential individuals, but pictured in a common enough way for them to appear a distinct group. Seen together, they would be the collective face of the Club.

Kneller's patrons were the members of the Kit-Cat Club, founded in the last years of the preceding century by the publisher and bookseller Jacob Tonson, whose own portrait, crowned with a raffish red cap, joined the National Portrait Gallery in 1945. Tonson's origins – son of a barber-surgeon – were modest. But he was the first printer-bookseller to aspire to and become what we would recognize as a modern publisher, cultivating personal relations with authors such as the playwright Congreve, who came to live in his house. Tonson was the first to think of his writers as a stable: a loyal troop who, barring

some unlooked-for falling-out or betrayal to a rival, would expect to be published by his house. To realize this ambition, he had to put out feelers – to potential subscribers, readers, critics; cheerleaders for Brand Tonson. But he was also held in serious esteem by the learned, because his breakthrough had come with the publication of the first critical edition of Milton's *Paradise Lost*. Once the reputation of the blind regicide had been culturally decontaminated and recovered for the English pantheon (there was renewed interest in Oliver Cromwell, too, at this time), Tonson could forge ahead in making connections with the aristocratic grandees of the literary world. The most important (or at least self-important) was Charles Seymour, 6th Duke of Somerset. In 1688 he had joined William's cause in arms, as a partisan of the Revolutionary Settlement. But Somerset was also Chancellor of Cambridge University. Had not Tonson been the resuscitator of the greatest of all Cambridge poets, John Milton, the 'Lady of Christ's'? Well, then: he was the man to revive the moribund University Press, especially if it could be relied on to turn out literature friendly to the Whig view of English history. The Somerset connection led naturally and straight away to the heavily propertied Whig oligarchs, the lords of county and city: the Cavendish Dukes of Devonshire, the Sackville Dorsets; Lords Somers, Halifax, Grafton, Wharton and Godolphin – all of whom fancied themselves as men of cultural sophistication as well as political clout. Many, like the Duke of Grafton, even wrote verse.

Tonson brought his troop of professional scribblers – the playwrights, poets, essayists – to meet the poetasting periwigs. He already knew that friendship, an idea on which so much of eighteenth-century society turned, was good for business as well as a tonic for the spirits. Cut off from each other's company, his writers were notorious melancholics, even when they were spinning jests in their plays. They were hungry for convivial entertainment, for the sight and sound of each other, even if they gossiped bitchily about their friends the very next day. So Tonson stoked the hunger for cultivated togetherness along with that for Christopher Catt's famously toothsome mutton pies,

cheese cakes and custards. In return for all the port and pastry, and the provision of helpful connections, the writers were to give him first refusal on any new work. The Cat and Fiddle (a nice tautology, since 'cat' was also London slang for a violin) was in the heart of town, close to the Inns of Court, and was the place where these connections were tied. The poet and playwright Dryden had for some time been holding court at Will's Coffee House in Covent Garden. But through the Somerset connection, Tonson brought to the Cat and Fiddle the cream of the Whig milords: theatre mavens all, and thus eager to trade banter with the likes of Vanbrugh and Congreve. Lords and luvvies rubbed shoulders, poked ribs, congregated, drank deep, roared their Toasts to the Beauties of the Town (wives excluded, of course), stuffed themselves until their waistcoats popped and sweat dribbled from their cockeyed wigs. Come morning light and a belch and heave or two, they lurched into the cobbled streets, squinting queasily around for a chair or a carriage to get them home.

Sir Godfrey, it went without saying, was not to paint the Kit-Cats in their cups. He was to produce handsome likenesses, erect and dignified: embodiments of elegant civility, their faces animated but not coarsely ribald or excessively haughty. Yet the matter was not simple, for the portraits had to be sufficiently similar to make it apparent they belonged to the same fellowship; a likeness to the likenesses. When they hung together in the handsome room purpose-built by Kit-Cat Vanbrugh for Tonson's house upriver at Barn Elms, they had to be seen as a single composition, a club portrait in forty-odd faces. They would be remarked on as individuals, yet tied together by politics, taste and humour. A wall of them was the absolute opposite from Althorp's Beauties, each of which was ready to claw the others' eyes out. The painted Kit-Cats, on the other hand, would collectively embody that new, self-consciously English principle in public life: manly friendship.

Kneller devised a unifying size: thirty-six inches by twenty-eight instead of the slightly larger rectangle customary for half-lengths; the format becoming known long after the club itself had disappeared as

'Kit-Cat'. He said that the size allowed him to show positions and gestures of the hands, 'allowing for greater variety of poses', but that was the least important element of the portraits' success. Without cramping the picture space, Kneller's format thrust the sitter forward towards the edge of the frame as if in social greeting, or at least lordly acknowledgement. Heads were turned a little right or left, at a bias from shoulders set square to the viewer. Unlike Locke or Newton, lost in bigger things, most of the Kit-Cats are open to our gaze, as if they might share a confidence, or even a jest.

Which is not to say that they are radically different. Their coats are velvet; their countenances smooth; the range of expressions limited. They seem to share the same slightly exophthalmic eyes; the same air of moneyed self-satisfaction (especially among the Whig peers). A more patient look reveals individuals. The wigs, which by concealing the contours of head and hair might impose a deadening uniformity, are in fact meaningfully various. Behold Congreve, who gave notice that he did not care to have his picture made. But when he saw Kneller's result he must have relented a little for, in his portrait, the thespian stands as grandly as a French marquis, gorgeous in his dusky-rose velvet coat, his tumbling wig as full and flossy as his writing. In case the mark of refinement is not strong enough, at his back is a pastoral landscape complete with green-gold poplar; perhaps one of Congreve's scenic backdrops straight from Drury Lane. The essayist Richard Steele, on the other hand, editor with Joseph Addison, first of the *Tatler* and then the *Spectator*, has a wig of dark curls, fitted closely to his pate. He is not all plumpness and jowls; the strongly set jaw and the flashing eyes belong unmistakably to the critic.

Occasionally there is no wig at all, but a cap or a turban. Charles Fitzroy, Duke of Grafton, fancied himself as a writer, hence the faux-informality of the deeply unbuttoned coat and shirt, made more self-conscious by Kneller having his right hand pull a little at the coat. Posed between lordliness and lyric, Grafton wears a green velvet cap thrown back from his crown. He fixes us with a look of eyebrow-raising curiosity just this side of disdain. The fleshy lips close to a moue, the

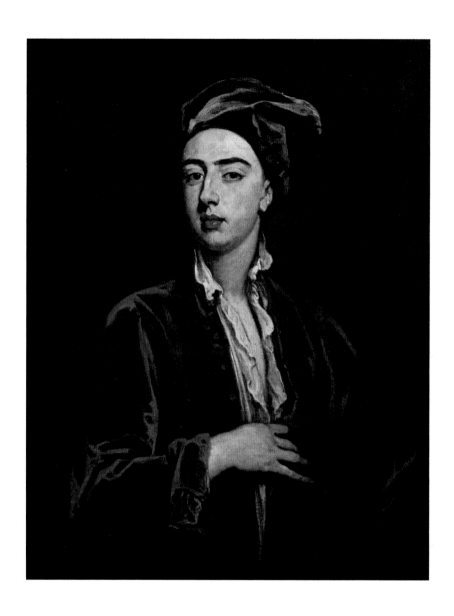

Charles Fitzroy, 2nd Duke of Grafton, by Sir Godfrey Kneller, circa 1703–5

cheeks are full and rosy; the gaze poised somewhere ambiguous between come hither and go away.

It's sometimes said that nothing distinguishes nobles from commoners in the Kit-Cat portraits. But that is not quite true. Many of the Whig milords – Stanhope, Cobham, the Earl of Scarborough, Montagu – feature triumphal scarlet, either in their velvet coats or in a bolt of silk thrown over a grandly patrician stone sill. In contrast, the Creatives are posed against elements of nature: a piebald sky; a touch of verdure.

Then there are other Good Fellows: Sir Samuel Garth, physician, champion of free dispensaries for the poor, entirely benevolent and floridly rubicund.

The forty-three surviving Kit-Cat portraits give the impression of a large company, but they were not all members at the same time. Generations overlapped; some, such as the Duke of Marlborough, came into the club when they were at their most Whiggish. There were probably no more than thirty members or so at any given time; but even so, that would have been a sizeable fellowship. It may have been the expansion of their numbers which made them move from the Cat and Fiddle to the Fountain Tavern in the Strand and then, eventually, to the bucolic Thames-side-suburb address of Tonson's house, which they would have reached by barge. Being a good 'True' Whig, having no doubts about the Protestant Succession, was the condition of entry, but the Kit-Catters spent less time debating politics than on gossipy imbibing (especially since, thanks to the Methuen Treaty with Portugal, port had become much less expensive than Bordeaux claret). Toasts were drunk to eulogized 'Beauties', each of them celebrated in verse, their names engraved on wine glasses. There was much Talk of the Town; periodic visits to the theatre, with or without Congreve and Vanbrugh; chuckling over scandal; promotion and demotion of reputations; and the warmly boozy-glow sense of kindred spirits.

Eventually, the club died of its own success. Whiggery had become the dominant political culture, unchallenged for any share of governing power until the 1760s. Perhaps, too, intra-Whig feuds and plots made the illusion of brotherly bonhomie hard to sustain. Many of the leading Kit-Cat

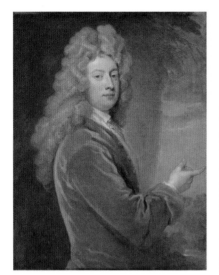
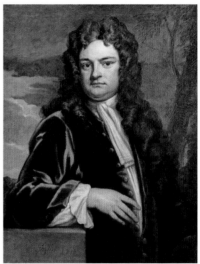
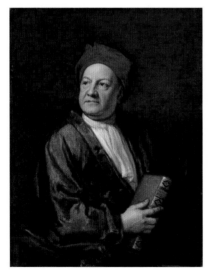
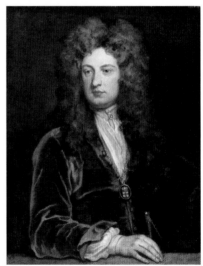

Clockwise from top left:
William Congreve, by Sir Godfrey Kneller, 1709
Sir Richard Steele, by Sir Godfrey Kneller, 1711
Sir John Vanburgh, by Sir Godfrey Kneller, circa 1704–10
Jacob Tonson I, by Sir Godfrey Kneller, 1717

lords – Stanhope, Townshend, Godolphin – had been in government at one time or another, but another of them, Robert Walpole, rose to power on the strength of damage limitation following the debacle of the South Sea Bubble, and kept it for two decades, from 1721 to 1742. Sometime membership of the club did not preclude growing and bitter enmity against the Walpole political machine. What had been a connection of the like-minded now seemed to those critics such as William Pulteney, creator of the viciously polemical *Craftsman*, to have been perverted into a corrupt quasi-despotism, secured through place and money.

The lapse in 1695 of the Licensing Act, which had regulated 'seditious' publications, had opened an astonishing field for unconfined freedom of expression. During the prime of the Kit-Cats, the Whigs used that freedom to attack Tories both in print and pictures. But Walpole's long ascendancy – justified, his foes said, hypocritically, as a fence against 'faction' and the rage of party – generated a new kind of political image. The formal portrait of the great man was hijacked by his enemies and used as a butt of ridicule and hatred. Walpole's likeness had escaped the control of its sitter and was at large in the public realm; an immensely momentous development. The sense that a portrait was public property meant that Kit-Cat Walpole, disinterested, peace-loving, dependable, could be made over by a hack satirist, George Bickham, into 'The Colossus'; taken from Cassius's sarcastic speech in *Julius Caesar*: 'Why, man, he doth bestride the narrow world/ Like a colossus.'

Increasingly beleaguered in the late 1730s, Walpole would not go quietly; not, at any rate, without using the methods of his enemies to counter-attack. One of the pro-Walpole prints used an engraved edition of the Kit-Cat portraits, appearing in the 1730s, to give William Pulteney, the self-styled 'Patriot', a dose of his own medicine. The Kneller Kit-Cat Pulteney is revealed as a mask of civility. Behind it lies the true face of the 'Patriot': the twisted leering of the devilish hypocrite. This is not yet true caricature, for the contorted features of the Bad Pulteney bear no relation at all to Kneller's silky portrait, although that, too, the satire implies, is a countenance of convenience not to be confused with physical truth. For a generation or two, political satirists used accepted likenesses

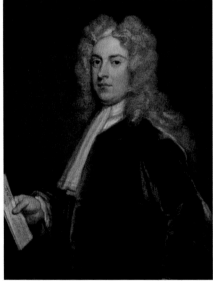

The Treacherous Patriot Unmask'd (William Pulteney, 1st Earl of Bath),
by unknown artist, 1742
William Pulteney, 1st Earl of Bath, by Sir Godfrey Kneller, 1717

against their own characters when they were not resorting to obvious, emblematic shorthand. Thus George III's first and favourite Prime Minister, the Marquis of Bute, was repeatedly pictured as a boot. The notorious manager of money and offices Henry Fox was of course the wily, sharp-toothed, brush-tailed vulpine. The comedy was already savage, and the public, pressing their noses against the windowpanes of print-seller Thomas Bowles in Cornhill, loved it. The nastier the invective, the more fun everyone had, except the victims. A mild measure of naturalization exempting Jews who petitioned Parliament from the obligation of taking the Christian oaths of the Test Act became, in the hands of the satirists, a campaign to turn St Paul's into a synagogue and force circumcision on Free-born Englishmen. Government ministers on the receiving end of the hue and cry – the Duke of Newcastle and Thomas Pelham – were seen to be in the pay of malevolently moneyed, hook-nosed Israelites, or offering themselves for circumcision to get their hands on Jewish money. The Naturalization Bill, which had already been passed by both Houses of Parliament, was hastily repealed. Any sort of foreigner was game for this kind of xenophobic ribaldry. Bute never got over being reduced to the Boot. A vicious strain of Scottophobia dealt in jokes about the 'Scottish itch'; the kilt behind the curtain: Bute's extreme closeness to Queen Charlotte. At some point Bute had had enough of the innuendo and ridicule. Laughter killed.

Comedy had become liberty's right-hand man in Britain. The history of liberties taken with jest was, of course, ancient. Lear's Fool says outrageous things to his King, pushing the limits of impunity. But cheeking the powerful was mutually understood as a temporary dispensation, after which deference was restored. The King got the joke; tell another at your peril. The Reformation moved satire to the centre of history and made it a matter of life and death, allegiance and salvation. The medium of Protestantism was print, and it was used to let fly a barrage of violent invective against the Papacy (aka the Whore of Rome) while having a lot of fun, in a grimly Lutheran way, with monks, nuns, saints and relics. It used the weaponry of one kind of imagery, the low kind that got people belly-laughing, against the other

kind: the lofty altarpiece which was now ridiculed as idolatry; the stupefaction of the credulous. Because this new kind of visual polemic was printed, unlike the jester's mischievous quip it was not going away. The assault on reverence extended into Europe's interminable Christian civil wars, both between and within its states. The Dutch immediately seized on satire to demonize, first, the Duke of Alva and his master Philip II, after which it became the standard way to mobilize patriotic passions against whichever enemy was at the door: the French, the English, the Bishop of Munster!

It is no coincidence, then, that when a Dutch prince, William of Orange, became a British king, William III, the gates of satire opened wide. This happened only indirectly. It was the 'rage of party' – the disagreements between Whig and Tory over the nature and extent of the revolution of 1688 – which nourished mockery, each side reaching for the poison pen and the acid-tipped engraver's point. Though the Tories, with their reverence for Church and Throne, were more uneasy about stepping into the miry puddle of satire than the Whigs, they certainly did not disdain it. Party competition for gifted satirists primed the pump of the new industry. When the Licensing Act expired without renewal (perhaps the real moment of cultural revolution), since there was no effective law of libel in the land, a host of printer-publishers generated and supplied a market for visual mockery; a bigger tribe of engravers grew up to service it. Laughter, liberty and licence began to dance round the pretensions of the mighty, and they have carried on going in Britain to this day. In the eighteenth century commercialized disrespect kept the oligarchs from locking up political Britain inside a culture of deference. It was a difference far wider than the English Channel. In France comedy was embalmed with Molière: the social satire of a bygone century enacted by a regulated, subsidized royal troupe; unthreatening to either the social or political order of the Old Regime – hence the sharp intake of breath, nervous chuckling and visit from the royal censors when Beaumarchais's *Figaro* dared to attack the presumptions of the nobility. By contrast, Britain was a non-stop carnival of rudeness.

5. *Attack Portraiture*

Attack portraiture was born as dis-likeness; faces redesigned for ridicule. Salient features – beetling brows, a fleshy nose, a weak chin – were exaggerated for comic effect. The appearance of a public man painstakingly put on to secure deference and win popularity mutates in the caricaturist's hand into a joke or a horror. As a take-down of the vain and pretentious, caricature had immediate appeal in the malicious world of English party politics. 'They tell me of a new invention called caricatura drawing,' the arch-bitch Duchess of Marlborough wrote. 'Can you find someone that will make me a caricatura of Lady Masham, describing her covered with running sores and ulcers, that I may send to the Queen to give her a slight idea of her favourite?' Even when not motivated by personal spite, caricatures violated the standard governing portraiture since antiquity, in which beautification in the name of an ideal countenance had been set down as the norm; a politely unspoken convention agreed between artist and sitter. The most ambitious artists, Rembrandt in particular, could be fearless in deviating from flattery, but paid a price for candour when patrons took exception to their definitions of likeness. Caricature was something else entirely: originally not much more than visual entertainment; spring-loaded for mirth. The etymology of the word is from the Italian *caricare*, to load or charge; and the pop and bang of the thing was meant for fun. Leonardo, and Annibale Carracci in the early seventeenth century, were always claimed by those who came after them as the inventors of the genre, but it was the early-eighteenth-century Roman artist Pier Leone Ghezzi who first made a name for himself as a specialist of *caricatura*, and whose work was widely reproduced in England in the 1740s by the printmaker Arthur Pond.

Traditional print-sellers such as Thomas and John Bowles, with shops in St Paul's Churchyard, Cornhill near the Royal Exchange and on Cheapside, began to fill their window displays with satires as well

as the usual stock in trade of topographical views and botanical illustrations. But in the middle of the eighteenth century the bolder husband-and-wife team Matthew and Mary Darly smelled business in caricature. Matthew was a jack of all trades – furniture designer with Chippendale; upscale interior decorator for City patricians; chinoiserie expert; wallpaper maker – and master of all; Mary was an accomplished caricaturist and gave lessons to aspiring amateurs. Should the fumes of aqua fortis (the acid used in etching) be 'noxious to the ladies', Mary also offered home instruction. By the late 1760s they had workshops and print shops in both the Strand and Leicester Fields, where they displayed 'Darly's Comic-Prints'. Better yet, the Darlys invented an entirely new product: pocket-sized cartoon cards, two inches by four, on which caricatures of leading politicians – the first batch drawn by the aristocrat George Townshend, son of a Kit-Cat – were printed. Darly cards could be pulled out for a chortle in the tavern or coffee house and became so popular that they were bound into little books as *A Political and Satyrical History*, revised and expanded editions of which appeared annually to incorporate choice new cartoons.

Written satire demanded attentiveness and often at least a measure of classical education to understand its many layers of allusion. But visual satire was for the people: unlearned as well as learned. It offered an instantaneous hit of pleasure, followed, should the viewer wish, by immersion in captions, short or dense, references to topical events and personalities. For the first time in history – anywhere – politics had become entertainment. As a result, caricature took off so spectacularly that artists who had flirted with it and made a little loose change on the side were now nervous of being identified as a 'mere' caricaturist. Hogarth was mortified lest he be thought a practitioner. 'I have ever considered,' he wrote in nose-holding mode in 1743, 'that character, high or low, was the most sublime part of the art of painting or sculpture', while caricature was 'the lowest indeed so much as the wild attempts of children'. It was because Hogarth himself was so much in the business of visual burlesque – the creation of social types, brilliantly fleshed out – that he was horrified at being taken for a mere

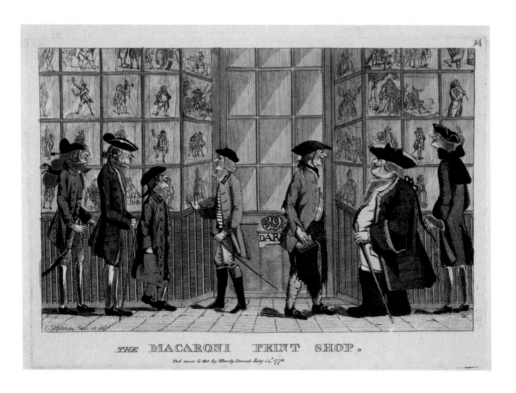

The Macaroni Print Shop, by Edward Topham, 1772

'phiz-monger', as he put it, a huckster of distortion. He was, after all, married to the daughter of the sententious history painter Sir James Thornhill and yearned to be taken seriously as one himself. Like the professional caricaturists, he came from the world of engraving: signs and satires, especially of the South Sea Bubble. He was not above a timely paid broadside, both at the beginning and the end of his career, which spanned some forty years. But his 'Modern Morality' print series had, he believed, a higher civic purpose: the reproach of vice, hypocrisy, corruption; of harlotry in the bedroom and prostitution in the public realm. Like his friend Henry Fielding, he aimed for a smile that would be the antechamber to graver thoughts concerning the State of Things. In a most English way, his pictures told stories, visually structured through a serpentine line within which elements of the story would unfold, one after the other, most often leading to a tumble from grace. His 'Election' series, based on the Oxfordshire election of 1754 of the MP Bubb Dodington, ends predictably, with the fall of the stout victor from the chair of his triumph.

Hogarth was deceiving himself about the line between character and caricature. What was his grotesque portrait of the radical politician John Wilkes, if not a caricature? Wilkes's newspaper *North Briton* had shown George III's Prime Minister, Bute, no mercy; so Hogarth's print, published in 1763, was part of the ministerial counter-attack. Hogarth took Wilkes's squint (for his admirers, the outward sign of lusty spirits), combined it with an antic grin and a wig coiffed into goatish horns and turned the Champion of Liberty into an imp of Satan dancing the credulous straight into the jaws of hell.

Humiliating defeats stoke the fires of ridicule. It was after the catastrophe of the American war that English anti-portraiture – already a popular culture – became, at the same time, a true art genre and a lethal political weapon. The time was packed with political drama. The American debacle broke the stranglehold of the Whigs on government or, rather, divided them into mutually embittered factions goading each other in Parliament. The King went mad; the Prince Regent made a secret, scandalous marriage; the Governor-General of

John Wilkes, by William Hogarth, 1763

the East India Company, Warren Hastings, was impeached before Parliament; the French Revolution erupted; and Britain went to war again, this time to stave off invasion. Caricaturists started going to the gallery of the House of Commons and making sketches of their prime victims. The news-hungry public could pore over the ocean of print in the daily papers and journals, but a large number preferred to consume it in cartoons; thousands of them plastered over the windows of the shops of the Darlys, S. W. Fores, or the new force, a brother-and-sister team, William and Hannah Humphrey, on the lookout to poach caricaturists from their competitors.

No one among the troop of caricaturists was more fought over than James Gillray, who came to be recognized as the incomparable virtuoso of the genre. Others followed, and were, in their ways, gifted comedians of line and expression – Thomas Rowlandson, Isaac and George Cruikshank – but none had Gillray's genius for turning polemics into an art form. He did too much, turning over caption-heavy journeyman jobs to keep him in cakes and ale. But when he was truly stirred – which, after the French Revolution went violent, was often – Gillray could dig deep and come up with mirthless jokes; ferocious unmaskings that were as potent and unforgiving as anything produced by Francisco Goya. *The Tree of Liberty must be planted immediately!* is, in its monstrous way, a portrait; the head dripping with blood instantly recognizable as belonging to the Whig Friend of the Revolution Charles James Fox, whose caterpillar eyebrows, plump jowls and five o'clock shadow were a gift to the cartoonist. In Gillray's implacable nightmare, Fox has remained blind to the last, his eyes covered by the cap of liberty, the heads of his self-victimizing comrades in revolutionary enthusiasm heaped at the foot of the bloody Tree. The caption is itself a piece of mordant contempt: 'The Tree of Liberty must be planted immediately! . . . to save the Country from destruction.'

As Britain became more embattled, ideologically and militarily, against Jacobin France, Fox obliged Gillray by refusing to repudiate his sympathies for the revolution, thus giving the caricaturist further opportunity to make him the embodiment of naive fraternity. Fox's

The Tree of Liberty must be planted immediately!, by James Gillray, 1797

showiness had always been a target. In the 1780s Gillray had turned him into an oriental potentate, Carlo Khan – a trumpeting elephant of an orator. But in the 1790s Fox became for Gillray dangerously risible (as did Tom Paine): an English Jacobin who would tear down the British constitution for the doubtful joys of French democracy. The clever Fox was the opposite of the honestly oafish John Bull, but it was the latter who was to be preferred to the former. Gillray was a true child of Romanticism: his imagination, like William Blake's, boiling with phantasmagoria. *Macbeth*'s witches, recast as government ministers, recur in his prints. But he was the opposite of Blake in seeing in the Jacobin revolution a fearsome apocalypse and one, moreover, which, if Fox and his like had their way, would cross the Channel. The horror comes to life in Gillray's nightmare scene from Paris, 1793. A domed church burns while a bare-arsed Jacobin (a heavy pun on *sans-culottes*) fiddles seated on the lanterne street lamps from which the clergy and magistrates hang while Louis XVI's head is taken by the guillotine..

The Promis'd Horrors of the French Invasion features Fox flaying William Pitt while leading a mob roaring down St James's Street where Gillray was living over the shop as a lodger of Hannah Humphrey. This time it is St James's Palace a few hundred yards away which burns while politicians are strung up from the balconies of Brooks' and White's, the London clubs. The print was so successful that it became a point of honour for all (except Fox and his friends) to want themselves recognized among the victims of the revolutionary rampage. George Canning was so bitterly disappointed not to discover himself in the print that he sought out Gillray personally and became one of his principal patrons.

Ultimately, it was S. W. Fores, or Hannah Humphrey, that Gillray worked for, not a politician. When opportunity arose, he could set about whomever it was who dominated the news of the day. It was plain to see that he was a British patriot; that he hated the French revolutionaries and Napoleon Bonaparte, whom he reduced to 'Little Boney', capering about or departing *tout de suite* from Egypt, abandoning his soldiers with a smirk on his face. Beyond that, and a basic faith

The Zenith of French Glory, by James Gillray, 1793

in the British constitution, no one could say with any confidence what Gillray's politics were, or indeed if he had any. That he wanted to be taken seriously, no less than Hogarth, however, was never in doubt.

He began, after all, in the Schools of the Royal Academy. Gillray's father had been a cavalryman and had lost an arm at the disastrous Battle of Fontenoy in 1745, so the son's precocious dexterity may have been some compensation. James grew up in Chelsea, at first near the veterans' hospital and then around the sombre Christian order of the Moravian Brethren, which had admitted his parents to their fellowship. Of five children, he was the only one to survive into adolescence. But an early exquisite drawing of a goldfinch shows us the kind of gifts which won him a place at the Schools of the Royal Academy, founded in 1768, when Gillray was just twelve. Presided over by Sir Joshua Reynolds and lodged in Somerset House, the Schools were the place to learn the art of portraiture, but Gillray entered in the engraving department, which already presupposed a lower tier of vocation. He seldom painted, for he was seen to be a skilled caricaturist, turning out whimsical and innocuous little vignettes of foppish macaronis, another speciality of the Darlys. While producing political caricatures, either clumsy or tentative by his later standards, and doing so anonymously, Gillray also turned his hand to book illustration – for Henry Fielding's *Tom Jones*, and Oliver Goldsmith's *Deserted Village*, a bitter lament at the destruction wrought by enclosures.

An opportunity to go in a different direction came in 1789, when Gillray was commissioned to produce a formal portrait of William Pitt, then in the sixth year of an administration which had begun when Pitt was twenty-four. For this portrait Gillray's interest would have been to flatter power, but something ingrained within him revolted. He looked at Pitt and saw Fox's opposite: bony where Carlo Khan was fleshy; severely angular where Fox was sensual; repressed where Fox was spontaneously witty. He was looking at Lent to Fox's carnival: the long pointed nose; the disappearing chin; and the upper lip stiff as a board, where both of Fox's were fat, shiny cushions. How could he resist? He didn't. The 'formal portrait' looked like a caricature,

William Pitt (An Excrescence; – a Fungus; – alias – a
Toadstool upon a Dung-hill), by James Gillray, 1791
William Pitt, by James Gillray, 1789

or at the very least a 'character'. It could not have failed utterly, since Fores produced several more, but possibly not for Pitt's warmest friends.

It may be that displeasure was shown. Or, on the side of the opposition, a sudden encouragement. For in the years which followed, some of Gillray's most wicked and brilliant prints made Pitt their subject: Pitt as the Toadstool, an image of a parasitically fungal Prime Minister planted on a dunghill; Pitt as Midas, his belly swollen with gold but vomiting and excreting worthless paper currency; Pitt as a mock-Colossus (an adaptation of the old anti-Walpole prints) with the judiciary locked between his legs; the 'Bottomless' Pitt, literally without a rump, in an age when to 'have bottom' meant to have soundness.

The most startling details of 'The Toadstool' are the botanically incorrect tentacular 'roots' of the fungus, planted about the nourishing dung heap in such a way that they form the unmistakable shape of the royal crown. It was a commonplace accusation that Pitt's government sustained itself by feeding off royal patronage and place. It was less routine to represent the monarchy resting on a mound of ordure, but then the caricaturists, whichever way they leaned politically, had no hesitation in including the royal family among the mocked. Scatological and bedroom jokes were standard form, to a degree that would be unthinkable today. A picture by Gillray which he certainly thought of as affectionately patriotic has George III in a jigsaw profile, shitting boats on republican France.

Pittites resented the moves for a Regency when the King descended into insanity, knowing the Prince of Wales would replace the Prime Minister with the arch-enemy Fox. So they appreciated the many caricatures of the Prince as bloated, lecherous and indolent, including the famous 'Voluptuary Suffering from the Horrors of Indigestion', a direct visual quotation from Hogarth's *Rake's Progress*; the debauched son, legs splayed out, much the worse for wear. If anything, even more liberties were taken with the King's younger brother, the Duke of Clarence, who would become King William IV, siring, for the monarchy, a record number of illegitimate children. The Duke's mistress,

The French Invasion; – or – John Bull,
bombarding the Bum-Boats, by James Gillray, 1793

the actress Dorothea Jordan, in Gillray's outrageous caricature is turned into the other kind of jordan, a chamber pot, and a cracked one at that, through which the Duke sticks his head. Nothing was off limits.

Through the years of revolution, war and madness, George III remained immensely popular, so the most caustic caricatures played more with his eccentricity and his notorious frugality and parsimony. Queen Charlotte, however, was another matter entirely. In 1792, during a quarrel within the government, Gillray produced *Sin, Death, and the Devil*, travestying lines from Milton's *Paradise Lost*, and featuring Pitt as Death, slugging it out with Edward Thurlow as Satan, with the Queen, half-naked, exposing pendulous dugs, hair writhing with serpents as befits the 'snaky sorceress' coming between the two. Astoundingly, nothing happened to him as a result. The only time he was arrested was for a comparatively mild print showing politicians arriving to kiss the rear end of the newly born Princess Charlotte. Even then, he was not imprisoned and the case was dropped.

British caricature was never so lethal again. Gillray's work weakened from a glut of the senses. Images of appetite compulsively recurred. Jacobins dined on human eyeballs; pig-like, lusty Britons crammed their faces while French Republicans became emaciated; Napoleon and Pitt got stuck into the world plum-pudding with their knives. Gradually, his attacks became mere spasms of visual nausea. His dependable gladiators, so perfectly antithetical – Pitt and Fox – both died in 1806. Gillray's spare energy went into anti-Napoleonic propaganda, understandable enough when the country was genuinely threatened with invasion in 1804–5. Something about the near-unanimity of British patriotism at this time dulled his edge. Every so often a flash of his old brilliance would reappear, as in Napoleon made over into 'Tiddy-doll' the gingerbread confectioner, baking up gingerbread kings across conquered Europe from his own family and marshals. But something had gone. More and more Gillray contented himself with gentle parodies of fashionable dress and manners. The old King was scarcely to be seen and mostly mad. Instead (in a striking

Sin, Death, and the Devil, by James Gillray, 1792

anticipation of Charlie Chaplin's comedy *The Great Dictator*), Gillray turned Napoleon into a 'maniac' unhinged by the din of his own empty bombast.

But it was his own powers that were failing. The bipolar downward trajectory occurred more frequently than the manic upswing. His eyesight went; then his sanity. More than once he threw himself from Hannah Humphrey's windows on to St James's Street. One attempt was farcically foiled by his getting stuck in terrace railings, a scene the old Gillray would have made use of. One day he appeared downstairs in the shop, stark naked and unshaven, rambling and shouting. In 1815, the year of Waterloo, he made another effort, and this time succeeded. Not long before, Gillray produced one of his most affecting images, drawn in a spidery hand, as the dimness closed in. *Pray Pity the Sorrows of a Poor Blind Man* was not a caricature. The toothless, stricken beggar, his mind seething with half-formed pictures, is a self-portrait.

Pray Pity the Sorrows of a Poor Blind Man, by James Gillray, circa 1812

6. Family Album

For the British monarchy to be rescued from the pit of ridicule required more than a change of personnel. It needed a new institutional personality and a fresh way of appearing to its people. It had been a dynasty; now it had to become a family. It helped that the decrepit lechers George IV and William IV, the one a bloated vessel of self-indulgence, the other a crankily opinionated martinet with a colony of illegitimate children, brought the Hanoverians to an end. It had not worked as their parents, George III and Charlotte, had hoped. Descending from dynasts who thought little of conjugal loyalty or tenderness, George had wanted to recast the monarchy as an exemplary family, with the Prince of Wales as a model of social virtue. By the time the boy was sixteen and already chasing actresses, it was clear that father and mother were in for disappointment.

Then, by the grace of Providence, along came Victoria, the daughter of the Duke of Kent: pink and tiny like a furled rosebud. Even more remarkably, the Queen fell deeply in love with the prince she married in 1840: Albert of Saxe-Coburg and Gotha. That passionate devotion never abated, even after Albert's untimely death in 1861. The couple did not need to be educated into family life; it came naturally to them. Before much time had passed a nursery full of children completed the domestic idyll. But how should this happy scene be represented to the British people? The exhibition of this new kind of majesty was bound to be a delicate operation. 'Royal Family' could easily be oxymoronic. Majesty, even in its modern, supra-political form, needs mystery, distance and distinction, or else it loses its symbolic power to personify an entire nation; ultimately, its whole point. On the other hand, too much formal remoteness risks estrangement; a loss of sympathy. Victoria and Albert were the first to try to find a place of equipoise between elevation and familiarity through a routine of selective visibility.

Their instincts, especially Albert's, were active, gregarious and public. Buckingham House had been originally built for Queen Charlotte as a *pied à terre* away from St James's, where formal ceremonies were held. John Nash had palatially expanded it for George IV at ruinous cost, but after all the time and expense the King declined to live there and offered it instead to Parliament, which rejected the offer. Victoria was the first monarch to make Buckingham Palace, as it now was, a true residence, but never thought of it as a concealing enclosure. Once married and with the Prince Consort's encouragement, the royal round came into being: state banquets; attendance at civic dinners and balls; the opening of buildings and bridges; the bestowing of honours; the reception of Privy Councillors. Horse and hound were not neglected, but the monarchy was now fully immersed in the bustle of industrializing Britain. It's not surprising, then, to find both Albert and Victoria immediately captivated by the brand-new wonder of photography. When she died the Queen left behind a prodigious collection of some twenty thousand photographs. Though neither of them became photographers themselves, Victoria and Albert would actively patronize the new art form and its institutions; install a dark room at Windsor so that favoured photographers could develop *in situ*; commission photographic projects and exhibitions. More than anything else, portrait photography would transform the image of monarchy in British life. Even though it wasn't, a photograph of the Queen seemed three-dimensional in a way denied to painting. Paintings were expected to be cosmetic, the portrait of an idea; photography was considered, not altogether falsely, to deliver reality.

Royal enthusiasm began with the medium itself, which was from the beginning a cross-Channel tournament of invention. Louis Daguerre first announced his success in fixing camera obscura images on a silvered plate in January 1839, prompting Henry Fox Talbot to show his calotype pictures, some taken three years earlier, at the Royal Institution on the 25th of that same month. In August 1839 Daguerre took out a patent for his process in England and Wales. The fascination was so universal that Albert, easily excited by technological

innovation, could not have missed it. Whether or not it would ever supplant painting or prints as a medium for portraiture, let alone for picturing the royal family, was another question entirely. Through the early 1840s the images fixed on plates and paper were mostly, though not exclusively, landscapes and townscapes, buildings and monuments. Figures began to appear, but the long sittings required for exposures made it seem very unlikely that the Queen and Prince Consort would ever consent to the necessary immobility.

But they did. One of the earliest British portraits is a daguerreotype, now much faded, of Albert, taken by William Constable in March 1842, probably as a gift for the Queen, for this is certainly the face with which she fell in love: serious and handsome, with a touch of the visionary about the distant gaze. It says something about this new monarchy that Constable was the first royal photographer, because he could hardly have been more self-made. The son of a Surrey flour-miller, and already in late middle age before he took up photography, he had been by turns grocer, watercolourist, land and road surveyor before working for a Lewes draper who was a scientific enthusiast and made his chemistry lab accessible to his employee. Constable had opened his own daguerreotype studio in Lewes in November 1841, complete with revolving chair for a variety of poses, and charging a guinea a picture. It may have been his advertising that caught Albert's attention, but it was at any rate an extraordinary thing for the working-class son of the miller and the prince to be closeted together for hours to create the image.

Albert posed for Constable as if for a formal court portrait, but he grasped very quickly the transformative potential of photography. He is said to have acquired a copy of the famous panorama of the mass meeting of the Chartists on Kennington Common in 1848, even though (or possibly because) the event looked like the beginning of a revolution. But Britain, by the grace of industry, had, in 1851, its Great Exhibition, where other countries had great insurrections. And since he was the patron of the immense show of technology, arts and crafts in the Crystal Palace, Albert was keenly interested in photographic documentation of the building; its displays and even its dismantling

for reconstruction at Sydenham. The photographer making a name and a comprehensive album of the exhibition commercially available to those who could not get to see it for themselves was Roger Fenton. His father was the other sort of mill owner, an industrialist, and after training for the law Roger did an abrupt volte-face, escaping to Paris, where he studied with Paul Delaroche, who specialized in Anglo-French histories, often of demure necks about to meet the axe (Jane Grey; Mary, Queen of Scots). Fenton followed Delaroche's interest in photography; joined the Paris Calotype Club, the first of its kind, and took the new art back with him to London. In December 1852 Fenton, together with Joseph Cundall, organized a major show at the Society of Arts in which seventy-six photographers exhibited some four hundred photographs. It was such a success with the public that it was extended longer than scheduled, to the third week of the new year. That same month, the Photographic Society (soon to be the Royal Photographic Society) opened, with Victoria and Albert as its patrons and Sir Charles Eastlake, President of the Royal Academy and shortly to become Director of the National Gallery, as its first president, a signal that photography was to be treated as Art.

By this time, photographic portraiture had been established at Windsor and Buckingham Palace. Albert insisted that his cultural major-domo, Dr Ernst Becker, learn how to take calotypes, and the Queen, self-consciously shy about her appearance, had allowed herself to be photographed. The age of her daughter the Princess Royal, sitting on her lap, dates one of the first portraits to as early as 1844. But it was only in 1852 that Victoria, bonneted and in day dress, had two pictures taken along with her three daughters and two sons. The photographer was Edward Kilburn, and the informal poses, Mama and the brood, would have been picture perfect had not Victoria closed her eyes at exactly the wrong moment. The second shot met an even more unfortunate fate. Though the Queen thought the children looked 'pretty', she felt so strongly that she looked 'absolutely horrid' that she rubbed out her face on the daguerreotype and took away the plate. On a third try she was taking no chances and wore an enormous bonnet which,

Queen Victoria with the Princess Royal, the Prince of Wales,
Princess Alice, Princess Helena and Prince Alfred, by Edward Kilburn, 1852

seen in profile, more or less hid her entirely. One feels for Mr Kilburn. And for the children.

Two years later Roger Fenton, persuasive and personable, managed to overcome some of the Queen's nervousness. His pictures of Windsor Castle were much admired. By 1854 Albert and Victoria had the idea of commissioning a set of family portraits they could send to foreign relatives such as the Queen's cherished uncle Leopold of Belgium, as well as to favoured parties at home. But although these were images in the first instance for private consumption, Fenton had a shrewd idea they might one day end up in the public gaze, or at the very least encourage his royal patrons to allow another set of images to be made for their people. More confident than Constable or Kilburn, Fenton always thought of these images as expressive art, a form to rival and surpass painting in veracity. A few suffer a little from painterly excess. In images shot in the royal drawing room, Fenton dresses up the Queen as if framed in a fairy tale or an opera: her eyes romantically downcast; ostrich plumes about the crown of her dark hair; florally festooned; silk and chiffon foaming all about her plump little form; the right arm sleevelessly exposed. But it is the other kind of pictures which testify to the care Fenton took to try to make Victoria and Albert at ease in the presence of the camera. The results are portraits not so much of a Queen and her Consort but of husband and wife: the portrait of a bourgeois marriage; not an epaulette or tiara in sight. In one of the most beautifully affecting, Victoria, costumed in a light-coloured (perhaps white) dress, sits close to Albert, her heart-shaped face turned away from him. He, on the other hand, looks at her with an expression of tender husbandly concern, as if he has caught something unsettling in her faraway gaze. Perhaps there are worries about the troops in the Crimea. The next year, Victoria would send Fenton to the war to take photographs of ordinary soldiers, and she would keep a private album of some of the most grievously wounded and mutilated in order to keep their suffering in mind. But one should resist projecting on to their solemn expressions news of the day. Serious combat did not begin in the Crimea until September, so it's more likely that Fenton posed

them this way – lengthily – as a little piece of parlour drama, which, however, was not all that far from the truth of their home life: the Prince Consort perpetually engaged in important business; the Queen anxious lest he overdoes it. They may just have been acting a part for Fenton's art: his ultimate models. But the pictures are loaded with unmistakably genuine emotion. In a second photograph taken during the same session on 30 June 1854 the husband has returned to his papers; the wife, once again, does not look at him. But she doesn't need to. She has her arm around his shoulder. No picture of royal life before or since has ever been so touchingly intimate.

Too intimate, in fact, for public consumption. When, six years later, Victoria and Albert did decide, in an act of great daring, to let their images go out into the public realm, some of them kept the informality of Fenton's poses, even though Fenton himself had retired from photography and returned to the law practice in which he had also been trained, alienated by what he considered the prostitution of his high art before the altar of commerce. The objectionable commodity was *cartes de visite:* literally, visiting cards, which traditionally had nothing but the bearer's name on them but which now bore his or her photograph, pasted on a stiff card about three and a half inches by two. The *cartes de visite* became so popular, however, that they began to be collected in their own right, and even traded, especially when bearing the image of someone famous.

The next step, then, was obvious, and it may have been a photographer born in Oldham but trained in Philadelphia, John Jabez Edwin Mayall, who persuaded Albert and Victoria to take the plunge. Mayall had been taught optics and chemistry in Philadelphia; had returned to London and set up a thriving studio, where the famous, including J. M. W. Turner, came for their portrait. In early 1860 he took a series of pictures of the royal family, many of them retaining the informality pioneered by Fenton but without the intensely private feeling. Victoria, by now the mother of nine, was more sombrely dressed, and the cares of state business had plainly aged Albert. But this, too – the evolution of the young wife into the burdened mother – responded to something

Queen Victoria and Prince Albert, Roger Fenton, 1854

instantly recognized by middle-class Britain. Queen Charlotte, George III's wife, had been similarly solicitous and often tragically sad when her husband descended into madness. But it was through photography and, especially, the royal *cartes de visite* that the image of the motherly Queen first imprinted itself on the mind of the British public.

The response to the announcement that an album of fourteen of Mayall's pictures could be purchased by the public astounded even the commercially minded photographer. Within days he had taken sixty thousand orders for the royal *cartes de visite*. Over the next year, many more would be sold worldwide, making Mayall a very rich man. The transformation of royal imagery, and thus of the monarchy itself, had been decisively accomplished. Surprisingly, by no longer looking like aristocrats, Victoria and Albert seemed more, not less, regal. Without any loss of dignity, they were visibly flesh and blood like their subjects: able to comprehend the ebb and flow of daily life, the pains and joys, because it seemed evident that they had first-hand experience. That, at least, was the notion. A revolution in imagery had pre-empted the real thing.

Yet hardly had the *cartes de visite* industry got going than it lost its leading man. On 14 December 1861 Prince Albert died at Windsor Castle. For months he had been suffering all kinds of muscular and intestinal pain. An inspection at Sandhurst in a downpour had weakened him; a furious scene with Bertie, the Prince of Wales, over his relationship with the actress Nellie Clifden had done more damage. The doctors thought it was typhoid fever. Recent research suggests acute Crohn's disease.

Two days after he expired, distracted by grief, Victoria summoned another photographer, William Bambridge, to take pictures of the dead Consort laid out on the bed in the Blue Room. Two negatives were made. When she could bear it, the Queen had prints made from them and promptly destroyed the negatives. The following year, Bambridge was called on again to photograph the Queen for the public, this time in the widow's weeds she would wear for the rest of her life. In one of the most affecting images, three of her children, also dressed

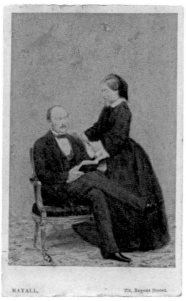

Prince Albert of Saxe-Coburg-Gotha, Queen Victoria and Their Children,
by John Jabez Edwin Mayall, circa 1861
Prince Albert of Saxe-Coburg-Gotha and Queen Victoria,
by John Jabez Edwin Mayall, 1860

in mourning black, are gathered about her. Albert is present only in the form of a marble bust, white as death itself.

Many more pictures of the mourning Queen would appear in subsequent years, even as Victoria disappeared entirely into her grief. The medium which had made the sovereign seem closer to her subjects, to live among them, now had precisely the opposite effect. It was a substitute for her actual presence – at state occasions, hospitals, universities, chambers of commerce; the whole royal round which had been established by Queen and Consort. A period of decent seclusion was understood by the public, but the very imagined closeness which had been established by royal photography had now been abruptly withdrawn. It was as though the British were not good enough to pay their respectful commiserations. By 1864 it had become clear to the government and the Queen's private secretary, Sir Charles Grey, that not all the *cartes de visite* in the empire could compensate for Victoria's physical invisibility. Republicanism began to stir. Talk of abdication was no longer taboo. Most telling of all was the return of satirical cartoons, albeit hardly as mordant as those of Gillray. In 1867 the *Tomahawk* published a cartoon by its Matt Morgan, of a British lion, recognizable only by its tail peeping out from a throne in which a slumped form was covered by a drape. On the blanketed thing's head the crown tilts perilously. 'WHERE IS BRITANNIA?' the caption asks. The real answer was Scotland, guarded by her ghillie, John Brown, about whom rumours swirled.

Eventually, Victoria was induced to leave the tomb of her inconsolable despair, though it took an assassination attempt on Bertie to reconcile her to the sight of her eldest son. Try as she may, she could never forgive his wickedness for bringing on his father's last aggravation.

A photographic iconography was re-established but, increasingly, as time went on, it was like a death mask plastered on the living matriarch; the face rigid with solemn resignation, her head never without the widow's cap. She slept with the cast of Albert's hand on her pillow; his shaving tackle neatly laid out for the morning. Life was a mausoleum.

Every so often, a photographer came to Osborne or Windsor, or even Balmoral, and she would assume the guise of whatever it was they wanted: Queen-Empress of India; matriarch of the people; grandmama of Europe. But the wife of Fenton's and Mayall's pictures was long gone, as dry and papery as an old flower pressed between the pages of a yellowing journal.

Queen Victoria, by Alexander Bassano, 1897

7. *Absent One Cigar*

Ottawa, December 1941

It was all very gratifying. Their Parliament had risen to him. He knew that, even in Canada, a jab at the French would go down well. The wrong kind of French, anyway: craven, capitulating General Weygand, who had confidently predicted that England's neck would be 'wrung like a chicken's'. It had come to him in the night, the joke. 'Some chicken.' Long pause. 'Some neck.' A gale of ha-ha, ho-ho, just the way he liked it. Laughter pushes back at fear. Some of them had boys in uniform, waiting to climb into their planes. He understood.

Elation was battling with exhaustion. He had been told he should think again about crossing the Atlantic to see FDR. Piffle. Now that Pearl Harbor had brought America into the war, he must see to it that they would fight the Nahzees in Europe, not just the Japs in the Pacific. The President had reassured him, and he believed him. The war would be won, however long it took. But this trip had been a lot to shoulder. He had put his heart into it; more than he knew, for in the evening following a speech to Congress he had felt a tightening in his chest, and an odd numbness in his left arm. Just as well Charles Moran was there. Once the doc had determined the heart attack was a little one, he took the biggest risk of his life deciding not to say those words to Churchill. What would it look like at this crucial juncture, if the living incarnation of resistance to fascism were to turn invalid? Still, going to Canada was imprudent. Some rest was wise. But Churchill woke the next day in fine fettle, and not much could prevail over Churchillian ebullience. How could he not go? he asked. The Canadians were our kin; sacrificing their sons for a cause across the ocean they embraced without question as their own. Shoulder to shoulder, heart to heart. It was the least he could do. Some tough old bird.

But now, the speech done, the fatigue crashed down on him. He had

113

been up half the night getting the words right. An aching pulse throbbed dully somewhere in his head. Nothing a stiff Scotch and soda wouldn't put right. It had been the damned flashbulbs popping off all the time in the chamber while he was giving the speech. And the bank of lights the Prime Minister Mackenzie King had supplied for the film cameras. He could scarcely see anything at all except the words on his papers. He had to peer at them, his glasses slipping down to the end of his nose. Ah, the Scotch and splash, thank God. Down the hatch. Winston chatted amiably with the politicians; whoever came to shake his paw. He felt rosy. The business of the day done, the informal dinner at Laurier House awaited. He could unwind; unbutton; tell some old stories; try to avoid jokes about Mounties. The Prime Minister lit a Havana.

He had left his overcoat in the Speaker's Chamber and, in company with a train of the Canadians, went to fetch it. But when the door opened he was met with a blaze of blinding light: six floods; two spots. 'What's this? What's this?' were all the words he could get out. He glared in the flare, white with rage. A tinny peal of nervous laughter rang around the panelled room. Churchill was not laughing.

Yousuf Karsh saw right away that this was going to be difficult. Impossible couldn't be ruled out. Could it be that Churchill had not been told that he was to be photographed following the speech? To judge by his clenched, angry expression, so it seemed. Through no fault of his own, the capstone of Karsh's career, his life, was suddenly in jeopardy.

He had come a long way from Mardin, in the south-eastern corner of Turkey; an Armenian born at just the wrong time, 1908, as the Young Turks came to power. In February 1915 the mass murders started and went on until a million Armenians had been killed. Karsh's family survived – just – by escaping over the Syrian border and settling in Aleppo. But who knew what the future held? In 1923 an uncle, George Nakash, already settled and working as a photographer in Sherbrooke, sent a ticket, and Yousuf found himself knee-deep in the snows of a Quebec winter. He called himself Joe; better that way. Joe had

imagined himself a doctor in a new world, but Uncle George Nakash, his handsome benefactor, needed an assistant and made him feel that it was only considerate to work his passage, as it were, for a few months; with pay, of course. 'Just try it for a little while. Who knows?' It was fate. Everything about photography pleased the young man: the alchemy of the acid bath; magic emerging in the dark. An apt learner, Joe was sent to Boston to study the art – and it was called that – with John H. Garo, who made paintings of landscapes and faces that happened to be photographs. Garo worked like a wizard and dressed like a bohemian to impress and provoke brahminical Boston. Joe followed his master's romanticism, taking soft-focus images of pretty, hazel-eyed girls from Lincoln and Wellesley, and himself in an Omar Khayyám turban; everything lit theatrically: strong lights and inky darks.

In 1931 he moved to Ottawa; an odd choice, except he imagined the capital must be where the powerful whose image he wanted to capture were to be found. He would be the Edward Steichen, the Cecil Beaton, of Ottawa. Better the small pond. But the slight, swarthy Armenian could not have chosen a whiter place to live, as white as the frosts of Ontario. In the circumstances, 'Joe' seemed ridiculous, so he reverted to Yousuf. Call a Levantine a Levantine, why don't you? He could not afford to be shy, so hearing that the Governor-General, Lord Bessborough (these British), had created an amateur theatrical troupe, Yousuf found his way to their rehearsals, offering to take publicity shots. The tungsten lights and selective spots made him think again of Steichen and Beaton. They had taught him drama, Uncle George and Garo. So he posed leggy amateurs and fine-boned juvenile leads in Canada on a lark from Cambridge so that they were transformed into Barrymores and Garbos. Gratitude came his way from the high-ups and he played shamelessly to their preconceptions by pouring on the dark charm. The girlfriend he ended up marrying, Solange, worked in the Canadian Parliament, which also helped send politicians and civil servants (even they had their vanity) his way. In between days of posing suits and ties he would photograph Solange nude, her body perfect, her face obscured.

In 1936 he met Steichen in New York. The great man's studio was full of experiment and his bank account overflowing with success. That did it. You could make a lot of money and still be faithful to Art. In fact, it was a whole lot easier that way round. When the war came in 1939, demand for his services soared. Young officers about to depart wanted photographs for their families and girlfriends. Government ministers wanted to record the gravity of their responsibilities, written on their faces. It was a coup when he photographed Mackenzie King and got him out of his dull suit and into a greatcoat and cloth cap. Karsh took a wonderful photo of the unprepossessing Prime Minister reading at night, his dog between his knees: Mr Canada. He could work this magic. So who else should be the one to immortalize Churchill?

Churchill was not the only one to have had little sleep. Karsh had had a bad night; nervily restless. An already famous photograph taken by Cecil Beaton in the Cabinet room of 10 Downing Street the previous year did nothing to calm his anxieties. Displeasure was written all over Churchill's face. He had been interrupted. Doubtless Beaton had been wanting the redoubtable look. What he got was exasperated truculence. But then, if Karsh thought about it, that misfire – reproduced around the world – would give him an opportunity to get redoubtable right.

When he got back to the Speaker's Chamber in advance of Churchill's arrival and inspected the bank of lights, Karsh's confidence returned as the brilliance powered up. It was high stakes: everything at risk. The door opened. His subject's face tightened into a mask of fury, the cigar smouldering. Karsh decided that he had to be the one to make a little speech; an appeal to history: 'Sir, these photographs may be the ones which will serve as a constant source of the hope and inspiration you have created in the heart of the civilized world.' It was Yousuf's version of Churchillian, and it worked. He would permit a single shot.

Just one. It had better be unique, then. All the others, Beaton's aside, the ones that showed up in the papers and the magazines, had the

homburg; the stick; the 'V' for Victory sign; the cigar; Churchill's face smiling amidst rubble or adoring crowds. Karsh didn't want the smile. He didn't want the cigar. He pointed out the ashtrays waiting to receive it. Churchill ignored them. Some demon moved Yousuf. He walked coolly up to Winston Churchill and without a word pulled the cigar from his incredulous mouth. 'By the time I got back to the camera,' Karsh remembered, 'he looked so belligerent he could have devoured me.' And this, he realized in a split second, was just what he was after. The shutter opened and closed a tenth of a second later and, did they but know it, the world was altered.

It was to Churchill's credit that he relaxed a little. Cheek could go either way with the Prime Minister. He had decided to be entertained by it. 'You certainly know how to make a roaring lion stand still,' he told Karsh, beaming, complimenting both of them. He even agreed to another shot. And this time he composed himself into warm-hearted, doughty hero of the free, giving Karsh one of his gold-plated smiles. Though Karsh had the feeling he had seen this umpteen times before, that compared with the thundercloud face it was a mediocre image, he had no idea which of the two would in fact be what the magazines, especially Toronto's *Saturday Night*, wanted. It turned out that they wanted indomitable not affable.

But then they saw Karsh's retouched version. The Churchillian face he saw as it developed, he thought, would be hard to take. There was too much glower. He needed to pull up the lights and brights, especially on forehead, nose and chin. The white of his shirt, pocket handkerchief and, touchingly, the speech notes poking from his jacket would set off the Churchillian bulk encased in his dark jacket. By the time he was done, the ring on Churchill's little finger and his watch fob shone with optimism; the famous striped trousers struck a friendly note. Then Karsh cropped his picture, losing most of the chair on which Churchill had leaned and the sharp bend of his elbow, pulling the whole figure towards the viewer. I am here for you, the expression now said. Our task is stern, but see my strength of resolve. We will prevail.

Karsh's photograph took wing. After *Saturday Night* published it as *The Roaring Lion*, together with passages from Churchill's speech, the American *Herald Tribune* and *Life* magazine reproduced it, followed in London by the *Illustrated London News*. Churchill himself saw its power and its incalculable usefulness to the good cause, repeatedly using the photograph in editions of his speeches. Smileyface Winston was utterly forgotten. The adamant warrior is the one which hangs in its own place in Downing Street; the only Prime Minister to get two photographs there.

Who made it? Yousuf Karsh, his Shakespearean lighting and inspired temerity? Churchill, whose default mode in the middle of war was defiance? Or the rest of the world, which had been longing for just such an image of fortitude? The face spoke to millions of invincible resolution. It was the face they conjured up when they tuned into Churchill's eloquence through the crackle of short wave. It was the face of the finest hour. No one needed to know that it was actually a face which had just been deprived of its cigar.

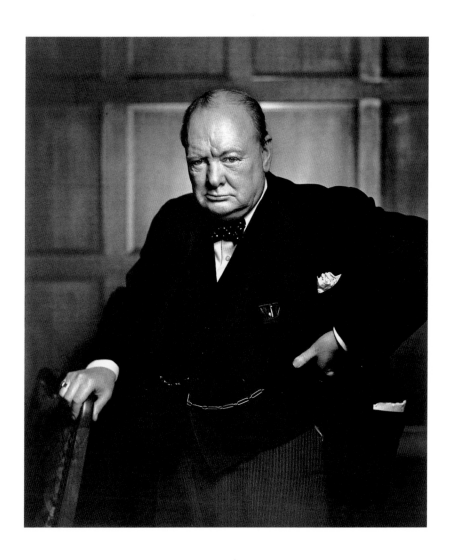

Winston Churchill, by Yousuf Karsh, 1941

II

The Face of Love

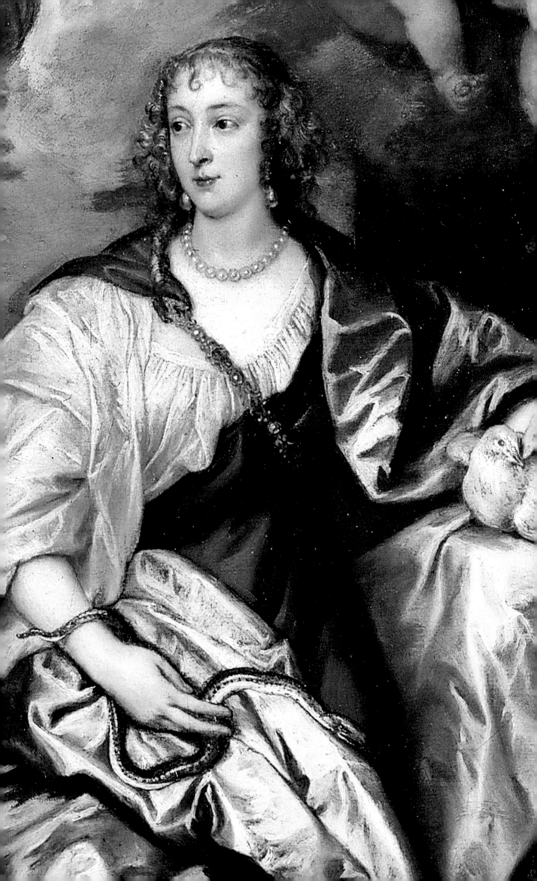

1. *Shadow Love*

Don't go. Don't leave. Don't die. Don't change. Don't disappear.

According to Pliny the Elder, portraiture began with the fear of lost love. In Book 35 of his *Natural History,* he tells the story of the daughter of Butades, a potter of Sicyon, who was the first to form 'likenesses in clay at Corinth, but was indebted to his daughter for the invention. The girl, being in love with a young man who was soon going from her to some remote country, traced out the lines of his face from his shadow on the wall by candle-light. Her father, filling up the lines with clay, made a relief and hardened it in the fire with his earthenwares.' Now Butades' daughter could keep her lost love or, at any rate, his double, his likeness, wherever he might roam. She could have his face before her day and night, for ever.

What nobler purpose could portraiture have? When the sentimental and romantic generations took up the fable of origins in the seventeenth century, they made even larger claims for Butades and his daughter. Now, not just relief modelling, or silhouette or portraiture, but all of painting, all of art, was said to start with that moment of resistance to loss; the fixing of a fugitive vision. Names were changed; sometimes the lovelorn maiden was a shepherdess. Charles Perrault, architect to Louis XIV as well as coiner and collector of fables, wrote about the girl as if she were in one of his fairy tales: 'if only there remained some imperfect image ... the hateful departure, cruel as it was, would be less painful.' What she wanted was, in both senses, a trace of the living, vanished lover.

To make a portrait was to cheat abandonment; to close distance, triumph over separation, to turn absence into presence. In many of the versions, engraved and painted, Amor – Cupid – intrudes and is the actual artist, physically guiding the hand of the maiden as she

draws in the flickering light, sometimes a lamp, sometimes a naked candle. In the later eighteenth century any number of painters, especially in France, England and Scotland, turned to the subject. For some, the genesis of the image is the heart of the story, and the emphasis is on the seriousness with which the girl sets about her work. When he read a poem on the subject by William Hayley, Joseph Wright of Derby had a mind to paint his version; always with the thought that his friend Josiah Wedgwood, the supreme potter of the modern-day as well as an authority on classical taste, could act the part of Butades and work up his painting into a jasper profile, perhaps two, of the girl and her lover; a delight for any connoisseur. Wedgwood gave Wright advice on antique dress and ornaments, but the painter was torn between wanting to give rein to the emotion of the scene and containing it within classical severity, worthy of the 'Origin of Painting'. He wrote to the poet Hayley for advice. 'I once thought rapturous astonishment was the expression to be given to the Maid (at the moment shadow art dawns in her heart and eyes) but now I think it is too violent ... her face I leave you to tell me what it should be.' Judging by the result, Wright's *Corinthian Maid*, Hayley advised restraint. The youth slumbers, a spear propped against the rough wall; and the hound (as elegant as the other two protagonists), who will be his only fellow wanderer, lies dozing by his chair. There is a small note of optical improbability in the scene, for the boy's head, resting on the wall, somehow still manages to cast a shadow on it. But the maid props her left knee on the chair for balance and leans in. One hand holds the tracing pencil; and in an exquisite little piece of body language, Wright has her hold the other hand up, graceful fingers extended as if fixing the moment, willing the boy to stay just as he is. *I have you.*

But there was another way to paint the scene. Restraint be damned. The Scots painter David Allan, in the most affectingly warm-blooded of the versions, has two lovers who cannot bear not to touch each other even as the token of their parting is being made. Both are half naked; perfectly fitted for each other. The girl is sitting on her lover's lap, one leg slung over his. His arm is around her waist; she steadies

his chin. The touch is for her work, but not only for her work. His expression is of the utmost seriousness; halfway between smile and tears. Their forearms rest on each other. Everything surrenders to tenderness in the lamp glow. But then tenderness is just one step from pain.

Don't go. Don't die. Don't disappear.

2. Kenelm and Venetia

May morning, 1633

Get up, get up for shame, the Blooming Morne
Upon her wings presents the god unshorne.
See how Aurora throwes her faire
Fresh quilted colours through the aire:
Get up, sweet Slug-a-bed, and see
the Dew-bespangling Herbe and Tree.
Each Flower has wept, and bow'd toward the East,
Above an houre since; yet you not drest,
Nay! not so much as out of bed?
When all the Birds have Mattens seyd,
And sung their thankful Hymnes: 'tis sin
Nay, profanation to keep in,
When, as a thousand Virgins on this day
Spring, sooner than the Lark, to fetch in May . . .

– Robert Herrick, 'Corinna's Going a-Maying'

In Charterhouse Yard, Puritan thunder against wanton games and idle pastimes had had no effect whatsoever. May Day was May Day and, even before daybreak, Clerkenwell girls had been coming to the garden to rub their faces with the dew, because they knew, however plain they appeared in the glass, May morning dew would make them beautiful for the rest of the year. The maypole was not as tall as the great one raised in the Strand, but it would serve for Smithfield, Clerkenwell and thereabouts. A Declaration of Sports published by the old king, James I, had made May-time recreation lawful, and it was said that this very spring King Charles would confirm it with another Act. To

be Christian was not to require the banishing of merriment. And, in any case, the young people needed no royal licence. They were already out under the trees of the yard, as generations had been before them, cutting boughs and garlands. Bright ribbons were bound about the pole, hanging loose, waiting for the skipping dance that would bring in the May. A chair would be set in the middle of the yard, strewn with flowers, the almshouse wisteria looking the worse for it; but the May Queen must be enthroned. Come noon, brawny Smithfield lads would hoist her in the air; rebec and bagpipes would sound the airs to wake snorers in the hospital from their drowsy old age. Those who could sing would do so at the top of their lungs, while those who couldn't would just bellow like oxen, their bellies full of mead and their breeches full of mischief. The London sky was washed clean of clouds. A sweet warmth was settling over a quarter of a million souls who, for a day, would forget plague and war and every kind of exasperation.

> *Rise and put on your Foliage, and be seene*
> *To come forth, like the Spring-time fresh and greene . . .*

The outer walls of the almshouse and the hospital were covered in greenery and blooms. So was the handsome dwelling of the Venetian ambassador on the north side of the yard. Against the wall of one of the grandest of the houses, built in the reign of Elizabeth, stacks of timber and brick were piled up, intended for a new galleried library which Sir Kenelm Digby was building so that it adjoined his residence. The skeleton was already visible: timber frames for the annexe walls, unroofed. But it would be made good soon, for Sir Kenelm had promised his wife, Venetia, a more retiring kind of life; freer of the many cares and encumbrances he had as Commissioner for the King's Navy; for the Virginia and New England Companies and the many affairs of the Privy Council, much multiplied now that Charles had determined to govern without Parliament. Sir Kenelm did not think of this as a retreat. His intricately curious mind was never at rest. There were

translations and editions to be thought of; his collection of recipes and cures to be put in order and perhaps published; work on the primary elements of matter; the medicine of Sympathies to be gone over again and again, as men of science should take care to do before professing opinions to the world; plenty to keep him occupied.

This morning, Sir Kenelm was patiently listening to Sir Thomas Hawkins's views on the *Odes* of Horace; a work he loved and revered. None had struck to their depth or illuminated their melodious subtleties quite like Sir Thomas. But try as he might to attend to Hawkins and Horace, he found his mind wandering to other, livelier matters: the fine mare he had got through a friend for Venetia. No woman was ever more gracefully seated nor rode her horses with more exuberant delight. He had read late the night before, and had retired to his own chamber so as not to disturb her. But it was surprising that she was so much later in stirring than was her wont, which was to rise with the sun, say her prayers and have her maid read to her while she dressed. Before he left to deal with state business he would go in and see her, tell her about the horse, and she would break into the smile which, even after all these years, made his heart dance. Enough of Horace and Sir Thomas.

Then came a sharp cry and the sun was blotted out. Kenelm raced to his wife's chamber. She was lying in the very same posture, the frantic maid told him, 'as she left her when she drew the curtaines att night and had covered her to take rest; there appeared not to have bin the least struggling, no part of the very linen or clothes were disordered or untucked about her but lay close to her bodie and thrust under her . . . even her hand, she observed, lay just as she left it.' Nobody would have thought other than that she had been fast asleep. But, he wrote to his brother John, 'She had been dead for hours before.' When he touched her face, arms and hands that lay out of the bedclothes, they were 'cold and stiff'.

How could this be? Venetia had not shown the least sign of illness. How could she leave him? Often they had told each other they wished to die both at the same time, in each other's arms, and many times had

gone to sleep together in that fashion. Now, 'whither shall I sail in this vast ocean? Here is no star or compass to steer by.'

> Get up, sweet Slug-a-bed . . .
> Rise and put on your Foliage, and be seene
> To come forth, like the Spring-time fresh and greene . . .

The shock was so great that, at first, it held back the crushing wall of grief that would topple down on him. For the first minutes 'amazement supplieth the room of sorrow'. 'It is strange,' he told John three weeks later, 'what various and sudden raptures one shall feel upon such an assault. In an instant my fancy ran over more space than is between heaven and earth. How many notions it had, and no one to any purpose. Soon they were at an end. I presently grew as senseless almost as the body I had in my arms . . . as soon as I was satisfied she was dead I knelt down by her and with words as broken as my thoughts could not but choose to pray to her, her looks were so like an angel I could not take her for any other.'

Then it began: the upheaval of body and soul; the racking sobs. In their green years, in the time of stormy courtship, she had flinched somewhat before the onslaught of his passion and had held him at some distance. To this he responded with augmented ardour. 'It hath ever been a maxim in me that one can have no happiness in this world or the next' (shocking, this, in a good Catholic) 'but by extreme and vehement love.' Now that he had found the 'noble object for the best part and action of my soul . . . I dare boldly say no man exceeded me in extreme loving.' Kenelm gave himself over to paroxysms of weeping so violent that they turned into soprano shrieking and wailing; coming upon him day and night, fits of coughing tore at his lungs and throat. He became so distracted by interminable wretchedness that the household feared for his wits, perhaps even for his very life. Some of his friends ventured, with as much kindness as they could, that such flights of passion were dangerously immoderate in a man of thirty. Day after day, they seemed unseemly. But Kenelm was no

Calvinist who thought himself duty bound to resign himself to the inscrutable will of the Almighty. If the ultimate purpose of life, as he supposed, was to love, then why should he not mourn incontinently, as wildly as the breaking tide, as if the universe itself were coming undone? As for dignified appearances, no, 'I will not hold my grief for the world's sake.'

It stopped only when he had to rouse himself to practical action, which is to say to preserve what he could of Venetia before her dismemberment beneath the surgeon's knife. Unusually, the King, whose high servant Kenelm was, had ordered an autopsy. There was talk that Venetia might have inadvertently poisoned herself with an overdose of the viper wine she drank to maintain her fabled beauty. This was a potion concocted from the innards of the snakes, ground up, cooked and suspended in an emulsion of aloes and balsamic spirits. Highly regarded as a tonic for the ageing complexion, viper wine was widely known and sold in Venice (a version of it is still popular in China). The well-travelled Kenelm prided himself on collecting the formulae for such elixirs, as well as the cookery recipes, simple and elaborate, for which he was famous. Anthologies of both cures and cooking would be published a few years after his death by George Hartman. It had been the husband who had prescribed viper wine for his beautiful wife, three years his senior, to keep her skin the shade of damask rose, the colouring John Aubrey thought was Venetia's. Aubrey also wrote that there were suspicions of poisoning, perhaps accidental, hence the order for the autopsy. Aware of the gossip, Sir Kenelm indignantly replied to his aunt that Venetia had been taking viper wine regularly for many years without suffering the least discomfort or sickness and that, right up to her death, she had appeared in the rudest health.

But the surgeons, among them probably Kenelm's friend Sir Theodore Mayerne, would come to do their work on the third day following her death. So there was no time to lose. First, Sir Kenelm cut off all Venetia's lustrous tresses: 'the only beauty,' he wrote to his son, 'that death hath no power over'; 'Her hair was tending to brown yet shining with a strange lustre and brightness and was by many degrees softer

than the softest that ever I sawe. Nothing can be imagined subtler . . .
I have often had a handful of it in my hand and have scarce perceived
I touched anything . . . she had much and thick upon her head.' Off it
came before the embalming and the laying of the body in sere cloth:
'I . . . shall keep it while I live as a holy relic of her.'

Don't go. Don't leave. Don't disappear.

Art had to be called in. Two days later, with 'the same sweetness' of
deep sleep on the dead woman's face, Sir Kenelm summoned his friend
Sir Anthony van Dyck from his studio house at Southwark. Casts were
made of Venetia's hands and her face in that attitude of repose. Later,
Sir Kenelm would have the death mask cast again in copper, to sur-
mount the elaborate tomb monument he designed for his late wife.
But Van Dyck had a greater task: to capture exactly that sublime image
of Venetia, as if she were but slumbering. Even two days after her
death, her blood, he thought, 'had not yet settled', so he and her maid
and the painter rubbed the cheeks of the dead woman in an effort to
bring roses to them; the same damask roses that Van Dyck painted,
the dewy petals pulled away, scattered on the counterpane.

Deathbed paintings, while not common, were not unknown in the
Netherlands, but most often they showed the dead with their families
and were an image of piety. It was clear to Van Dyck that what Sir
Kenelm desperately wanted was something altogether different: the
illusion that Venetia was still very much alive: the look of her as he
had so often seen it when he gazed at her asleep and was undone with
adoration.

If you have ever had the misfortune to see a loved one dead, you
know that Van Dyck's painting is not of a corpse. The tousled hair
falling from under Venetia's night cap still has the springiness of her
curls. Her lips are full and seem warm enough for Kenelm to kiss,
which he did. The right hand cradling her head was what Venetia did
when she went to sleep. The faint blue veins at her wrist seem still to
carry life's blood, the folds and waves of the sheets and the blue silk
counterpane seemingly stirring with the rise and fall of her breathing
body. The dimpled double chin (for Sir Kenelm conceded affectionately

Venetia, Lady Digby, on Her Deathbed, by Sir Anthony van Dyck, 1633

that of late she had grown a little 'fatt') endearingly invited a chuck or a caress. So Anthony van Dyck performed the part of a faithful friend, pretending that love had preserved her in a form, as Sir Kenelm insisted, that was even lovelier '(if possible) than when she lived; only wanness had defloured the sprightliness of her beauty, but no sinking or smelling or contortion or falling of the lips appeared in her face to the very last . . . the last day [before the surgeons came] her body began somewhat to swell up but the Chirurgeons said they wondered she did not more and sooner . . . lying in so warme a room.'

Was Kenelm there when they opened her up? It seems unlikely he could have stood it, even though within him the man of science contended with the stricken husband. But he reports that her heart was found 'perfect and sound, a fit seat for such a courage as she showed when she lived'. Not everything was quite perfect, however. There was a gallstone in her bladder bigger than a pigeon's egg, which 'entirely possessed the bag that contain'd it'. But Venetia's appetite had been good, and always moderate in consuming wine and meat, and she never complained of pains in the stomach, nor of headaches, which, given what was found on the opening of her skull, was surprising. For as Sir Kenelm unflinchingly wrote some weeks later, her brain was 'much putrified and corrupted; all the cerebellum was rotten and retained not the form of brains but was mere pus and corrupted matter'. Her sudden death, much like her mother's abrupt demise, is now usually attributed to a violent cerebral haemorrhage, but Kenelm says nothing of the blood that would have filled the cranial cavity had this been the case.

In any event, when it arrived at Charterhouse Yard, Van Dyck's painting reassembled the dissected Venetia; restored her to the perpetual sleep her widower craved. He kept it by him all day, and at night it was propped against a chair by his bedside so that when he stirred from his sleep (not that there was much) she would be there with him, lying at the same angle, gently glowing and peaceful. Sometimes the picture brought Venetia back to life too well; so that he sat up and beheld her right there in his chamber, smiling at him and talking to him until

the sickening moment when he realized he was being haunted by 'vain shadows' and was thus all the more tormented by the irreparable reality of his loss.

The funeral swept past the unhinged madness of the widower, who could think of nothing but 'coming home' to Venetia; who occasionally saw her beckon to him with her finger, from her resting place in the other world. But he was not so lost as not to feel gratified by the huge crowd that came for her obsequies. Never had so many coaches been seen. The yard filled up, and then there was a serious parking problem in the streets around it. Coachmen jostled each other for what little space remained, leaving the defeated drivers with no alternative but to move off and return later. 'Most of the company came of free motion and good will,' Kenelm wrote, 'for neither the shortness of time nor the extremity of my passion admitted me to invite any.' Afterwards, all seven major rooms of their house were packed with mourners, among them privy councillors, sheriffs and aldermen of the city; secretaries of state. Even the courtiers who had gossiped maliciously about Venetia now made a show of their deep commiseration. Common people were there, too; some from the almshouse and hospital on the yard, for Venetia was famous for her charity. She had a gaming habit that Sir Kenelm indulged (had he not, it would have made no difference); and when she won, most of the winnings went to the poor.

After the rites, he collapsed back into his weeping and communing with memories, which came upon him with torturing vividness: their walks in Hyde Park 'for ayre and pleasure', when she would avoid strollers and riders, especially those known to them, but simply take his arm and find a corner by a tree so that they could talk like the best friends they were. As often as this happened, Sir Kenelm recalled, as if pierced by a dagger, there had never been enough time for all they wanted to say to each other. On they came, the memories, relentless, like unwelcome mourners refusing to leave him be. There was the time when they were out riding together and a sudden downpour sent them under a spreading tree for shelter. There was a hawking party close by

and Venetia saw a falcon busy with the partridge it had just downed when a great hound made to attack the bird. With no more ado she leapt from her horse, shooed away the dog and took the hawk on her bare wrist, despite Sir Kenelm shouting for her to beware its talons. 'But the courteous bird sat so gently upon her snowy hand and looked so gently upon her fair eyes that one would have thought she had been in love with her.'

Further pleas to restrain his passion fell on deaf ears. He could not eat, sleep or, worst of all, read. One line of a book and his brain revolted at the effort. Sometimes Kenelm wrote to his much-put-upon brother John: 'I fall into impatience and wish I had been all my life brought up in some servile labouring course that I might never have had means to know what love was or to enjoy the happiness that the enjoying of beauty, goodness and mutual affection createth.'

No one, least of all his brother, was going to believe that of Sir Kenelm Digby.

Like most men of science in his day, Kenelm Digby put much trust in astrology, so he may have thought some alignment of celestial bodies had determined his union with Venetia Stanley. Their origins did have something in common. They were both half orphans; both the progeny of traitors. When Kenelm was two years old, his father, Sir Everard, was hanged, drawn and quartered for his part in the Gunpowder Plot against King James and Parliament. The familiar phrase goes light on the details. The condemned man was strapped to a wattle hurdle and dragged through the streets of London behind a horse to the place of execution. There he was dropped from the gallows just short of loss of life so that he would be fully conscious for his subsequent castration and disembowelment. The several pieces of Sir Everard Digby were then spiked on London Bridge. Surprisingly, perhaps, the Digby estate, much of which had come from Sir Everard's wife, the wealthy Mary Mulsho, was not entirely forfeit; not, at any rate, the house at Gothurst, in Buckinghamshire, where Kenelm grew up. Venetia, as Kenelm often liked to boast, came from far grander (but equally treasonable) stock.

Her grandfather was the great Thomas Percy, Earl of Northumberland, one of the leaders of the northern rising against Queen Elizabeth in 1569, aiming to replace her with Mary, Queen of Scots. He ended on the block. His daughter, Lucy Percy, Venetia's mother, married Sir Edward Stanley of Tonge Castle in Shropshire, and of the dynasty of the Earls of Derby, one of whom had turned his coat in the nick of time to make Henry Tudor King Henry VII. Lady Lucy died when her daughter, born in 1600, was just three, and Sir Edward, being, it was said, of a melancholy and retiring disposition, sent her to Salden, also in Buckinghamshire, to be brought up by Lady Grace and Sir Francis Fortescue, whose father, John, had been Elizabeth I's Chancellor of the Exchequer, and who had survived, barely, the treacherous political reefs of the old Queen's final years. The constellations were moving the two closer.

Seen from James I's court, the good, loyal section of the Digby family offset the odious memory of the wicked traitors. John Digby, in the former category, was in good enough standing to be entrusted with the delicate mission of trying to win a Spanish infanta for Charles, Prince of Wales. Originally, there had been talk of a Spanish bride for his older brother Prince Henry, but, to the general dismay of the kingdom, he had died in 1612. Now Earl of Bristol, John Digby was to attempt the same for Charles, and the fourteen-year-old Kenelm, already precocious in most things, went with him. The mission was not a success, but Kenelm, a Catholic, walked amidst the Habsburg court, rustling with dark silk, ceremonious dwarfs and Inquisition-happy prelates. Oxford was next, as it had to be for someone of his rank and aptitude.

There, his Catholicism kept Kenelm apart from the riot of youth. But the separation was intellectual good fortune since, at the non-collegiate Gloucester Hall, he was taught by the venerable Thomas Allen, who combined mathematics and astrology in a way that gave him the reputation of being something of a magus. Under Allen, he became a cultural omnivore; greedy for learning in languages ancient and modern, philosophies natural and metaphysical.

And so he came back to Buckinghamshire (without a degree), seventeen years old, tall and bulkily good-looking, with a voluble tongue; exuberant manners refined by the charm and gracefulness everyone who met him remarked upon. His time in Spain had given him confidence without coarse swagger; he thought little of peers who were quick to draw their daggers in some tap-room brawl.

In 1628, on a privateering expedition in the Mediterranean, Kenelm anchored off the Aegean island of Milos and while lodging on the island began to write for his own pleasure a thinly disguised memoir he called *Loose Fantasies*; more or less the romance of his love for Venetia, albeit with their names changed to Theagenes and Stelliana. In its pages, the two, who live near each other in Buckinghamshire, exchange first kisses, 'serious kisses among their innocent sports: and whereas other children of like age did delight in fond plays, these two would spend the day looking upon each other's face and in accompanying these looks with gentle sighs'. After Oxford it became much more like love in earnest. Venetia was twenty, and already a famous beauty, spoken of sometimes as too free with her favours. Gossips connected her with the Sackville brothers; first, the vain, empty-headed Richard, 3rd Earl of Dorset, who squandered much of the estate at the gaming table; then, more seriously, his younger brother, Edward, who would become the 4th Earl. Said to be 'the handsomest man in England', Edward was dangerous when drunk. In August 1613, deep in his cups, he insulted Lord Kinloss, a suitor of his sister Clementina, so grossly that a duel ensued. Because King James had outlawed such affairs, it took place at Bergen op Zoom in Zeeland with the duellists sloshing about in meadow water; the prancing etiquette of the swordfight degenerating rapidly into a mad business of wrestling, slashing and stabbing. Sackville lost a finger and Kinloss, who refused to beg for it, his life.

It has been commonly but wrongly supposed the fight was over Venetia (she would have been twelve at the time); but there is no doubt that Edward Sackville, married as he was, was still a dangerous rival to Kenelm. But around the time Kenelm was back at Gothurst,

Sir Kenelm Digby, by Peter Oliver, 1627

Sackville was off on travels, either as one of the directors of the Virginia Company or sent to help the Protestant cause of the King's son-in-law Frederick of Bohemia. The boy–girl embraces were no longer puppy love. Venetia, with her oval face, mane of brown hair, often left loose to fall down her shoulders, her come-hither lips and the figure described by John Aubrey as *bona roba*, which meant enticing, was irresistible. But it was her high spirits, the hot temper, the teasing wit, the sheer cleverness of her which most convinced Kenelm that they were meant for each other. She wore no face paint; her face needed none. She was his Beatrice. He would have her. What he got for the moment, though, was 'but half of what men seek to possess', and that with a show of shocked affront.

Kenelm's mother looked on the change from flirting to plans of betrothal with great alarm. Venetia was damaged goods and not much even of that, for all her Stanley–Percy forebears. She would not do. Mary's displeasure took the usual strategic form: packing the boy off on a Grand Tour; doubtless with the standard speech 'if your love is what you say,' et cetera. To the kisses were now added tears on both parts more copious than any company of players could contrive. Kenelm gave Venetia a diamond ring to wear; she gave him a bracelet of the hair he so loved to fondle. All would be well. They would be constant. He would return the master of his fortunes and they would be united, whatever Mary Mulsho thought of it.

You know the play. The course of true love never did run smooth. The scenery changes. In Paris, Kenelm, who combined polished French with handsome strength, was a magnet for the ladies of the court, which might have been mere form, had they not included the Queen Regent Marie de' Medici, who made no secret of her partiality to the young Englishman. Since it would have been discourteous and dangerously impolitic to turn his back entirely on her advances, there came a point where Kenelm had to make his regrets plain. The avid Queen took this badly; so very badly that in an ensuing affray between her following and that of her deadly enemy, her son King Louis XIII, Kenelm made sure to put it about that he had been killed. It was, he

thought, his only exit from Marie's clutches, or her revenge, and he was unsure which was more likely to prove fatal.

The news reached the Queen. But it also reached Venetia. What did not reach her were Kenelm's letters assuring her that he was still alive, for his vigilant mother intercepted them. Distraught or not, Venetia responded to Sackville. Aubrey thought she bore him a child, but there is no evidence of this and none at all of the money he was said to have settled on her as his mistress. But the stories of their scandalous affair circulated. Worse, in Italy, where he first encountered his friend Van Dyck, news came to Kenelm that Venetia was about to marry Sackville, the likely next Earl of Dorset. Cursing, he tore off the bracelet of her hair and threw it on a fire. In Spain once more with John, Earl of Bristol, and the disguised Prince of Wales, Kenelm picked quarrels; pursued women; affected cynicism; was wounded in a fight; and generally behaved with reckless, mindless fury.

After three years he came home again. Venetia was not married, but the talk of her and Sackville was on everyone's smirking face. The young knight resolved to be done with her, and with all of womankind for that matter, if anyone asked. But then he caught sight of her at a masque, unmistakable beneath the courtly disguise, and the armour of his cynicism at once dropped away. Like Beatrice and Benedick they began again, with mutual accusations, violent arguments. How *could* you throw yourself at that man, the minute I was gone? *I, I?* For shame! How could *you* not let me know you were *alive?* Inconstant woman! Weak *man* to suffer and endure such a mother! And on and on till they were spent in their unhappy rage. Some matters could not be undone; not yet. They allowed they might, if they could, be friends. And Kenelm endeavoured to hold his peace and keep his distance. Until, that is, these cautionary manoeuvres became intolerable and he would charge at her like a maddened bull let through a gate. Venetia recoiled. Dismayed and infuriated by her coldness, Kenelm lobbed grenades of wounded feelings back at her. Wherefore have I given you offence? 'Allow me but to love you (as I do beyond all creatures) and to tell you so. And on your side tell me that you are pleased I should do so and

that you have received me into a place of your heart where nobody else hath admittance. I ask no more.' He goes on, unconvincingly, that once she has declared as much, he would be content if she did not 'entertain . . . too near a familiarity . . . I shall cheerfully submit to your will.' He would withdraw into some hermit-like solitude 'where I will study nothing but God and you'. So there. Then came the emotional blackmail: 'My heart is absolutely in your hand; you may crush it to death or make it the happiest of any man's alive.'

Nothing would stop him. He proposed marriage. To his astonishment, Venetia turned him down, opening a deep wound then rubbing in the salt by telling him she was, to some measure, committed to Sackville, who was in possession of her picture as a token. Art counted. But Sackville was abroad. He had fallen out of favour with King Charles for some misconduct in the affairs of the Company of Virginia. When he returned to England, Kenelm's blood was up and, despite Sackville's reputation as a swordsman, he was prepared to fight him for Venetia. The cool Sackville surprised him with a patronizing smile, saying it need not come to any such extremity; he would cede the field to the ardent suitor and may good fortune come of it. Sackville could afford the gesture. He was about to become the 4th Earl, as his feckless, childless, hopeless brother stumbled into his grave, and there was, after all, still the matter of his wife, Mary.

Freed from the connection and Kenelm's finger-pointing, Venetia allowed herself to be drawn to him once more. Their friendship turned fond and their fondness turned amorous. One morning when Kenelm was due to travel into the country on some business, he came to take leave of Venetia. It was barely light, as he had calculated. But he charmed the giggling maids. They knew young Sir Kenelm; what a man. He would never do anything untoward. The door of Venetia's chamber was opened. He stepped into the chamber and feasted his eyes on her sweetly sleeping face. Later, on Milos, the glittering sea at his back, Kenelm combed pleasurably through the memory of what happened next, using the third person of Theagenes for himself. 'He . . . went to the bed side, where the curtains were yet drawn, which

opening gently, he might perceive that Stelliana was fast asleep and yet the closing of her eyes made the beauties of her face shine with the greater glory.' This was the remembered look he asked of Van Dyck.

He remained awhile like one in a trance, admiring that heaven of perfection ... at length being transported beyond himself ... he concluded not to omit that opportunity, which chance gave him, of laying himself in the same bed by her naked side, which he was sure he could never gain by her consent. So then ... with the greatest haste, and the least noise ... [he] put himself between the sheets in the gentlest manner that he could; but yet the stirring of the clothes half waked Stelliana, as he might perceive by her turning about to the other side, with a slumbering groan, which made him remain immoveable, whilst his eyes were blessed with the rich sight of the perfectest work that ever Nature brought forth.

For as she rolled herself about, the clothes that were sunk down to the other side, left that part of the bed where she now lay wholly uncovered; and her smock was so twisted about her fair body, that all her legs and the best part of her thighs were naked ... The white pillars that were the supporters of this machine of beauty, looked like warm alabaster ... Her belly was covered with her smock, which it raised up with a gentle swelling, and expressed the perfect figure of it ... Her paps were like two globes, wherein the glories of the heaven and earth were designed, and the azure veins seemed to divide constellations and kingdoms, between both which began the milky way which leadeth lovers to their Paradise, which was somewhat over-shadowed by the yielding downwards of the upper-most of them as she lay upon her side; and out of that darkness did glisten a few drops of sweat like diamond sparks, and had a more fragrant odour than the violets or primroses, whose season was newly passed to give way to the warmer sun ... the nipples of them were of so pure a colour, and admirable shape [in a French version described by Kenelm as coral], that I believe Cupid still retaineth the appearance of a child only in hope to suck there ...

It was all too much for Kenelm/ Theagenes, as it may well be for us. 'He resolved to steal what she had often refused him, and made his lips share in the happiness hers enjoyed by their blessed union; but his flaming soul being wholly drawn into those extreme parts, his kisses were such burning ones, that (striving to moisten them) Stelliana wakened.'

Furious. And yet not. Kenelm promised he would proceed no further, so her chiding softened and became 'angelical', and he kissed the rebukes away.

They were married in 1625, but in deep secrecy; partly to pre-empt Kenelm's mother's prohibition and also so as not to compromise Venetia's share of an estate which was coming to her through the Percys. Secret, too, was the pregnancy which quickly followed. After Venetia's death, Kenelm's letter to his eldest son, of the same name, described how he came to be in the world as an instance of his mother's bravery and fortitude. A secret lying-in place had been arranged, but a fall from a horse (pregnancy was not going to get in the way of Venetia's daily ride) brought on labour. Since it was impossible to get her to the lying-in lodging, she had to be taken back to her country home, where only a maidservant with no knowledge at all of matters of childbirth, and terrified by the moans and pains, was in attendance, along with Kenelm himself. Venetia steeled herself but, as Kenelm made sure to tell his son, she refused to follow the English practice of exiling the husband and father from the room. 'She had so excellent and tender a love toward me that she thought my presence or my holding her hand (which she would have me do all ye while) did abate a great part of her pains.'

By 1628 Kenelm Digby had the enviable life he had long sought: love he had pursued since he and Venetia were children; a wife who was also best friend and companion; two fine, healthy sons; means, office and respect at court and in the world. What more could a man possibly desire? Something, at any rate; for in that same year, over Venetia's tearful, angry protests that he would leave them orphans and widow, he was off on the ship *Eagle* with letters of marque to take French

prizes. He explains this in *Loose Fantasies* with Kenelmian perversity as a need to secure 'honour' before ridding himself of worldly business and devoting himself to learning and family. He could not begin with uxorious contentment, he says, lest the world think him weak.

He might have had time and cause to consider the vanity of the venture when his little flotilla (three ships) was first becalmed and then struck by shipboard plague; so many sailors dying that bodies were stacked on deck to stink in the Mediterranean heat before they could be heaved into the sea. Venetia's reproaches might have come back to haunt him when he thought, with a tremble, that he himself was sweating more than the sunshine accounted for. But he survived, and the fleet was strong enough to take on much bigger Venetian galleasses protecting the French merchant ships they were hunting. The Battle of 'Scanderoon' (İskenderun) off the Turkish coast made Kenelm a hero on his return, his name mentioned now in the same breath as those of Drake and Hawkins. He made an expedient conversion to the Church of England, which allowed the King to load him with offices. He watched Kenelm and his son John grow; dabbled in his science and cookery; collected recipes; patronized the theatre and befriended Ben Jonson, who was clearly and gratifyingly in love with Sir Kenelm's wife. It was in these years that Van Dyck was called in to paint the Digby family. Kenelm, grown rounder with ease, his hair thinner and retreating from his brow, sits by the armillary sphere that had become his device, while Venetia, her brow patterned with *crève-cœurs*, heartbreak curls that were the fashion at court, directs her gaze at her impossible mate. One arm is around the fair-haired John, who looks out with the same kind of intense engagement that was his father's unsettling habit.

He had resolved to be true to his word. He would shake off the drumming business of state and the world. He gave instructions that work on the new library should begin.

Towards the end of summer 1633 Kenelm forced himself to return from the country to the empty house in Charterhouse Yard:

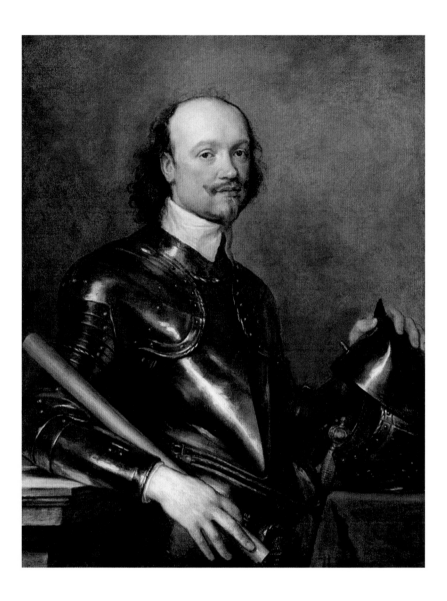

Sir Kenelm Digby, by Sir Anthony van Dyck, circa 1640

Here where I have had so much company, so many entertainments and so much jollity, now reigneth desolation, loneliness and silence. The very walls seem to mourn for all my hangings on my going into the country were taken down and sent to be mended and they proved in so ill plight they are not yet done for where they were doubled in by reason of their exceeding length the rats, the inseparable companions of a ruining house, had made themselves nests and their young ones (it seems) to exercise their teeth had gnawed holes in many places about a yard long.

The white walls of their rooms were yellow, pitted and dirty; the piles of lumber laid down for the library work still there, crawling with insects and foul with refuse.

All this suited Sir Kenelm very well; a poetic conceit for the shambles of his body and mind. He went about now wearing an untrimmed, shaggy beard which made him look like one of Tintoretto's Venetian bravos from the previous century. His pate, on the other hand, had become quite bald, save some unruly and unattended tufts; his head was covered occasionally with the plain high hats more common among the Puritans. Top to toe Sir Kenelm Digby was shrouded in the black of his perpetual sorrow; a long, heavy cape sweeping the ground, caked with mud at its hem. His relentless mourning was now thought immoderate to the point of self-indulgence, even by readers of Robert Burton's *Anatomy of Melancholy*.

Digby withdrew to the sanctum of Gresham College, not a cloistered retreat but a place of study and discussion of matters philosophical and scientific, close to the Royal Exchange. Gradually, his appetite for reading returned and he wrote compulsively and endlessly of his lost Venetia – to his sisters and his brother; his aunt; and his children. The latter got a detailed eulogy of their dead mother, feature by feature; her eyes alone taking almost a page; as if they had never seen her for themselves or looked at her with sufficient attention. It was a way, of course, for Kenelm himself to try to make stick in his memory and on the page the smallest detail of her face and her body. He then collected

his letters and those of others as *In Praise of Venetia*, which was added to the growing body of verse eulogies by Ben Jonson, Owen Feltham and William Habington. There could never be enough, and Kenelm kept wondering out loud whether poetry or picturing could do her more justice.

He availed himself of both. A miniature of Van Dyck's deathbed sleep was made so that he could take it on his restless travels; copies of other images of her, too; and he himself was painted and engraved, in a state of lamentation. As the immediacy of Venetia's death receded, so the gossip that had compromised her earlier reputation began to be murmured again. The viper-wine rumour never quite went away; in some circles it was even whispered that perhaps Kenelm had himself poisoned his wife on discovering an infidelity and then had collapsed into expiating remorse. Digby's response was to bring Anthony van Dyck back to create an irrefutable pictorial monument to her spotless reputation. Allegorical paintings were far from being Van Dyck's speciality but, prevailed on by his suffering friend, he produced a marvel, summoning the radiance of both his old master Rubens and their common paragon Titian. To this Van Dyck added his own flash of silky brilliance. To close the mouths of the malicious, Venetia appears as Prudence, with her right foot on Cupid, demonstrating her mastery over the baser forms of love, while defeated Fraud skulks in the shadows. The serpent – or perhaps viper – of wisdom lies in her lap while that of venomous wickedness is crushed at her feet. Putti crown her with the laurels of immortal virtue. Flowing over her is a river of silk, given the full Van Dyck treatment and coloured damask rose, the hue that her husband and mischievous John Aubrey said came to her cheeks when she was animated; a blush of which is present on her ravishingly beautiful face. Van Dyck's first painting repaired and restored her poor body dissected by the surgeons; his second made restitution against her slanderers. There are two versions: one painted on the grandest scale imaginable; and the middling-size one now in the National Portrait Gallery; large enough to make an impression but modest enough for Sir Kenelm to take on his wanderings.

Venetia, Lady Digby, by Sir Anthony van Dyck, circa 1633–4

For he did indeed turn into a wanderer: always in his heavy black cape; retracing some of the steps of his youth: to France, where Marie de' Medici was still alive but beyond the years of date rape; to Florence and Rome. Pursued by women, he took them to his bed and went to theirs, but never for a minute did he consider another marriage. To the angry dismay of his friend Archbishop Laud, he returned to the Roman Church now that he had no use or wish to be established in any sort of office. On his travels he continued to collect herbal and cooking recipes, which George Hartman published as the 'Closet' of Sir Kenelm Digby. He attended to his science, both alchemically eccentric and attentively empirical, pronouncing that matter was constituted from minute particles known as atoms; that it was in constant motion until arrested; and that plants lived by absorbing some sort of element in the air.

England fell into warring parties. His friends Laud and the Earl of Strafford were both tried and executed. The house of his kinsman George, still prominent in Charles I's government, was attacked by a London crowd in 1640. Families, including his, divided. George's wife, Anne, had to defend their home at Sherborne Castle against her own relatives the Russells, fighting on the side of Parliament. Kenelm watched at a distance in France and the Netherlands, where he was close to Queen Henrietta Maria, first attempting to raise funds for the royalist cause and then, when it was defeated, in bitter exile. Agonizingly, the two boys whom Van Dyck had painted in the sweet bloom of their childhood were lost to the war: John was mortally wounded during the siege of Bridgwater Castle in July 1645. Three years later, in July 1648, during the second war triggered by the obstinate rashness of the imprisoned King, young Kenelm found himself among the few hundred exhausted royalists retreating from an overwhelming defeat at Kingston upon Hull. Their general, the Earl of Holland, declared to the townspeople that he and his soldiers wished only for overnight respite and the return of peace. At two o'clock in the morning they were attacked by a pursuing Parliamentary troop and, while his men and comrades drowned trying to swim across the Ouse, young Kenelm died under fire.

Sir Kenelm Digby, by Richard Gaywood, after Sir Anthony van Dyck, 1654

The next year his father slipped into London. Following the execution of Charles I, he wrote to a correspondent in the Netherlands about 'that black tragedy which was lately acted here [and which] hath filled most hearts amongst us with consternation and horror'. And yet, like a surprising number of royalists, he not only met with Oliver Cromwell but became familiar and even friendly with him, discussing learned projects and the results of experiments with the Lord Protector. In 1661 the remains of Cromwell were disinterred and his head was stuck on a spike. Sir Kenelm Digby was now living in Covent Garden, thought of as the eccentric projector of all manner of learning; respected enough at any rate to be one of the founding Fellows of the newly created Royal Society that same year.

He died in 1665, as plague was raging through the city, perhaps one of its countless victims, and was interred beside Venetia at Christ Church, Newgate. It has been speculated that the sculptor for the immense tomb of black marble he had built for her was Hubert Le Sueur, the cavalier choice for such monuments. It was surmounted by the head of Sir Kenelm's beautiful wife, whose features, to judge from engravings, were well beyond the powers of the sculptor. That, too, alas, suggests the hand of Le Sueur. A year after Kenelm's death, the Great Fire swept through the City, consuming everything in its path, including the church of their burial and, apparently, the tomb, though marble ought to have resisted the flames. Some years later John Aubrey said that he saw what was left of it, the copper bust of Venetia, stripped of its gilding by fire. He was reminded by its very absence that the colour of her cheeks had been that of damask rose, 'which is neither too hot nor too pale'.

3. *George and Maria*
Richard and Maria
Tom and Maria

Tiny Cosmetic had to get this one right. He needed to make the Prince of Wales irresistible. Again. The task should not have been beyond him. God knows he had had practice enough at painting miniatures of the young man. The Prince had been sixteen when he had first folded himself into the red damask chair in Berkeley Street and lifted his rosy face to the painter's considering eye. That had been five years before, in 1780. What a pair they made entering the studio in Berkeley Street. George was tall, already a little florid, good-looking in three-quarter profile but from other angles a little pulpy, as though the puppy fat would never thin down to the bone (which would indeed turn out to be the case). The artist, Richard Cosway, was a tad under five feet, hence the nickname and the relentlessly repeated joke about his being a miniature painter. But like the Prince, Cosway took care to look his best. Tiny's stature was considerably extended by a high wig, powdered dove grey, as favoured by the *bon ton*. The top of it stood tall like the crest of a grebe, while the bottom fell in soft curls about his ears. Since his lodging and studio faced the back of Devonshire House and the grandest of his sitters had come through the patronage of the Duchess, Georgiana, who held fashionable court there, Cosway could not afford artistic dishevelment, but in any case it was not his style. He had left the world of his Tiverton schoolmaster father long behind. Shipley's Drawing School had taught him well. He had made a name with one kind of clientele – officers and gentlemen and their pippin-cheeked children – and a different kind of name painting scenes of priapic merriment on snuffboxes. It was amazing how much lively detail could be recorded in so small a space! None of this was a

bar to Cosway's admission to the Schools of the newly created Royal
Academy. It might even have helped. In short order, he became a Fel-
low and showed his miniatures (the decent kind) at their annual
exhibitions, along with fellow limners of the older generation John
Smart and Jeremiah Meyer, and his contemporaries Ozias Humphry
and George Engleheart. In the quarters that mattered it was said that
Cosway's stippling was beyond compare. It needed to be, since mini-
atures were now painted on ivory, not vellum, and it was difficult to
make watercolours adhere to the slippery surface of the material. Stip-
pling, the application of minute dots of paint with the licked tip of a
squirrel-hair brush, helped prevent running streaks, but the micro-
points of paint had to read to the eye as texture and line, especially
since the miniature would be seen close up. To help the adhesiveness
of the watercolours, Cosway (who was very particular about his ivory
suppliers) would remove much of the oiliness by ironing the surface
of the ivory between sheets of linen or cambric. Combined with paints
of exceptional translucence, he achieved (without loss of brilliance or
precision) an atmospheric softness, a misty love-light through which
the mutually devoted could register the warmth of their bond. Cosway
increased the size of the ivories from around one inch to three (his
thirty-guinea format), which gave him room to pose figures against
a blue sky broken with gentle white clouds: the scenery of pastoral
amorousness. It is repeatedly said that he enlarged the eyes of his
subjects, but this is untrue. What he did do was pay special attention
to them: to catchlights on the pupil; an intensified blue or chestnut;
to the brows and lashes – all of which gave the impression of a
wide-open, artless stare right back at the eyes that were gazing at
the face.

No one understood better the visual psychology of the miniature.
Unlike full portraits, which were hung on walls to be seen in company,
stood back from, the miniature was kept about or on the body like a
jewel. Often it was framed within a circlet of hair, the one part of the
body which never died, so that it kept company with the equally
immortal image. And if you so wished it would never leave you. Reach

Self-portrait, by Richard Cosway, circa 1790

into your pocket, lift the chain from your throat or bosom, and there he was; there she was, smilingly yours for ever.

So, of course, the Quality came to Berkeley Street; the dukes and the barons, their wives and their mistresses (usually not at the same time); the bright-eyed children and dashingly uniformed officers. Cosway held his head high in their company not only because his heels were so elevated but because he was confident of their repeated custom. His buckles glittered with silver and gemstones; waistcoats were gay with brocaded flowers; and the jabot at his throat was creamily abundant. Being thought a dandified macaroni brought him pleasure, not embarrassment, for he knew that the Prince of Wales himself had macaronic inclinations.

From the start there was a bond of sympathy between prince and painter, separated by twenty years. Richard Cosway was as unlike the Prince's father as it was possible for anyone to be. King George III was earnestly conscientious, suspicious of worldly pleasure, resolute in the performance of royal duty. He and Queen Charlotte were determined to make the monarchy anew, in the first instance by replacing dynastic right with domestic virtue. Never again would the throne of Britain be brought into disrepute by the shameless parading of mistresses. Never again would a Prince of Wales be a magnet for disobedience and opposition to the sovereign's wishes. Through diligent education and the inculcation of public and private virtues, *their* Prince of Wales, the eldest of their fifteen children, would be a dependable ruler-in-waiting. The royal family would be a school for rule and the King was its principal teacher.

High expectations met with bitter disappointment. Despite being kept under his parents' watchful eye at Kew or Windsor (while his brother Frederick of York went to Hanover, and William, Duke of Clarence, into the navy), and despite their putting a high fence between temptation and duty, George found a way to embrace all the turpitude of his Hanoverian ancestors. Instead of German, Latin, French and mathematics, he graduated swiftly and enthusiastically from the several academies of gaming, whoring, drinking and gluttony.

When admonished for his dissipation, the scandalous neglect of his studies, the disreputable company he kept (including his reprobate uncle the Duke of Cumberland), the boy would sulk or pout, or feign remorse, sometimes managing a trickle of tears down his plump cheek. He was really, truly sorry. Then he would hasten to renew and refresh his apprenticeship in debauchery. After one particularly mortifying scandal in which the Prince had made advances to the wife of the ambassador of Hanover, Countess von Hardenberg (eagerly reciprocated after a while), the afflicted father, resembling King Henry IV of Shakespeare's history giving a dressing-down to Prince Hal, attempted yet again to make his son see the disgrace attaching not just to his person but to the dignity of the monarchy itself: 'It is now allmost certain that some unpleasant mention of you is daily to be found in the papers . . . Examine yourself . . . and then draw your conclusion whether you must not give me many an uneasy moment. I wish to live with you as a friend, but then by your behaviour you must deserve it. If I did not state these things I should not fulfill my duty either to my God or to my country.'

But George was not listening; he was looking in the mirror. By and large, he liked what he saw, though his vanity was not blind. His limbs were 'well-proportioned and well made' but he had 'rather too great a penchant to grow fat'. There was a little too much 'hauteur' about his countenance. The eyes were grey and 'passable' with:

> tolerably good eyebrows and eyelashes, *un petit nez retroussé, cependant assez aimé* [a little turned-up nose which is still rather attractive], a good mouth, though rather large, with fine teeth, a tolerably good chin, but the whole of his countenance is too round. I forgot to add very ugly ears. As hair is looked upon as beauty, he has more hair than usually falls to everyone's share . . . His sentiments and thoughts are open and generous, he is above doing anything that is mean, (too susceptible even to believing people his friends and placing too much confidence in them from not yet having obtained a sufficient knowledge of the world . . .) . . .

His heart is good and tender if it is allowed to show its emotions . . .
rather too familiar to his inferiors . . . [vices or] rather let us call
them weaknesses . . . too subject to give loose or vent to his pas-
sions of every kind, too subject to be in a passion, but he never
bears malice or rancour in his heart . . . He is rather too fond of
wine and women.

Let it never be said that the future George IV was devoid of self-
knowledge. After he died, his sister Elizabeth agreed he was 'all heart',
but that very quality allowed him to be led astray by his poor choice of
company. Included on that list would have been the 7th Earl of Barry-
more, known for good reason as Hellgate; his two brothers Augustus
and Henry, respectively Newgate and Cripplegate, and their sister, whose
startlingly foul mouth made her, inevitably, Billingsgate. But then the
earl's mistress Charlotte Goulding, whom he eventually married, was a
bare-knuckle boxer. No wonder the King was worried.

The Prince came to Cosway around the same time that he began
his adventures with women, starting, tactlessly, with one of the
Queen's maids of honour, Harriet Vernon. Courtship for George almost
always meant sending the love object – and George did, invariably,
suppose he was in love – a miniature of himself, preferably against a
blue Cosway sky streaked with clouds to show off his features to their
best advantage. Ironically, and probably to her acute mortification,
George got this idea from his mother, Queen Charlotte, who, touch-
ingly, had initiated the habit of wearing the miniature of her husband
which had been given to her as a wedding present. Specifically, the
Queen wore it over her heart as a very public expression of her devo-
tion: a lovely signal of the new kind of monarchy that would be based
on conjugal and family loyalty.

To see the visual gesture borrowed in her son's impulsive pursuit of
love could not have been a happy thing for the Queen. Never mind
that; before long, Cosway was painting two or three a year, the Prince's
amorous turnover being high, and recycling the same miniature from
one woman to the next; deucedly impractical, if not embarrassing. The

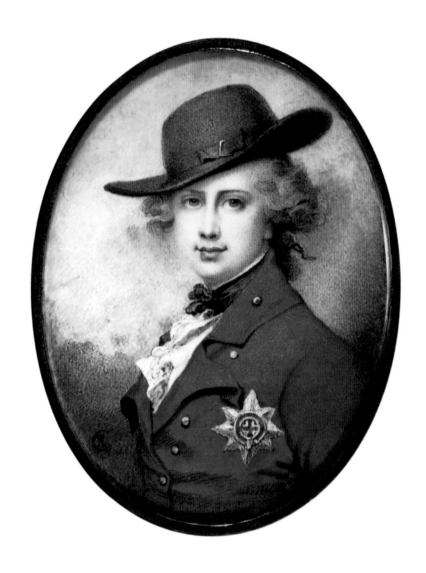

George, Prince of Wales, by Richard Cosway, circa 1780–82

National Portrait Gallery has a lovely example from these salad days with George's hat set at a rakish angle, a high-collared coat of grenadier scarlet, eyes full of come-hither mischief; the lips seemingly on the verge of a campy moue. Pinned to the coat, a little incongruously, since this is evidently not the kind of garter uppermost in his mind, is the Order of the Garter. Cosway has given the pictorial billet-doux his all, but you can see what George's friend Georgiana, Duchess of Devonshire, meant when she said that sometimes he looked 'too much like a woman in men's cloaths'.

Which is itself ironic (or possibly revealing) since in all likelihood the miniature was painted for an actress who had played a sensational Juliet to David Garrick's Romeo but who had become famous for 'breeches parts' at Drury Lane, Viola and Rosalind in particular: the very pretty Mary Robinson. In December 1779 the Prince, aged seventeen, had gone to see her play Perdita in Garrick's version of Shakespeare's *A Winter's Tale*, retitled *Florizel and Perdita*. The Prince was in his box (this being a condition of the King allowing him to go to the theatre at all); the King and Queen in theirs, on the opposite side of the theatre. Sometimes, simultaneous appearances by the mutually hostile parties could cause trouble, on one notorious occasion degenerating into fisticuffs between incensed father and hysterically yapping son in the theatre vestibule. On this particular night, though, the Prince became fixated on the leading lady, declaring his praises loudly enough for her (indeed the entire orchestra stalls) to hear, thus causing the King yet more grief.

The usual siege opened, George writing letters of feverishly juvenile passion and signing them Florizel. Mary Robinson was married, to the ruinously prodigal Thomas Robinson, who had risen from being a lowly clerk, possibly a procurer, on the strength of his wife's beauty, while taking serial mistresses himself and spending so freely that he landed in debtors' prison, where, during one incarceration, he was joined by Mary. So, although it was bound to cause trouble, Perdita did not reject Florizel's courtship out of hand. When twenty thousand guineas was added to the suit, she succumbed. In her memoir, Mary

wrote of that moment: 'the unbounded assurance of lasting affection I received from His Royal Highness in many scores of the most eloquent letters, the contempt often expressed from my husband and my perpetual labours for his support at length began to weary my fortitude.'

In a gossip-drunk culture the liaison between the Prince of Wales and the Drury Lane actress could never be kept private. Caricaturists had a field day. The King and Queen were beside themselves. The twenty thousand guineas had been intended as advance compensation for Perdita suffering damage to her theatrical career but, needless to say, the money failed to materialize. Instead George sent her a Cosway with 'constant until death' inscribed on a heart-shaped piece of paper fitted into the back.

He was, in fact, constant only until setting eyes on Elizabeth Armistead, the latest thing in London courtesans, who after a long relationship would end up as Mrs Charles James Fox. Mary-Perdita must have had her suspicions, since, when the Prince commissioned Thomas Gainsborough to paint her full length in a rustic setting, she turned the picture to her advantage. The image is of autumnal melancholy; her gaze reflective, on the edge of bitterness. In one hand she holds a handkerchief to absorb her sorrows; in the other, as if in accusation, the miniature.

Unsurprised at being given the heave-ho but shocked at the manner of its execution – a note declaring summarily merely that 'we must meet no more' – Perdita had taken the precaution of keeping the Prince's compromising letters. With them in hand, she went directly to the King. Undignified haggling ensued. Desperate, Mary settled for a quarter of the promised settlement: five thousand pounds and a small annuity. A year or so later John Hoppner would paint her again, looking rosily confident as she embarked on a literary career which saw her produce eight novels, six volumes of poetry and three plays.

Resilience was not matched by judgement in men, however, since Mary went on to make an even more disastrous choice in Banastre Tarleton, the terror of South Carolina in the American war: Liverpool

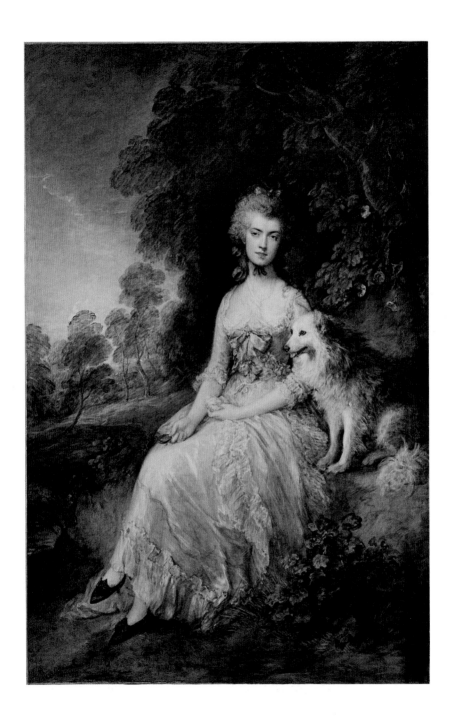

Mrs Mary Robinson (Perdita), by Thomas Gainsborough, 1781

slaver, brutally handsome, reckless prodigal and the kind of all-round Bad Sort usually confined to the pages of Gothick-Romantic fiction. No wonder, then, that a year before she died in 1800, Mary published, under a pseudonym, *A Letter to the Women of England on the Injustice of Mental Subordination*.

Serially romantic himself, the Prince continued to lay waste to London's stock of fashionable beauties, becoming, as he did so, fatter, drunker, lazier; a bone in the throat of his long-suffering parents. More seriously, he became the focus of political opposition to William Pitt's government. Though he was still in his early twenties, his circle included Charles James Fox (with whom he shared Elizabeth Armistead), the Duchess of Devonshire and Richard Brinsley Sheridan, playwright as well as politician. They were all regulars of the musical evenings thrown by Cosway and his Anglo-Italian wife, Maria, at their new apartments at Schomberg House in Pall Mall, where their neighbour in the west wing was Thomas Gainsborough.

Maria Cosway sang sweetly and played flute, harp, harpsichord and fortepiano. But that was the least of her talents. She was also, in her own right, a considerable artist, regularly showing (to mixed and often sneering reviews, as was frequently the lot of women) at the Royal Academy, along with Mary Moser and Angelica Kauffmann, who were founding Fellows. For once, her husband's miniatures and drawings did not have to be cosmetic at all. Maria was slight, pretty, with grey eyes and, when unpowdered, blonde hair; she had a vivacious manner which expressed itself in delectably fractured English with the Italian accent that had regency bucks reduced to a puddle of adoration. As Maria Hadfield, she had been raised in her father's Locanda di Carlo, on the Oltrarno side of the river in Florence, not far from Santo Spirito. Perhaps some of her vivaciousness came from the fact that she was the first of her parents' four children to survive serial murder by a deranged wet nurse who claimed that she had sent the little Hadfields, one by one, to heaven. By way of compensation for the gloomy horror, Maria grew up in a bustling, noisily Anglo-Italian house. Charles Hadfield's hotel was a refuge for the many Englishmen who, like Edward Gibbon,

professed to be heartily sick of 'Italian soups and stews' and craved something comprehensively boiled, be it pudding or joint of mutton, to remind them of fair Albion. Among the crowd were pilgrims and practitioners of art: Thomas Patch, who made money from Views and caricatures sold to Grand Tourists; the antiquities shopaholic-connoisseur Charles Townley; and Ozias Humphry, who tried to move to the head of the queue of those with designs on Maria. She responded to his obvious torment by offering friendship and sending him mince pies when he was away in Rome.

Maria's precocious talent was recognized early enough for her to be sent for drawing lessons with artists visiting Florence. Two of them were among the most important painters in Europe: Johann Zoffany, who had been commissioned by King George III to paint the Tribuna of the Uffizi; and the German neo-classicist Anton Raphael Mengs, on his way to becoming court painter to Charles III in Madrid. At some point it was thought that she and the *famiglia* Hadfield would do better in London, but hardly had they transplanted themselves to George Street in Mayfair than father Hadfield's fortunes evaporated. Townley, who had asked Zoffany to paint the astonishing collection of antique sculpture he had installed in his house overlooking St James's Park, took the embarrassed Hadfields under his wing. He knew all of Society; his bosom friend Georgiana, Duchess of Devonshire, was hostess to the rest. In came beautiful Maria with the arched eyebrows and flashing eyes. At this moment, 1781, Tiny had more thirty-guinea sitters than he could handle. His house in Berkeley Street was packed with Old Master paintings, drawings and sculpture, from antiquity through the baroque masters he venerated: Rubens, above all. He was a fixture at the Royal Academy, where his air of exuberant confidence exceeded his inches. The sniggering bothered him not at all. When he heard that he was being caricatured as a monkey, he went out and bought himself one, to show his amused indifference, and led it about park and town until it repaid his companionship by biting him on the leg and had to be summarily disposed of.

Tiny was an enthusiast of Italian girls. When he was thirty he had

written to Charles Townley, then in Rome, as ever hunting for busts and statues, 'Italy for ever, I say – if the Italian women fuck as well in Italy as they do here you must be happy indeed. I am such a zealot for them that I'll be damned if I ever fuck an English woman again if I can help it.' In Maria he would have the best of both worlds: Italian sensuality and English spirit. Moreover, she was an inventive artist who could turn her hand to almost all genres, though most of all she loved the fantastical myths and histories made popular by Henry Fuseli. Cosway was forty-two; she was twenty-four; nothing unbecoming in that. It was not ardent sentiment as the author of *La Nouvelle Héloïse* understood it, but then Rousseau had made his heroine, Julie, in the end settle for the older man. There was some preliminary courtship. The young woman was unsure. But with Papa's estate in ruin, what was to be done? Needs must, Maria's mother, Isabella, insisted; needs must. If Mr Cosway was a little too much on the macaronic side, even (or especially) for those who had lived in Florence, he was kind, ambitious and an indisputable worldly success. They were married at St George's, Hanover Square, in 1781 and moved into Schomberg House three years later, early in 1784.

Which was around the time, on exiting the opera, that the Prince caught sight of a tall woman endowed with the fine embonpoint to which he was decidedly partial on the arm of his friend Henry Errington, who turned out to be her uncle. Who was this person? he demanded to know. She was Maria Fitzherbert (née Smythe), and she had habitually bad luck with husbands. The first died three months after they were married. He was succeeded by Thomas Fitzherbert, whom, it was said (at least by *The Times*), she had asked to walk from London to Bath and back again without a penny to prove his love, and so he had. As the 'Fitzes', they were a showy item in London, until Thomas, too, died, of some stomach infection of which there were too many and various to name, leaving Maria a rich widow with a thousand a year and property as handsome as she was, in Staffordshire, and Park Street in London.

Though the Prince pronounced her devilish pretty, Maria wasn't,

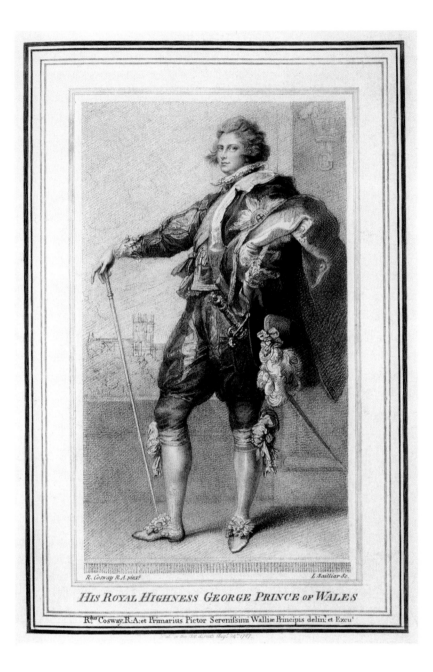

George, Prince of Wales, by Louis Saillar, after Richard Cosway, 1787

but she was certainly attractive, with fair hair, a strong jawline, hazel eyes, a rather long nose and that fine figure which could sail into a room and immediately impose itself on any opposition. As was his habit, the Prince lost no time. There were balls and parties at Carlton House. One night he rapped on her Park Street door but failed to gain entrance. Maria was not interested in the currently vacant mistress position. She was a Catholic, and a good, even pious, one. The Prince could and did launch his usual barrage of passion her way. Poor Georgiana, who had appointed herself friend-protectress, had to listen to howls of petulant anguish; threats to do himself in should she not be his. Frantic, he began to speak of marriage. But a Catholic marriage with a widow was, dynastically and constitutionally speaking, out of the question. It would automatically remove George from the line of succession; but even had Maria been Protestant, the Royal Marriages Act of 1772 made consent by the King an absolute condition of any match. This was well known to both parties. George could damn the Act, claim he cared not a fig for the Crown; he would take both of them to, yes, America; but Maria was no fool and didn't for a minute believe the histrionics. The onslaught continued regardless. Thomas Gainsborough was summoned to paint Maria's portrait. Jewels and, of course, a Cosway miniature came her way. Gossip had it that the Prince was 'making fierce love to Mrs Fitzherbert'. Not if Maria could help it, for she could see no right outcome. In the first week of July 1784 she decided to do the sensible thing and leave forthwith for Europe. Gainsborough put down his brushes. The King and Queen could not have been more relieved.

Their son, on the other hand, did not take the news well. The Duchess of Devonshire wrote to her mother that 'the Prince of Wales has been like a madman. He was ill last Wednesday and took three pints of brandy which killed him. I fancy he has made himself worse than he was in hopes to prevent the departure . . . of a certain lady.' On the eve of Maria's departure, 8 July, trunks packed, four of the Prince's immediate entourage, including his doctor, came to Georgiana's house, where she was giving a farewell supper, with startling news. The

Prince had repeatedly said he would die, kill himself if Maria were not his. Now it seemed he had done something about it. He had stabbed himself, missing the heart by the breadth of a nail. Even now, blood was pouring though his bandages, which, in distraction, he kept tearing from the wound. For him to desist in this suicidal folly Mrs Fitzherbert would have to assure him that she would, after all, consent to a marriage. She must come, in haste, before it was too late.

She was not going to do this alone. The good-hearted Georgiana went with Maria. When they reached the royal bedchamber, there he was, pale as the sheets would have been had they not been amply saturated in Hanoverian blood. A keen student of the modern theatre, George proceeded to put on a star performance, foaming at the mouth, bashing his head against the wall, screaming and shouting. It may have been the brandy flask Maria noticed beside the bed that gave him strength for the coloratura turn. Blackmail commenced. If she wished him to live, she must become his wife. A ring suddenly appeared and the Prince slid it over the appropriate finger. Maria did not, for the moment, remove it, but once she got back to her house she made sure a document was drafted stating that this betrothal had been made under extreme duress and could not, for a minute, be supposed binding. The next day found her in her carriage on the Dover Road. Thomas Gainsborough was stuck with an unfinished portrait, which he delivered to the freshly distraught Prince.

Nothing as trifling as the English Channel would make George desist from his campaign. His letters, ever more extravagant, pursued Maria across Europe. When he was not writing he was raving, rolling on the floor, crying for hours on end; ripping hanks of hair from his scalp. This went on for nearly a year and a half, through all of which George insisted on addressing Maria as his wife. Finally, in November 1785, he loaded all of his big guns and wrote Maria Fitzherbert the love letter to end all love letters, at least in length if not in poetic quality: a full forty-three pages, complete with copious underlinings for additional emphasis, which, given the general tone, was probably redundant: '. . . your husband a name I will never part with till I am

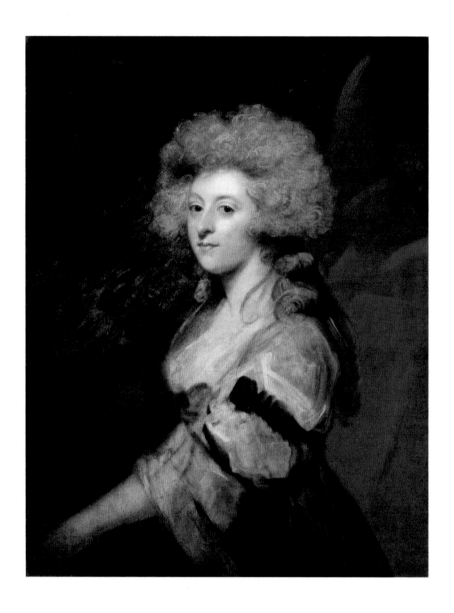

Maria Fitzherbert, by Sir Joshua Reynolds, circa 1788

unworthy of it or till death shall tear me from thee . . . can I, could I, ever enjoy a moment's happiness, a moment's joy, a moment's comfort without thee? No, thou art my life, my soul; my all, my everything.' Then followed the little gnat bite of blackmail: 'Think one instant how I am situated and yet my fate is at present in your hands and I think you will not hesitate. By coming [back to England] you make me the happiest of men, by staying or doubting one instant you not only make me think yet you are dead to feeling and to everything I have undergone for you but you ruin and blast my reputation in ye world and with my friends . . .' He was bursting with plans. They could elope to the Netherlands. They could live in America. She was already his wife and had been for a year and a half. 'Come then. Oh come, dearest of wives, best and most adored of women, come and forever crown with bliss him who will through life endeavour to convince you by this love and attention of his wishes to be the best of husbands and who will ever remain until the latest moments of his existence *unalterably thine.'*

Before dispatching the monster billet-doux, the Prince of Wales went to see Cosway. To drive home the attack, to make Maria *see* his ardour, required a little something extra: not just a miniature; she had had plenty of those. But perhaps his eye alone; his right eye, to be specific, painted on ivory, minus the rest of his face. Undistracted by any other feature, the eye of the Prince would always be looking at her; in unbroken adoration, he liked to think.

The single eye was, in fact, a popular eighteenth-century conceit. But it was known mostly as the omniscient Eye of God and as such appeared in all the symbolic devices of the Freemasons. Translated across the Atlantic, it was adopted into the design of the Great Seal of the United States on the suggestion of Benjamin Franklin.

The eye of the Prince of Wales, however, set in a gold locket, was something else entirely. Hanneke Grootenboer convincingly suggests that eyes as a decorative object might have begun as fancy tailcoat buttons which already often had whole miniature landscapes on them. At any rate, they were seen by the mid-1780s as a dubious French

import, a pocket extravagance. This changed when Cosway painted the eye for the Prince of Wales.

'I send you . . . an Eye,' he wrote as a postscript to his letter. 'If you have not totally forgotten the whole countenance I think the likeness will strike you.' But, in fact, an eye, isolated from the rest of the face's features, can never be a likeness of anything but itself: brow, lashes, cornea, sclera, iris, pupil. It can have no expression. But it works, if at all, by synecdoche; the part begging to be surrounded in the mind by the rest of the face. In this way it takes firm possession of those on the receiving end of its monocular stare. It would never blink, never close in sleep; it was always open, observing, imploring, demanding. And this particular eye that Cosway did for the Prince was unlike others, in which the eye filled most or all of the space of the ivory. Cosway paints it on almost the same scale as he would have done had the rest of the face been filled in. But it hasn't been. The little eye floats, disembodied, ghostly, orphaned from the countenance.

Poor Maria. She could close the locket and she would sense the eye within continuing its stare, boring through the gold. She could put it away in a reticule or the drawer of a secretaire; she could leave the room and, somehow, that eye would go with her. She capitulated.

Rumours of her return and a possible marriage were flying. They alarmed Charles James Fox, who begged the Prince not to embark on this 'desperate' action. With George removed from the succession, of course, Fox's own political prospects would suffer, perhaps irreparably. Even as he was making the arrangements for the secret wedding at Maria's house, officiated by a clergyman winkled out of the Fleet debtors' prison and bribed by having his obligations paid off and being promised a diocese when George was King, the Prince was reassuring his friend Fox that the rumours were mere unfounded slander. On 15 December the Prince's friend Orlando Bridgeman stood in front of Maria's front door in Park Street, sword drawn while the couple swore their vows to each other. One of the two Catholic witnesses was Henry Errington, who had first introduced them. The marriage was legal but,

to pre-empt questions, the Prince wrote out a statement for Maria declaring they had indeed been wedded.

George's continued denials led Fox to say the same in Parliament, innocent of the fact he had been lied to. The Prince's act was either one of monstrous self-indulgence or touchingly unswerving love. If discovered, he was prepared to pay the price, up to a point. He and Maria continued to live at separate addresses. The Prince was either at Carlton House or Brighton; she stayed in Park Street, where he came to visit. Though she was much caricatured in the press, no one in her society blamed Maria Fitzherbert. It was thought she had done something noble. Alone of his serial conquests, she had refused to be a mistress and insisted on a proper marriage. Even King George and Queen Charlotte found this admirable. There was something dignified about her evident loyalty.

Although very few were deceived, George never could make up his mind whether to keep the secret or shout the truth to high heaven, so he alternated as the mood took him. Not long after the wedding, he summoned Cosway to paint a twin miniature, this time of Maria's eye, which, although equally surrounded by featureless ivory, manages to be more humanly pretty than his own slightly piggy stare. He had it framed in gold, encircled by a braid of her light-brown hair, and wore it beneath his shirt. But there was at least one occasion when the wish to declare the truth before the world got the better of constitutional discretion. At Drury Lane in his box he was seen to be wearing and at one point flourishing Maria's eye. It was, in itself, a declaratory performance. George would have had to have stood, unclasped the locket and then triumphantly flourished the eye, much as one would flash a wedding ring at those who doubted a marital union. All eyes would have been on it, a whole auditorium of eyes staring away through the lorgnettes and spyglasses, which were taken to the theatre as much to behold the antics and stratagems of society as anything taking place on the stage. Revelling in the moment, the Prince of course knew that this game of eyes would be widely reported. That was the point. Even Georgiana, usually not much worried about such things, wondered if it was wise for Maria to 'change from a very prudent behaviour about [the Prince] to a very

imprudent one, suffering him to sit and talk to her all the Opera, to carry her picture (or her eye), which is the same thing, about and shew it to people . . . All these things put it past a doubt that they are married.'

Throughout the two long periods of their conjugal relationship, broken only by his brief and catastrophic marriage to the unhappy Caroline of Brunswick and undermined by constant affairs, the Prince was never without a Cosway miniature of Maria. Even after they had parted for good in 1811, he gave instructions that it was to be placed in his tomb, an order that was carried out on his death in 1830. The Duke of Wellington, who was not normally given to sentiment of this kind, thought it right that Maria – who had not seen George for nineteen years – should know this. When he told her of King George IV's last wish, he saw a tear fall from her eye.

Tiny had done the Prince proud. He now thought of himself not just as George's miniaturist but the tutor of his artistic taste. Queen Charlotte was the only one of the royal family with much discernment in such things. But the young Prince, led through Cosway's vast and ever-growing collection – a one-man history of art installed in Pall Mall – saw this as instruction in collecting, given by someone he, and not his parents, had chosen. Cosway's wit and easy manner made a change from the succession of grim teachers to whom the King had subjected George. The tuition worked. As Prince Regent and King George IV, he would turn into the most passionate and educated of all royal collectors since Charles I. In return, Cosway was allowed to style himself as if he were indeed Rubens, as *Primarius Pictor Serenissimi Walliae Principis* (Principal Painter to His Highness, the Prince of Wales), a very big title for a small man.

The connection opened other royal doors. Cosway painted the Duke of Clarence (later King William IV), and Princesses Sophia and the frail Amelia, the last exquisitely. He also did fine pictures of children, both delicate and exuberant and thus perfect for the time when one day brought laughter from the nursery and the next tears, sometimes mourning. In 1786 he was called to Paris to paint the children of the Duc d'Orléans, who thought of himself as a leader of liberal opinion

The Eye of George, Prince of Wales, by Richard Cosway, late eighteenth century

and who, as Philippe Égalité, would turn revolutionary, but not revolutionary enough to avoid the guillotine under the Jacobin Terror. His son would become the constitutional monarch, King Louis-Philippe, in 1830. Orléans was also the owner of the Palais-Royal, a stone's throw from the Louvre and the Tuileries, where Parisians could shop, gawk at the courtesans, see waxworks, dine sumptuously, take a cup of chocolate, promenade or discuss dangerous politics, for, as Orléans's private property, the Palais was beyond the jurisdiction of royal police and censors. It was here the Paris revolution would begin, on 12 July 1789.

This was the commission of Cosway's dreams. There was no question of Maria not going with him. Pictures from the later 1780s suggest he never tired of looking at her; that he imagined the two of them as the reincarnation of his hero Rubens and his wife, Isabella Brant, or sometimes, the second, much younger wife, Hélène Fourment. There they are, in Flemish-baroque fancy dress, in Rubens-Cosway's courtyard garden, seated in a springtime idyll amidst the statuary, attended on by a black servant; the husband artist staring into creative space; the straw-hatted wife looking on in companionable affection.

It might not have been quite like that. When they got to Paris they were immediately introduced to a talky world in which art, learning, music and liberal politics were all part of the same bubbling broth of excitement. In 1786 there was a sudden sense of beginning again in France, even if it had come about through a desperate fiscal crisis. An 'Assembly of Notables' drawn from different orders of the nation had been called to Versailles by the Controller-General Calonne, to find a way to raise revenues more equitably. Radical political implications were unavoidable. The liberal nobility would not hear of reform without a national consultation. French arms on land and sea had made the difference to the cause of American freedom. The habit of speaking liberty to monarchy had come back with them.

As had Americans. Among the first people the Cosways met was John Trumbull, the painter who had been aide-de-camp to General Washington during the war and had become the foremost history painter of the Revolution. He was in Paris to sketch, for a grand

Richard Cosway and Maria Cosway, by Richard Cosway, 1784

Thomas Jefferson, by John Trumbull, 1788

painting, the French officers who had been present when Lord Cornwallis surrendered his army at Yorktown in Virginia five years earlier, the event that effectively ended the war. The American party in Paris were, among other things, non-stop sightseers, and one of them was the minister (that's to say ambassador) to the court of Versailles, Thomas Jefferson. In keeping with his passion for political economy and all things agricultural, Jefferson had put the spectacular Grain Market, the Halle aux Blés, on his list of unmissable sights: enormous, encircled by streets broad enough for the grain carts to unload, and housed in a vast structure roofed with a cupola copied from the Pantheon in Rome, albeit without an oculus open to the sky.

There, amidst the motes of chaff hanging in the air, he was introduced by Trumbull to Maria Cosway. He found himself, he later wrote, looking 'at the most superb thing on earth'. Jefferson had been a widower for five years. Of his six children, only two daughters had survived, and they were away at school. He was, he told himself, first and last a creature of thought. Not invariably, it turned out.

During the late summer there were excursions, almost every day; sometimes in the company of Richard; sometimes not: a *concert spirituel*; the Comédie Italienne. By day Cosway was busy with the Orléans children out in Bellechasse; Jefferson made time in the afternoons. On one such afternoon he excused himself from a dinner, claiming he was, alas, detained by official business, when he was actually walking along the arcades of the Palais-Royal with Maria. They stood on the terrace of the chateau at St-Germain-en-Laye. 'The day was a little too warm, I think, was it not?' he would recollect, speaking not just of the late-summer glow. On a single day they visited the little chateau at Marly where Louis XIV had escaped the tedium of Versailles ritual; saw the great groaning engines that pumped the water to that monstrous palace's myriad fountains, and rainbows trapped in the spray; in Chambourcy they walked the fantasy park of François Racine de Montville, full of mad things: a Chinese house; an Isle of Happiness set in the middle of a lake on which a Tartar yurt had been built from tin and painted brilliant yellow-and-blue stripes. Why not linger on

the Isle of Happiness? Rising from a grove of lindens was a vast, truncated column; a standing fragment from some shattered temple of the Titans. Within its hollow frame, a narrow spiral staircase took pilgrims up three storeys past the square and the circular windows to the jagged roof where they could catch their breath, stand looking over the park and not at each other for as long as they could bear it. 'Every moment was filled with something agreeable. The wheels of time moved on with a rapidity of which those of our carriage gave but a faint idea and yet in the evening when one took a retrospect of the day, what a mass of happiness we travelled over!' We will never know if they made love, or rather they certainly did make love. It's the physical side of it we don't know about, and don't need to. She was overwhelmed and moved by his talkative grip on life; his habit of cutting to the quick of things. It could not have done any harm that he was also not tiny: six foot two, straight-backed, handsome in a ruddy-faced way. For Jefferson, Maria was the woman he had been looking for: instinctive, voluble, flashingly beautiful, warm-hearted beyond anything he'd known.

She was also married. This detail scarcely troubled most of the society they moved among in Paris, and Cosway was certainly not a faithful husband. But, inconveniently, Jefferson liked Richard Cosway, paid him the high compliment of calling him an *honnête homme*, good in heart and eminent in art. Maria, like Mrs Fitzherbert, regarded herself as a faithful child of the Church and, besides, there were great uncertainties of destination hanging over both of them. Romantic promenades, him delivering witty asides about architecture, landscape, politics, and then stopping in the middle of sentences to regard her, drink in her high spirits, lean close over her shoulder to look at her sketches, were one thing; figuring out where they would be, where they were going, quite another. Richard would be finished with his work for Orléans before long; Jefferson's world lay in Virginia and with the government of the young Republic. They tried to put these heavy thoughts out of mind; planned another walk; a final day of delight, the last grains of sand running through the tyrant hourglass.

Right on cue, the weather shifted. September's heavy skies; pelting rain, *feuilles mortes* spinning in the brimful gutters. There are no accidents and – at least according to one speculative version – on that last expedition Maria suddenly realized she had left a fan she had painted herself somewhere earlier in their walk. Jefferson ran to fetch it, feeling, as he had for weeks, stripling young. But he was forty-three. Taking a short cut, he jumped a stone-walled ditch and misjudged the other side. Falling, he broke his right wrist. The fan was recovered but not their good humour, since he was in a lot of pain. The wrist would never mend properly. His remembrance of Maria would always come with a sharp pull on his writing hand.

Jefferson hired a cabriolet to drive round Paris one more time with Maria. But the jolting ride over the cobbles was murder on his angrily swollen wrist. Out of sorts, he begged off the last meetings arranged before the Cosways' departure. For all sorts of reasons he tossed and turned: 'No sleep, no rest. The poor crippled wrist never left one moment in the same position, now up, now down, now here now there.' But as Maria and Richard were boarding the coach at the Porte St-Denis, Jefferson stepped out of a suddenly appearing carriage to wish them well. He was in every kind of pain. To the Baron d'Hancarville, the artist-connoisseur of antiquities who had been their companion, he confessed he was '*très affligé*' at their departure. D'Hancarville was not stupid. He knew Jefferson was not speaking of Tiny Cosmetic.

Don't go. Don't leave. Don't disappear.

That night, as the Cosways were on the road to Antwerp, where they would meet up with John Trumbull, Jefferson tried writing with his left hand:

Having performed the last sad office of handing you into the carriage at the Pavillon St-Denis and seen the wheels get actually into motion, I turned on my heel and walked, more dead than alive, to the opposite door, where my own was awaiting me . . . I was carried home. Seated by my fireside, solitary and sad, the following dialogue took place between my Head and my Heart.

A VIEW from M.ͬ COSWAY's BREAKFAST-ROOM PALL MALL,

WITH THE PORTRAIT OF M.ͬˢ COSWAY.

The Landscape Painted by W.ᵐ Hodges, R.A. and the Portrait by R.ᵈ Cosway, R.A.

& engraved by W. Birch, Enamel Painter.

Published Feb.ͬ 1, 1789, by W.ᵐ Birch, Hampstead Heath, & sold by T. Thornton, Southampton Str.ͭ Cov.ͭ Garden.

A View from Mr Cosway's Breakfast-Room Pall Mall, with the Portrait of Mrs Cosway,
by William Russell Birch, after Richard Cosway and William Hodges, 1789

It was twelve pages long, the only love letter that Thomas Jefferson ever wrote or which has survived. It was delivered to Maria in Pall Mall, courtesy of John Trumbull, who had agreed to act as postal go-between. The thinness of Jefferson's pretence that he was the cordial friend of both Cosways is belied by the pains he took to prevent the correspondence falling into the wrong hands, should it be sent by diplomatic or regular mail.

In Pall Mall, Maria read it slowly. It was so like Thomas Jefferson to shape the expression of emotions as a philosophical discussion. And to take the added precaution of writing as if his sorrow was due to the absence of both husband and wife. When he wrote that his mind brooded 'constantly over your departure' she was supposed to understand the 'your' was plural. No, she wasn't. In this dialogue, the heart was doing most of the talking.

HEAD: *Well, friend, you seem to be in a pretty trim.*

HEART: *I am indeed the most wretched of all earthly beings. Overwhelmed with grief, every fibre of my frame distended beyond its natural powers to bear, I would willingly meet whatever catastrophe should leave me no more to feel, or to fear.*

. . .

HEAD [turning the screw a little tighter]: *The lady had, moreover, qualities and accomplishments belonging to her sex, which might form a chapter apart for her; such as music, modesty, beauty, and that softness of disposition which is the ornament of her sex and charm of ours. But . . . all these considerations would increase the pang of separation . . . that you rack our whole system when you are parted from those you love, complaining that such a separation is worse than death.* [What could he expect?] *. . . We have no rose without its thorn . . . it is the condition annexed to all our pleasures . . . true, this condition is pressing cruelly on me at this moment. I feel more fit for death than life. But when I look back at the pleasures of which it is the consequence I am conscious they were worth the price I am paying.*

As the dialogue went on and on, the head rather took over. Maria must have skipped. There were suggestions that the Cosways should come and live in America; consolations that they would return to Paris; meditations on the comfort of company with which to share sorrow; reports of conversations with the famous prisoner of the Bastille, the '*chevalier*' Latude. But Maria would have felt still the heart more eloquent. 'Hope is sweeter than despair,' he had written with his scribbly left hand.

How and what to reply? 'How I wish to answer the Dialogue! But honestly I think my heart is invisible, and mute, and at this moment more than usual it is full and ready to burst with all the variety of sentiments which a very feeling one is capable of; sensible of . . . It is an excess which must tear to pieces a human mind, when felt.' She wanted to write to her Friend, but such a Dialogue as that made her feel she was also writing to the author of the Declaration of Independence. 'You seem to be such a master on this subject that whatever I may say will appear trifling, not well express'd, faintly represented.'

And then, for a month, nothing. But when he wrote, Maria could see the wound was still open, livid. The flimsy pretence that he was addressing himself to both Richard and Maria was dropped. The cry was for Maria alone:

When those charming moments were present which I passed with you, they were clouded with the prospect that I was soon to lose you . . . Thus, present joys are damped by a consciousness that they are passing from us . . . I am determined when you come next not to admit the idea that we are ever to part again. But *are* you to come again? I dread the answer to this question, and that my poor heart has been duped by the fondness of its wishes. What a triumph for the head! . . . May your heart glow with warm affections, and all of them be gratified! Write to me often. Write affectionately, and freely, as I do to you. Say many kind things, and say them without reserve. They will be food for my soul. Adieu, my dear friend.

More delays as winter dragged on and the nights closed in on Pall Mall. But when word arrived it was worth waiting for: 'I am always thinking of you.' Why did she not mention a spring return to Paris? She should be packing her baggage:

> ... unless you really mean to disappoint us. If you do, I am deter-mined not to suppose I am never to see you again. I will believe you intend to go to America, to draw the Natural bridge ... I had rather be deceived, than live without hope. It is so sweet! It makes us ride so smoothly over the roughnesses of life ... Think of me much, and warmly. Place me in your breast with those you love most: and com-fort me with your letters. *Addio la mia Cara ed amabile amica!*

The intensity of Jefferson's sentiments made Maria feel awkward not because she did not return them in kind but because – especially in English – she felt clumsily unable to put them in writing. So she wrote political gossip, news of the opera, their mutual friends.

Innocent trivia can break the spell; make the recipient feel emotion-ally short-changed. The knot of their mutual understanding loosened. Nothing more came from Jefferson for a long while. And then it was, as she thought, cruelly brief and self-pitying:

> I am born to lose every thing I love ... when are you coming here? If not at all, what did you ever come for? Only to make people miserable at losing you. Consider that you are but four days from Paris ... Come then, my dear Madam, and we will breakfast every day á l'Angloise, hie away to the Desert, dine under the bowers at Marly, and forget that we are ever to part again.

This is all it took for Maria to feel desperate about getting back to Paris while Jefferson was still there. When Cosway told her he thought he would not be returning, she wondered if he would much mind her going without him. He did not.

Off she went. And it was not as she had imagined. What had once

Mrs Cosway, by Valentine Green, after Maria Cosway, 1787

happened could not be exactly repeated. They were not in some romantic drama performed with the same words, intonations, sentimental emphasis, every night on the same stage. The American minister to Versailles seemed always occupied; always accompanied. She tried to busy herself. She went to the American residence; he went to her apartment. He was out. She was out. And then he vanished to the country. Between his frantic writing and the reality of her arrival something had cooled, become odd, between them.

They managed an afternoon which ought to have been like the old days – a walk through the colonnade at the Palais-Royal; a concert, a play. But it was not. Jefferson was polite, good-humoured, charmingly attentive. It was terrible; like a cracked bell.

She had to go. They agreed to have breakfast together the morning of her departure. But when it came to it, Maria knew she could not bear it. She rose very early. It was bitterly cold and the November daylight was yet to break. She had written him something: 'I cannot breakfast with you tomorrow; to bid you adieu once is sufficiently painful, for I leave with very melancholy ideas. You have given, my dear Sir, all your commissions to Mr Trumbull and I have the reflection that I cannot be useful to you; who have rendered me so many civilities.'

Ah, art! He had disappointed her even in that. So she wrote to him as if to some faithless patron. Maria climbed into the coach and was gone.

The note arrived too late. After two months there was a letter to London: 'I went to breakfast according to promise and you had gone off at 5 o'clock in the morning. This spared me indeed the pain of parting but it deprives me of the comfort of recollecting that pain.' For the scarcity of their meetings during her time in Paris, Jefferson implied he was not entirely to blame. 'You are sought and surrounded therefore by all. Your mere domestic cortege was so numerous . . . one could not approach you quite at ease . . . When you come again you must be nearer, and move more extempore.' So it was her fault . . . Sentimental tennis had commenced.

Maria had in fact written from Pall Mall a further note of regret and explanation:

I could not bear to take leave any More. I was Confus'd and distracted; you Must have thought me so when you saw me in the Evening; why is it My fortune to find Amiable people where I go, and why am I obliged to part with them! 'Tis very cruel . . . You are happy you can follow so Much your inclinations. I wish I could do the same. I do all I can, but with little success, perhaps I don't know how to go about it.

They would never see each other again. The letters became more intermittent. Jefferson did some travelling in Europe. More silence, and when it was broken it was with notes from the tour; making matters between them much worse when he decided to be clever. In his mind he said he had led her through the gardens at Heidelberg and at Strasbourg he sat down to write to her but could think only of a chapter of *Tristram Shandy* about a man who caused comment wherever he went because of his outsize nose. Maria was not amused. 'How could you lead me by the hand all the way, think of me, have Many things to say and not find one Word to write *but on NOSES*?'

There were too many things coming between them now. In the autumn of 1788 Jefferson wrote to Maria that he would be returning 'on leave' to America; principally to see his daughters and to affairs at Monticello. Neither of them was fooled. Maria had become friends, all too visibly for the gossips, with Luigi Marchesi, the prize castrato of the London opera, whose special condition and talent, contrary to vulgar presumption, was no impairment to non-operatic performance. Tongues wagged. Maria no longer cared. She wanted Italy, not Marchesi, but they might go together. Jefferson pretended that their separation was still to be thought of as temporary: 'I am going to America, and you to Italy. The one or the other of us goes the wrong way, for the way will ever be wrong which leads us farther apart.'

Neither of them was really deluded. They would look at each other now only in the form of likenesses. Whether it was on Jefferson's or Maria's initiative, their mutual friend – and truly gifted artist – Trumbull painted a miniature for her. It is easily one of the more

sympathetic portraits of Thomas Jefferson ever made; and certainly the only one in which the animation of his heart does seem to match the mighty machinery of his mind. His expression is caught between humour and wistfulness; the face is not that of the politician or the philosophizing president. It is, perhaps, as Maria would have seen him: the picture of someone tantalizingly on the verge of happiness. She kept it all her life.

He had to settle for something more remote from their memories: a drawing of her by Richard, owing something yet again to Rubens and to Van Dyck. The dress could be Antwerp, 1620s, but her hat, loaded with plumage, was very much in the faux-pastoral fashion of her time. Marie Antoinette liked to be pictured the same way. It was as artificial as Trumbull's image of Jefferson was utterly natural. It seems unlikely Maria had given it to him, for he has the engraved version by Francesco Bartolozzi, who did reproduction work for them both. Did Jefferson, the lover of sincerity and authenticity, think it caught anything of the Maria he had known and loved? At least he had something. When he died in 1826 at Monticello it was there, and it still is.

In 1790, a few months after Jefferson had left France, then in the throes of revolution, to become Washington's Secretary of State, Maria Cosway gave birth to a daughter. The girl was named Louisa Paolina, after her godparents: Louise of Stolberg, Countess of Albany, who had been married to what was left of Bonnie Prince Charlie; and Pasquale Paoli, the leader of the Corsican revolt against the French and a popular hero in London. The pregnancy was difficult; labour even worse. But the little girl was well and merry. When she was two, Cosway painted a sweet picture of her: curls and rosy cheeks.

But her mother was not there to see it done. A few months after her daughter was born she had departed to Italy, where she travelled to Florence and Rome and then entered a convent near Genoa for eighteen months. It seems an astonishing démarche. There were the health reasons duly given. She had never really recovered from an exceptionally difficult birth. But she was gone for *four* years. Letters to Richard

Maria Cosway, by Francesco Bartolozzi, after Richard Cosway, 1780

speak of his 'displeasure' with her, but if there was anything to the Marchesi rumours, it was the husband who was straying into the arms of others. Years later Maria wrote that she had expected him to ask her to return, but he had done no such thing. Instead he told her he would come to Italy, another prospect that did not materialize. Whatever had happened between them, by 1794 both were ready to restart family life.

When Maria stepped into the new house in Stratford Place off Oxford Street, she broke down at the sight of her little daughter, who wondered why her mama could be crying. Eighteen months later, at the end of July 1796, Louisa was painfully troubled with a sore throat, developed a fever and in a matter of days had died. Richard brought out his pencil and drew her just as she lay, to all intents and purposes a sleeping angel.

Maria locked herself in her room. Ten days after Louisa's death, when Horace Walpole came to pay his respects, she had still not come out. The father, so the malicious Horace Walpole said, seemed much less afflicted. But that may have been a mask. The truth is that Tiny could do without Maria, but he found the loss of his little daughter insupportable. He had Louisa embalmed and set in a marble sarcophagus which rested in his drawing room at Stratford Place.

Don't go. Don't leave. Don't disappear.

The couple struggled on. Eventually, Maria got back to work, showing paintings at the Royal Academy and opening a school for Catholic girls in Knightsbridge. Richard remained in demand. He had fallen out with the Prince Regent, quite reasonably, since George never bothered to pay what he owed the artist, which by 1795 was some seven thousand pounds – a small fortune – but he was still hired to paint his little daughter Princess Charlotte, and there was always a steady clientele from the nobility and the likes of the Duke of Wellington.

In 1801 Maria left again, and the sixty-year-old made no effort to stop her. One of the last things she did in England was to produce illustrations for a poem written by the crippled and near-penniless

Maria Cosway with Her Daughter Louisa, by Richard Cosway, circa 1794

Mary Robinson, who, as Perdita, had once been the toast of Drury Lane and the apple of the Prince of Wales's eye. The poem was called 'A Wintry Tale'. Her old lover was once again set up with Maria Fitzherbert in Brighton, where they would stay, quite happily, for another decade.

Maria went first to Paris, where hard memories were waiting for her. But she banished them for a visionary project to make engravings of the entire collection of the Louvre, still young as a public museum, and make the reproductions available to those who could not visit the art *in situ*. She made friends among the cultural grandees of the Consulate and then the Empire, including Napoleon's uncle Cardinal Fesch, who found her work in Lyon. But the ghost of her little Louisa haunted her and could only be exorcised by committing the rest of her life to the education of girls. A school was opened in Lodi, where she could imagine her daughter growing in wisdom through the years.

She made two visits back to London when her husband had suffered strokes, in 1815 and 1817. He was still working but in his seventies had become eccentric, turned Hebrew mystic, growing his white beard very long, like an Old Testament prophet, and wearing black silk brocade robes and cap. When the Prince of Wales asked him to supper for old times' sake, he declined, saying he had put such vanities behind him. When a friend of Maria's wondered whether she had loved him, Maria replied that how could she not have loved someone who had taken her in without fortune and name and with whom she had shared nine happy years? Perhaps that had not been enough; but she cared for the increasingly ill and cranky little man; taking charge of and then selling off much of the immense jumble of art piled up in Stratford Place. Maria moved both of them to 31 Edgware Road, north of Tyburn, an address which was still a little rustic. Throstles woke them and buttercups shone at the lane's edge.

In July 1821 Tiny suffered a final seizure. Maria organized the grandest possible funeral: the kind he would have enjoyed attending. A team of six black horses pulled his hearse and a train of carriages followed. Those who could not come in person sent an empty carriage instead.

Richard Westmacott, who did not come cheap, was hired to make an imposing memorial in Marylebone New Church.

Three days after the funeral she wrote to Thomas Jefferson, who himself had but five more years to live. Never perfect, her English had suffered further from long years in France and Italy. She didn't care. Not any more, not even when she was writing to the ex-president, the founding father of a great university as well as his nation. 'Your patriarchal situation delights me,' she wrote, with an epistolary smile. 'Such as I expected from you.'

My dear and Most esteem'd friend
The Appearance of this letter will inform you I have been left a widow . . . I took a very charming house & fitted it up handsome & comfortable with those pictures & things he liked most – all my thoughts and actions were for him . . .
We had an auction of all his effects & house, in Stratford place, which lasted two months, my fatigue has been excessive – The sale did not produce as much as we expected but enough to make him Comfortable & free of embarrassment . . . After having settled every thing here and provided for three Cusins of Mr C's I shall retire from this bustling & insignificant world to my favorite college at Lodi . . . where I can employ myself so happily in doing good.

Then another thought came to the handsome signora:

I wish Monticello was not so far. I would pay you a visit if it was ever so much out of my way, but it is impossible. –
I long to hear from you . . .

4. *Molly and the Captain*

Molly and the Captain, five and three, were out chasing cabbage whites. Their father the painter watched them scamper and shout. There were days when this is all Gainsborough wanted to do: sit with his back propped against a wall or a rock and sketch the girls bounding about; filling his book with leaping lines. In his studio, pursuing likenesses and money, stillness and decorum perforce had to reign, the sitters frozen in their chosen attitudes of importance and he the faithful transcriber of their self-regarding ambition. What Thomas Gainsborough really respected was nature. There was no shortage of face-painters in England now, not even in Suffolk, but few who captured the real nature of the persons, much less the character of the country. To bring those two things together: to paint the figures in a true landskip, not some fanciful pastoral glade, that was the thing. Mr and Mrs Andrews had liked it well enough when he had pictured them at the edge of one of their enclosed fields of ripening wheat, hound and gun, land put to profitable use. But there was, he discovered, a limited taste for this kind of propertied pastoral. It was the patrons who wanted portraits done in high style, coat and gown, wig and pearls, who kept the wolf from his door, and so he must oblige.

But when Gainsborough took time to picture his 'dear girls', his hand, following his heart, could skip a little. Yet the subject was not trifling. Looking at Mary and Margaret chase a butterfly, Gainsborough was smitten by poignant illumination; reminded perhaps of a page of John Bunyan's a century before where a similar scene had made an emblem for pleasures as fleeting as the lifespan of the pretty insect. But although Gainsborough had had the kind of Dissenter upbringing in which such homilies were instructional bread and milk, he was not, by nature, a sententious artist. It was not the commonplace of the world's transient vanities that was the weighty undertow of his painting so much as the fugitive moment of the girls' lives: the airy sweetness of their play,

The Painter's Daughters Chasing a Butterfly, by Thomas Gainsborough, circa 1756

which could no more be held still than the elusive butterfly. Trap the beating wings of the instant and spontaneity would die.

Especially before Dr Jenner's vaccine had been introduced, small children perished with terrible regularity. Smallpox and scarlet fever carried them off. Mortality was especially high in London, where Gainsborough's first child, Mary, had been born. His wife, Margaret Burr, had been carrying her when they married in 1748. He had come to the city from Sudbury to make the most of his talent; studied at Hogarth's academy; tried to find a dependable batch of sitters; but could never get established. The baby died; his fortunes withered on the vine. It may have been his wife who resolved they should return to the country, away from the poisonous foulness of the town. When replanted back in Sudbury, Gainsborough tried to catch a moment before the sorrow, and set mother, father and child outdoors, as if they had all been in the country, the little girl like a pippin in their laps. But the picture had gone wrong and lost its consolation; become stiff, like her dead form, and had turned into a *memento mori*. He and his wife sit, awkward in their solemnity, and as physically distant from each other as they had been in the wake of the calamity. 'My wife is weak but good,' Gainsborough would later write, a little mean-spiritedly, of Margaret Burr; 'never much formed to humour my happiness.' The autumnal, leafless scenery speaks of loss and desolation. The rakish angle of Gainsborough's tricorn looks like the effect of indifference to outward appearance: a manner undone.

Perhaps his wife had been right, though. For God was kinder to them in the country, and when another daughter arrived they called her (as was often the custom) after the lost one. This Mary the second was a sturdy, pretty girl, and the sister who came soon after her, Margaret, every bit as lively, with her mother's strong, curving nose planted in the middle of her face.

Now, in Ipswich, Gainsborough wanted to turn their little world into something big; something that would make those who saw the painting smile and sigh. Children were no longer pictured as they once had been: miniatures of their elders, albeit smothered in infant skirts;

solemn, unnaturally still; incipient adults. Nor were they any longer seen as wicked imps, in need of stern governing lest their unbroken animal nature lead them astray. Their play was now looked on as the sport of their innocence. Parents had become so enamoured of the romping that they had even asked artists to record it, but those like Hogarth who had made the attempt had somehow made the children animated dolls: gleeful, but oddly jerky in their motions, as if strung by a puppeteer, the room about them a toy theatre. Gainsborough had another idea entirely. He would have his two girls fill a big canvas, catch them in whooping pursuit of the butterfly, at the very moment when it had landed for an instant, upon – why not? – a thistle: the sweetness of the moment pricked by the thorn on the leaf.

The little drama, as it had become in his mind, required at least a touch of poetic licence. As if enticed by a magical butterfly in some fairy tale, the girls run forth out of a darkling wood into a blaze of light. Though their sleeves are rolled up and Gainsborough has them clothed realistically, simple skirts covered by bodices and aprons, the swishing, brightly coloured dresses are loose enough for their father to describe the movement of their bodies, the dancing nimbleness of their feet. But there is a brilliant conceit at the heart of the composition, turning on the business of their hands. One of the loveliest things about his paintings of the girls is that Gainsborough plainly saw their differences: 'Molly', the more reserved and careful, a little bit like her mother; Margaret earning her nickname, 'the Captain', from her sweet impetuousness. So it is the Captain who lunges towards the cabbage white, while her older sister, more circumspect, stands back a little, throwing the sash of her dress over her left shoulder. Different, then, the girls, but also complementary, inseparable; their hands clasped together at the moment of excitement, turning the two of them into a single human butterfly, one a fluttering wing of gold, the other creamy white.

If only masterpieces had the power to stop time. But they don't. The instant of perfect innocence would last no longer than the life of the flitting insect.

The Painter's Daughters with a Cat, by Thomas Gainsborough, circa 1760–61

Surprisingly, when the Gainsboroughs departed Suffolk for Bath and more fashionable opportunities, they left the butterfly painting behind, albeit with a neighbour, the Revd Robert Hingeston, whose parsonage backed on to their garden and who must, many times, have watched the girls at play. Other portraits, made when Molly was around eleven and Peggy nine, preserve, in exquisite and unusually affectionate poses, the strength of their sisterly bond. None of them was finished, as if Gainsborough could not bear to trap their freshness and spontaneity within a coating of embalming varnish. In the painting where Mary has a protective arm slung over the shoulder of her sister, the dashing freedom of Gainsborough's brushstrokes is still uncompromised by finish. Given that later on in his career Gainsborough would turn into a one-man service industry of sentimental images of children, whether beggar urchins or Blue Boys, these early pictures of his girls are utterly free of winsome ingratiation. They are his own children of nature, and he paints truth revealed on their faces. Mary's copper hair is sweetly windblown up from her brow. Margaret's pout and the raised eyebrows plead with the artist for release from the torment of posing. *Pleeeease, Father, dear . . . Isn't it over yet . . . pleeease?* There was to have been a cat, cradled in Mary's left arm; the outline sketch visible; a Cheshire grin weirdly apparent and fugitive. Kitties appeared all the time in eighteenth-century pictures of children, especially those of young girls, whether or not they happened to be around; a conventional emblem of playfulness with claws. It would have been like Gainsborough at this stage of his career to disdain the commonplace. Another, still more tender, painting has Mary extending her arm full length to grasp a lock of hair on her sister's head. Since Mary herself has a little nosegay of flowers in her hair, it's possible to read the gesture as her clasping Margaret's hair before likewise dressing it. But there is something unsettling and even unhappy about the look Margaret is giving her father, something more than the tomboy who doesn't care to have pansies stuck in her hair.

There was something the matter with Mary. In 1771, called in to examine a fit of odd behaviour, Dr Abel Moysey declared it 'a family

complaint', one so inescapable that he did not suppose 'she would ever recover her senses again'. This was a prematurely gloomy judgement. In fact, despite the occasional bout of strangeness, Mary had certainly been lively enough to be sent, along with Margaret, to the Blacklands School in Chelsea, facing the Common in what is now Sloane Square. The school specialized in 'French education', which included instruction in the arts. While they were in their mid-teens, living in Bath, Gainsborough had decided that the 'dear Girls' should be properly trained as artists. There was surely some reaction to Bath society life in this determination: the musical gatherings and the promenades and the rest of the social circus about which Thomas had mixed feelings even as he joined it. 'I think,' he wrote, '(and indeed always did myself) that I had better do this [the art teaching] than make a trumpery of them and let them be led away by Vanity and subject to disappointment in the wild Goose Chase.' The ganders were, of course, prospective husbands. Better his daughters should become artists. By the middle of the eighteenth century this was not such an extraordinary thing. Mary Beale had been one such woman portraitist in the previous century. But Gainsborough was also determined that the girls not just be restricted to the kind of crafty arts thought fitting for women: pastels and decorative drawing. In 1764 he wrote to a friend that he was 'upon a scheme learning them both to paint landscape that is somewhat above the common fan-mount style. I think them capable of it if taken in time and with proper pains bestowed in that they may do something for their bread.' Another double portrait painted around that time shows the girls, joined once more by an arm slung over a shoulder, at their work, attending both to their father and to their practice. Mary holds portfolio, sketchpad and porte-crayon, while Margaret studies the kind of plaster modello (this one of the Farnese *Flora*) that was basic to academic drawing studies for men as much as women.

The plan was, at best, only a partial success. A move to London was going to make the project of keeping the girls honest painters all the more difficult. The social blandishments were too many, not least because Gainsborough was not immune from them himself. Of the

girls' gallivanting, he complained that 'these fine ladies and their tea drinkings, dancings and husband huntings and such will fob me out of the last ten years and I fear miss getting husbands too.' And yet he now painted beautiful full-length pictures of each of them, designed to advertise their attractions as if they were the most eligible heiresses in town: Mary, nineteen, pretty rather than beautiful; Margaret, eighteen, always plainer but with the fire of the Captain still in her dark eyes. Gainsborough had become the glass of fashion; just as indispensable to society's self-regard as Joshua Reynolds: the yang to Reynolds's yin. Reynolds provided Anglo-classicism: a kind of stentorian grandeur for the men; a sculptural dignity for the women. In contrast, Gainsborough, who wished to catch the subtle movements of facial and body language, was softly forgiving and airy; the lightly mixed paint was laid on with dancing grace. In 1799 Margaret told Joseph Farington that her father's colours were so liquid that, should he not hold the palette perfectly horizontally, they would run over the rim.

The perfect analogy for Gainsborough's style was music; one he made himself. 'One part of a picture ought to be like the first part of a tune,' he wrote to his friend William Jackson '[so] that you can guess what follows.' He was an accomplished performer on no fewer than seven instruments, including viola da gamba and flute, which may have made him too much of a severe critic of Margaret's 'jangling' on the harpsichord, though many others admired the girls' talent. Music was all around them, not least coming from the Cosways' concerts next door, which the Gainsboroughs must surely have attended. Gainsborough painted Carl Friedrich Abel with his viola da gamba and Johann Christian Bach holding one of his own scores but looking out of the frame, his mind lost in composing thought.

It may have been this closeness to the world of London music which helped Gainsborough make the best of a family disaster. His wife, Margaret, had died in 1779, and it had been she who had insisted that instruction in the arts need not be at odds with the girls' search for suitable matches; that it might even further it. But the mother had also kept a careful eye on suitors. This vigilance was evidently now missing,

for, at the end of February 1780, Mary eloped with the German oboeist and composer Johann Christian Fischer, marrying him in the church of Queen Anne's, Soho. Perhaps Fischer had something of a reputation, for Gainsborough, shocked at his daughter's act of romantic liberty, not least because he suspected the musician had been courting Margaret, wrote to his sister, 'I have never suffered that worthy Gentleman ever to be in their company since I came to London and behold, while I had my eye on Peggy, the other slyboots I suppose had all along been the object.' Dismayed and angry though he was, it says something about Gainsborough's character that he could not in the end bring down the full force of condemnation on the couple. He said that he did not in any case have much choice in the matter, though, like other angry fathers, he could in fact have threatened or carried out disinheritance. But, to his credit, this was not Gainsborough's way:

> The notice I had of it was very sudden, as I had not the least suspicion of the attachment being so long and deeply settled . . . as it was too late for me to do anything, without being the cause of unhappiness on both sides, my *consent*, which was a mere compliment to affect to ask, I needs must give, whether such a match was agreeable to me or not, I would not have the cause of unhappiness lay upon my conscience.

Once he recovered from the blow to his widower's sense of guardianship, Gainsborough hoped for the best. Was not music, after all, the emblem of family harmony? He came round enough to paint a full-length portrait of his new son-in-law. No one could have asked for a more handsome gesture of nuptial reconciliation. Dressed in an elegant rose velvet suit, Fischer is pictured as virtuoso, master of three instruments: the viola da gamba propped on a chair; and the oboe resting on the top of a harpsichord, evidently painted with the attentiveness of someone who knew all about music. Fischer himself is seen in mid-composition, gaze distant, quill in hand, the score spread out; a stack of music lying beneath the harpsichord. If there seems to be a

look of self-admiration on Fischer's face, it may be Gainsborough's way of registering the musician's 'oddities and temper', which the painter referred to in another letter to his sister, making sure to add that he had no 'reason to doubt the man's honesty or goodness of heart, as I have never heard anyone speak anything amiss of him'. As for those high-strung moods of her husband, '[Mary] must learn to like them as she likes his person for nothing can be altered now. I pray God she may be happy with him and have her health.'

Gainsborough's nagging anxieties were well founded; the marriage was a calamity. Hardly had the couple settled into a home on the Brompton Road than the artist realized he had in fact been deceived by Fischer as to the means by which he claimed to be able to support himself and his wife. And though there was nothing fraudulent about it, Gainsborough was horrified to find Mary buying up bed linens in order to resell them quickly at a profit. There was an ugly scene. Distraught and angry, Mary 'convinced me [she] would go to the gallows to serve this man'. Desperate, and without his wife for support, Gainsborough asked his sister to intervene: 'Send for her and give her such a lecture as may save her from destruction. Do it in the most solemn manner for I am alarmed at the appearance of dishonesty and quite unhappy.'

That was the least of it. Fischer's eccentricity collided with Mary's mental instability and after six months they separated for good. Presumably, Mary went back to live with her father but, after he died eight years later, the sisters lived together for the remainder of their long lives, in the suburban garden villages west of London: Brentford, Brook Green and then, for a long time, in Acton. Though Mary became quite deranged, Margaret never had any thought of packing her sister off to one of the terrifying Bedlams and devoted much of the rest of her life to tending to her.

When death came to Gainsborough in 1788, it took him by surprise. Habitually worried about his health as well as his wealth, he had always put his faith in physicians, but the one whom he consulted about sudden pains told him there was nothing to worry about. In fact, a tumour was galloping through his body.

His last decade had been crowned with extraordinary success: fully the equal of Reynolds's. No one important in Britain could do without one of his portraits: from Queen Charlotte and the Prince of Wales to the latter's many inamorata – Perdita Robinson and, of course, Maria Fitzherbert, as well as Georgiana, Duchess of Devonshire, whom he had first painted as a sparky little girl. That was when his pictures of children still had a wonderfully observed freshness and truth. Realizing now he could capitalize on a sentimentalized fashion for depicting waifs and strays, the older Gainsborough created a special genre of cosmetically adjusted beggar children, rustic boys and girls outside cottage doors, or else the progeny of the better-off dressed up *à la* Van Dyck in velvet breeches: the sugary confections of his Blue Boy period. He was looking at children differently now: as money-models striking poses which would appeal to his chin-chucking parental clientele even as they climbed into carriages for an assignation with their latest lover. He had begun with human truth and had ended in lucrative falsehood. To the end, Thomas Gainsborough had the eye of the loving father, but, no more than any other artist, or parent, was he able to cope with his children growing into adults. Perhaps this was because a good piece of himself, possibly the best, in fact, had never altogether grown up. In his very last letter, at death's door, he confessed the blessed truth: 'I am so childish that I could make a Kite, catch Gold Finches or build little Ships.'

Self-portrait, by Thomas Gainsborough, circa 1758–9

5. *Alice in the After-time*

To begin at the end, Lewis Carroll, aka Charles Lutwidge Dodgson, imagines, on the very last pages of his book, a grown-up Alice. Or, perhaps, since this was intolerable, he puts the imagining in the mind of her older sister Lorina (called Dinah in the book). Sitting on the riverbank, Alice tells her sister about her 'curious dream' of growing and shrinking and never quite knowing who she is, even if she was, indeed, still a little girl. 'It *was* a curious dream, dear, certainly,' says Ina/Dinah, 'but now run in to your tea; it's getting late,' and so she does. But Ina 'sat still just as she left her, leaning her head on her hand, watching the setting sun'; dreaming of 'little Alice herself, and once again the tiny hands were clasped upon her knee and ... that queer little toss of her head to keep back the wandering hair that *would* always get into her eyes'. Then she inherits the Wonderland, but only 'half believed', for Ina has gone through the looking glass of childhood and out into the world. When she opened her eyes, 'all would change to dull reality – the grass would be only rustling in the wind ... the rattling tea cups would change to the tinkling sheep-bells'. But she was comforted by the fact that:

> this same little sister of hers would, in the after-time, be herself a grown woman, and how she would keep, through all her riper years, the simple and loving heart of childhood: and how she would gather about her other little children, and make *their* eyes bright and eager with many a strange tale, perhaps even with the dream of Wonderland of long ago: and how she would feel with all their simple sorrows, and find a pleasure in all their simple joys, remembering her own child-life, and the happy summer days.

Thus would the perfect little girl be succeeded by the perfect mother, the listener by the storyteller. What a pity, then, that there had to be

205

an in-between time and that Dodgson couldn't escape it. In 1865, three years after the excursion up the Isis into Wonderland, thus when Alice Liddell was twelve – around the time he was receiving the proofs of *Alice's Adventures in Wonderland* – he ran into her at the Royal Academy show. It was not an altogether happy encounter. Dodgson commented that she 'seemed changed a good deal and hardly for the better'. But then he must have told himself that Alice was, after all, in 'the awkward age', as Victorian men liked to call it (the awkwardness was in fact their own), when delicate, angelic features become, in their eyes, coarsely physical. Writers repeatedly insisted that the charm of little girls was gone by the time they were in double digits, if not before. On the other side of the looking glass, Humpty-Dumpty would tell Alice, over her protests, that 'one can't help growing older', that since she was at the 'uncomfortable' age of seven years and six months she really ought to 'leave off at seven'.

It was not given to the vast majority of Victorian children to stay children for very long at all. The reality on the other side of the social looking glass from the Christ Church Deanery was that young'uns in their millions were dragged swiftly and irreversibly deep into the merciless adult would as soon as they could be of use to it. Despite the high child mortality rate, there were too many of them – mid-century, one in three Victorians was under fifteen – not to be of inestimable value to the workforce. So, for all the Liddell girls in their flouncy white skirts and aprons nibbling on muffins in the Deanery, there were whole armies of soot-caked, blood-spitting, tiny walking skeletons, greasy rags falling off them; sticking bony hands out to beg in the alleys or cutting purses of the unaware, for Fagin's kitchen was not entirely an invention of Dickens's imagination. Nor were the other starvelings of his pages imaginary. There were indeed factory-floor toilers sent to poke around between the cogs and grinding wheels of machines where grown-up hands couldn't reach. There were still more of them gasping in the filthy clouds of grey-and-yellow choking dust which clogged their lungs and shortened their lives. Rickety-limbed urchins tottered over the back-lane cobbles; child prostitutes with

running sores bleated from murky doorways; little battalions of the houseless slept rough under bridges, batting away the rats; emaciated crossing-sweepers like Jo in *Bleak House* scraped the horse turds from the streets between the oncoming clatter of carriages, barely recognizable as humans at all, more like scurrying, whimpering, grimy-clawed vermin. Pillars of society high-hatted and tidily bonneted stepped over child-shaped bundles of rags, whether they were squirming or inert. Survival for the rag-bundles depended on precious exposure to the kind of worldly wisdom taught in the Artful Dodger School of Useful Knowledge.

It was because these unnumbered battalions of destitute children were so inescapably visible that they moved into the centre of Victorian moral debate; and into the pages of the novels of Mrs Gaskell and Dickens; fired up the speeches of Ragged-trousered Philanthropists. But what the Do-Gooders could do about the appalling conditions endured by poor children was always limited by a common acknowledgement of their indispensability to the industrial machine. That it was deemed a great victory when Ashley's Children's Employment Commission banned all girls and boys under ten from work in mines only reveals what the crusaders were up against.

But in the dream-realms of Victorian storytelling, picture-making and photo-taking, the little ones could be restored to their childhood. Copperfield would find Aunt Trotwood; Oliver, Rose; or else, like Little Nell and Paul Dombey Jr, the angels would find their place in heaven. No sooner had portrait photography become widely available than newly bereaved parents were having their dead infants and small children captured as if merely lost in sleep or, in some more startling shots, forever transfixed with their eyes wide open. There were less drastic ways to fix small children – especially girls – in their age of innocence, and image-makers were obsessive about doing just that. John Everett Millais, who made a tidy fortune by selling his images of 'Cherry Ripe' and 'Bubbles' to Pears Soap, wrote that 'the only head you could paint to be considered beautiful by EVERYBODY would be the face of a little girl of about eight years old before humanity is

subject to ... change.' Ernest Dowson, who published 'The Cult of the Child' in 1889 during a public debate about whether to keep small children off the stage (two hundred were hired for the Drury Lane panto every year), and who was himself fixated with small girls, put it more bluntly: 'I think it possible for feminine nature to be reasonably candid and simplex [*sic*] up to the age of eight or nine. Afterwards, *phugh.*' Dodgson/Carroll was only one of a multitude of photographers who liked to photograph small children, and more often girls than boys. Oscar Rejlander's photos, including one child nude, were much approved of by the Queen. Julia Margaret Cameron photographed a naked boy Cupid for *Love in Idleness*. Henry Peach Robinson, similarly popular for the same kind of pictures, wrote that 'I do not know a more charming occupation than photographing little girls from the age of four to eight or nine. After that they lose their beauty for a while.'

Charles Dodgson tried to capture Alice and keep her forever in this dreamscape of childhood twice over: first in the photographs he took of the three Liddell sisters from 1856 to 1858 and then, of course, in the Wonderland he created. If his object was, as he said, to keep enchanted readers young, it was because a part of himself also liked staying that way. He had, after all, a sizeable collection of toys, mechanical and dancing dolls and every imaginable kind of puzzle in his rooms at the Oxford college. But one of the reasons why the Alice books are so perennially fresh and bewitching is that the voice of the girl herself is entirely free from sugary sentimentality and fairy-talk. Alice is bossy, headstrong, petulant and – understandably – irritably perplexed by the situations she finds herself in, not least the abrupt alterations in size she undergoes and the vexing characters she encounters. Very often she assumes the role of schoolmistress reproving the inhabitants of Wonderland for their childish follies.

But then, at the same time that the child-fixated writers and image-makers of Victorian culture made a great deal of keeping children children and walling off their innocence from the contaminations of

the grown-up world, they themselves were drawn to the embryonic adult dwelling within the form of the child. Fondness for the girl child dwelled very close to passion for the young woman, even as they professed to adore the one and abhor the other. The history of the deathless gazers is full of men falling head over heels for pubescent girls, twelve to fourteen; imagining making them their own. Wilkie Collins had an obsession for a twelve-year-old girl whom he called his 'darling', even while he kept two adult mistresses. Dowson went from one fixation to a lifelong passion for the fourteen-year-old Adelaide, the daughter of a Polish restaurant keeper whom he met in the establishment. John Ruskin – who gave Alice Liddell drawing lessons – fell very hard for Rose La Touche and proposed marriage. G. F. Watts the Pre-Raphaelite painter married the teenage Ellen Terry. And later in life Ina Liddell wrote to Alice that, in response to a journalist's questioning curiosity, she had told him that a break had happened because Carroll 'became affectionate to you as you grew older and that Mother spoke to him about it and that offended him so he ceased coming to visit us again'. A more dramatic version, repeated by Lord Salisbury (later Conservative Prime Minister), who knew the Liddells, had it that Dodgson had actually paid court and proposed to Alice, further scandalizing her father, the dean.

And yet, on 25 June 1870, Dodgson wrote in his diary that a 'wonderful thing occurred. Mrs Liddell brought Ina and Alice to be photographed; first visiting my rooms, then the studio.' Why did the mother do this? Her two daughters were now of an age to go into society, at least Oxford society, even to be considered as potential matches. Perhaps the pictures were meant to be made into *cartes de visite*. If so, the photograph of Alice is a dramatic failure for the sitter is making not the slightest effort to please. In his recent, fine book on Alice, Robert Douglas-Fairhurst reads her expression as boredom. But, along with the twisted body language, it looks a lot more like passive-aggressive resistance: a refusal to meet the eye of the lens and its operator; a decision not to play the latest version of the game.

Twelve years before, the six-year-old model for *The Beggar Child* had been a picture of composure. Though it is disturbing to think of Dodgson pulling the costume down from the girl's left shoulder to expose a nipple, there is absolutely nothing to suggest that her mother and father or anyone else thought this, or even more undressed poses, improper, much less sinister. In later years, Alice would remember the times with Dodgson, both posing and storytelling, as merriment, during which, she said, he treated the sisters as 'friend[s]'. What makes Dodgson's photographs different from more run-of-the mill, sentimental images is that he somehow managed to capture the fierceness of girlhood, the foot-stamping, high-spirited truth, paused for a moment, but caught in all the Liddell pictures. It is as if the sisters were as much the makers of their images as the photographer; full collaborators in their poses. There is this thing that Alice does: turning her head and tucking her chin down a little under the top of her dress, which, together with the challenging gaze beneath the glossy fringe of hair, registers a watchfulness coming right back at the watcher. Alice looks back, just as, in Wonderland, she will, uniquely in Victorian fiction, be the girl who talks back.

This share of command has all gone in Dodgson's photograph of the eighteen-year-old Alice. Hands folded, she is resigned to the imprisoning armchair. She is still averting her eyes from a controlling gaze but this time the expression is mournfully defensive. Now it is possible that this face is imprinted with the pain of adolescent understanding about what she had been subjected to as a child. But the awkwardness is much more likely to come from the embarrassment of Dodgson's changed manner to her as she grew older, the possibility that he may even have proposed. It was, after all, Dodgson, not Alice or her parents, who had broken off the visits, evidently in some pain. And there is yet another possibility: that Alice's downcast eyes are actually the projection of the photographer's wistful regret for the passing of the childhood which had been their shared Wonderland.

That the model did not feel the same way about the flowering of

Alice Liddell, by Charles Dodgson, 1870

her womanhood is documented in a set of startlingly powerful photographs shot just two years later in 1872 when Alice was twenty. The difference (though not the only one) is that this time the photographer is a woman: the great female portraitist of her generation, Julia Margaret Cameron, whose sitters also included Tennyson, Thomas Carlyle and the astronomer Herschel, all lit with dramatic intensity. The pictures of Alice were taken on the Isle of Wight, where, along with Queen Victoria, the Liddells spent their summers and where Cameron had her year-round studio.

In keeping with her dramatizing, literary style, Cameron's photographs of Alice present her in the allegorical guise (or at least with the attributes) of classical nymphs. But the particular roles were artfully chosen: Alethea, the personification of candour and honesty; Pomona, the nymph of fruitfulness and abundance who was courted by Vertumnus disguised as an old woman. It is as if, in full knowledge of the ambiguities of Dodgson's photographs – the obstinate denial of the changes that turned Alice from child to woman – Julia Margaret Cameron had resolved to make an issue of it; to present Alice, now famous as the Alice of Wonderland, in the fully unapologetic bloom of her womanhood: frontally posed, staring directly, in one case confrontationally, at the camera and at us.

Yet more tellingly, Alice-Pomona repeats both the setting and the pose of Dodgson's *Beggar Child*, in ways that presuppose the latter picture was well known to Julia Margaret Cameron and perhaps to the Victorian public. There she stands in the midst of a profuse garden bower, as she had done twelve years before, with one hand on her hip, the other cupped again, as in *The Beggar Child*. The flashing dark eyes and the challenging stare are instantly recognizable as unchanged from the small Alice, but now they return the gaze with steady, almost disdainful, forcefulness. The hand on the little girl's hip spoke almost of precocious coquettishness; now it is a gesture of strength. The cupped hand of the beggar child is now filled with a sense of her womanliness. Her hair is neither the glossy little fringe of young Alice, nor the tightly ribboned pile in Dodgson's last picture but falls loosely

down over her shoulders; the classic attribute of inviolate maidenhood. The white stage rags of the beggar girl have become the white costume of the nymph-woman, fitted to her body. Her throat, not her childish breast, is exposed. If ever she had been, Alice Liddell is no longer the possession of the storytelling don. Julia Margaret Cameron has recorded something else entirely: self-possession.

Alice Liddell as a Beggar Child, by Charles Dodgson, 1858

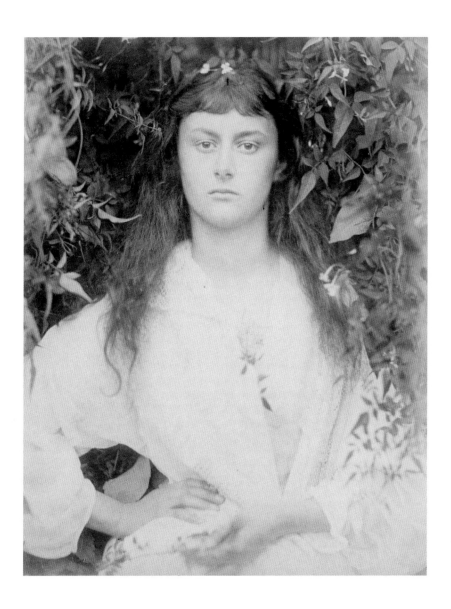

Pomona (Portrait of Alice Liddell), by Julia Margaret Cameron, 1872

6. Capturing Janey

It was not the wandering armadillos, the kangaroos, the intermittently braying jackass, the Brahma bull (acquired because its huge eyes reminded Gabriel of Her), the two wombats, the cawing raven, the tunnelling woodchuck which laid waste to the lupins of riverside Chelsea, or the perpetually escaping raccoon which infuriated the neighbours on Cheyne Walk. No, the straw that broke the camel's back (and there was talk that Rossetti might be getting one of those, too) were the bloody peacocks: shrieking and carrying on whenever they pleased as if there were murder or something indecent happening at number 16; which, for all the neighbours knew, was probably the case. They were God's little joke, the peacocks, so iridescently beautiful that they had to be equipped with a sound like a Wapping fishwife at throwing-out time. Naturally, their screaming only endeared them still more to Rossetti, who was a bit of a strutter himself. The wombats were his babies. When one snuggled its damp snout into John Ruskin's waistcoat while he affected not to notice, continuing to talk of how they must remake universal brotherhood, Gabriel thought he was in heaven, or at least Eden. When one of them died in September 1869 he drew a comic image of himself weeping by an urn.

Into this Noahide backyard in July 1865, taking care not to tread on the dormice or the slithering salamander, stepped the tall figure of Jane Morris in her flowing gown. She had come to be photographed by the camera of John Robert Parsons, though it was Rossetti who was directing exactly how this was to be done, which was emphatically not in the style of bridal pictures but as high Romantic art. A marquee of the kind erected for the many parties at Tudor House had been put up in the garden. There was a Japanese screen, a wicker armchair and a couch on which Jane might lie, especially when her chronically troublesome back pained her. She was wearing the loose-fitting, uncorseted, long silken dress of the kind she wore when she sat to Rossetti's

paintings, often made by herself. The heavy waves of dark hair were parted in the middle and fell all the way to her thick brows, while the summarily brushed locks rose rather than rested on the nape of her neck as if touched by sensual electricity. Rossetti made sure that Parsons caught her in profile, showing off to most dramatic effect her strong nose and unsmiling Cupid's bow mouth, the upper lip full and arched. That day in high summer 1865 Jane Morris was the most magnificent of all the animals in his collection. It was just as well he had the perfect pretext constantly to stare at her; adjust her hair and her dress with the brush of his fingers.

Rossetti had first set eyes on Jane Burden in Oxford eight years before, in 1857. He had already made a name for himself as poet and painter; the loudest and most uncontained of the group that had, since 1848, called itself the Pre-Raphaelite Brotherhood. The son of an Italian political refugee who taught the language at King's College London, Rossetti showed enough early talent to be enrolled at the Royal Academy drawing schools, but its academic discipline left him cold. In the chronicle of their dawning it was an encounter with the hauntingly awkward engravings of the late-Gothic frescoes of Benozzo Gozzoli which convinced Rossetti, as well as his friends William Holman Hunt and John Everett Millais, that what they characterized as the glossy 'self-parading' polish of High Renaissance painting had eclipsed an innocent devotion to the truths of nature (their professed god). This over-varnished inauthenticity lived on, they thought, in the vulgarities of Victorian paintings and in the arid classicism embalmed in the teachings of the Academy's first president, 'Sir Sloshua' Reynolds; the butt of their ridicule. In its place the Pre-Raphaelite Brotherhood sought to recover through purity of colour, unaffectedness of design and truth to nature what had been long lost. Giotto and Gozzoli would live again in the London of the horse-trams. Ruskin, who himself believed that the Renaissance had ruined truth and beauty, loved their flamboyant passion and wrote in support.

In 1857 they accepted a commission to paint murals for the Oxford Union chamber. Rossetti's choice of subject was Malory's *Morte*

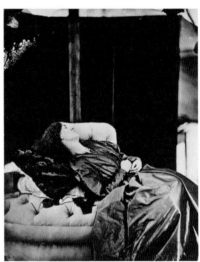

Jane Morris, by John Robert Parsons, 1865

d'Arthur: almost as much a holy scripture for the Brotherhood as the Bible or the painter's namesake Dante. Rossetti himself was most interested in painting the tragic passion of Lancelot for the Queen; the moment, in fact, when he was discovered in her chamber. At the theatre with Ned Burne-Jones, he saw the young woman who had to be his Guinevere. Jane Burden was seventeen, the daughter of a stable-groom, poor and uneducated; in other words, exactly how Rossetti – and most of the Brotherhood – liked their 'stunners': beautiful in their obliviousness to the pretensions of the middle class; soft wax waiting to be moulded by the apostles of the Natural.

It didn't always go according to plan. Lizzie Siddal, Rossetti's first great passion, for many years chafed at being model and educational project. Storms, increasingly violent, broke over them. The opiate laudanum quieted her torn-up lungs and her distress, but living together became a mutual torment. In 1857 Lizzie had gone north, so Rossetti was free to project the heat of his Arthurian fantasies on dark Jane. While he frolicked and raved, she remained quietly enigmatic, which provoked him further. But there was competition from the younger, bearded enthusiast William Morris – wealthy enough from the family copper mines to be aspiring poet, painter, designer and, eventually, socialist. As an undergraduate he and Burne-Jones had fallen for the gospel preached by Augustus Welby Pugin, Carlyle and Ruskin, which imagined the Perpendicular England of the thirteenth century as a lost time of Christian community and beauty. If industrial England was to be saved from the brutality of the machine age, the spirit and practice of its craft had to return.

This was lute and sackbut to Rossetti's ears. From 1856, Morris and Burne-Jones shared lodgings in Red Lion Square in London, where Morris made his first designs for the house-beautiful – furniture, wallpaper, tapestries – with Burne-Jones specializing in the stained glass of which he would stay a graceful master. Morris looked at Jane Burden and saw the person who was destined to share this remade medievalism. She looked at his big, generous, whiskery-frisky self and saw protection, a future. They were married in 1859. Algernon Swinburne

wrote, 'the idea of marrying her is insane. To kiss her feet is the utmost man should think of doing.'

He may have been right. Those who fell for Jane could not help *doing* things for her as a way of fully possessing her, or at least inhabiting a life with her; and the more they did, the more enigmatic she became: floating about in the long gowns which pleased them; wincing occasionally when her treacherous back hurt; arranging herself decoratively on the couch. The way she carried herself, unencumbered by hoops and stays, the dresses flowing with her limbs along with the intense gaze coming from the grey eyes, mesmerized everyone. It was the living Janey who was the work of art. Morris flung himself into creating their model house: designed and built at Bexleyheath, ten miles into Kent from London. It would, he thought, be an easy commute to Red Lion Square, where the 'Firm', including Rossetti and Burne-Jones, had established themselves to design and make – using artisanal techniques – their perfect decor for house and home.

Love was not wholly absent, even though, much later, Jane said she had never really loved her husband. Two girls were born. Morris wanted the Red House to become itself an ideal community, but the commute was taking four hours a day and Burne-Jones grimaced at the thought of leaving London for good. They sold up and moved to Queen Square. Morris might have rented out the Red House so that one day he could return, but was too saddened by the uprooting to face ever seeing it again. In London they saw more of Dante Gabriel Rossetti, who made little secret of how he felt about Jane.

By the time of the photographs in the garden of Tudor House, Rossetti had been a widower for three years. He had finally married Lizzie, only for her to suffer a stillbirth, which led to a mental collapse. All that helped was laudanum. In 1862 she took enough to kill herself. Horrified and distracted with guilt, Rossetti threw the manuscript copy of his most recent poems into her coffin to be buried with Lizzie. He would come to regret the extravagant gesture. In 1869 he decided to have the coffin opened to retrieve the poems. To those aghast at this literary exhumation, he claimed Lizzie herself would have

'approved of my doing this. Art was the only thing for which she felt seriously. Had it been possible to her I should have found the book on my pillow the night she was buried; and could she have opened the grave no other hand would have been needed.'

It wasn't money which made Rossetti perform this act of selfish desecration. He was making plenty: two thousand pounds in one year, more than enough for him to take Tudor House in a Chelsea which was not yet smart. He stuffed it with beautiful things and with a mass of antiques and porcelain acquired while trawling the stalls of Hammersmith and Leicester Square. Chinoiserie abounded. Some rooms were packed with mirrors; others with Delft tiles and brass chandeliers. Pictures banged into each other on the crowded walls. It was madhouse and funhouse. Whistler and Swinburne were close by. Fanny Cornforth, voluptuous, golden-haired, deliciously dirty-mouthed, moved in as model and warm company in the big oak four-poster hung with heavy green velvet. Let the dull neighbours be scandalized; who cared? Rossetti was painting a succession of women, some of them models he charmed into sitting when he encountered them in the street, like the gorgeous Alexa Wilding. Poetry would fall from his lips; his dark eyes locked on to theirs and he laughed like Mephistopheles. It was hard to say no. He painted these women in hotly sensual colours, crowding the picture space so completely that their bewitching faces and generous bodies were pressed to the greedy gaze of the beholder. There was drapery, greenery, pierced fruit, peaches and pomegranates; flowers which were shedding petals and tight buds beginning to open. With every tiny, curling, scarlet tongue of a honeysuckle blossom, Dante Rossetti perfected these visual seductions and called them poetry, art, the enchantment of the senses. Despite all the doctoral theses, it's essentially Victorian soft porn, but the most beautiful soft porn that has ever been realized in paint.

Janey, as everyone now called her, was different: dark where they were golden-haired; silent while they were raucous and gigglesome; gracefully elongated while they were roundly buxom. Morris was not an idiot. But he was also principled in his conviction that true

marriages should never be bound by constraints. So he put up with Rossetti's many visits and let Janey go and sit for a series of drawings, each one the mark of deep, unshakeable adoration; love letters in soft black chalk.

In the garden that afternoon in high summer 1865, Janey stood, lay down, sat, leaned forward; all with the identical expression of inwardly resigned, cow-eyed secret sorrow that aroused Rossetti so intensely. Off and on went the lens cap of John Robert Parsons; off and on. Gabriel took the photographs and drawings as studies for a great painting he would make of her in the lustrous blue silk dress she had made, probably at his suggestion. It would take him three more years to finish and, even then, with good reason, he was not wholly satisfied with it, knowing that he had worked her face in particular until it looked oddly cosmetic and waxen, with none of the graceful looseness of his drawings. But whatever its shortcomings, *The Blue Silk Dress* served as a kind of notice that, if her person was not Rossetti's, her picture was. He knew what an impression she made on visitors like Henry James, who described her as a:

> figure cut out of a missal . . . an apparition of fearful and wonderful intensity . . . a tall lean woman in a long dress of some dead purple stuff, guiltless of hoops (or of anything else, I should say), a maze of crisp black hair heaped in great wavy projections on each of her temples . . . a thin pale face, great thick black oblique brows joined in the middle . . . a long neck without any collar . . . *in fine* complete.

And now he, Rossetti, was the maker and keeper of this vision, and he was shameless enough to say this in a Latin inscription painted on the top of *The Blue Silk Dress*. Making a disingenuous nod to her marriage, it declared Jane 'famous for her poet husband; most famous for her face; finally let her be famous for my picture'.

However impassive the mask Jane showed to the rest of the world, Rossetti knew she was not indifferent; so did the increasingly

tormented Morris. She came to Cheyne Walk, sittings or not. She and Rossetti shared complaints: her back; his eyesight, which had started to give him trouble; headaches, of course, on both sides; heartaches evidently, too. Partings, even for a few days, became painful. And notwithstanding the *Blue Dress* picture, try as he might, the painter-poet still could not contrive a picture remotely adequate to the fierce acuteness of his gaze and the force of his desire. In January 1870 he wrote as much to her:

Dearest Janey

. . . the sight of you going down the dark steps to the cab all alone has plagued me ever since – you looked so lonely. I hope you got home safe & well. Now everything will be dark for me till I can see you again. It puts me in a rage to think that I should have been so knocked up all yesterday as to be such dreadfully dull company. Why should it happen when you were here? . . . How nice it would be if I could feel sure I had painted you once for all so as to let the world know what you were; but every new thing I do from you is a disappointment, and it is only at some odd moment when I cannot set about it that I see by a flash the way it ought to be done. Such are all my efforts. If I had had you always with me through life it would somehow have got accomplished. For the last two years I have felt distinctly the clearing away of the chilling numbness that surrounded me in the utter want of you; but since then other obstacles have kept steadily on the increase, and it comes too late.

Your most affectionate Gabriel

Did those 'obstacles' include the inconvenient husband? Rossetti was painting stories of unhappy unions: *La Pia de' Tolomei* featured Jane as the wife unjustly accused and locked in a tower in the Tuscan Maremma, where she died of poison; in *Mariana* she is depicted as the character in *Measure for Measure* betrothed to and abandoned by the sanctimonious sexual hypocrite Angelo.

Yet, however distressed Morris was by the obviousness of Rossetti's infatuation, he never thought of bringing things to a crisis and forbidding him her company, since he knew that would further alienate his wife. An alternative was to disappear himself, and this he did in the summer of 1871, all the way to Iceland, where he set about translating *Njál's Saga*. There seemed no bottom to William Morris's put-upon good nature. Before he departed for the landscape of treeless black lava beds and geysers, he and Rossetti went in search of a country house to rent for this and, perhaps, succeeding summers. They found what they were looking for in a miraculously unspoiled Elizabethan manor house at Kelmscott, near the headwaters of the Thames on the Oxfordshire–Gloucestershire border. Rossetti described it as an earthly paradise, and so it was and still is. There were seventeenth-century tapestries *in situ*; a walled garden; a parliament of rooks (also still there); an outdoor privy for three (convenient, in the circumstances); and no close neighbours peering in to confirm the scandalous gossip. Rossetti brought two of the antique Chinese lacquer cabinets he had been collecting and collared the perfect north-facing studio space, where he installed his bed. Morris's unoccupied bedroom adjoined his and, beyond it, Janey's room. On the ground floor there was a modest dining room and a living room with a hearth of Dutch tiles installed by Janey and supplied by the Firm.

We will never know for sure whether, once the little Morris daughters were asleep, Janey or Gabriel walked through William's room, separating them, and joined their bodies. Whatever happened or didn't happen, Rossetti was content, playing with the girls, making lovely sketches of them, walking together down to the willow-hung river; writing his sonnets in a sun-dazed trance of love. Some of them are so heavy with sexual pleasure that it is difficult to believe Rossetti was writing from wishfulness.

> *Even such their path, whose bodies lean unto*
> *Each other's visible sweetness amorously, –*
> *Whose passionate hearts lean by Love's high decree*

Together on his heart for ever true,
As the cloud-foaming firmamental blue
Rests on the blue line of a foamless sea.

When summer ended, so did the idyll. Morris came back from Iceland loaded with runic gifts for the girls. Now, at night, the missing husband and father lay literally between Gabriel and Janey's rooms. *The House of Life*, the sequence of sonnets Rossetti had written as a hymn to their passion, was ridiculed by one particularly vicious critic, who sneered at him as the founder of the 'fleshly School of poetry'; work that was indecent when it was not ridiculous. Rossetti took it badly, had a paranoid breakdown, reached for the chloral hydrate, was taken to Scotland to avoid commitment to a lunatic asylum. There, devoted friends did what they could to restore his sanity and calm. In London, in the garden of Tudor House, the animals were behaving badly. The young kangaroo had eaten its mother; the raven had bitten off the head of Jessie the owl; the armadillos were falling prey to prussic acid laid on as bait for them in the next-door garden; and a deerhound had torn another dog to pieces. Probably none of the beasts was being adequately cared for. His friends saw the menagerie as an amusement for Rossetti, who, whatever the neglect, expected the animals to perform entertainingly for guests. He tried coming back to Kelmscott, but the summer of 1871 was never to be recaptured. He mooched and brooded, and alternated between chloral hydrate for his insomnia and whisky to cut its bitter taste. The drug put him down and the booze woke him up. By 1874 it had become unendurable. Rossetti marched out from Kelmscott, never to return, leaving behind the Chinese lacquer cabinets, which are still there. Two years later Jane decided she would see him no more. In her absence, stricken by the loss, Rosetti found release for his desperation in the form of a succession of great, strange paintings.

His creative imagination returned to Italy, the land of his ancestry, and to Michelangelo in particular; the old mannerist Michelangelo whose figures stare and brood, turn their elongated limbs about the

pictured space. There was something about Jane's face, almost androgynous, that put Rossetti in mind of Michelangelo's prisoners struggling to get loose from their bed of stone. He painted her in entrapment: the many Proserpines doomed to imprisonment in Hades after nibbling a single pomegranate seed, the fruit painted by Rossetti with tormented vividness, the gem-like seeds lying in their split casing. The paintings were accompanied always by sonnets spelling out her mournful predicament, the daylight of the earth remote in the background. Then there was Janey lost in a daydream halfway up an entangling tree, her book forgotten, a wilted honeysuckle bloom in her lap. In *Astarte Syriaca*, Aphrodite's archaic predecessor, she is turned frontally to the beholder, eyes bigger, mouth fuller than ever, the green gown much closer than usual to the lines of her breasts and thighs, as though Rossetti was painting to remember; at once more physically present and more remote than ever.

In the last years, the alternation between chloral hydrate and whisky became extreme. Rossetti's kidneys were half destroyed and he was in a lot of pain. By the end of the 1870s he could barely walk. Tudor House was in disarray; the back-garden zoo emptied; friends sighed when they felt they should go and see him. There were days when he lay in bed staring at the blue vases filled to the brim with peacock feathers. In the summer of their delight he had painted Janey in a format small enough to fit a particular 'beautiful old frame I have'. Her head is tilted on the long swan neck; the eyes are impossibly large, the lips impossibly full; behind her are the silvery stream, a gentle swelling hill and the gables of the house: Rossetti's house of life. Rossetti sold it, but Jane had a good copy made. Morris's daughter May inherited the care of Kelmscott and kept it there; you can see still see it in Janey's bedroom, where every day she would be confronted by the look of her own inconsolable wistfulness.

Water Willow, by Dante Gabriel Rossetti, 1871

7. Francis and George

1963. Man, thirty-odd, walks into a pub. He's wearing a cocky expression and a dab too much brilliantine; bit of a pompadour and his eyebrows look like two caterpillars are having a conversation on his forehead. But the Stepney spiv style is all right. London has barely begun to swing, Carnaby Street still has traffic running through it, and Soho means looking sharp the old way: big lapels, broad shoulders, clean-shaven with a bit of a curl to the lip; tight knot to the tie. George Dyer has all this. He's done a little time in the nick so he knows what's what, and he knows that a man who also likes a little grease on his mop is giving him the once-over.

Francis Bacon fancies what he sees over the rim of his pint. He could see the boy behind the swagger. That sort of boy would be nice, a change from some of the rougher stuff, the roughest of all being ex-fighter pilot Peter Lacy, who ran out of people to torture, especially Francis, so decamped to Tangier, where he killed himself. Bacon was not over Peter, never would be really, but this flash boy leaning on the bar could be something. One of them goes over to the other (history is not clear which) and starts it. It would indeed be something, and then it would end badly.

Bacon never stopped thinking about bodies, the pleasure and pain of them, the twist and tangle, grip and release; faces, too, sometimes; faces you could chew up and spit out, including the one he saw in the mirror when he shaved. Use the brush like a razor: slash and scoop. The most ridiculous thing about portraits was the stillness; the result of all those sittings and the relentless transcription of features. Bacon didn't do sittings; he worked from photographs, which had a better chance of documenting vitality. And he didn't do anyone he didn't know and know well. The assumption had always been that you needed sittings to capture likeness. But the literal trace was a piss-poor definition of likeness; a shorthand map of a face and body. Writers

about portraits had always gone on about the necessity of capturing the essence of someone, assuming that it was written on the appearance. Bacon was sure it could not, and what he was after was what he called the 'pulsation' of a person, their aura, the effect they had on you when they came into a room. It was a kind of emanation; something that issued from within, like a secretion. What he liked about George was not the assembly of features that made up the mug (though he was fond of the jaw and the curving nose); what he liked was the inside of him and the way that pressed against the outside; the whole slithery jumble of a person. You didn't get that from a sitting; not that kind of sitting anyway. You needed to slam into the character.

Bacon had come to painting, his instincts uncompromised by any formal training; no life classes for him. But he had perfect touch as a draughtsman; just not the kind they drilled into you in the art schools. He understood modelling, plane, space, the mass and volume of bodies, the play and splay of muscle and limb and the way they could be disarticulated as well as articulated; the way, in fact, one could be inferred from the other. This he had got, in the first instance in 1927 in Paris, when at the Rosenberg gallery he saw one of Picasso's startling deconstructions of the nude. He stood there in a moment of illumination and decided he had better try to be a painter. The body, he quickly grasped, was a theatre, often of pain and cruelty, without which he thought there could be no deep engagement; one kind of penetration was necessary for the other; for an intimacy of understanding. The trick was how to reproduce the sensation of that inside-outness without losing recognizable form altogether. So he let impulse take over. He would stare at photographs of the models (or of himself), sometimes beat them up a bit, cut off a corner, tear off bits of the surface with masking tape, concentrate on the image until a sense of the body – often in motion – would come to him; then he would set about it with a loaded brush; sometimes different colours in the same stroke; working off a recognizable line – the chin, the nose, a leg, an arm – but never letting anything settle or resolve; everything in a state of becoming; everything open and provisional: the brush swooping and looping;

Francis Bacon and Muriel Belcher, by Peter Stark, 1975

turning and pasting. Occasionally he'd throw gobs of white paint at the image, a whiplash hurl like ejaculate. It was like a good fight or a fuck, a spilling of the guts; and the thing was to catch it in the middle before it was just a mess.

George moved in. Bacon had him photographed by their drinking friend John Deakin, who had worked for *Vogue*. Pretty quickly it became clear that George had a thing about the bottle, but then Bacon was no sobersides himself. The trouble was that, dropped into Bacon's world of tough, clever friends, gay and not, Lucian Freud and Isabel Rawsthorne, he felt all at sea and needed a tot to buck him up. Bacon began by being touched at George's insecurity, until he became irritatingly dependent; a perpetually wet-nosed puppy hanging on his trouser leg. But the paintings of George were as he wanted, sensational and almost never stock-still: *George Talking* had him spinning naked on an office stool; a triptych, the form Bacon was experimenting with, had him perched on trapeze-like bars or wires, swinging in indeterminate space. The will o' the wisp of nailing a figure just so was obviated by making portraits that sought to embody instability, movement, mutation; flesh itself in some sort of process of decomposition and reconstruction; wounds that leaked and then coagulated; openings that gaped and then half closed; shadows and substance, reflections and solid presences, all of which melted into one another. Nothing quite like it had ever been seen before.

Even the French, who had passed when offered a retrospective from the Tate in 1966, came to recognize this. Bacon was accorded the honour of a big one-man show at the Grand Palais. Only Picasso, among living artists, had been given the like. It was to open in October 1971. George asked to go with Bacon. But his drinking had become non-stop, sometimes washing down pills into the bargain, and it had all become unsexy for Bacon, who had had enough: 'There had been nothing between us for ages. But since so many of the paintings were of him I could hardly say no.' Bacon insisted on a condition: that Dyer commit himself to drying out with the help of a specialist in booze addiction. Dyer said yes, tried it out and of course relapsed.

The two of them were booked into the Hôtel des Saints-Pères. Bacon had full days and was more occupied with the hang. Neglected, as he thought, George flew off the handle in drunken rages, brought an Arab boy back for their pleasure, which made everything worse; they came to blows; guests complained. It couldn't go on, and after they got back to London Bacon decided it wouldn't.

It was when he was at the Grand Palais on 24 October worrying over the final installation and paintings that somehow had still not arrived that he was told by the hotel manager that his friend had killed himself. George's room was a pit of miserable horror: pills and bottles everywhere. There had been times when George had told Francis he would do this, but it had been just another round of emotional blackmail. And even this time, George had apparently panicked after a massive dose of barbiturates sluiced down with alcohol, the pills which Bacon kept carefully hidden sought out and used. Dyer had tried to vomit up his death sentence but couldn't do it, and he died sitting on the loo, terminally pathetic.

Bacon went ahead with everything as planned, showing President Georges Pompidou, famously a connoisseur of contemporary art, around the show, doing interviews for the BBC and *L'Express*. It was only a little while later that he sank into an agony of remorse. He sat at La Coupole in Montparnasse, with the kindly David Hockney, who had come over to see what he could do, confessing his weight of guilt. If only he had not gone to the show that night George would 'be here now but I didn't and he's dead. I've had the most disastrous life in that kind of way. Everybody I've ever been fond of has died . . . they're always drunks or suicides. I don't know why I seem to attract that kind of person. There it is. There's nothing you can do about it.'

'Nothing will make him come back,' Bacon reiterated. But a version of him could be brought back. When the funeral, packed with a crowd of weeping East Enders, was over, he got to work on the first of a number of memorial triptychs. Though he said that making a picture of a dead person was a futile exercise, that there never could be a

recovery, what else was he to do? It was a way of making his own grief and self-accusation material. In the left panel, Dyer's body is a tangled confusion of writhing limbs, his head upturned as if after a fall; on the right, there are two Georges, one laid out on a morgue-like square table. From George's head issues a spill of black which also reads as a pedestal support for the slab-like table top, while the profile of George, a gash of white from brow to cheek, is embedded in a tombstone. In the centre, a shadow George, a bloodied arm poised on the keyhole of a door, turns towards a flight of steps illuminated by a single naked bulb; the ascent from one existence to the beckoning dark.

Bacon needed to make the triptych, but it has the narrative quality he always said he avoided. The second triptych, stripped down and bare, is, on the other hand, overwhelmingly moving in its sculptural simplicity, not least because each of the two side panels is, for once, quite still, while the central one contains just the bucking heap of their love-making; thighs and shoulders readable but not the heads, pressed into each other, another of the thrown white whiplashes a convulsion crowned with slick black hair. To the left, Dyer sits in profile, as statuesque as a classical figure of the kind Bacon had avoided all his life, eyes closed as if in meditation, his torso cut away, filled not with innards but the flat black background, as though pieces of him are disappearing bit by bit.

Don't go. Don't disappear.

On a chair in the right panel the figure, his life leaking out in a pink pool of paint, as it does in the other two pictures, sits slumped, eyes closed again, hands at the groin of his Y-fronts. Opinion divides as to whether this is once more George or possibly Bacon himself; and that division of view is itself a calculated Baconian ambiguity. Reality is not the skin of appearance. The reality is the melting together of the two of them at this moment of mortal memory.

On the evening we were filming the painting, I was struck for the first time by something so obvious I hadn't noticed it before. Bacon was a great, sly manipulator of planes, and the wedge-shaped diagonals at the bottom of each of the right and left wings can be read simply as

one of his indeterminate abysses over which the sweated figures are perched as if on a precarious platform. But they also convey the sense of the panels as swinging, hinged doors, as was the case with the medieval triptychs Bacon liked; in which case each of them could close on the central panel of two bodies forever thrashing into each other, on and on until the very end.

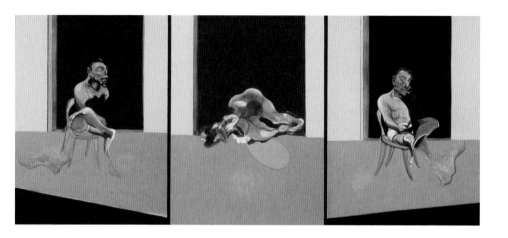

Triptych – August 1972, by Francis Bacon, 1972

8. *Julia*

Don't go. Don't die.

Five hours later he was dead. This made the photo Annie Leibovitz had taken for *Rolling Stone* bear a weight of poignancy she could not possibly have anticipated but which now seemed fatefully indispensable, as if Leibovitz were some sort of sibyl. What is unbearable, of course, is Lennon's nakedness, the vulnerability of it even as he hooks his arm about Yoko's head and plants a tender kiss on the soft swell of her cheek; the kind of kiss which stays put. The digital world did not yet exist. Jann Wenner would have to wait a day to see the picture, by which time it had already become a memorial icon. After the photographer, the next people to have seen John's body would have been the police, the forensics, and then the morticians who would have inspected it pierced and torn by the bullets of the fan, Chapman.

Leibovitz had wanted both of them undressed and expected them to agree. Nude Yoko and John, back and front, had appeared as the cover of their album *Two Virgins*, rock's Adam and Eve in all their primal innocence; throwing back their love in the teeth of all those who hated her, if not both of them, for the unpardonable sin of what they saw as Breaking Up The Beatles, the ultimate family crack-up. That Yoko did not conform to the kind of looker for whom they could, at least, *understand* John abandoning the family, that she was a Japanese performance artist, just made it worse. It was as if the couple should have asked permission from the great British public, from the world.

So John and Yoko love-bombed back. Just hide your love away was not an option since the press ferrets would always chase them down even the deepest burrow. They took their love public; made it a cause; invited everyone to the Amsterdam bed-in and smiled at the disappointment of those who expected a sex scene and instead got a happily married couple blinking amiably from under the sheets. The

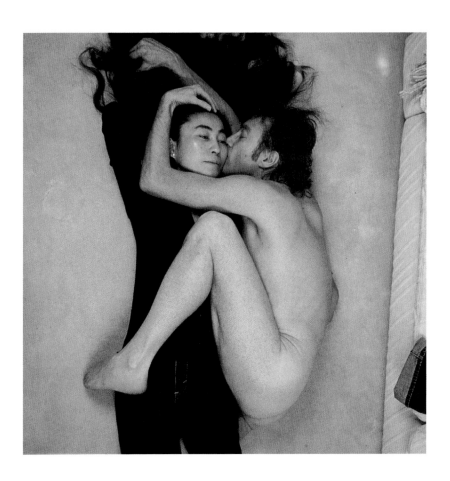

Yoko Ono and John Lennon, by Annie Leibovitz, 1980

idea was to shame the snarlers and sneerers and to convert that sheepishness into the love crusade that would save the world. Just give it a chance. All you need.

Looking at the photograph, more than one person, some at the magazine, noticed John's foetal curl. The top shot could be read from above the way Leibovitz shot it, or almost as if John were climbing up and into Yoko, who then became not just wife and lover but, unmistakably, mother, too. Lying with his legs curled over her, eyes closed, he felt safe at last; he felt he was home.

And he could finally forget two abandonments by the same person, by Julia, his actual mother.

The first time was when she handed him over or was, in her telling, *made* to hand John over to her older sister, Mimi. The Stanley girls all agreed that Julia had always been a handful: beautiful and smart as a whip but apt to treat life as one long jitterbug. The merchant seaman Alf Lennon was always off somewhere, war or not, and when he told her one time to get out and be happy she took the chance and the result was Victoria, made with a Welsh soldier, Williams, who had no intention of sticking around. Then there was John 'Bobby' Dykins, the spiv with his pencil-thin moustache and slicked-down hair and an easy grin; she couldn't resist him either and stuck her tongue out at talk of 'living in sin'. Two more girls arrived; she was a one, that Julia. But she couldn't cope, or was told she couldn't cope, so the little bundle of John went to his Aunt Mimi and Uncle George at the terrace called Mendips, where he had the bedroom over the front door looking on to Menlove Avenue.

For which he was duly, truly, thankful. But Mum was Mum and no mistake. And since everyone lived more or less on top of each other, he was always going round to see Julia and she popping in to see him. She sang and danced for and with him, eyes bright with mischief, kidded around with the kid, and to Mimi's horror bought him the guitar he had his heart set on. When he struggled with the chords she helped him learn them first on the banjo and the ukelele. One day she put a record on the radiogram and a deep, dark voice vibrated against

the speaker cover like nothing John had heard. 'Elvis,' Julia said, 'it's Elvis.'

Despite all the comings and goings, Mimi and Julia seldom fell out. As the years went by, if anything, they became closer. Julia would pop round for a cuppa and a slice of cake, crack a joke with John. There was an evening in July 1958 when he wasn't there. The sisters stood chatting in the scrap of a front garden as the light faded. Julia strolled up the street towards the bus stop with Nigel Walley, the tea-chest picker for the Quarrymen skiffle group. As she was crossing the street she was hit by a learner driver who was also an off-duty policeman. Walley heard a terrible thud, turned to see her body rise high in the air before falling to the ground.

John had to have someone to blame, so he blamed Nigel the tea-chest strummer. It wasn't enough. He picked fights whenever he could; got blind drunk more than he should. A red demon of unassuageable fury took up residence somewhere deep within him. Twice she had left him; twice.

Paul's mum, Mary, had gone, too, when he was fourteen, dying of the breast cancer no one could name to the boy. The motherless boys bonded. On the tenth anniversary of her death they wrote 'Julia', the only song of intense love, loss and longing on *The White Album*. But until he met Yoko he felt somehow homeless. Apple was not home. The Beatles were not home. She could see the red demon deep inside, listened to him and sent him to someone who told him to scream. They screamed together. *Waaaooooo.*

Every so often he would let it out, sometimes in the songs. Especially in 'Mother':

> *Mother, you had me, but I never had you*
> *I wanted you, you didn't want me*
> *So I, I just gotta tell you*
> *Goodbye, goodbye.*

Poor Julia. It was unfair and untrue, but then John could remember his seventeen-year-old orphan self screaming it was unfair. The end

of the song is a chorus, repeated over and over and, with each repetition, John's scream gets louder and louder. But when the screaming is all out of him he would go home to Yoko, to the home that was Yoko, and he can stop singing.

> *Mamma, don't go*
> *Daddy, come home.*
> *Mamma, don't go*
> *Daddy, come home.*
> *Mamma, don't go*
> *Daddy, come home . . .*

Julia Stanley, by Mark and Colleen Hayward, 1949

III
The Face of Fame

1. *Trouble*

Cramped and cropped, the space Marlene Dumas has given *Amy-Blue* seems claustrophobically tight for the woman it memorializes, not even room for the towering beehive, taller than the rest of her. The dimensions of the sketchy little portrait are uncharacteristically modest for Dumas, who specializes in tragic expansiveness. But that's the point of course: the confining format into which the subject is stuffed only amplifies the break-out of her voice, which was, from the beginning, when she belted out jazz and swing numbers with such smoking power that it engulfed the bands trying to accompany her, gloriously excessive. Inches were the only things that Amy Winehouse was short of; that, plus any sense of how to stay alive for a decent while. Everything else – the livid gash of a mouth, the wickedly flashing eyes dramatized by the bird's-wing eyeliner, the sheer lung-power on her, the sleeves of tattoos – was all outsize. I saw her up close once, in an unswanky Marylebone fish restaurant: white T-shirt, trainers, a tiny thing with a dirty laugh that turned heads and made the Dover sole curl on its bone. Her entourage was hardly worth the name, fitting as it did around a small corner table where they stabbed merrily at the chips. Amy chirped at the waiters, who couldn't do enough for her, and no wonder, since she treated them as if they were old friends, making sure to thank the manager and ask about his family before skipping out of the door, leaving a gust of glee behind her. Was that really *her?* everyone was saying. The foul-mouthed drunk had not shown up that night; just a breezy little bird having some time off from the paparazzi. When she was gone I was suddenly reminded of all those other nice Jewish girl pop singers with the sexy voices – deep and earthy – who had gone before her: Alma Cogan (née Cohen) with the 'giggle in her voice', who for a while was John Lennon's Yiddishe mama/lover, before ovarian cancer sank her; Helen Shapiro, translated from Bethnal Green to Hendon, who at sixteen had been the headliner

while the Beatles supplied the warm-up. Though she never saw or heard the song, it was for chocolate-voiced Helen that Paul and John wrote 'Misery'.

Marlene Dumas's picture is a post-mortem painting, a death mask with the eyes wide open, the expression taken from a photograph so that Amy's mouth might be read as if performing one of the dark, self-knowing songs that made her famous. More melodramatically, the ink-blue-stained image might be the other Amy: slack-jawed and helpless, snared in the trap of her addictions. Amy's self-destruction was hardly unique in her line of business, but it has been terrible when doing in monstrously original talents like Billie Holiday, Janis Joplin and Jimi Hendrix. With unnecessary faithfulness, Amy followed the Lady Day script to the bitter end, acting out on her own body the disasters of which she sang. Really, integrity doesn't have to be *that* blue. In the end game, Billie and Amy were so dissolved into their roles that they lost touch with embarrassment. The theatre of cruelty – the drunken stumbles; the wandering, gurgled doo-dum sounds that replaced the lyrics; the enabling boyfriend; the hopeless enslavement to the junk of the week (smack, blow, pills; you name it, I'll do it); *wot'ever* – all thrown in the face of horrified fans. Hey, what did you expect? 'They tried to make me go to rehab but I said, "No, no, no"/ Yes, I've been black but when I come back you'll know, know, know.'

After the crash, inevitably, some hack in search of a tabloid homily was going to lay the blame on Fame. You all know how that sad old routine goes. Everything came too soon: the celebrity, the money; she couldn't handle it; so many parasites feeding off her notoriety. Go on, Amy, do it again, I dare you; hold the pose; right, just like that; great, just great. She cast herself as Trouble because she knew the publicity hounds would eat it up and never mind if she turned into the dog's dinner while they were at it. So the reputation and the songs looped back on each other, mutually self-reinforcing: 'I said, "No, no, no"' – and the loop turned into a noose.

Are we all in it together, accomplices in the fame game? Do we *like* our heroes to smash themselves up? Is that the *idea*? They are created

because we crave larger-than-life figures; those who stand out from the crowd; who push the limits; achieve mighty things from daring greatly; not paying heed to the clucking voices of warning. What's the point of a cautious hero, after all? We especially like them when they sound and look like us, not some breathing version of a Greek statue; because we can then have a share in their glory, feel we are going along for the ride, even if we know when to get off while they go hurtling over the cliff, waving as they disappear.

Fame is a two-way game. It's wired for tragedy because that's the way we want it, and we shiver at the oncoming wreck and ruin which cut the gods down to size. Giddy with the eulogies, the famous imagine themselves to be invulnerable, but they never are. The ancients who invented fame knew this. Proud Hector must be dragged by the heels behind the chariot of Achilles, who in turn will be pierced at his vulnerable heel. Alexander can conquer the known world and yet die a miserable death somewhere in the Asian wastes; Caesar might fancy himself but an inch away from divinity or at least kingship, yet the invincible would sink, choking in his blood, while his familiars, his assassins, carry on lunging away until the shuddering ends.

Moral: don't go to bed with Fame because you might wake up dead.

2. *Dragon's Breath*

In the spring of 1588, Sir Francis Walsingham, Queen Elizabeth's Secretary of State, spymaster and resolute enemy of Spain, received a letter from his agent in Venice, Stephen Powle, about a painting apparently causing a stir in Ferrara.

> Sir F. Drake's picture was brought to Ferrara by a gentleman that came out of France this last week, which being given to a painter to refresh, because the colours thereof were faded in the carriage, was so earnestly sought after to be seen that in one day's keeping the same, the picturer made more profit by the great resort from all places to behold it than if he had made it anew. About it were written these words – *Il Drago, quel gran corsaro Inglese* [The Dragon, the great English pirate].

Why would crowds have gathered and paid good money to see a picture of an English pirate-adventurer in the city where art meant Giovanni Bellini's *Feast of the Gods*, completed by Titian, or the beautiful pictorial conundrums of Dosso Dossi? And why would Walsingham have been interested in this little scrap of intelligence about a travelling portrait of *Il Drago*, England's fire-breathing terror of the seas? Doubtless the scene painted by Powle would have entertained him: those Ferrarese thronging to catch a glimpse of the likeness of Drake as it was being retouched. He may have allowed himself a moment of smirking self-congratulation that his dangerous creature had become the object of a cult of excitement abroad. But it was the propaganda value of the image that would have pleased him most.

By the spring of 1588, all-out war with Spain seemed a certainty. An armada of more than a hundred ships was being fitted to sail for Flanders, from where it would convey an invasion army to England. If it

succeeded, the heretic Queen would be dealt with and the country restored to its proper obedience to Rome. Philip II, King of Spain, had, after all, been the husband of Elizabeth's Catholic half-sister, Mary, and thus King of England himself. He owed it to his dead wife's memory, as well as to God, to accomplish this mission. And now he was on the brink of success.

To anyone less resolute than Walsingham or the other Protestant militant in the council, the Earl of Leicester, the immediate outlook would have been discouraging. The Duke of Parma had reconquered Flanders. William the Silent had been assassinated four years earlier, depriving the Dutch revolt of its precious, indispensable leader. England was alone, isolated; militarily outmatched. France, divided between Catholic and Protestant confessions, held back. Henri III was not a Spanish ally but he was not to be trusted either. No one spoke any longer of the Queen marrying the King's brother, the Duc d'Alençon, and the King was busy appeasing the Catholic League by revoking rights he had previously granted the Protestant Huguenots. The best that might be expected from him was Machiavellian neutrality. So it would have interested Walsingham to hear that Drake's portrait had been circulating in France. He might have taken heart from learning that such was Drake's popularity, the King had had copies made for courtiers clamouring to have one for themselves.

Drake's increasingly familiar face had thus become a touchstone of allegiance, both in England and beyond. This did not necessarily mean sympathy. There was something about Drake which fascinated the very people he had outraged. It had been his enemies the Spanish whose poems, ballads and plays had first broadcast his startling and violent deeds to the world.

In his twenties, Drake had been just another small-time West Country captain, commanding one of the ships in the slaving and raiding flotillas of his kinsman John Hawkins. But in 1568 he had been present at the catastrophe of San Juan de Ulúa, when Hawkins's flotilla, trapped by a bigger Spanish force at the Mexican port, had been

all but destroyed; the men massacred. To save his ship, the *Judith*, Drake had sailed away. The only other seaworthy ship, the *Minion*, had taken on hundreds of survivors but without the provisions necessary to make a safe run back to England. Her fate was dire. Half the men put ashore so that the other half might survive, but even then the remnant on board was reduced to eating rats and boiled leather. Those who tried to walk to the French Huguenot colony in Florida died on the endless march; the rest were taken by the Spanish, tortured, hanged or sent to slave in the galleys for the remainder of their days. Only the young boys survived, being carted off to monasteries to lead a life of penance and prayer as far from Devon as one could imagine.

Whether or not Drake felt misgivings about sailing off in the *Judith*, iron entered his soul after the calamity at San Juan de Ulúa. Raiding and robbing remained his principal vocation but, when the targets of opportunity were the shipping and colonies of the Spanish Atlantic empire, they counted as acts of war against a religious enemy. His father, Edmund, might have been the source of this doubled vocation: a scripture-reading criminal. An Edmund Drake was known as a sheep stealer who fled Devon for Kent. But there was also an Edmund Drake, possibly but not necessarily the same person, who became a Protestant preacher near the Medway; and Francis certainly liked to believe his father had been a fugitive from religious oppression. When the Spanish called him a *Luterano* – a Lutheran – they were not altogether wrong, since he took John Foxe's ferociously anti-Catholic *Book of Martyrs* with him on his expeditions, corresponded with its author and read psalms and sermons aboard, sometimes outdoing the chaplain. Whatever else he brought to his prodigious career, the element of holy war on the high seas was never very far away. Piety and piracy were mutually reinforcing.

Drake shared this conviction that the Reformation needed defending by ruthless boldness with Walsingham, who, on entering the Council of State in 1573, encouraged Drake to go rogue in the Caribbean. Taking Spanish treasure and prizes, incurring the enemy's fury, would help sabotage William Cecil's patient efforts to effect a

reconciliation between Spain and England. Walsingham was convinced that a peace policy with Spain was deluded so long as the Counter-Reformation was sworn to stamp out heretical regimes. Drake's appetite for mischief and loot was exactly what was called for to keep things usefully bellicose. His capture of a mule train loaded with silver, and a hit-and-run attack on Nombre de Dios, the Panama port from which treasure was shipped back to Spain in 1573, were outlier actions which could be used to pull the Queen away from Cecil's compromises. Elizabeth would put on her solemn, tut-tutting face and deplore the lawless provocation. In private, however, there would be the wink, the smile, the hand ready to accept baubles, and the ear to listen to Leicester and Walsingham when they told her Drake's exploits were depriving Spain of the means to wage war.

On the other side of the conflict, the Panama raids made Drake infamous in the Spanish Atlantic world. The suddenness of his armed men appearing in swift-moving boats; the fury of their attacks; Drake's own appearance: small, wiry, blue-eyed, a beard that was variously described as dark brown, red or even fair – all made him a legend to his foes. Thus materialized 'the great corsair', *El Draque* (in Latin, *draco*), the sea-dragon; born from some hellish realm, spewing fire and quite possibly aided by the occult arts. Sixteenth-century Spanish epic poems and ballads, heavy with chivalric fantasies, needed a dark knight as the enemy and made the most of what Drake gave them. This included stories – often true – of Drake treating the officers and grandees aboard his captured prizes with elaborate magnanimity: exchanging gifts, entertaining them at his table, returning slaves (especially female ones). When one nobleman begged Drake not to impound his extravagant and expensive wardrobe (for what is a grandee without silk?), Drake assured him that all his property would be returned, a courtesy he could generally afford, since he had already got his hands on the hard treasure. While Spanish verses and broadsides still depicted him as a heretic driven by the naked greed which one day would be his undoing, the strain of reluctant admiration never quite went away.

Surprisingly, it took longer for Drake to become famous in his own country and for his face to become an English icon. Throughout the 1570s, he was still Walsingham's secret weapon – against Cecil and the peace party as much as Spain itself. Though the Queen was always happy to be presented with booty – especially when it took the form of outsize gems – she continued to vacillate between the two poles of her counsellors. In 1574–6, however, influenced by the advice of Dr John Dee – astronomer, geographer, alchemist and coiner of the expression 'Brytish empyre' – she was persuaded to license expeditions to see if a route around the Americas to Asia could be discovered. Along with other geographers, Dee assumed a narrow strait to be all that was separating north-west America from China. That elusive North-west Passage had been tried, notably by Martin Frobisher, and efforts frustrated many times, but Drake and Dee thought there might be an alternative route via the 'Southern Sea' round Cape Horn and up the Pacific coast of America as far north as it might take you. For the first Atlantic leg of that voyage Dee envisaged the creation of an English colony near the mouth of the River Plate: the seedbed of a Protestant empire and a thorn in the side of Spain. While that southern colony failed to materialize, Drake's little fleet got itself down the Atlantic coast, through the Magellan Straits, and then sailed north to mount devastating attacks on Spanish ports in Chile and Peru, where treasure was mined and stored before being shipped home. Further north, off the Pacific coast of Mexico, Drake took a ship known colloquially as the *Cacafuego* (translatable more or less as 'Hot Shit') carrying bullion treasure amounting to a full fifth of Queen Elizabeth's annual revenues. Sailing still further north, he fulfilled Dee's plan by declaring, somewhere on the northern Californian coast, that America north of New Spain was now 'New Albion'. Later narratives of the voyage had Drake attempting to turn Miwok prostration before him into conversion with a gentleness that was meant to contrast with the notorious brutality with which the Spanish coerced Indians into submitting to the Cross. In those accounts, Protestantism went with trade, and in Ternate in the East Indies (the first English contact with Asia) Drake

was said to have planted the seeds of mutual commerce. Edward Howes, the Puritan rector of Goldhanger in Essex, and a great champion of Protestant 'planting', certainly saw Drake's circumnavigation as the charter event for a righteously Christian empire that would be blessed with wealth.

Despite this prodigious achievement, the fame which ought to have greeted his return to Plymouth in September 1580 was initially restrained by the interests of state. The bling-happy Queen was delighted by his present of a gold crown and in a five-hour audience lost no time learning the details of the circumnavigation. But because knowledge of Drake's route was itself such a strategic weapon, he was forbidden from publishing its details and especially the location of New Albion. A map was made for the Queen at Whitehall but any general publication was strictly banned. (An enterprising Dutch publisher nonetheless succeeded in pirating the pirate's copy.) And in 1589 the Flemish engraver, cartographer and globe-maker Joost de Hondt (grandly known as Jodocus Hondius), who had escaped Ghent in 1584 just before the Spanish reconquest, managed to publish the location of 'New Albion Bay'. Many, less enamoured with the returned pirate-become-hero, remained snobbishly dismissive. When Drake tried to sweeten Cecil with a present of gold bullion, he was loftily informed that accepting stolen goods was *quite* out of the question. The matter of whether or not to return the captured Spanish treasure was lengthily debated before the Queen finally (and predictably) decided against it.

Drake was now rich. He joined the landowning classes, becoming Mayor of Plymouth, Member of Parliament and acquiring what had once been the Cistercian Buckland Abbey in Devon. Buckland had in fact been owned by the rival Grenvilles (also slavers and pirates) and was, unbeknownst to them, bought by Drake through two intermediaries. He allowed himself a moment of public swagger. In 1581, the Queen knighted him on the deck of the *Golden Hind*, anchored at Deptford, handing the dubbing sword to the French ambassador in an attempt to further the languishing marriage strategy and co-opt

Sir Francis Drake, by unknown artist, after an engraving attributed
to Jodocus Hondius, circa 1583

France into the anti-Spanish alliance. She further ordered that his ship would remain dry docked there in perpetuity as a monument to his achievement (a first in the creation of a historical museum). The scholars of Winchester College competed with verses intended to be pinned to the mast of the exhibited ship: 'Sir Drake whom the worlds end knows/ Which thou didst compass round/ And whom both poles of Heavens once saw . . ./ The starres above will make thee known/ If men here silent were/ The sunne himself cannot forget/ His fellow traveller.' Writing early in the next century, London's chronicler John Stow claimed that Drake's face became so famous that people would run after him in the streets and would take it badly if anyone spoke against him. The fact that not everybody at court approved of Drake only augmented his popularity in the taverns.

The picturing began. In the same year as his knighthood, Nicholas Hilliard (another Devonian) painted the miniature which first portrayed that face as a wonderful combination of common man and courtier. The foxily bearded face is framed by the elegantly lacy ruff more commonly worn by the nobility and sits atop a doublet of snowy silk ornamented with a gold chain, the mark of favour bestowed by monarchs. That one version of the Hilliard was painted on the reverse of an ace of hearts playing card (owned, moreover, by the Earl of Derby) speaks to the sudden glamour of the dashing hero. Two years later, Drake sat for an unknown artist who produced the kind of grandiose full-length portrait reserved for princes and aristocrats; a format which disguised his short stature. Unlike portraits of his patron Walsingham, which are invariably austere, Drake is a sight to behold in coral-coloured silk, sleeves slashed with silver. To one side is the plumed headgear, reserved for the greatest commanders (for so he had become) and royal defenders of the realm; on the other, the globe which had become the symbol of his circumnavigation. But the globe had also been used as an emblem of universal empire (not least by Philip of Spain's father, Charles V). So its transfer to the effective father of the English empire was, in itself, a pictorial proclamation.

In the preamble to Henry VIII's 1532 Statute in Restraint of Appeals,

Sir Francis Drake, by Nicholas Hilliard, 1581

Sir Francis Drake, by unknown artist, circa 1580

which ended any allegiance to 'the Bishop of Rome', it had been declared that 'this realm of England is an empire and so hath been accepted in the world.' John Dee had applied that principle to actual geography. Now, in Francis Drake, there was an authentic imperial hero, risen from modest origins to the utmost heights of renown: the scourge of Spain. Drake's ferocious raids on Santo Domingo and on Cartagena in the Caribbean, and his sacking of Cádiz in the year before the Armada, only added to this reputation, both in England and Spain. For Thomas Greepe, who published his *Trewe and Perfecte Newes of the Woorthy and Valiaunt Exploytes . . . [by] Syr Frauncis Drake*, he is the peer and equal of his enemy Philip II: 'God be praysed for hys good success to the great terror and feare of the enemie, he being a man of meane calling to deal with so mightie a monarke.'

Around 1583, an elaborate portrait print of Drake – *Franciscus Draeck, Nobilissimus Eques Angliae* (most noble knight of England) – appeared. It is unsigned but is almost universally accepted as the work of 'Hondius' and it includes all the emblematic details of his imperial grandeur: the 'encompassed' globe, with the continents of Asia, Africa and 'Oceanus' prominently inscribed, a view of Plymouth at his back, and the sword and helm of his knighthood. Presumptuously, as Bruce Wathen has noticed, Drake took the West Country dragon, the wyvern, with displayed leathery wings, for the first and third quarters of his coat of arms, even though they had already been used by another family of Drakes from east Devon. This was just his latest prize.

The fame had already become international: an icon of the European and global war of faith and riches being fought between Spain and the Protestant powers. About the same time as the Hondius print, another appeared by the engraver Thomas de Leu, after a now-lost portrait by Jean Rabel. This time Drake is bearing a shield on which a naval battle is featured, exactly comparable to the shield of Aeneas said in Virgil's *Aeneid* to presage future events, not least the founding of Rome. Explicit comparisons with the famed heroes of antiquity – Hercules, Odysseus, Aeneas – had begun. England – or the Brytish empyre – was destined to be the new Rome.

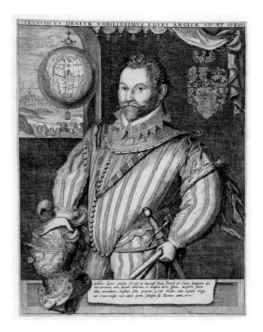

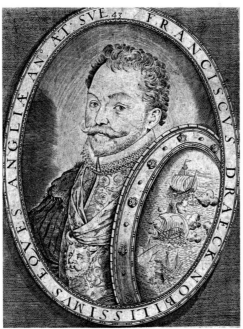

Sir Francis Drake, attributed to Jodocus Hondius, completed by George Vertue, circa 1583
Sir Francis Drake, by Thomas de Leu, after a painting by Jean Rabel, circa 1583

Reproduced in England and Europe, the chivalric Hondius print became the template for the many other versions of Drake, probably including the foot-square panel, painted on the same English oak from which his ships were built, of Drake's head and shoulders. Though there is no evidence that it was the very picture reported to be in Ferrara in April 1588, its modest dimensions and wear and tear at one corner suggest it was the kind of portable painting which might have gone travelling. Now carefully repaired and cleaned by the National Portrait Gallery, X-ray examination has revealed a circular or oval form behind Drake's head, likely to have been the image of the globe which had become standard in his iconography. Since Drake's name is spelled the Dutch way (Draeck; also Dutch for 'dragon'), the artist may have been one of the many Flemings and Dutch, like de Hondt, working in London, or it might have been produced for a Dutch market much in need of anti-Spanish heroes. Clumsily modelled, the picture is no masterpiece, the artist no Hilliard or Isaac Oliver. But in its simplicity lies its significance. Drake was no longer just the 'Queen's pirate' or the instrument of Walsingham's strategy. He had escaped into the people's imagination: the first truly famous Englishman.

And he lodged there, more or less for ever, notwithstanding the usual dismal ending expected of heroes. Drake had played his part in ensuring that the Invincible Armada failed to live up to its name, even though he was made subordinate Vice-Admiral in the chain of command to the Lord High Admiral, Howard of Effingham. Howard had no battle experience but he was Drake's social superior; the knight deferring to the earl. It was Howard who deployed the fatal fireships while Drake was initially assigned the role of worrying attacks on the Spanish fleet as it sailed up the Solent and the Channel.

But Drake emerged from the battles, especially the decisive one at Gravelines, with his fame enhanced, as he had taken a *capitano* flagship, the *Rosario*, though it was noticed he had made it his personal prize. In 1589, Richard Hakluyt's *Principal Navigations* finally produced the first thorough narrative of his voyage around the world.

This was the pinnacle. Then followed the long anticlimax, including a failed, massively mobilized reverse Armada in 1589 intended to destroy the remnant of the Spanish fleet as it lay in the harbours of La Coruña and Santander. But Drake's expedition failed to achieve its aims, which included the taking of Lisbon and the raising of a Portuguese revolt. The defence of La Coruña, in which citizens came to the aid of the garrison, became Spain's own version of heroic resistance. With the English Treasury much depleted by the costs of resisting the Armada, the follow-up had to be jointly financed by the Crown and private venturers whose gain would be the plunder of the expedition. Drake had bet on prizes, selling his London house to fund the expedition, but the gamble had not paid off. Suddenly, too, there was an outbreak of nose-holding at court. A full-length portrait from this period by the Flemish painter Marcus Gheeraerts the Younger, who was also painting the Queen, has a noticeably older Drake in much more sombre costume, albeit with a miniature of Elizabeth hanging from a chain.

This was a time when heroes – Ralegh as well as Drake – could fall as steeply as they had risen. Everything depended on the most recent success. But in 1595, another ambitious voyage across the Atlantic ended in fatal disaster. Drake's target was the scene of his first great triumph, the terminus of the treasure mule-train at Nombre de Dios. But he had learned that a great ship had been driven by a storm at Puertobelo, to the west. Both Spanish strongholds, however, were forewarned and better defended, and held the sea-dragon back. Drake anchored off Puertobelo, where a devastating tropical fever burned its way through the fleet, taking one of Drake's captains before he himself fell victim to a 'scowring' bloody flux, the violent dysenteric spasm that killed him. He was buried at sea while psalms were sung.

His fame survived. The Spanish, jubilant at his failure, could now make much of the stature of their enemy; the better to celebrate his end. The greatest of their poets and playwrights, Lope de Vega, had served in the Spanish fleets and was on board one of the Armada ships

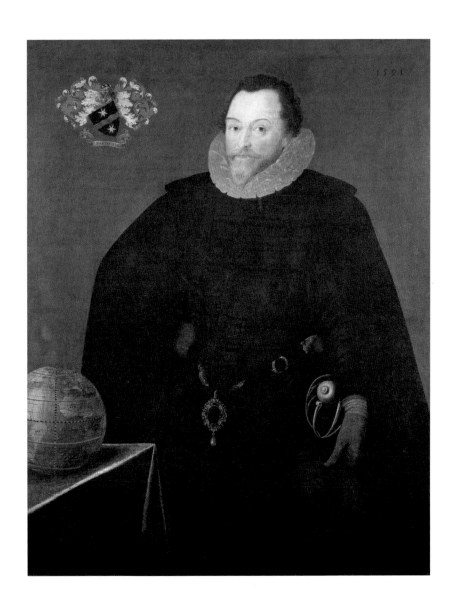

Sir Francis Drake, by Marcus Gheeraerts, 1591

which engaged with Drake. His *Dragontea* was the most fantastic of all the poems, turning El Draque into a legendary monster:

> *His eyelids, raised, released the light of dawn;*
> *His snorting breath lit up the heavens with fire;*
> *His mouth sent tongues of flame into the sky;*
> *His nostrils poured out black and smoking clouds.*

English eulogists attempted to pay the Spanish back with interest, but instead of a Lope de Vega they had to make do with Drake's fellow Devonian Charles Fitzgeoffrey:

> *The sea no more, heaven shall be his tomb,*
> *Where he a new-made star eternally*
> *Shall shine transparent to spectator's eye*
> *But to us a radiant light*
> *He who remains alive to them a dragon was*
> *Shall be a dragon unto them again . . .*

Whenever England and Spain went to war – which was often enough in the seventeenth century – Drake's fame was sung again. Another long narrative of the circumnavigation, *The World Encompassed*, appeared in 1628. During the Interregnum, a full opera by William Davenant was performed at the Cockpit, Drury Lane, in 1658–9. When France became the principal foe, Spain was usually its ally, so the durability of the Drake legend persisted, culminating later in the myth of the ghostly drum said to have been carried around the world, which would beat of its own accord whenever mortal danger threatened Albion's shores. Though not a self-beater, there was, in fact, a drum, which may have been on the *Golden Hind*, which was treated as a patriotic relic by the pilgrims who, generation after generation, made their way to Buckland Abbey. It is said to have been heard at the outset of the First World War; then again when Hitler threatened in 1940; and as recently as 1966 perhaps, when the oncoming enemy was

thought to be the German football team competing in the World Cup, then being held in England. My father took me to see the drum in 1953, before the coronation, directly inspiring me to write a short play about Drake 'singeing the King of Spain's beard' at Cádiz, a metaphor I took literally enough to set fire to a friend's cotton-wool beard with my dad's cigarette lighter. That evening Drake's drum beat a rhythm on my little backside, courtesy of my patriotically responsible mother.

3. *The First National Portrait Gallery*

Your French guest had come armed with *Les Charmes de Stow*, so when he enquired whether a visit to Earl Temple's country seat and park, the like of which he had heard to be unequall'd for curiosity and modern taste, you could hardly, in all conscience, deny him. You wondered all the same whether a place said to be so very *demonstrative* in its British patriotism might not open wounds barely closed since the last round of hostilities between the two kingdoms. But Benton Seeley's admirably comprehensive and elegantly illustrated *Description* suggested a wealth of unexceptional diversions: a Chinese pavilion; a Temple of Ancient Virtue; a Temple of Bacchus; and the like. Where could be the harm? Very well then, summon the post-chaise!

How thoughtful of Benton Seeley to begin the latest edition of the Guide with detailed directions of the route from London, listing the towns through which one should pass if the way was not to be lost. This was helpful to the considerable traffic making its way to Stowe after Viscount Cobham had opened its gardens for pleasure and instruction. This was the first time any country-house owner had thought to make their residence a tourist attraction. As Seeley advised, the traveller now rattled through Uxbridge, Chalfont, Amersham, stopping perhaps at Great Missenden before proceeding the next day to Aylesbury and Wendover before finally arriving at Buckingham, fifty miles distant from the capital. Seeley had further selected a choice of inns for dependable lodging – the Cross Keys, the Cobham Arms or, at a pinch, the George, supposing, as was usually the case, the New Inn, which had been built expressly to house visitors to Stowe, was fully occupied.

It was not difficult to know when you had arrived. A vast triumphal Corinthian arch, looking for all the world as if it had been shipped in from Rome, sixty feet wide and 'sixty feet high', big enough to lodge the gatekeepers, dominated the approach. Through the archway you

would catch your first sight of Stowe House, 'proudly standing on the summit of a verdant Hill'. A broad avenue would take you to the grandly colonnaded façade with the improbably martial equestrian statue of George I standing before it. A second road led down from the arch into the garden itself, where, as Seeley put it, 'the beautiful disposition of the Lawns, Trees and Buildings at a distance, gives a kind of Earnest of what our Expectation is raised to.'

That expectation may just have been amusement and delight, for Stowe certainly supplied those attractions: a shell-lined grotto; a painted Chinese House; a little rusticated 'Shepherd's Cove' by the lake, on the walls of which were engraved a dedication to his dog 'Signor Fido'. You could linger in William Kent's Temple of Venus, where the ceiling was decorated with scenes from Spenser's *Faerie Queene*, the cavortings of the runaway Hellidore from her elderly husband and the statutory naked Venus: all much disapproved of by the likes of Dr Johnson. After all this excitement you could always calm down in the Cold Bath or sit on the rude straw couch in St Austin's (St Augustine's) cell, a hut made entirely from tree roots and moss where you could pretend to sigh for a life of simple self-knowledge.

But the Lord of Stowe, Richard Temple, Viscount Cobham, had something more ambitious in mind than amusements. The reason Cobham had opened his estate to the public was that it might be educated in the admirable history of British liberty, at least as he saw it in the mirror of his own life, in the chronicle of the past and in the immortals who personified its special destiny. Stowe was Whig gardening with a vengeance.

All his life, Temple had been a soldier for the Protestant cause, which, as far as he was concerned, was the same thing as the battle for freedom. The family vocation went back many generations, to the Puritan Temples, who had farmed sheep in Warwickshire before one of them, Peter, moved to Buckinghamshire, leasing land around Stowe for his flocks. A flourishing wool trade enabled the family to buy the estate, along with the Parliamentary seat of Buckingham that went with it and which of course remained controlled by these battlers for

Richard Temple, 1st Viscount Cobham, after Jean Baptiste van Loo, circa 1740

liberty through many generations. Though they made shrewd marriage alliances, the dowry that came to Sir Thomas Temple MP in the reign of Queen Elizabeth was not enough to support his family of thirteen children, especially as the wool trade fell into a long and irreversible decline. Thomas attempted to sell off some of the land, provoking his heir, Peter, to mount a successful campaign of obstruction while also whining that his father loved his younger brother John better than himself. The full Elizabethan beard was replaced by a Van Dyck trim and, though Peter looked the picture of cavalier elegance and collected the hated 'ship money' for King Charles, those Puritan roots tied him firmly to the Parliamentary cause, which, as things turned out, was a good decision. Peter sat in the Long Parliament and was called on to be a judge at the trial of the King. At this point he disappeared from view, also a good move, since it allowed his son the first Richard to switch allegiance from the Cromwellian Protectorate to Charles II even before the new King had arrived in town. In 1676, this 3rd Baron Temple decided to build a new, four-storey brick house from one of Christopher Wren's principal assistants, William Cleare.

Something much grander, however, was in the offing. The Temples had survived the religious and political upheavals of the seventeenth century by astute judgement and good timing. But Protestants they had been from the beginning of the Reformation, and Protestants they stayed. They would fight for the cause if need be. So it was natural that the second Richard should have served in an English regiment garrisoned in the Netherlands and which returned triumphantly with William III in 1688. This Richard was at the Battle of the Boyne in Ireland (1690), where the Catholic cause of James II went down to bitter defeat, and then fought in all the wars against Louis XIV and his Spanish allies. He rose through the ranks, became Baron and then Viscount Cobham. And like his general, Marlborough, with whom he fought in the War of the Spanish Succession, this generation of Protestant commanders believed they should celebrate their ascendancy by building on a palatial scale. From 1711, Cobham began to remodel the house and park with the self-taught architect and playwright Sir

John Vanbrugh, who had built the stunning piece of architectural drama that is Blenheim for Marlborough and who now obliged his new patron and fellow Kit-Catter with a colonnaded portico of comparable grandeur. Thereafter, Cobham's choice of architects and landscapists comprised a succession of geniuses – Charles Bridgeman, James Gibbs (despite his being Catholic and Tory) and William Kent – that lived up to the Guide's characterization of magnificence. Later Temples brought Capability Brown, Robert Adam and Sir John Soane to put their mark on the house and the park.

Even more important than Viscount Cobham's military laurels and his social pretensions was his marriage to Anne Halsey, heiress to the biggest brewing fortune in England: the Anchor Brewery in Southwark. The Stowe admired by Georgian tourists was built on dark-malted porter. Cobham's life outside the army, like many of his generation, was itself a union between drum-beating national pride and international classical taste. Both his architects, Gibbs and Kent, had spent their apprentice years in Rome. Kent in particular had ambitions to be the principal British Palladian of his generation, but he also understood that what Cobham had in mind for the garden buildings was a dialogue between classical and British history: a Palladian bridge close to a Gothick temple; a systematically planned walk that would build into a thoroughly patriotic picnic.

As prickly as he apparently was, Cobham was the patriarch of a group of dissident Whig politicians who self-consciously attached the label 'Patriot' to themselves. The foe of their patriotism was the erstwhile capo of the Whig ascendancy, Sir Robert Walpole, whose clean-out of Toryism after the Hanoverian succession and the first Jacobite revolt in 1715 had in fact guaranteed the prospering of their class and a fat share of the spoils of government. But Walpole, they came to believe, had become an arrogant oligarch too accustomed to everyone else doing his bidding. There were ugly arguments. Cobham retreated back to Stowe to gather about him a group of his extended family, the Grenvilles, younger up-and-comers such as William Pitt and, not least, Frederick, Prince of Wales, who followed the custom

of going into bitter opposition to his father, King George II, and all his ministers. Together they were 'Cobham's Cubs'; bellicose when it came to defending the young empire against the French and watchful lest the country stray from the sacred principles of the glorious Protestant revolution of 1688. At Stowe, where they met, their chief resolved to make a statement in his gardens about the right course of British history, and to throw open his gates so that present and future generations would understand and celebrate it. At almost every turn through the oaken glades, you and little Sophia and Jemmy would encounter the imperishable virtue and fortitude of true British history.

And so can you! Five hundred and thirty-eight pounds will buy you four nights in James Gibbs's Gothick Temple (sleeps four), originally called the Temple of Liberty, a secular church of ancestral Anglo-Saxon freedom, done in quasi-Perpendicular, complete with tower and belvedere and a mock-medieval hall with a gilded ceiling ornamented by one of Cobham's two sculptors, Rysbrack, with statues of the Germanic gods who gave their names to the days of the week. Notwithstanding Prince Frederick's estrangement from his father, it was a received wisdom that British liberty began in the mists of the Saxon woods, had to be renewed against the 'Norman yoke', revived by the righteous resistance to the autocratic Stuarts until it burst forth into ultimate flowering in 1688. As a result, you can go to bed beneath paintings of Cobham's entirely spurious Anglo-Saxon ancestors parading on the ceiling.

But it was in Kent–Cobham's Elysian Fields that the lesson in the garden reached its climax. Winding paths ensured that the three key structures were experienced in proper order. First on the guidebook route was an artificial ruin, ironically called 'The Temple of Modern Virtue': an allusion to the desolation which Walpole (insultingly represented by a headless figure sitting in the debris) had brought to the British house of liberty. Walking ahead, you could then reflect on how the wisdom of the ages had been shamefully abandoned when, around the corner, set on a gently rising knoll, Kent's Temple of Ancient Virtue

appeared: a small, graceful, circular, domed pavilion surrounded by Ionic columns. Inside, set in niches, were exemplary figures from the ancient world – Homer, Socrates, the Spartan lawgiver Lycurgus and the Theban statesman Epaminondas. All except Lycurgus had made an appearance in Alexander Pope's epic poem, published in 1715, *The Temple of Fame*, in which a glittering pantheon including Confucius and Perseus stood 'high on a rock of ice'. In Cobham's miniature version the classical heroes were made over as ancestral Whigs, Lycurgus, for example, 'having planned, with consummate wisdom, a system of Laws secured against every Incroachment of Corruption, and having by the expulsion of riches, banished luxury, avarice, and intemperance, established in the State for many ages, perfect liberty and Inviolable manners'.

Exiting the Temple, a lovely prospect opened up, over a stretch of water called the Serpentine, crossed by a shell-encrusted bridge, to the climax of the day's perambulation: the Temple of British Worthies, all sixteen of them, present in the form of busts of the famed; heroes of the figures of the mind to the left, heroes of action to the right. The two groups were separated by a pyramid-topped structure serving as a plinth for Mercury. God of both commerce and eloquence, he was evidently Cobham's choice for guardian deity of the rising empire. The design team was hand-picked by Cobham: William Kent was responsible for the structure; Peter Scheemakers and John Michael Rysbrack sculpted the busts. Drake is there, of course, in the company of heroes of action (though Ralegh could as easily have been in the company of creative minds), together with Alfred the Great, hailed by the Whigs as the progenitor of the immemorial constitution of Anglo-Saxon liberties; William III, the inheritor of that tradition; and Queen Elizabeth. There was one obvious and glaring omission, but even for these ultra-Whigs it was not yet possible to anoint the regicide Oliver Cromwell a worthy. Given the history of the Temple family, however, the Interregnum's role in securing liberty had to be honoured and was less controversially personified by the Parliamentarian John Hampden, who 'began a noble opposition to an arbitrary court in defence of the

The Temple of British Worthies, with Busts of Milton and Shakespeare, 1735

Liberties of his country, supported them in Parliament and died for them in the Field'.

Amidst the great thinkers, however, was a figure almost as incendiary as Cromwell, one who had defended the trial and execution of Charles I: John Milton, deemed (in one of the shortest inscriptions) to possess a 'sublime and unbounded Genius' and there principally by virtue of the great lyric-epic poems, but also perhaps because of *Areopagitica*, his profound and eloquently stirring defence of freedom of speech and of print. It probably helped that the liberty Milton wished to grant to everyone else he denied to Catholics, as did Locke, canonized by the Whigs as the philosophical patriarch of a limited monarchy 'who understood the powers of the human mind, the Nature, End and Bounds of Civil Government and . . . refuted the slavish system of usurped Authority over the Rights, Consciences and the Reason of Mankind'. There, too, were Pope, Newton (of course), Francis Bacon, Inigo Jones and, a little more jarringly (amidst men of the mind, though he had founded a college on the site of a dissolved monastery), the Thomas Gresham honoured for creating the Royal (Stock) Exchange in the reign of Elizabeth.

The busts were modelled on already familiar engraved portraits of the famous – Milton's melancholy blindness, Locke's sober demeanour, the 1623 folio frontispiece by Droeshout of the balding Shakespeare. But Kent did something ingenious to bring the luminaries into the immediate presence of the beholder. Instead of setting them in niches high on the curving wall, he put them very much at eye level with the viewer. You mount a low flight of three steps extending the breadth of the shallow amphitheatre and stare into the eyes of Newton or Francis Drake, who stare back at you from across the centuries. You are in the same space, as well as the same history; it's as if the Worthies were greeting you at a superior dinner party. From somewhere over the Serpentine you can hear a band beginning to play 'Rule, Britannia!', composed by Mr Arne for one of the Stowe company, the Prince of Wales. And though you pride yourself on your aversion to shallow sentiment, that lump in your throat is not imaginary. It is 1760-something, and by God it feels good to be British.

4. *The Star*

He was dead and yet very much alive; sleeping the endless sleep yet permanently wide awake. It was not just the enormous bull-like eyes which Robert Edge Pine (who had painted them four years before, when David Garrick was still living) now focused again on the beholder with the same fierce intensity which had made the actor famous; it was the brows above them, each doing their own independent thing; one more arched than the other. They were themselves a theatre company of two, those eyebrows: tragedy and comedy, sorrow and slapstick, dancing on the stage of his face. When Gainsborough complained that Garrick was his most difficult sitter, it was because those two wouldn't keep still: 'When he was sketching-in the eye-brows, and thought he had hit upon the precise situation, and looked a second time at his model, he found the eye-brows lifted up to the middle of his forehead, and when he a third time looked, they were dropped like a curtain close over the eyes, so flexible and universal was the countenance of this great player.'

Perhaps Pine's head, floating in its dark eternity, was too uncanny for the multitudes of Garrickomanes collecting whatever memorabilia they could grab after his death in January 1779, for few copies of the mezzotint have survived. But England – and Europe, where he was also famous – was awash with Garrick memorabilia in every conceivable form. The invention of transfer printing in the late 1750s meant it was now a simple process to reproduce an image on the surfaces of ceramics and enamels. Now you could pour milk from a Liverpool creamware jug with Garrick's face on it. Staffordshire pottery modelled Garricks in famous roles, Richard III especially, in the parlour; and, thanks to Thomas Frye, who was both painter and ceramicist, you could have your actor in Bow porcelain. If you wanted to furnish your house with Garrick you could upholster the chairs in cotton fabric roller-printed, in a choice of black or red, with Caroline Watson's

Publish'd April 4th 1779 by R. E. Pine.

stipple engraving after another of Pine's works, commemorating the Shakespeare Jubilee which the actor orchestrated at Stratford in September 1769. There he is, right arm extended, gesticulating at the statue of the Bard which had just been unveiled in the new Town Hall while reciting his grand Ode, composed for the occasion. Around him (as they were that rainy day in Stratford) were actors variously costumed as Falstaff, Lear and Macbeth. You could eat off Garrick plates; drink from Garrick-engraved rummers and goblets. If you couldn't get enough of him, you might cover your walls with mezzotints of portraits of Garrick by Hogarth, Gainsborough, Reynolds; Garrick with Mrs Garrick; Zoffany's pictures of him in his most celebrated roles: Abel Drugger in Ben Jonson's *The Alchemist*; Hamlet in his 'alteration', of which not everyone approved; the skirted Sir John Brute in drag from Vanbrugh's *The Provok'd Wife*.

Or, after 1797, you could pay homage to Garrick in Poets' Corner. In the spirit of not letting Garrick sink passively into the arms of death, the inspired memorial, commissioned from the sculptor Henry Webber by Garrick's solicitor and friend Albany Wallis (whose teenage son had drowned in the Thames), has the actor parting stage curtains as if taking a final bow, posed between Comedy and Tragedy. There is a ponderously sententious inscription by the poet-actor Samuel Jackson Pratt, who, after a career of scandal (a pseudo-marriage) and stage flops, had written an orotund eulogy for Oliver Goldsmith and thereafter became England's verse obituarist. The lines are taken from Pratt's 'monody', composed at the time of the vast funeral arranged by Richard Brinsley Sheridan, more imposing than any given to defunct Hanoverian monarchs. Fifty mourning coaches processed from the Garrick house in the Adelphi to the Abbey, escorted by files of guards, mounted and on foot; while a crowd of fifty thousand watched the hearse pass on its carriage. As Garrick would certainly have wished, Pratt's lines twinned him inseparably with the Bard, to whom he admitted he 'owed everything'. 'To paint fair Nature, by divine command, her magic pencil in his glowing hand, a Shakspeare [*sic*] rose, then to expand his fame wide o'er this "breathing world", a Garrick came. Though sunk

in death the forms the poet drew, the actor's genius bade them breathe anew ... Shakspeare & Garrick like twin stars shall shine, and earth irradiate with beam divine.'

Garrick's Westminster memorial is directly in front of Shakespeare's, which seems right, since it had all begun with the erection of the Bard's own monument thirty-eight years earlier in 1741. As yet, the collection of monuments to genius was rudimentary and under-populated. Chaucer had been the first non-prince, non-aristocrat, non-ecclesiastic to be buried in the Abbey, but was laid there principally as Clerk of the Works. Francis Beaumont, Edmund Spenser and Ben Jonson had followed, the last with a terse inscription. As early as 1623, the year of the publication of the first Folio edition of the plays, one of Shakespeare's eulogists had suggested that there ought to be a monument to the Bard in the Abbey, but Ben Jonson truculently resisted any such idea, declaring that 'the man was the monument itself'. At the other end of the century, genius was admitted in the person of John Dryden in 1700, and then in 1727 Isaac Newton was given an immense and spectacular funeral before being laid in the nave.

Only when the grandiose and beautiful Shakespeare monument was set in the south transept in 1741 did that particular space turn into a mausoleum of genius, and one which, as in the case of the Bard, did not require any transfer of bones. It was none other than Cobham's Cubs and the Stowe circle, together with Lord Burlington, who had created the Shakespeare bust for the Temple of Worthies six years before, who now raised subscriptions to make it happen. Alexander Pope, the poetical eulogist of Stowe, and the editor of a new six-volume Shakespeare, lent his efforts, as did Charles Fleetwood, the manager of Drury Lane, and one of his actors, Thomas King. William Kent, Cobham's landscape architect, drafted the design for the memorial, and Peter Scheemakers sculpted a full-length figure, legs crossed, lost in compositional thought and leaning on a pile of books. The piece was as much a fanfare for British history as a monument to the country's greatest writer. At Shakespeare's feet are busts of three monarchs: Richard III, Elizabeth (for the obvious reason, but also for the less

obvious of her personifying English resistance to ill-intentioned foreigners) and, as the memorial was conceived and unveiled in wartime, with Britain and France on opposite sides of the War of the Austrian Succession; hence the inclusion of the third monarch, Henry V.

The completion of the Shakespeare monument happened with enough fanfare to attract Garrick the Bardolater, then just twenty-four years old, a wholesale wine trader in London together with his brother Peter, but also an amateur actor and author of a popular entertainment, *Lethe*. Garrick would have had no difficulty in making the connection between Bardolatry and the drumbeat of national-imperial pride. He would go on to make an entire career out of beating that drum on both sides of the English Channel. Yet again, the epic of Protestant liberty had a lot to do with it. His grandfather David Garric was a Bordeaux Huguenot who had come to England when the rights of French Protestants were liquidated by Louis XIV's revocation of the Edict of Nantes in 1685. Like Drake and Viscount Cobham, the Garricks knew who their enemy was. Years later, David the actor would take the fight over Shakespeare right to the doors of the Comédie-Française, which fell over him in belated adoration, much like Princess Katherine at the feet of Henry V. Garrick's father, Peter, inevitably perhaps, joined the King's army and became a recruiting officer in Tyrrell's Irish Regiment, stationed for much of the boy's childhood in the newly acquired fortress port of Gibraltar, the front-line rock abutting Spain.

Peter moved the family to Lichfield, in Staffordshire, where David went to the same school as Samuel Johnson, who was a few years his senior. He was already stage-struck when he moved to London to work with his brother in the wine trade. And because the Garricks supplied wine to the Bedford Coffee House round the corner from Covent Garden, the infatuation only grew stronger and deeper. It would be nice to think that, given his father's occupation, he made a beeline for George Farquhar's very funny comedy *The Recruiting Officer*, which had become a staple in the repertoire of Henry Giffard's theatre out in Goodman's Fields, Whitechapel. 'Over the hills and far away. Over

the Hills and O'er the Main/ To Flanders, Portugal and Spain/ The
Queen commands and we'll obey/ Over the hills and far away.'

Like all actor-managers, Giffard had had his ups and downs. The
Licensing Act of 1737, which restricted performances to Drury
Lane and Covent Garden, had closed his Whitechapel theatre (the
second one in Goodman's Fields) not long after he had built it. But
palms were greased, approaches made, and in 1740 he was allowed to
reopen. Garrick must already have known Giffard, since he had writ-
ten *Lethe*, in which a predictable parade of fops and fools are offered
the possibility of forgetting their life of troubles, for the manager's
benefit performance. While waiting for his Whitechapel theatre to
reopen, Giffard toured East Anglia with a scratch company, and it was
at Ipswich that the amateur thespian Garrick first tried out his art,
billed as 'Mr Lydall'. Giffard saw something out of the ordinary in the
little fellow who could write, act and seemed to know enough of the
bon ton already to be useful where it mattered. There was something
brisk and vigorous about Garrick which Giffard recognized as theat-
rical fresh air.

On 19 October 1741, Garrick, all of twenty-four, appeared as
the murderous monarch in *The Life and Death of Richard the Third*,
sandwiched between a 'Vocal and Instrumental Concert', a dance act
and 'the Virgin Unmask'd'. The lead role was billed as being played by
'[a] Gentleman who has never appeared on any stage'. So much for
Ipswich.

The anonymity might have been Giffard's attempt to pique curiosity,
or even the habitual sadism of the audience, who, if things went badly
wrong, would at least be entertained by a debacle: a stripling nobody
biting off more than he could chew. They would pelt him with boos,
hisses, choice abuse and solid objects. Or it is possible that Garrick
chose anonymity because he had not yet decided whether he should
go professional? The reception of his Richard made up his mind. On
the following day, he wrote to his brother Peter that 'my mind as you
know has always been inclined to the stage.' Though he expected Peter
to be displeased with his decision:

yet I hope when You shall find that I may have y^e genius of an Actor without y^e Vices You will think less severe of Me and not be asham'd to own me for a Brother. Last Night I play'd Richard y^e Third to y^e Surprize of Every Body & as I shall make near three hundred pounds p[er]Annum by It & as it is really what I doat upon I am resolv'd to pursue it.

Garrick was right about his brother's mortified embarrassment, even though the two of them had found it a struggle to make money in the wine business. Although some actors such as James Quin, Thomas King and Charles Macklin were well known to the public, acting was mostly considered an occupation rather than a profession, and a lowish one at that, somewhat akin to a fiddler or a barber surgeon. It was also notorious for its backstage promiscuousness. Worse still, actors seemed to indulge their notoriety in the full glare of Grub Street publicity without a second thought, as if it added to their reputation – which may indeed have been the case. One of the most complaisant and cynical, the actor and critic (itself a neat combination) Theophilus Cibber, countenanced a *ménage à trois* in Kensington, but only on the understanding that his wife's lover would subsidize his stage performances.

What Garrick brought to the stage would transform all this. Although he had lived with the Irish actress Peg Woffington (who had earlier done a stint in a high-end brothel), he would end up an exemplary married man, his conjugal happiness represented in double portraits by Hogarth and Reynolds. More importantly, he would change what acting was supposed to be. Much later, the actor-playwright Richard Cumberland would remember seeing Garrick 'come bounding' on to the stage in 1746 in *The Fair Penitent*, 'light and alive in every muscle and feature . . . it seemed as though a whole century had been stept over in the transition of a single scene.' Alexander Pope was one of many of his contemporaries who thought that Garrick was the first to stake a claim for acting to be a true art.

London saw this right away. Garrick's Goodman's Fields Richard fell on the city like a clap of thunder. No one who saw his debut ever

forgot it. Every coffee house and tavern talked of it. For a few nights, coaches clogged the streets of Whitechapel. The play was not Shakespeare's original text but a cobbled-together amalgam of lines written by Theophilus Cibber's father, the actor-manager Colley Cibber, together with chunks of *Henry V*, *Henry VI* and *Richard III*. But the great moments from Shakespeare, including many of the lines – the king's haunting by the ghosts of his victims on the eve of the battle; and of course Bosworth itself, with the unhorsed king flailing his sword to the bitter end – were exploited for all they were worth. Audiences were accustomed to seeing the grand actors of the day declaim in a rhetorically lofty and mannered style. Most often, they did so with grandiose gesticulation, milking the pauses, investing speech with weighty gravitas. But instead of the usual crookback shuffle with the mouth-curling cackle-and-sneer, Garrick's Gloucester appeared without any signs of the unhinged sociopath. Garrick prided himself on conveying the complexity of a character and on the ability to move from one state to another, both inwardly and outwardly. So the seductive Richard, the merry Richard, the twitching Richard and the monstrously brave Richard all appeared in their turn within the one frame, each convincing in their moment.

In 1745, the artist William Hogarth, himself on the way up, thought a picture should be made of Garrick's Richard. It was a commission for a patron who wanted to preserve for posterity a record of the transformative power of the performance. Garrick was of course flattered by this, but he probably had something else in mind as well: the creation of a reputation through engraved versions of the painting. Hogarth, who came from a jobbing world of sign-engravers and satirical prints before making his own name with 'Modern Morality Tales' such as *The Harlot's Progress*, immediately understood the value of this. But he was more ambitious. At heart he longed to become the great history painter Britain still wanted, especially in the time of its budding empire. The nearest thing was his father-in-law, Sir James Thornhill, who had provided ceremonious ceilings featuring William III and George I for the Royal Naval Hospital at Greenwich. To Thornhill's horror, Hogarth

had eloped with his daughter Jane. So the demonstration that Hogarth had all the qualities of an English Michelangelo was meant as an unapologetic assertion to both father-in-law and country.

In 1745, Britain needed history painting. The war with France had not gone as well as anticipated, and the Jacobite army of Charles Edward Stuart had got as far south as Derby. (Hogarth would also supply a picture of that shaky moment in a satiric rather than grandiose vein with *The March to Finchley*). But he seized the Garrick moment as an opportunity to bring the English back to their history with a vengeance and to do it on a heroic scale.

At over eight by three feet, the picture is big enough to deliver Garrick life-size into our presence, much as if we were sitting in the front row of the pit, or in a box close to the stage. Garrick's haunted, terrified face is in ours. His gesticulating hand (a ring has slipped over the joint of a finger in his sweaty fear) presses against the picture plane. The tent – in fact the whole painting – as large as it is, feels claustrophobic, oppressive, the right sensation for Richard. Beyond, in the background, the fires of his and his adversary's troops burn dimly as dawn comes up on his last bloody day.

Between them, Hogarth and Garrick had invented a completely new genre, hitherto unknown to any school of art: the theatrical portrait which at one and the same time delivered a likeness of the man (though in Garrick's case it was said that it flattered him – as would generally be the case with stars) and a likeness of the performance. In its all-out rendering of the actor's peerless ability to capture extreme passion – the talent for which he would become internationally famous – the picture was a textbook for future generations. With his Richard, and with the record of it, now reproduced in multiple prints, Garrick had fundamentally altered what true acting should aim for. Liberated from high academic style, it was free now to go after what he thought of as human truth written on the face and the body. Garrick would tell the aspiring actors who followed him that before all else they must study the part, make every line their own, inhabit, as we would say, the character; let it take full possession of them. He had also learned from

David Garrick as Richard III, by William Hogarth, 1745

Charles Macklin, who, when he was preparing Shylock, went to the length of going to see Sephardi Jews in London go about their business, that the book of nature written on the bodies and faces of contemporary humanity needed ceaseless study as well. Garrick's instruction to fellow actors as well as himself was to lose one's identity in the part. When he saw him do this in 1765, Friedrich Grimm commented on the 'facility with which he abandons his own personality'.

Garrick was also familiar with the classic art literature on the *affetti*, the passions, especially Giambattista della Porta and the French painter and academician Charles Le Brun, both of whom had published what were in effect anatomies of the emotions: how they registered on the musculature of the face. How one mood succeeded another mattered to him, as he prided himself on letting the evolution of a character show through its many complicated modulations. (A favourite party trick was to sit wordlessly and let lust, terror, anguish and the rest follow each other on his mobile face.) This was especially true of his Macbeth, first played in 1744 and surprisingly accompanied by his writing a pre-emptive pamphlet attack on himself designed nonetheless for contrasts with his ponderous peers.

Garrick acted with all his body. He was no more than five foot four but the athletic force of his acting made him seem much bigger, as though his frame were built on springs. To the consternation of some other cast members, who liked to take things slowly, he was *fast*, vital, animated, nimble, almost like a dancer, darting from one spot to another. The envious Macklin said he was all 'bustle bustle bustle', but such was the energy that when a moment like Hamlet's first sight of his ghostly father, or Macbeth's of the dagger, required him to be absolutely stock-still, his immobility had a correspondingly electrifying effect. One admirer spoke of his own flesh creeping even before the Ghost was seen, though that may have had something to do with the little hydraulic device Garrick used in his wig to make the hairs stand on end. Garrick's Richard was an immediate legend, talked about for years, becoming a staple of his repertoire, and the part (a little closer to the original folio text) which all great performers – Kemble,

Kean, the American Edwin Forrest and his rival Macready – would feel in their turn that they must own.

Truth to human nature was not, of course, incompatible with making money. Hogarth and Garrick were perfect partners in their understanding of this brand-new commercial opportunity: the marketing of stardom. The Goodman's Fields Richard would be engraved; the prints would make Garrick's face famous; act as catnip for the box office; and in turn would generate a new cycle of demand to see him both live and preserved on paper. The star business had been born. In the first instance, Hogarth was responsible for the translation of his great Garrick–Richard into multiple prints, but he was not swift enough in delivering to satisfy his friend Garrick (who called him 'Hogy'). Thereafter, especially once he had become partner-manager of Drury Lane, Garrick took control of his own publicity. In the 1750s he hired Benjamin Wilson, mostly a scene painter, to capture his most popular performances: Abel Drugger, Sir John Brute, Lear and Romeo, and the rest. The demand became inexhaustible. A stable of printmakers was assembled, many of them specialists in mezzotints, a relatively recent medium in which the plate was roughed up by the use of a toothed 'rocker', so that if printed at this point it would give a completely black page. The fully worked plate was then selectively scraped back and burnished to produce a whole world of tones, perfect for the picturing of dramatic scenes and expressive portraits. They could also be produced much more quickly, cheaply, and in a variety of formats to suit different pockets. James MacArdell, an Irish printmaker-portraitist with a shop in Covent Garden, was one of Garrick's most reliable promotional printers, but demand was constantly outstripping supply and he worked with Edward Fisher and Richard Houston, and many others. By the time Garrick made his triumphal foray into Paris in 1764, his fame had travelled enough that he had to write to his brother George back in London for a speedy dispatch of prints to satisfy his admirers. The finer ones (often prints made after paintings by Reynolds and Gainsborough) he would personally supply to his notable fans; the rest went to market.

David Garrick was not just an actor superstar; he was also impres-
ario, theatre manager, public relations man; image designer; discerning
art collector, especially of Venetian paintings – Marco Ricci and
Canaletto – and of Dutch pictures, which made him able to deal with
artists on terms of mutual understanding. Garrick was as well a great
bibliophile, bequeathing his priceless collection of 1,300 'Old Plays' to
the British Museum: the first great drama collection of its kind in the
world. But Garrick was bookish in a modern way: perfectly in touch
with shifts in public culture. From the 1750s, a cult of nature, of trans-
parency and sincerity – the opposite of fashion, artifice and high
manners – began to take hold in the pages of the first tear-soaked
sentimental novels; in the freshening of landscapes; the recovery of
original from corrupted texts; in the simplification of portrait style.
Garrick's antennae were acutely attuned to this alteration of sensibil-
ity, of which, in any case, he was an apostle. Sometimes, presenting
himself as natural man was a half-truth. His acting style was natural
only in contrast to the high rhetorical manner he replaced. His Shake-
speare plays were often still 'altered versions', sometimes adapted by
him so that Cordelia not only lives but is romanced by Edgar. *A Mid-
summer Night's Dream* was turned into a musical entertainment called
The Fairies. On the other hand, Garrick restored Polonius and Laertes,
who had gone missing from previous performances of *Hamlet*, to their
proper stature, though it took him only sixty lines to get from the
death of Ophelia to the end of the play. In some ways, however, he was
a true restorer of Macbeth in most of its Shakespearean integrity.

To record all this needed a better artist than Benjamin Wilson. Gar-
rick told Hogarth that Wilson was not 'an Accurate Observer of things,
not Ev'n of those which concerned him'. He had given some
theatre-scene subjects to his friend Francis Hayman, but it was in
Wilson's own studio, toiling away as the assistant given costumes to
paint, that Hogarth had discovered someone who might be just that
artist in the person of Johann Zoffany. Zoffany's family origins were
in Bohemia, though he had been born in Frankfurt and had come to
London in 1760. Before plunging into the overpopulated world of

jobbing art he had worked for a while as a decorator of clocks. His northern European, Dutch-influenced background had given him a talent for 'conversation pieces', the genre of informal scenes, multiple characters in a small format, which was perfect for rendering the kind of play-scenes Garrick needed. And there was something else as well that Garrick now had in mind as an extension of his fame: the opening of his personal and domestic life to the admiration of his followers.

Of course, the sex life of actors had been a staple of Grub Street printed gossip. But Garrick had a happy marriage and he had turned this unusual situation into another asset for the house brand. The story was the stuff of thespian romance. Eva Maria Veigel from Vienna, stage name Violette, fell for Garrick the moment she saw him on the boards; he couldn't get enough of her dancing. She was a rose-cheeked Mitteleuropa blonde to his flashing, dark-eyed exuberance. Eva's patroness, the Countess Burlington, thought Garrick beneath the dancing beauty who had performed before the courts of Europe, and attempted to break the romance, but *amor vincit omnia* and they were married in 1749. A few years later, Hogarth produced a double portrait of them which is one of the loveliest paintings he ever made. The actor is busy writing his Prologue to a play called *Taste* when he is playfully interrupted by his wife, flowers in her hair, aiming to snatch the quill from him. Garrick's smile suggests he doesn't mind the interruption a bit. It's hard to imagine a sweeter evocation of the informality of a 'companionate marriage' – one rooted in love and friendship. And yet Garrick seems to have been unhappy with the Hogarth, especially the depiction of himself, enough at any rate to decline to accept it even after paying the painter his fifteen pounds. There are signs of a scratch through one of his eyes and, originally, a domestic setting. More than twenty years later Garrick tried again, this time commissioning Joshua Reynolds. Though the later picture keeps something of the gently humorous intimacy of the Hogarth, it is much grander. At the pinnacle of his career, only four years from retirement, Garrick has acquired some avoirdupois along with his international fame, even while Eva, wearing a queenly concoction of silvery silk, lace and muslin, has

287

Following page:
David Garrick and Eva Maria Garrick,
by Sir Joshua Reynolds, 1772–3

become more spare. Set in their garden beneath a romantic sky, Garrick has been reading to his wife. But Reynolds has posed him with the book still open, a thumb marking his spot; the actor has lowered it to gaze at his wife. Instead of returning the gaze she is caught lost in thought, though the thought could as easily be: 'How long this time?'

The garden was by the Thames at Hampton. But its riverside lawn was inconveniently divided from the Palladian villa by the road to Hampton Court Palace. What to do? A bridge would have displeased the neighbours, who included the likes of Horace Walpole, so Garrick had a tunnel built under the road. In 1762, eight years after acquiring the villa, he asked Zoffany to come for a weekend and paint husband, wife and company. Wilson, who thought of himself as Zoffany's mentor as well as his employer, was livid at the thought of being displaced by his own junior and told Garrick so. Garrick put on one of his broadest epistolary smiles and disingenuously told the affronted Wilson not to trouble himself with trifles. But the truth is that Zoffany quickly became the engine of Garrick's promotional machine. At Hampton he rose to the occasion with a pair of graceful conversation pieces showing the home life of the Famous Man. Together they are also the first painted idyll of the English weekend: tea out of doors by the river, the King Charles spaniels flopped on the grass; a discreet servant, Charles Hart, ready to pour; a family friend, Colonel George Boden, making himself at home; and Garrick himself gesturing and speaking to brother George, who is fishing but has turned to hear what David has to say. You can smell lawn, river and cake, and everything smells good. Its pair has Eva leaning on the shoulder of her husband in front of the little Palladian octagonal shrine with its Ionic columns he had built in 1757 for his alter ego Shakespeare. Just visible through the door is the centrepiece, a statue of the Bard commissioned from Louis-François Roubiliac, another London Huguenot, who charged Garrick a huge sum (either three hundred or five hundred pounds, depending on the source). But nothing was too good for Shakespeare. The temple to the Bard housed sacred objects: a chair made from what was said to be

The Garden at Hampton House with Mr and
Mrs David Garrick Taking Tea, by Johann Zoffany, 1762

Shakespeare's own mulberry tree, and other treasures. And at the foot of the little flight of steps in Zoffany's picture is a boot scraper. Woe betide those who might desecrate the shrine of the immortal with riverside mud or the droppings of animals!

The obsession never faded. In 1768, the empire was at its Georgian zenith. Britain had taken possession of French Canada and French India; it was awash in wealth from the sugar and slave economy of the Atlantic and, if there had been unfortunate riots in the American colonies over the Stamp Act, those disagreeable troubles seemed to have receded. The mood was triumphal self-admiration, not least for the greatest writer the world had ever seen. In that same year, the Stratford Town Council wrote to Garrick asking him if he could find a way to contribute a statue or a painting for their new Town Hall. In return they offered him the Freedom of the Town. Flattered, Garrick, who had had Gainsborough paint him leaning on a column with his arm around Shakespeare's bust, the Bard seemingly inclining his head towards his champion as if recognizing their kinship, seized the opportunity. A colossal multimedia production would be mounted in September of the following year. There would be fireworks, a performance of Thomas Arne's *Judith* (perhaps because of the name of Shakespeare's daughter); a horse race; a custom-built rotunda for a great orchestra; a recitation by Garrick of a Jubilee Ode he would compose; and a parade of the most celebrated Shakespearean characters in costume, though no actual plays. But even David Garrick could not control the English weather. Torrential rain crashed down on Stratford. The Avon burst its banks; the horse race and the fireworks were cancelled; and people sloshed around in the muddy rotunda where Garrick still performed as best he could his great Ode. He was not to be defeated, however. Back in London he devised a theatre version of the Jubilee, increasing the size of the orchestra and the massiveness of its sound, and with characters from nineteen scenes distributed around the space. It, too, was multimedia; an immense hit running to ninety performances. Against the derision poured on the Stratford event along with the downpour, Garrick, as usual, had the last laugh.

David Garrick, by Valentine Green, after Thomas Gainsborough, 1769

In 1776 he took his last bow, declaring with immense emotion, and aware of the ambiguity, that 'this is an awful moment for me.' For his final performance he played one of the crowd pleasers, the *young* Felix in Mrs Centlivre's *Wonder*. But that same year he also came back to Lear, and this time dressed the cast not in the usual Georgian dress but something thought to correspond to the ancient British. Antiquarian history was then in style, including books about costume. When the mad old King was reunited with Cordelia, tears flowed freely down Garrick's big face. But then the audience had also noticed wet cheeks in scenes with Goneril and Regan, both from the daughters and their father. The later eighteenth century was in fact the golden age of crying, the surrender to the promptings of the heart. Garrick's waterworks that night were copious. He claimed that he owed his famous version of Lear to having personally known a man who had killed his daughter by dropping her from a window and then spent the rest of his mad life endlessly repeating the action, his face wet with tears. But at that particular moment David Garrick hardly had to act at all.

David Garrick, by Thomas Gainsborough, 1770

5. Lookers

What was so special about Kitty Fisher anyway? Not her beauty, to judge even by Joshua Reynolds's best efforts on her behalf. She had a downy-peach kind of face, creamy skin and a tumbling mass of hair. But Giustiniana Wynne, the Anglo-Welsh Venetian much praised for her own beauty, couldn't see how, with her rather ordinary features, Kitty made a living, much less had become the Toast of the Town. The ultimate connoisseur in such matters, Giacomo Casanova, encountered her in London, draped in diamonds, and was offered her for ten guineas. But he grandly declined on account of Kitty's limited linguistic skills: 'She was charming but spoke only English. Accustomed to loving with all my senses I could not indulge in love without including my sense of hearing.' Nonetheless, legends were already attaching themselves to Kitty. Casanova also reported that 'La Walsh [presiding over a house of assignation for high-class courtesans] told us that it was at her house that she swallowed a hundred-pound bank note on a slice of buttered bread.' Even this stunt was unoriginal (if not apocryphal), for famous Women of the Town before Kitty had also caused a stir by consuming this expensive form of sandwich, to show off their indifference to lucre even as they avidly trawled for it.

What really made Kitty Fisher stand out in the heaving fleshpot of Georgian London was her prodigious marketing skill. She came from the usual obscurity – possibly a stay-maker, possibly a silversmith, for a father – and worked for a while as a milliner, an occupation famous as an apprenticeship to vice. But it would have been impossible, while buying a bonnet from the girl with the bright but rather narrow-set eyes, to have predicted that she would become the maker and manager of her own immense celebrity. According to contemporaries, the famous, both classical and modern, became so by virtue of heroic deeds (Drake) or incontestable and enduring genius (Shakespeare and Garrick). But celebrities were famous for nothing other than the

fact of being themselves. They had to work at their own, ultimately trivial, distinction. Their consciousness that fashion was fickle and their time in the sunshine of publicity likely to be fleeting tested just how skilfully they could seize their moment and make a fortune out of it.

Though she had help from her more illustrious patrons and clients, and from Joshua Reynolds, Kitty was the entrepreneur of her own celebrity; the manufacturer of demand for her face, her body, her aura of merry sensuality. She also made herself into a fashion plate. For about three years, London women, most of them respectable, wanted to know what Kitty was wearing and to imitate her long lace sleeves and the tantalizing combination of shawl and décolletage. Kitty intuitively grasped the conditions which could give her her opportunity. First, the retreat of the court into dimness had been filled by the vast, chaotic carnival of London life: a social theatre that was played out (in parallel with the actual theatre) on the wider public stage of pleasure gardens, coffee houses, salons and parks. The city was a performance space, an arena of insatiable ogling. The strutting, cavorting human comedy of London also needed a rich cast of characters and was forever auditioning for replacements when it tired of last year's personalities. In the previous century the craving for licentious Beauties had been supplied by Charles II's procession of mistresses, all of whom made their way into Lely's portraits, which, in their engraved versions, serviced the bottomless English appetite for sexual celebrity. Now it was papers and magazines, such as *Town and Country* and the *Public Advertiser*, which fed the gossip mill and which had to look elsewhere than the Hanoverian court for a parade of mistresses and courtesans to keep their readers interested. And, not least, Kitty knew, from her own experience, that London sex – at least for girls like her, who set their sights high, rather than the troops of abject, diseased street whores crowding Covent Garden – could bring the grand and the working girl together in ways which horrified incredulous foreigners, more accustomed to keeping mistresses and courtesans well away from the public view. Still more astonishing was the reported phenomenon of

the gentry and aristocracy promoting such creatures from mistress to wife. This week's actress or 'actress' could, apparently, turn into next week's Countess of somethingshire and no one in St James's Park would think it an outrage. 'Only in England!' they exclaimed, rolling their eyes and twirling their quills.

But then, only in England were sex and violence so coupled in a dance of public fame. There were two kinds of affairs which kept the readers of *Town and Country* excited: the military kind and the licentious kind. Happily for editors, booksellers, print shops and painters, the two sets of protagonists were drawn towards each other. Britain's dizzying advance into global empire, especially at the expense of the Catholic powers of France and Spain, had produced a gallery of heroes: many of them young, dashing and impetuously indifferent to risk or contemptuous of convention. They, too, were models for the masters of fashion and had no shame at all at being seen on the arm of their mistress or the most talked-about Women of the Town; in fact, they relished the publicity. This new aristocracy of sword, ship and skirt, the conquerors of India, America and the high seas, posed for the full-length portraits which had previously been the prerogative of the landed nobility.

It was as the celebrant of martial swagger that Joshua Reynolds first encountered Kitty Fisher. He was then in his late thirties, and had been specializing in officer heroes, whom he posed beneath stormy clouds and distant blazes, cocksure invincibility written on their faces, their hair unpowdered, their figures restless with energy, primed and loaded for detonation. It was a world which, even as the son of a Devon schoolmaster, Reynolds knew well; which West Country boy schooled in the deeds of Drake did not? He had been sent to London to work with his fellow Devonian Thomas Hudson. Every so often he would come back west to portray the local worthies, but Reynolds – gregarious, exuberant and precociously worldly – was made for London. He established himself in relatively modest quarters around St Martin in the Fields, but sallied forth in the evenings to the coffee houses and taverns, where he cultivated the theatre crowd and, through

them, writers and jobbing hacks. There never was, in all the annals of English painting, such a born networker so hungry for fame. At twenty-five, he painted his own likeness, palette clasped at an odd angle; a light falling on his face so hotly that he shields himself from its glare, the brilliance perhaps of impending renown.

One of the new-minted heroes, Augustus Keppel, was such a friend that, when the time came for Reynolds to complete his apprenticeship with a stay in Rome, he offered to take him there, gratis, aboard his new ship. Reynolds spent three years in the city, doing his drawings of marvels and Michelangelos and professing to be guided by Renaissance loftiness even as he had Rembrandt and Rubens in his painterly bloodstream. When he came back to London in 1752, a line of Beauties and officers sat for him, and his work was so dazzling that he not only charged the same rates as much more established portraitists but kept putting his prices up. Every morning he began promptly at nine, perfectly shaved, suited and powdered, and went on until five; six or seven days a week.

It was one of his sitters, probably Keppel, one of the many blades who had enjoyed her close company, who first brought Kitty Fisher to Reynolds's studio in April 1759. Or, rather, the truth was that Kitty brought herself, for, as usual, she knew exactly what she wanted out of the painter. Courtesans of her generation enjoyed business opportunities denied to the common harlot or the older style of professional attached to a single patron-protector. Kitty, as the more obvious wits liked to say, could afford to fish around, and the likes of Keppel, Lord Ligonier and Reynolds's own patron Richard Edgcumbe were easily hooked. She had been in the public eye for barely a year, paraded there by one of her beaux, the ensign Thomas King, but she quickly learned enough to choose a particular place and style of showing her wares, and that was on horseback in St James's or Hyde Park. The fact that a new fashion had arisen for women wearing men's riding coats and boots only added to the attraction. Thus kitted out, Kitty was quickly the object of fashionable ogling.

But then she took the game one step further, staging the stunt that

would make her name. Out riding in St James's Park early in April, she stationed herself exactly in the way of an oncoming troop of trotting cavalry so that her mount reared up, throwing her on to the ground. (Doubtless a little spur pressure was applied to guarantee the spill.) As she fell her skirts rose, and stayed that way. Underwear being unknown, a great deal of Kitty was revealed to a cheering crowd of spectators. Kitty burst into a gale of tears, whether provoked by physical hurt or humiliation, but when the tears turned with equal suddenness into giggles it was apparent that little harm had been done. From nowhere, a sedan chair magically appeared, carrying the chuckling girl away to her skilfully organized notoriety. The joke was widely appreciated. The incident, staged for maximum exposure, was immediately reported, drawn, printed and sung in ballads as 'The Merry Accident'. Squibs and caricatures featuring the usual cast of spectators – leering men using spyglasses to peer up her dress; tittering youths – deluged the coffee houses and gin shops. In short order, a spurious 'Memoir' appeared of her adventures, allowing Kitty to respond with pretended indignation, sustaining the publicity. 'Kitty's Fall' became a hit song as soon as it was published, and the courtesan had made herself a Name.

It was not enough. She also needed to be a Face, and there was only one Face-painter who could supply her with the image she had in mind. An introduction was made and Kitty showed up at Reynolds's studio prepared to pay whatever was asked. Why would Reynolds stoop to painting a notorious courtesan, especially when his sights were set on being society's most eminent artist? Well, why not? There was a long tradition of portraitists painting royal Beauties; why should he not do the same for the Toast of the Town? Reynolds did in fact pay a price the following year when the new King, George III, passed him over for Allan Ramsay, and would pronounce him 'poison', even though he knighted him a few years later. It says something about the freewheeling commercial character of British culture that Reynolds was more interested in the promotional potential of painting (and then engraving) images of Kitty Fisher than in what the court might think of it.

Reynolds saw no incompatibility between picturing Kitty Fisher and becoming the patriarch of British painting, faithful, in Reynolds's own mind, both to his classical apprenticeship in Rome and to his great role models Rembrandt and Rubens. Ostensibly, he subscribed to the views of Jonathan Richardson, who in 1715 had argued for painting's role in elevating manners. But the social reality of Georgian Britain was that the barriers between high and low society, the lord and the tart, the grandee and the actress, were more porous than anywhere else in Europe. Reynolds knew this because he lived it. Just a year after Kitty first sat for him, he would move to a much grander house in Leicester Square that would serve as non-stop studio (housing assistants who would be assigned to details of costume or background so that Reynolds's production would not have to slow down) and a place of entertainment for his wide and brilliant circle of friends, so many that one of them complained that Reynolds was always overcrowding his dining table more than was comfortable for the guests. In the same year, a Society of Artists, largely founded by Reynolds, would inaugurate its annual public exhibitions, where every kind of picture from miniatures and conversation pieces to history paintings would be on show. This great, greedy, culturally omnivorous public would flock there less for the moral elevation Richardson had in mind, more to see the latest thing in Famous Faces, whether the new writing sensation Laurence Sterne, whose *Tristram Shandy* was a novel like no other that had ever been dreamed up or written, or the skin-deep charmer Kitty Fisher. And Reynolds, the great ringmaster of the urban circus, would duly serve them up.

For a while, then, Kitty and Reynolds became partners in unembarrassed mutual promotion. She came to him to make the most of her moment: to create an image that was somehow simultaneously refined and teasingly sensual. All the signs are that he leapt at the opportunity. The first of four portraits has Kitty in her trademark black lace and flowing sleeves leaning forward over what looks like the sill of a theatre box and offering the best possible view of her ample bosom. Around her throat is a rope of pearls, the emblem of chastity; a nice

Laurence Sterne, by Sir Joshua Reynolds, 1760
Kitty Fisher, by Richard Purcell, after Sir Joshua Reynolds, 1759

touch, that. Her arms are gently folded, the fingers of the left hand spread so that the sense of what it would be like to touch that creamy skin is transferred from painting to viewer. On the ledge is a note of inspired ambiguity which, since the only words that are visible are 'Dearest Kitty', could either be a love letter, a message from a friend or a reminder of an assignation.

Out of such teases are celebrities made. It took but a few months for the painting to be turned into a mezzotint by Edward Fisher and then published and sold by both Thomas Ewart and Robert Sayer. The images, appearing in Sayer's establishment, pumped up demand and supplied the cult of Fishermania. Versions of Kitty appeared in every possible medium, including a miniature printed on the little circular card lining a watch case to protect the delicate instrument from dust. At moments of boredom or restlessness in court or counting house, you could take the watch from your inside waistcoat pocket, affect an anxiety about the lateness of the hour, and snatch a quick look at the girl of your fantasies. The success of the front-leaning pose and the vaguely searching gaze can be measured by the number of paintings of women, most of them perfectly respectable, who adopted it for their own portraits. Reynolds himself repeated much of the pose for a picture of the courtesan Nelly O'Brien, mistress of the violently abusive Viscount Bolingbroke. She, too, leans ever so slightly forward so that the sunshine can play a game of light and shade on her simple face, down over her perfect throat to the inviting cleavage. But, in the Kitty way, Nelly too has an air of comforting sweetness: a country straw hat on her head, her poodle asleep in the lap where others might lay their head.

Kitty and Reynolds were now partners in the making of their mutual celebrity. Quite how far the extent of that partnership went we will never know. The painter was part of a culture in which high minds could revel in low thoughts. Reynolds would portray his fellow members of the Society of Dilettanti, making the jocund copulatory 'O' with their fingers, thumbs and, in one case, a garter; less startling when one knows that another member, Richard Payne Knight, was the author of a work on the cult of Priapus. So there was bound to be an

Miss Nelly O'Brien, by Sir Joshua Reynolds, circa 1762–4
The Actress Kitty Fisher as Danae, by Sir Joshua Reynolds, 1761

outbreak of sniggering and rib poking at the number of sittings Reynolds seemed to need from Kitty Fisher. And there is one little unfinished oil sketch of her, spectacularly topless and with a small dog by her side, that was certainly not meant for public view and which has all the marks of an erotic memento.

But for general consumption, the sexual teases had, at least, to pretend to be more subtle. Nathaniel Hone's portrait, in which Kitty holds a loose shift over her otherwise exposed chest, also features some heavy punning: a kitten about to pounce on a goldfish. In another, the girl dangerously extends a finger to toy with a parrot (Reynolds's pet).

The most popular of all, though, and the most widely reproduced as a print, is Reynolds's portrait of Kitty as Cleopatra showing off to Mark Antony by dissolving a pearl in a goblet of wine. The carefully composed painting, created in 1759, a few months after Kitty and Reynolds first met, manages, simultaneously, to hit the heights of refinement and the depths of crass innuendo. As she undoubtedly wished, Kitty has been altogether classicized, not just in her little history role-acting but as if she were herself a figure from Roman painting or sculpture; her skin pale, the colours of her antique-ish costume pure and restrained. On the other hand, what she is doing with that pearl, or rather the way she is doing it, is something else entirely. It may be that this is the only way to let the pearl drop, but the circle made by her graceful thumb and index finger would have been seen as an invitation to the sexual act; the more shocking when made by a woman rather than the hellfire Dilettanti. There she is, queen of desire, available and softly accommodating, but only to a modern Mark Antony.

What she got, unfortunately, was John Norris, grandson of an admiral and MP for the pocket borough of Rye. He was known as a notorious wastrel when Kitty married him in 1766, but she may have thought that in this new life she could reform him while she settled into the role of country lady: riding to hounds and doing good works among the poor and sick. She certainly had in mind the competition from another contemporary beauty, Mary Gunning from Ireland (also painted by Reynolds), who had ended up as Countess of Coventry and

Kitty Fisher, by Nathaniel Hone, 1765
Kitty Fisher as Cleopatra, by Sir Joshua Reynolds, 1759

with whom Kitty had a long-running catfight. When asked by the countess where she had acquired a particular dress, Kitty was reported by Giustiniana Wynne to have replied that Mary had better ask her husband, since it was he who had given it to her. The countess, alas, would (and probably did) have the last laugh. Barely four months after marrying Norris, Kitty died. As with Venetia Stanley, malicious wits made a connection between beauty and poison. She had killed herself, it was said, by years of applying a lead-based cosmetic to her face to preserve its perfectly milky complexion.

Moral. Don't go to bed with Fame. Because when you wake up you might be dead.

> Lucy Locket lost her pocket,
> Kitty Fisher found it;
> But ne'er a penny was there in't,
> Only ribbon 'round it.

There were times when the knighted President of the Royal Academy walked the short distance between Leicester Square and Covent Garden, threading his way between piles of ordure; scuttling vermin; howling infants, possibly abandoned; the caked remains of dogs and cats run over by carts and coaches; gin-soaked bodies, deaf to the city roar and rumble, flat out, their heads resting in a gutter brimming over with slops; criers and vendors in their various styles, of oranges and lemons, of pies and buns, ribbons, buttons, knives, mirrors and whips; sleeve-tugging Jews with old clothes stuffed in a bag and three hats one piled above the other like a West End wizard. But Sir Joshua knew what he was doing and where he was going. He was sufficiently interested in the bagnios and brothels of Covent Garden to make a note when a new one, not yet included in *Harris's List of Covent Garden Ladies*, had opened its doors: Mrs Goadsby's, for example, joining the competition with Mother Kelly and the rest. He needed models to pose for the fancy pictures loosely based on classical motifs then in much demand – the bacchante, the dryad, the nymph of the woods – so he trawled the town

307

for beauty. It was a buyer's market. One in eight adult, and not so adult, women in London sold their bodies in some way or other, many of them as a top-up to the pittance they were paid as a servant, a shop girl or a tavern server; many others as a full-time occupation: thirty thousand of them indoors and outdoors, in houses and alleys.

One such girl caught Reynolds's eye in Soho; enormous dark eyes, a cascade of chestnut hair, mouth like a cherry-juice stain and, as for the rest of her, he was put in mind of what his friend Burke, in his *Essay on the Origins of the Sublime and the Beautiful*, extolling the breast, had happily called its 'easy and insensible swell'. She was perhaps thirteen or fourteen, with the cawing tone of the North Country on her tongue, but she did not disappoint. Back in Leicester Square, he turned her into Venus, Dido and Thaïs. Did she have the makings of a different life, perhaps on the stage? For the girl had the warmly outgoing manner needed for the theatre. When there was no more money to be had from selling flowers, Frances Abington, now the adored queen of Drury Lane, once had to turn to the bordello, where she waited on gentlemen as 'Nosegay Fan'. Could this Amy rise from the life of a hoyden? She could, but not on the stage Reynolds had in mind and not through his hand, either.

On a wet day in March 1782, Charles Greville brought his seventeen-year-old mistress to the Cavendish Square studio of George Romney. Greville was the younger son of the Earl of Warwick, a keen student of antiquities, tropical horticulture of the kind brought back from the Pacific by his friend Joseph Banks, and precious stones, which he tried to collect with whatever was left over from the niggardly five hundred pounds per annum of his allotted income. And then there was the extra expense of the girl, Emma (once Amy), going now by the surname he had given her of Hart. She had been callously mistreated by Sir Harry Featherstonehaugh, who had discovered her in a brothel and had acquired her for his exclusive use from Charlotte Hayes aka Mrs Kelly. For a while this went well. Emma was treated as a supper entertainment for his country-house company. It turned out that the girl

had a precocious and cunning knowledge of how best to display her ample charms with this posture and that, to the general delight of his friends. Damned if she didn't look like one of those Greek statues when the candlelight was low. Then arrived the inevitable pregnancy. Swollen, bloated Emma, her skin erupting in eczema, no longer pleased her protector. He contrived reasons to be rid of her: spurious accusations that the bastard could not be his. In desperation she had turned to Greville, the quiet one in the uproarious company. Greville looked at her; with a little polish, she could be his latest gem. He took her to Paddington and set her up, together with her mother, Mary, then going by the name of Mrs Cadogan. The street was Edgware Row, the very same line of urban cottages, of fences and elms and drovers' inns, where Tiny Cosmetic would eke out his days. In return for his benevolence – indeed, as a condition of it – Greville wished Emma to reform in the tradition of penitent Magdalens. She would dress and live in simple domesticity and receive a modicum of decent instruction. On no account was she to gad about town or think of being familiar with anyone other than himself. Given all that the girl had been through: an impoverished childhood in a mean miners' village in Cheshire; service in London, first to a doctor then an actress, which had given her heady ideas; sent hither and thither like a pretty parcel, reduced to earning her bread from her blossoming body; exhibited as an amorous dancer in James Graham's 'Temple of Health', where she pranced gamely about the Celestial Bed (guaranteed to make the impotent vigorous and the sterile fruitful); and thence to Mother Kelly's House for the satisfaction of gentlemen, where Sir Harry, who had particular tastes, found her and made her his toy. Given all that, Edgware Row and Greville were a very Eden of contentment.

Greville had come to Cavendish Square for his own portrait, and Romney had done him proud, or at least in the manner he wanted to be seen: a rather studious fellow amidst all the flashy rakes; soberly dressed, an intense stare off somewhere from beneath the caterpillar brows. But George Romney's own stare was elsewhere, at the girl Greville was talking about; how he had a notion she, too, might be painted

in some or other guise of innocent charm; simply and purely, with a bird or a spinning wheel or some such fancy, and so Romney had reason to look and look, and the more he looked the more he knew he was lost.

George Romney had been searching for someone this artless for a long time. He was at the acme of his success; as much in demand as his rival Reynolds, with whom, it was said, he 'divid'd the town'. For skill at conveying likeness and the brilliance of their technique, there was not much to choose between them; the decision on whether to go to Leicester or to Cavendish Square was as much a matter of social choice – whom one knew and who the recommendation came from – as any quibble of artistic taste. They had both spent time in Rome; both had a sense of drama they brought to their portraits, perhaps Reynolds a little more in the classical vein, Romney in the Romantic temper.

But there the similarities ended. Where Reynolds was affable and gregarious, Romney was notoriously inward, anxious and afflicted with melancholy. Reynolds had sailed out of Devon and into society portraits with connections to the glamorous fleet, but kept something of his father-schoolmaster's hunger for learning. George Romney had been taken out of school at ten in his Cumbrian village so that he could master his father's craft at furniture making. This was not to be despised and dismissed. In his prime he designed and made his own frames, which were in themselves minor works of art and much in demand. When his temper darkened he could take himself off with the lathe and plane, away from the world's idle chatter. Like Reynolds and Hogarth, he too yearned to be a great history painter and thought that would be the only manner in which British art would be able to hold up its head with the Italians, but the histories he had in mind and dabbled in were the wilder poesies of the Bard; Lear, in particular, whom he painted with immense pathos in the act of disrobing on the blasted heath so that he could be a fellow of poor, naked, mad Tom/Edgar.

Reynolds was sunlight; Romney was the tempest. And he had his own history of disaster to live with. In his peripatetic years in the north he had taken up with his landlady's daughter, older by some years, had a child by her and married her. But opportunity took him elsewhere,

Self-portrait, by George Romney, 1784

first to York and then to London. He would send for her when means and occasion allowed, he told her, and then of course he never did. The abandonment stayed with him, a shadow clinging to his fame.

That darkness shades his eyes in the extraordinary self-portrait he painted around the time that Emma Hart was sitting for him. A polar contrast to Reynolds's confident expansiveness, it is inward, brooding, suspiciously self-scrutinizing. And the body language of folded arms is knotted up at the expense of any sort of actual mirror image. Instead of even a gesture towards brush and palette, Romney has taken pains to hide the instruments of his art-making (which feature so prominently in the self-portrait tradition): his hands. Circling his head, the seat of inspiration, is a blooming stain of shadow, like a migraine coming on to strangle him in its painful grip. Ever since Vasari's Life of Michelangelo, there had been a tradition of artists said to be under the baleful influence of Saturn; governed by an excess of the black-bile humour and given to oscillating between the heights of creative euphoria and the abyss of melancholy. Reynolds was the exception; Romney the rule.

But Emma came into his practice and his life like a sudden ray of light in the encircling gloom; so, naturally, he became addicted to her, having her sit, pose, spend time with him, give him a reason (not a pretext) to stare and stare and stare. The result of one of the first sessions in 1782 was a little oil sketch for the full-length painting of her as Circe. It is a visual lexicon of Romney's own confused, aroused longing: the brilliant mouth, the shadowed eyes, the loose shift with its invitation to see more. She was the enchantress, though there is nothing swinish about the pictures. The full length has her striding towards the beholder, lissome, supple, unselfconscious, mistress of a realm larger than Charles Greville and Edgware Row.

Romney was captive, but his creativity brought forth unsuspected freedom. His brush was looser, less calculating; the countless sketches he would make little miracles of light and movement; lustrous ink washes. The contrast with Reynolds's heavily dressed beauties could not have been stronger; Romney posed Emma in the simplest white

dresses: cotton, cambric, muslin, materials that would float and drift and turn with the motions of her sumptuous body. From the first two sittings all kinds of pictures emerged. Then, in all probability, Greville began to be disquieted by his friend's unstoppable enthusiasms, set down on the canvas, and noticed that engraved Emma was starting to attract attention. The sentimental cult of nature was taking hold of the Quality. Emma was its incarnation: at once somehow redolent of classical purity but without the petrification. No woman in English art had ever been painted with as much glowing flesh-and-blood warmth.

A halt was called. Romney went through sixteen long months without Emma at Cavendish Square and then, in 1784, she came back and there was no stopping either of them: Emma in a straw hat like a gypsy, a hand provokingly tucked under her chin; Emma as 'Nature' itself, vine leaves and ivy in her chestnut tresses; *many* Emmas as a bacchante, allowing what was not supposed to be allowed – the open lips of a smile or a laugh, and in one case an exposed breast; full-length Emma in body-hugging classical dress as Melancholy; and to stifle the chuckles, Emma in the personification of domestic virtue, chastely wrapped in a robe, complete with long scarf that no known spinster ever wore at work, sitting at her wheel, one fine thread of yarn held between thumb and forefinger, another guided by her extended little finger. The setting is rustic-romantic (including a chicken), the wheel spins, the girl in white turns her heart-shaped face, framed in the mass of dark hair, to the intruder – us – and we follow the painter in his deathless meltdown.

She had sat for Romney 118 times between 1782 (when there were only two prolonged sessions) and 1784. Other sitters, his bread and butter, were fobbed off. The hardest-working portraitist in London had to force himself to look at anyone else. By 1785, Greville had had enough of this. His mistress had become a sensation. There were occasions when she couldn't help playing to the crowd. In the Ranelagh pleasure gardens, wearing a fashionable cap associated with penitent Magdalens, she sang to a throng of admirers. Greville was not pleased by the spectacle. It was not for this that he had rescued her from the

unspeakable Sir Harry and set her up in the cottage on Edgware Row. Desire began to yield to distaste. He was now Treasurer of the Royal Household, a sinecure held through his father the earl and the young Prime Minister Pitt, but he needed money, the kind of money a marriageable heiress would supply. What he did not need was Emma.

A scheme was concocted, the cynicism of which would make Sir Harry, by comparison, seem positively angelic. Greville's uncle Sir William Hamilton, ambassador to the Kingdom of the Two Sicilies in Naples, antiquarian and classical scholar, learned guide to intrepid Grand Tourists wanting an ascent of sulphurously smoky Vesuvius, had visited and had looked at Emma a second or two longer than ought strictly to have been the case before hurrying his glance away. A bacchante had been ordered from Romney expressly for the widowed Hamilton, to brighten his days in Naples. In 1786 Greville suggested that Emma might like to travel back with Hamilton, provide some charming company, don't you know, for the benign uncle? All innocence, she agreed; what else was she to do?

Greville, however, had told Hamilton a quite different story: that Emma was coming as Hamilton's mistress and was complaisant in the matter. For a time she remained ignorant of what was afoot. Greville had told her he would be joining her in Naples. When he failed to come and the uncle made advances, met with furious, distressed rejection, the ugly truth came out. Greville had passed her to his uncle like a bill of exchange and now he instructed her to be obedient and accept that she was to be Hamilton's mistress. So much for all his sanctimonious talk of making a reformed Magdalen of her, of letting her be painted in chaste white. Emma's letter to Greville was an explosion of anguished fury: '... now you have made me love you, you made me good, now you have abandoned me.'

> ... if you knew what pain I feel in reading those lines where you advise me to W[hore]. Nothing can express my rage! I am all madness! Greville, to advise me! you that used to envy my smiles! How, with cool indifference, to advise me to go to bed with him, Sir

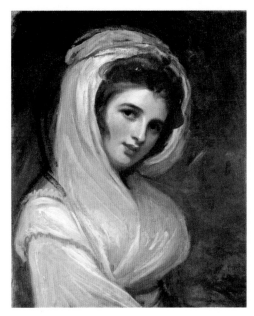

Emma, Lady Hamilton, by George Romney, circa 1785

Wm . . . I wou'd murder you and myself both . . . I will go to London, their [sic] go to every excess of vice till I dye, a miserable, broken-hearted wretch, and leave my fate as a warning to young whomen [sic] never to be two [sic] good.

But what could she do? At Naples, Hamilton was at least kind to her, enough for her, eventually, to give him what he wanted. In return, he treated her as an ambassadorial consort; a *maîtresse en titre*. There was much about Emma, in addition to the pleasures of her voluptuousness, that he loved: her artless candour; her incorrigible exuberance. Rather than hiding her away, he took her to the Bourbon court, where Queen Carolina befriended her. Emma took to performing her costumed Attitudes and turned out to be something of a genius in designing her own productions. Genuine warmth grew between her and Sir William amidst the Campania pines, and Emma turned fond enough to think and then speak of marriage. Being Lady Hamilton would show the world something and would efface all she had suffered.

In 1790, not yet wed, Hamilton and Emma returned to London. Electrified at the news, Romney cancelled sittings with almost everyone else. She came back to him; yet more pictures were produced, many of them versions of the Attitudes. The odd trio – Romney, Emma and Hamilton – were Grub Street heaven. *Town and Country* gossiped, the *Public Advertiser* prattled. Prints of Emma in this and that hat poured from the presses. Her face appeared on china and snuffboxes. She was a cult. She had every reason to be content.

And then, as in the best and worst sentimental romances, lightning struck. Lightning was short, uncouth, brutally merry, self-possessed and called Horatio Nelson. The first time he came to Naples in 1793 was a glimmer; the second time, when his ships had to take the Bourbon court and the *casa* Hamilton under protection and get its inhabitants to safety, out of the way of the French to Sicily, was Vesuvian fire. Emma could not help herself and surrendered to it, first as nurse to Nelson's mutilated body and painful eye socket; then to everything else. Poor Hamilton, now in his sixties, resigned himself to

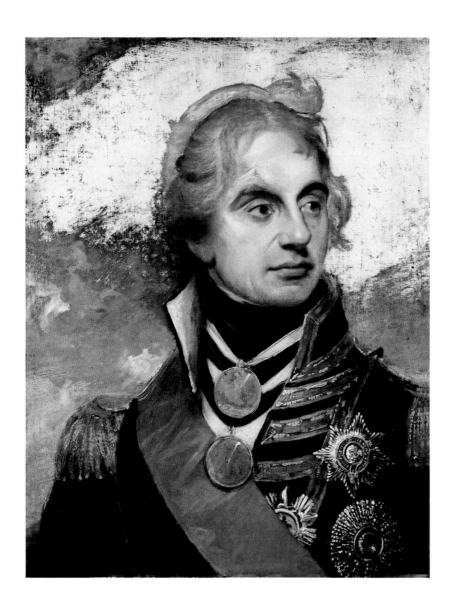

Horatio Nelson, by Sir William Beechey, 1800

it, prepared to suffer the humiliation, anything except the loss of her. Nelson was himself married, and with his abandoned wife, Frances, or Fanny, refusing to countenance any kind of divorce, there was nothing for it but an extraordinary *ménage à trois*.

It relocated to England, where Nelson bought the villa of Merton Park for the three of them. The publicity hounds of the press of course ate all this up, especially when Emma swelled with Nelson's child, their daughter, Horatia, supplying the caricaturists with endless ribaldry. Even more breathtakingly, there were appearances of the four of them in public, at the opera and the theatre, in which Nelson behaved vilely to his cruelly treated wife. Not everyone liked the parade they made of their passion. Emma was a shopaholic who stuffed Merton Park with Nelsonian bling. Lord Minto, in his thin-lipped, aristocratic way, sneered that 'not only the rooms, but the whole house, staircase and all, are covered with nothing but pictures of her and him, of all sizes and sorts, and representations of his naval actions, coats-of-arms, pieces of plate in his honour … the flag-staff of L'Orient, &c.' It was, Minto concluded, 'a mere looking-glass to view himself all day'.

Somehow, though (perhaps inured to any permutation of ostentatious passion by the Prince of Wales), England did not repudiate the admiral and his mistress. Emma Hamilton, celebrated for nothing much except being herself and the most beautiful woman in England, was wrapped in the flag of Nelson's deserved renown. Her looks became one with his deeds. Together, as he liked to think, they conquered both France and Britain. It helped, of course, that Nelson was the genuine article: marrying courage and audacity to tactical and strategic genius. At Aboukir Bay he had saved the British empire; at Trafalgar he would save Britain from invasion. That threat was not trivial. There were 400,000 troops waiting at the camp de Boulogne. Napoleon had made a special exhibition out of the Bayeux Tapestry as boast and prophecy. The hero took that ambition and sank it.

The price was fatal. England had never seen such a funeral, certainly not for any monarch. Nelson's body, shipped home in a cask of spirit

to preserve it, lay in state beneath Thornhill's painted ceiling at Greenwich Hospital, where an estimated hundred thousand grief-stricken Britons passed before it. On the day of the funeral, his body was taken by barge upriver to Whitehall landing, draped in black. Immense crowds lined the bridges and then the streets as it was borne on a carriage modelled to resemble the prow of the *Victory* to St Paul's. Thirty thousand guardsmen escorted the carriage. Another seven thousand were inside the cathedral: all the Great and the Good of the country, and especially the navy, including, controversially, the common seamen from the *Victory*. The government was still nervous of crowds, but it knew to deny the seamen entry was to ask for riotous trouble. At the conclusion of the service, Nelson's body in its immense sarcophagus – such a vast weight for a little hero – was lowered through an opening at the dead centre of Wren's great dome, into the crypt. The flags of his ships were supposed to be laid upon it, but at the last minute the seamen seized one of the biggest and rent it there and then into pieces so that each could carry it forever with them.

Two people were missing: the wife and the mistress, Fanny and Emma; both kept out. Hamilton had died two years earlier. Emma had her mother, Mrs Cadogan, and her daughter, Horatia. A second daughter had died as an infant. For a few years she managed to keep the creditors away – for Nelson had not left her much – and there was an audience for the Attitudes, though, as she was growing stout, this was increasingly likely to provoke hurtful ridicule. The sharks closed in. Fame was fled and mere celebrity was unequal to the task of keeping up appearances. The house was sold off to the kindly Jewish banker neighbour Asher Goldsmid, who had helped with loans but who ended up, like his brother Abraham, who had thrown an immense party for Nelson, committing suicide. Emma and her mother went from pillar to post, ending up in Calais, a servant in tow, in a small apartment, where Emma died in 1815. George Romney had himself died in 1802, leaving behind *hundreds* of Emmas, all shapes and sizes, quasi-finished, definitely unfinished, to bewitch future generations with Circe's spell.

6. Halls of Heroes

It was all very well celebrating and mourning heroes in wartime, but did peacetime Britain need them as well? Even as level-headed a writer as John Stuart Mill thought so. In 1832, the year of Goethe's death, Mill wrote that the modern age was wanting in genius and that the 'deficiency of giants' was being filled by 'a constantly increasing multitude of dwarfs'. The heroes of the French wars were either, like Nelson, dead or else, like Wellington, had hardened into flinty authority figures. The ultimate romantic hero, Lord Byron, had died unheroically of a fever, albeit while doing what he could for the romantic cause of Greek independence. Shelley had drowned in the bay of La Spezia. Politics was dominated by Whig grandees such as Lord John Russell, or prosaic northern industrialists such as Sir Robert Peel.

Eight years later, Mill's friend Thomas Carlyle, historian and scourge of the small-minded, delivered a set of six public lectures in London *On Heroes, Hero-Worship and the Heroic in History*. Though the activity would become one of the great Victorian cultural phenomena – mastered supremely by Coleridge, Hazlitt, Dickens and Thackeray – it did not come easily or naturally to Carlyle. He who thundered on the page confessed that when he had to perform in public, his tongue would become 'dry as charcoal'. Money had first driven him to the ordeal in 1837. His *French Revolution* had been acclaimed but as yet had not earned him very much. Throughout the weeks of preparing the lectures sleep deserted him, headaches hammered at his temples and only the daily ride on his mare, Citoyenne, could calm him. Yet Carlyle felt he must address the 'meanness' of the 'Times', as he called them, the misplaced admiration given to the paragons of the soulless 'machine age': railway and shipping magnates; bankers and factory owners; men who lived by the rewards of the counting house rather than being fed by spiritual imagination.

Once, Carlyle had thought that the world was made by the many,

not the few; by 'innumerable biographies'; now he had come to believe that the 'history of the world is but the biography of great men'. It was precisely because of his own age's suspicion of the great (starting with the still-raw memory of Napoleon) that Carlyle sought to reassert their moral and creative grandeur.

> I liken common languid Times, with their unbelief, distress, perplexity, with their languid doubting characters and embarrassed circumstances, impotently crumbling down into ever worse distress toward final ruin; – all this I liken to dry dead fuel, waiting for the lightning out of Heaven that shall kindle it. The great man, with his free force direct out of God's own hand, is the lightning. His word is the healing wise word which all can believe in.

Carlyle objected especially to the whittling down of genius by endless historical contextualization; to the reduction of independent minds to mere expressions of the age.

> Show our critics a great man, a Luther for example, they begin to what they call 'account' for him; not to worship him, but take the dimensions of him –, and bring him out to be a little kind of man! He was 'the creature of the Time', they say; the Time called him forth, the Time did everything, he nothing – but what we, the little critic, could have done too! This seems to me but melancholy work. The Time call forth? Alas, we have known Times *call* loudly enough for their great man; but not find him when they called! He was not there . . .

Thus Carlyle appeared before his audience, handsome, simply dressed, the seer in his mental toils, to make good this charisma shortage. Caroline Fox the Quaker diarist was there, and watched 'a glow of genius . . . flashing from his beautiful grey eyes, from the remoteness of their deep setting under that massive brow . . . he began in a rather low nervous voice with a broad Scotch accent but it soon grew firm

and shrank not abashed from its great task.' It was, she thought, that he must have felt that his thoughts were so weighty that they resisted communication within the frame and form of a mere lecture. Carlyle often expressed his fear of base popularity, even as it pursued him. 'When the Englishman's sense of beauty or truth exhibited itself in vociferous cheers he would impatiently, almost contemptuously, wave his hand as if that were not the sort of homage which Truth demanded.'

Carlyle paraded his cast of mighty men (and they were, of course, exclusively men) – Luther and Oliver Cromwell; Dante and Shakespeare; Muhammad and Rousseau – before his audience, making their presence as immediate and vivid as he could. His chosen instrument was word-painting. He himself thought portraits were worth 'half-a-dozen written Biographies'; and that character could be read in physiognomy. He and his wife, Jane Welsh Carlyle, covered the walls of their Chelsea house with every conceivable portrait, painted and engraved, that could be found of the favoured Greats, and his lectures did their best, without benefit of lantern slides, to convey the look of the heroes: 'In Cranach's portraits I find the true Luther. A rude plebeian face; with its huge crag-like brows and bones, the emblem of rugged energy; at first; almost a repulsive face. Yet in the eyes especially there is a wild silent sorrow.' Sometimes the painting was anti-heroic, the better to contrast with the paragons. Dr Johnson was a titan, but his companion and biographer Boswell, on the other hand, was betrayed by his face: 'In that cocked nose, cocked partly in triumph over his weaker fellow creatures, partly to snuff-up the smell of coming pleasure and scent it from afar; in those bag-cheeks, hanging like half-filled wineskins still able to contain more, in that coarsely-protruded shelf-mouth, that fat dewlapped chin; in all this, who sees not sensuality, pretension, boisterous imbecility enough.'

The greatest figure of all, for Britons and for the world, was William Shakespeare: 'the chief of all Poets hitherto; the greatest intellect who, in our recorded world, has left a record of himself in the way of Literature . . .' The want of images of Shakespeare was such that Carlyle could not bring himself to word-painting, contenting himself instead

with exhilarated astonishment that such a genius could emerge from the stock of what he called a 'Warwickshire peasant'. But the highest accolade he could give Shakespeare was that he was a 'calmly *seeing* eye ... it is in ... portrait painting, delineating of men and things, especially of men, that Shakespeare is great ... no *twisted*, poor convex-concave mirror, reflecting all objects with its own convexities and concavities; [but] a perfectly *level* mirror'. Only because Shakespeare was such an observer, such a portrayer, could he make so various a cast of human types – an Othello, a Juliet, a Falstaff – come so completely and richly alive.

Carlyle thought Shakespeare was the reason to be happy to be British; the incomparable gift to the world. He posed a rhetorical question. If one were forced to give up either the Indian empire or the works of Shakespeare, which would it be? A foolish question really, for 'this Indian empire at any rate will go but this Shakespeare does not go.' If only, then, Shakespeare had painted his own self-portrait! But since he had not, Carlyle must have been delighted, seventeen years later, to see that the very first painting presented to the newly established National Portrait Gallery was the so-called 'Chandos' portrait of the Bard. It had been given by Lord Ellesmere, one of the Good and the Great, who had finally persuaded Parliament to establish and fund (albeit on a modest scale) such an institution. The championing of a portrait gallery of historical figures had been the obsessional cause of another aristocrat, Viscount Mahon, who was himself something of a historian and who wanted to counter the banality of the machine age with a gathering place where Britons could commune with their heroes. By his own account, Mahon had been moved by seeing something of the same in the historical museum at Versailles, and ground his teeth somewhat at all those images of Napoleonic battles and the faces of the marshals and wondered why on earth his own incomparably grander nation, the victor after all, should not have something similar. Why, moreover, should British history be left to the Dr Dryasdusts guaranteed to bore the reader to sleep with their musty volumes, all written in a tone of lapidary remoteness and deadly decorum?

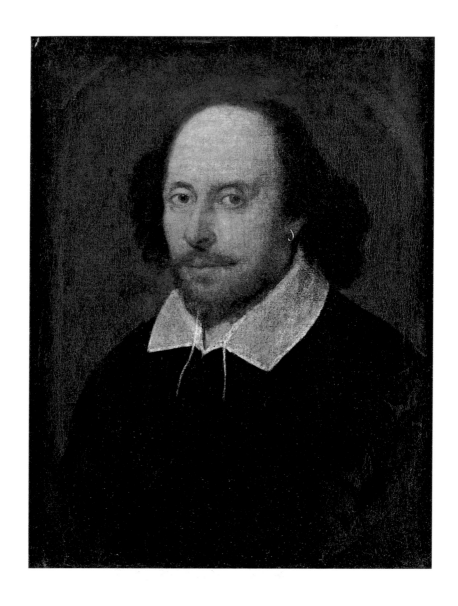

William Shakespeare, associated with John Taylor, circa 1610

Others had had similar ideas. Sir Robert Peel had started to assemble a collection of historical worthies at his Staffordshire country house, Drayton Manor, though the project had come to a halt with his death in 1850. On the Whig side, Henry Vassall-Fox, 3rd Baron Holland, had begun a gallery of oils and busts at Holland House, where the gatherings of luminaries he liked to assemble – among them Macaulay, Scott and Disraeli – could muse on the mystic connections tying together the British past and present. It was the 4th and last Baron Holland who brought the painter G. F. Watts to Holland House to add to the gallery, though Watts seemed a lot more interested in painting Holland's slightly bug-eyed wife, Lady Mary Augusta, over and over again. In his turn, though, Watts, the most historically minded of Victorian painters, a friend of Gladstone, Lord John Russell and Tennyson, and who was creating a fresco cycle of lawgivers through the ages at Lincoln's Inn, wanted to create his own 'Hall of Fame', featuring 'individuals whose names will be connected with the future history of the age', all recorded 'as inartificial and true as possible'.

But these were all private exercises in collective historical self-admiration. When the National Portrait Gallery finally opened its doors in 1859 in modest quarters in Great George Street, not far from the Palace of Westminster, it was intended, like Stowe's Temple and Poets' Corner, to be a place of public instruction in the great epic of the British past. The national mood in the 1850s swung between triumphal self-congratulation and anxious self-scrutiny. After nervousness in 1848 that Chartism might bring the revolutions sweeping over Europe to Britain, that movement had fizzled out in mass meetings which could not bring themselves to cross the line from Sunday speeches to gunfire. Instead of insurrection there was the Great Exhibition of 1851, where millions came (some of them on discounted railway tickets) to marvel at the heavy machinery of the industrial empire. There was nothing like imperial swagger as a bromide for discontent. On the other hand, matters did not go uniformly well in the years that followed. Newspaper reports from the front in the Crimean War told stories of inconclusive manoeuvres and death-trap

hospitals. The shock of the Sepoy Rebellion in India followed shortly after. The next year, 1858, was the summer of the Great Stink, in which the sewage and slaughterhouse refuse clotting the Thames produced not just stench but an epidemic of sicknesses for those whom an exit from the poisoned city was not an option. The climax of Dickens's *Little Dorrit*, published in 1855, sees the house at the centre of the story, morally as well as structurally rotten, collapse in on itself in a great spasm of destruction, burying a money-mad, mean-minded, grasping ethos in its debris.

But, as if in defiant response to these omens and warnings, the 1850s also saw an extraordinary flowering of cultural institutions, all designed to reassure the British people that they were, in fact, living at the centre of the 'civilized world'; its benefits to be shared by high and low alike, and that the story of Britain, combining, as it did, liberty with material progress, was an apogee of human achievement. In 1856, the Turner bequest went on show at the new quarters of the National Gallery in Trafalgar Square, five years after the death of the great painter. In 1857, the South Kensington Museum (later known as the V & A) opened the doors of its handsome new premises. It had been established five years earlier to make the best of contemporary art and design accessible to the public, along with courses of instruction in the material arts. Proceeds from exhibitions would in their turn fund a 'Museum of Manufactures'. William Dargan, the great mogul of Irish railways, was not only the driving force behind the establishment of the National Gallery of Ireland but (to his ruin) the impresario of a Dublin Exhibition held on Leinster Lawn in 1853. Not to be outdone, Manchester had its turn in 1857, with the mother of all art shows, 'The Treasures of Britain': *sixteen thousand* works of art, with the British tradition at its heart, displayed in vast (but temporary) halls of iron and glass. The ruling sovereigns of Europe, beginning of course with Victoria and Albert, all visited, and factory owners gave their workers the day off and free transport there to walk through the marvellous show. Even Ruskin, normally horrified by anything smacking of crowd-pleasure, was forced to admire some, if not all, of it. Before it

closed in October 1857 after a six-month run, 1.3 million visitors had walked through its halls. All these massive public projects were designed to advertise to Britons and the rest of the world that the alliance of creative design, commerce and technology announced a great modern British renaissance.

The man who had been at the hub of the Manchester show, its art secretary, was the art historian, book illustrator and painter of classical antiquities in Asia Minor George Scharf, who proved that a career in art need not necessarily be incompatible with efficient administration. Lord Ellesmere, who had donated the Chandos Shakespeare to the National Portrait Gallery, and who had a hand in almost all the cultural enterprises of the times, including the Manchester show, snapped Scharf up to be the first Secretary of the National Portrait Gallery, then to be promoted to Director, in 1882. He would stay in that post, publishing the occasional learned article on its holdings, especially the Chandos 'Shakspeare' (as he insisted on spelling it), in *Notes and Queries*.

Compared to the imperial scale of the temporary shows and the ambitions of the Kensington museums, the National Portrait Gallery was a cottage of painted memory. Its modest quarters in Great George Street meant that display was limited to forty-odd pictures. The Trustees, including Macaulay and Carlyle (who could agree on hardly anything, including their respective reputations, except this), had restricted the display to portraits of the eminent dead, thus precluding paintings by gifted painters such as Watts, who was eagerly recording writers and politicians of his own times. But then, the gallery was also supposed to be acquiring works only according to the historical significance of the sitters rather than for any artistic quality.

Despite all these difficulties, once the gallery was given more space at South Kensington, it became popular enough for staff to be concerned about overcrowding, especially during the long Easter weekend when handlists of the paintings were available gratis. The crush was so great that umbrellas and walking sticks had to be left at the entrance.

Interior of the south wing with Sir George Scharf seated, South Kensington,
by unknown photographer, 1885

Among rows of worthies, only one portrait in the early collection was an enduring masterpiece: Sir Thomas Lawrence's unfinished painting of the abolitionist campaigner William Wilberforce. Painted in 1828, two years before Lawrence's death and five before Wilberforce's demise, it was the meeting point of two dramatically different careers. In his prime, Lawrence had been the supreme glamourist of Regency Britain, always ready to make the Prince Regent himself thinner, more handsome and more dashing than he ever was; apply his flashing highlights and his capture of fabric and flesh to Beauties and soldiers. No one in his generation captured the romping playfulness of children with as much freedom; possibly because he himself had been a child prodigy, forced to grow up a little too quickly by his serially bankrupt father. The six-year-old Tommy was paraded before the likes of David Garrick and made to recite poems or supply an instant likeness in pastel. Disastrously in love with *both* the daughters of Sarah Siddons, transferring his ardour from one to the other and losing both, Lawrence never married and kept his emotions tightly buttoned. But he made radiant portraits. Actresses, princes and generals all got the Lawrence treatment of brilliant colour; poses which suggested, but with subtlety, the essential character of the sitters: the spirited animation of the actress Elizabeth Farren; the lethally magnificent disdain of Wellington. But the Wilberforce commission was a different challenge for the President of the Royal Academy. The abolitionist hero was not long for this world. Ten years older than Lawrence, he was an encyclopaedia of ailments: ulcerative colitis, feeble eyesight, almost to the point of blindness, and chronic spinal pain had made him resign his Parliamentary seat in 1826, just as the campaign proper to abolish slavery was getting a head of steam. Lawrence was being called on to preserve for the nation the memory of an evangelical hero; and the formal vocabulary in which this could be done had to be at the same time sober and sympathetic.

Lawrence manages to register the famous affability of Wilberforce's personality by what looks, at first sight, to be a disarmingly informal pose: the gently gathering smile; the eyes simultaneously cordial but

searching. Wilberforce's numinous brow, hair handsome but grown silver from a life spent on the great campaign, the whole face a presentation of sweetness and light, is all the more radiant when set off by the dark corona of the brushed-in ground. That the coat, usually such a feature of Lawrence's grandstanding show portraits, while freely and beautifully sketched, remained unfinished almost testifies to the insignificance of dress beside the stature of the man.

In fact, Lawrence had executed yet another of his doctored appearances, but this time in an act of transforming empathy. What appears to be Wilberforce's relaxed lean to one side was in fact the product of his crippling back condition: a curvature of the spine so extreme that he was forced to wear a brutal metal apparatus to prevent a complete vertebral collapse. The tilt of Wilberforce's head that looks like a mildly quizzical engagement with the beholder was likewise a discreetly edited portrayal of the lolling forward of which he was gradually losing control. Only the unseen brace supporting the back of his neck prevented poor Wilberforce's head from collapsing altogether on to his shoulder or chest. Somehow, Lawrence manages to allude to these ordeals without making Wilberforce their victim. Instead, the disabling pain seems vanquished by the force of the hero's unconquerable decency and humane sympathy. 'Am I not a man and a brother?' was the famous motto adopted by the abolitionists for their crusade, always accompanied by the image of a chained slave. It might almost have been equally adopted for the great portrait, so that liberal-minded Victorian mothers and fathers bringing their children to the National Portrait Gallery could stand them before the picture and say, 'Now, that is a Briton.'

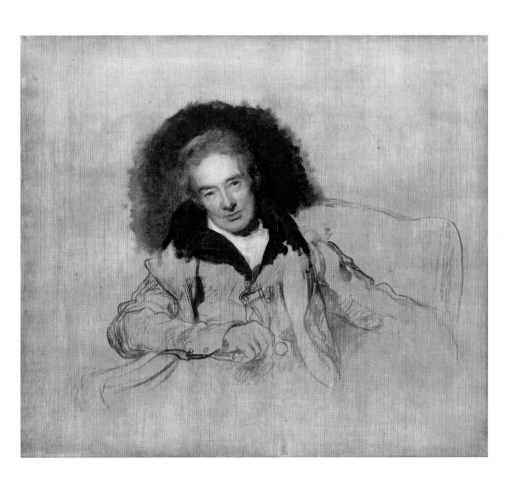

William Wilberforce, by Sir Thomas Lawrence, 1828

7. *Farewell to the Famous*

The dark day must have been in 1955. I remember it as cold but that might be because the calamity gave me the shivers. It was the day I had to say goodbye to my own portrait gallery, all my famous uncles and aunties: to Jack Hobbs and Stanley Matthews, Steve Donoghue the jockey and Ted 'Kid' Lewis the Jewish boxer, to naughty George Formby and nice Mr Attlee, to George Bernard Shaw and to Bud and Ches and the Crazy Gang, to Winston Churchill and our Sally down the alley, Gracie Fields, who wished me luck and waved me goodbye. But I couldn't join in her song, nor was I ever likely to believe Auntie Vera when she promised me we'd meet again and that the bluebirds would really be over those white cliffs of you know where. They were all gone, all my famous ones. John Lewis had seen to that; not the Never Knowingly Undersold JL, but the dangerous, ruthless John Lewis, like me aged ten, and now, I had to concede, the supremo high-roller of cigarette-card games. We had gone head to head during lunchbreak in the playground: his collection against mine; a death-match series of Flicksies, Dropsies, and the killer, only for the truly skilled, Topsies. Flicksies was the warm-up; a seven-year-old could do it; just flick yours on to the card leaning against the wall and, if it fell, you got the two, and so on. Dropsies was for sissies; you just needed your card to lie atop another. But Topsies was a matter of free flicking *and* overlaying and was definitely not for the under-tens or those of a nervous disposition. It was hard to bring off, so many cards were likely to lie on the ground waiting for one to cover the one before. But I had prevailed in many a Topsy bout. On this day, though, the cards, the Ogdens and the Players, the W. D. and H. O. Willses, all rained down inconclusively. My collection was running down, fast. John Lewis, with his short haircut and tight little mouth, seemed to have untold reserves. Desperate, I was forced to do the unthinkable: gamble a Gally. Gallies were Gallahers: the thickest, stiffest, most

beautiful cigarette cards of all; strong enough to do the bidding of a ten-year-old flick. I had six left. I'd go for broke.

Cigarette cards ended up being the people's portrait gallery, but they began life in the last quarter of the nineteenth century purely functionally as an anti-crush insert in the packs. The idea of printing pictures on the cards as a bait for brand loyalty began in the United States, where smokers were encouraged to collect whole teams of baseball players or vaudeville favourites. Britain began by being typically more hifalutin, recycling Victorian photographs of the Great – many of the same names that could be seen in the National Portrait Gallery – and which had already been used for *cartes de visite*. Thus photographs of Disraeli, Gladstone, the Queen and the Prince of Wales, military heroes such as Gordon of Khartoum or Kitchener – even a very early picture of the elderly Duke of Wellington – were a bonus for staying loyal to this or that brand. There were also music-hall stars, Gaiety Girls, society belles, authors such as Wells and (before his fall) Wilde, and if one had a mind to it, one might be able to collect an entire set of the mistresses of Edward VII.

The First World War may have been a graveyard for the traditional kind of pantheon, but smoking had conquered the country both in the trenches and on the home front and had become a woman's habit as well as that of men. Fashions and sportsmen were added to the canon, and cards now came with a dense screed of description in tiny print on the back; whether of the career of a boxer or the films of a silent-movie star. The essential thing was to make the series as extensive as possible so that collector-smokers would not flirt with Bloggs's Virginia Gold and their golfers or racehorses. Politicians were now often represented by artfully elegant images from *Punch* cartoonists or caricaturists, used to doing celebrities in *Vanity Fair* and *Bystander*. Occasionally, the cards used serious talent such as Alick Ritchie, who had been trained in the École des Beaux-Arts in Antwerp before becoming a commercial artist and poster designer back in London. Ritchie acquired a reputation for mocking avant-garde art, especially

CHARLES CHAPLIN.

Rt. Hon. DAVID LLOYD GEORGE.

Mr. GEORGE BERNARD SHAW.

JACK B. HOBBS.

cubism, but he himself had something of an art deco aesthetic and his miniature portraits of the likes of Chaplin, Lloyd George and Shaw are tours de force of descriptive shorthand.

In addition to the famous, there were cards of everything and anything that might feed the collecting mania: butterflies and moths, old roses, dandies through history; castles of Britain; rulers of the Balkans; railway trains and steamships. The texts on the reverse became so detailed that they constituted a miniature lecture on the chosen subject. Not for nothing were sets of the cards known as 'the poor man's encyclopaedia'. My own first book (written at the age of eight) was a history of the Royal Navy principally consisting of cigarette cards with bits of research borrowed from the back on vessels from the Tudor *Mary Rose* to the aircraft carrier HMS *Ark Royal*.

It was just as well that those treasures were not available for my last desperate throw. Of the six remaining Gallies, I flicked two: one greyhound; one Society Beauty. Then came catastrophe. Lewis's Ogden landed squarely on one of my cricketers, masking it entirely. A howl of glee went up from the wall of boys watching the shake-down; something akin to the baying of hounds when the quarry is down and blood has been drawn. Lewis was on his hands and knees, scooping up his winnings; my lost treasures. I fled the scene, clutching my last four Gallies, sobbing so inconsolably that even the offer of a Marmite crumpet could not check the tears.

I had lost my portrait gallery. Now I'd have to go and see the one round the corner from Trafalgar Square.

Charlie Chaplin, David Lloyd George,
1st Earl Lloyd George,
Sir John Berry ('Jack') Hobbs, George Bernard Shaw,
by 'Alick' Ritchie, 1926

IV

The Face in the Mirror

1. . . . but on Reflection

A good-looking teenager catches sight of himself in the mirror of a still pool. Happening, as this does, long before the age of flat mirrors, it is the first time he has beheld his own rosy lips, dark eyes and shock of curls. Not so bad, a teenager might think, not a pimple anywhere, making a mwah-mwah *at his own grin. But this sixteen-year-old isn't joking. He is horribly smitten; taken by the violent onrush of love. Staring, not daring to move a muscle, Narcissus is impervious to everything and everyone else, especially the nymph Echo, to whom he has already given a heartless brush-off. Poor, formerly chatty Echo, punished for failing to reveal the carryings-on of Zeus – as if anyone needed a bulletin on that score – had been robbed of the gift of starting a conversation, reduced instead to repeating the fag end of anything she happens to hear. She does what she can with this limited means of introduction. 'Anyone here?' yells Narcissus when he gets the feeling he's being stalked. 'Here,' cries the plaintive Echo, trembling invisibly in the glade. It's no way for a girl to make an impression. Hurt by his indifference, she wastes away, becoming nothing but a heap of brittle bones before disappearing altogether into what's left of her voice.*

Really, men, what a sorry lot! The goddess Nemesis decides to punish Narcissus by letting him know, first hand, how unattainable love can do you in. Cue the pool, pond, spring, fountain, depending on how you translate your Ovidian fons. *Narcissus can look and look, but the second he reaches towards his beloved with his hand, with his lips, the beautiful boy disappears in the ripples. Spectators see a crazy person crying, talking to himself. 'O lovely youth,' he sobs, his head shaking and breaking the vision in the water: 'Why do you flee me? . . . Why do you vanish when I come to you, just as I reach out to you? . . . when I smile, so do you; when I weep, I see tears pour down your face . . .' He's not the brightest, our Narcissus, so dim in fact that, later, incredulous authors would rejig the myth to give him a sister for whom he has an incestuous passion, thinking it is her face which appears on the water. (This is supposed to be an improvement.) Either way, desperation takes its*

toll. His flesh attenuates, turning paler and paler until there is nothing left but a spectre. Pity at his plight stirs among the gods, but they are too late. Narcissus has become a spray of white petals with a yellow heart at its centre, rooted beside the mirroring water. In the second century CE*, the travelling note-taker Pausanias claimed he had found the site of the Narcissian transformation on the chilly summit of Mount Helicon, beside the spring of Lamos. Cold and humid, the bloom was thought just right for funerals, but beware: its fragrance carried the power of great, if pleasurable, drowsiness: the condition the Greeks call* narke*. Apparently, self-infatuation was the first narcotic.*

Almost a millennium and half after Ovid, in Florence, Leon Battista Alberti would write that that instant of narcotic rapture was the origin of all painting. In Book II of *Della pittura*, the first theoretically loaded treatise on art, Alberti defines painting as a vision of depth, an illusion projected on to a perfectly flat surface. 'Consequently, I used to tell all my friends that, according to the poets, the inventor of painting was Narcissus, who was a flower, for as painting is the flower of the arts, so the tale of Narcissus fits our purpose perfectly, for what is painting except the embrace, by means of art, of the surface of the pool?'

How like the humanist optimist of the Renaissance to make the best of a bad situation. Earlier commentators and recyclers of the myth had always taken its moral to be chastening. 'Has the story of Narcissus frightened you?' Petrarch asks in his *Secretum*. Then beware the spell of vain apparitions. Never confuse surface with depth; illusion with reality. But Alberti shoos away the homily. The pathos of the floral metamorphosis becomes instead a self-congratulatory bouquet presented by painters to themselves. Perspective captures what had eluded Narcissus. Through the application of optical mathematics, the mirror-surface could metamorphose into an open window behind which depicted objects and figures take on an independent life of their own. Flatness is punched through to make the infinite depth in which stories could be enacted. Having his cake and eating it, as Renaissance

writers were wont to do, the ingenious Alberti elsewhere concedes that painters fully understand that they are in the deception business. Even when art is committed to collapsing the difference between our perception of reality and our perception of a painting, it knows it is offering nothing more than a beautiful trick – but then again, why would you not want that?

Lucian Freud, twenty-five years old, drew Narcissus absorbed in his own reflection. He had been commissioned by the publishers MacGibbon and Kee to illustrate Rex Warner's compendium of myths *Men and Gods*. All of his chosen heroes – Actaeon, Hercules and Hyacinth – came to bad ends; the last another floral post-mortem metamorphosis. But Freud, who would declare that all his work was, in the end, autobiographical, did not picture himself in the role of the self-struck lover. Instead it is the thick-lipped corduroy boy he had drawn smoking somewhere near Delamere Terrace, W2, where Freud was living. Just west of Little Venice and the Grand Union Canal, this corner of Paddington was entirely innocent of flat whites. Instead, there were working girls and dodgy louts lurking by the bridge, which is why Freud was attracted to the area. 'Delamere was extreme and I was conscious of this. A completely unresidential area with violent neighbours. There was a sort of anarchic element of no one working for anyone.'

Over the course of his long career, Freud would mirror himself over and over again. Mostly, he liked what he saw, but he always stopped well short of narcissism; horrified by any kind of deluded self-infatuation, or even the unchecked outpouring of emotion. Expressionism was to be avoided at all costs. As if in resistance to his grandfather's insistence that, whether we like it or not, we are all constructs of our repressed infantile desires, Lucian Freud set out to be sovereign over the instinctual. His ego never took its boot off the neck of his id. In 1948, rooting around Paddington and Maida Vale, he adopted the pose of undeluded cool, before the word had been re-coined. His painting and drawing was self-consciously hard-edged, linear and spiky (not just different from, but the antithesis to, the style

which would make him a great artist). An early self-portrait from 1946 has him looking sidelong (a pose which would recur) at a thistle lying on a window ledge, an emblem of his own prickliness. All his life, Lucian Freud enjoyed the company of animals, sometimes more unequivocally than the company of people. As a schoolboy, he had driven a flock of sheep into the hall of his school. But in the 1940s he was more taken by dead ones – a defunct, half-shrivelled monkey; a rotting puffin; a heap of unplucked chicken parts in a bucket; his beloved stuffed zebra head – than the living editions. But there was one kind of pet to which he was especially partial. From Palmer's pet shop Freud bought birds of prey, plus, to the distress of even the roughest neighbours, a buzzard. He would later say that there was nothing quite like touching the plumage of a wild bird, and it was evident that he felt some mysterious affinity with the sharp-eyed hunters, swift and lethal. In 1947, he drew a sparrowhawk perched on the head of a horse (another of Freud's favourite animals), and around that time he made a pastel of one of the birds, the yellow beak disturbingly frontal. No genius is required to recognize this is an early self-portrait in thinly feathered disguise.

Freud was in no danger, then, of falling for the Narcissus syndrome. Instead, the gaze is transferred to the corduroy boy, but even then it is something other than mesmerized self-infatuation. The long-lashed lad stares, head in hands, at his reflection, but the mirror image is cropped to exclude the return gaze of the eyes, so the doubling is incomplete. Rapture is replaced by an expression of intense yet guarded meditation.

It was only later that Freud came to believe that his paint could remake flesh. That was because he had taken a decision to paint without drawing, a skill in which (with some reason) he always felt insecure. The young Freud battled that anxiety by making art which was seldom anything *but* drawing: all flattened contour and no texture. No wonder, then, that the grasp of reality eluded him almost as much as it did Narcissus. In July 1954 he published his 'Thoughts on Painting' in *Encounter* magazine, ending with the reflection that:

a moment of complete happiness never occurs in the creation of a work of art. The promise of it is felt in the act of creation but disappears towards the completion of the work. For it is then that the painter realizes that it is only a picture he is painting. Were it not for that the perfect painting might be painted on the completion of which the painter could retire. It is this great insufficiency that drives him on.

And, in his case, the 'great insufficiency' would drive Freud on to get much closer to the authentic life-effect, not least his own.

But in 1954, he was still a wary watcher: the hawk perched on the roost. That year, he took his second wife, the beautiful Caroline Blackwood, to Paris. And there he painted the two of them; her, as a friend noticed, looking much older than she actually was, haggard and stricken with anxiety in bed, bony fingers pressed neurotically into her cheeks as though about to tear the skin away. In the extraordinarily unpleasant picture, Freud enjoys painting himself in sinister silhouette, outlined against the hotel window, glaring unsympathetically at his miserable wife. His hands are dug into his pockets the way they are when disgust, uncomplicated by even a murmur of guilt, tramples on kindness. But then what does kindness have to do with art, any more than it stops the flight of the hawk?

Hotel Bedroom, by Lucian Freud, 1954

2. *This is Me*

The first self-portrait in English art studiously avoids looking us in the eye. This is because the artist has more important things on his mind than addressing himself to posterity: salvation, for instance, and the commendation of the patron who has commissioned a sacred book full of his brilliant pictures. So when, around 1240, William de Brailes features himself as the maker of illuminated Bibles, psalters and a Book of Hours, it is not an ego-announcement; not quite, anyway: rather, a carefully judged combination of self-promotion and self-effacement. In the Book of Hours devised for the eight times of daily prayer, from matins in the wee small hours to compline last thing at night, William inserts himself into the historiated capital 'C' concluding terce (around midday). The 'C' is for *Concede nos* ('Grant us'), and within it the tonsured William kneels in prayer, his eyes shut, while the hand of God, two fingers extended in blessing, reassures him with a gentle touch to the side of his face. So far, so humble. None of William's four known pictures of himself is a mirror image, not only because such mirrors as there were, of crudely polished steel and silver, were notoriously distorting surfaces, but also because artists were acutely aware of being taken to task (even as the Church depended on images) for their preoccupation with depicting outward appearances, the vanities of this world.

Once, however, the illuminator had established himself as a good servant of the Church and a disseminator of piety, William de Brailes could indulge in a little nicely placed advertising. In the margin beside the capital is an inscription in red, written in a tiny, exquisite hand in French: '*W de brail q(ui) me depeint*' ('William de Brailes depicted me'). And since the hand is not scribal style, and the red marginalia are instructions to the scribes writing the text about the overall design of the page, it has to be the artist himself who wants to remind his patroness (for it is in fact a patroness, also drawn elsewhere in the book,

345

Self-portrait from a Book of Hours, by William de Brailes, circa 1240

attired in pink and scarlet), whenever her book is open at terce, of just who made the book as beautiful and as lively as it was.

In a psalter (a book of psalms for daily devotions) from a little later, de Brailes appears again, this time in a half-medallion in a miniature of the Last Judgement. While this plainly draws attention to himself, he contrives to do it in a way that could not be read as immodest or unseemly. For the artist does not include himself among the righteous blessed but rather hanging in suspense over the naked, cowering masses of the damned while the Archangel Michael, who ushers them to perdition with his sword in his right hand, uses the other, protectively, to safeguard de Brailes from sharing their fate.

Even with this balance between self-importance and pious submission, William de Brailes could only go beyond the scribe's colophon signature to create a self-portrait because he was working for a new kind of patron and in a wholly new world for the book: the world of lay readers. Before the thirteenth century, sacred manuscripts had been produced overwhelmingly for and by monasteries and the clergy; written in the scriptorium and used by the brothers of the community. Though there was a smattering of literacy among the laity, it was not widespread enough to generate the demand which flowered so spectacularly in the following century. William de Brailes worked in Oxford because the university was itself a centre where traditional clerical readers and scribes mixed with university men and the novel element of a pious laity eager to consume works which they could then own and keep with them for their personal devotions. This was the birth of the individual reader and, to meet the demand, a whole industry of interconnecting crafts arose: scribes, parchment preparers, binders and illuminators such as William. Together, they revolutionized what a book was, and how it would be used. The great manuscripts that were the property of the monastic orders and the high ecclesiastics needed the large format so that they could be displayed as a treasure of the whole community. When lay individuals commissioned a book, they wanted it to be lighter and more portable so that it could be taken wherever they went and used for their personal devotions.

Self-portrait from a Psalter, by William de Brailes, circa 1240

The new book industry obliged, with much thinner leaves of parchment, a durable binder of wooden boards covered in calf or pigskin, and a size approximating to our own paperbacks. But small though they were, the text needed to be large and strikingly clear for the lay reader, and punctuated by the diversion of the illuminations. They were as much a breakthrough for the reader as our tablets; much the same size, and flashy with colour and Christian entertainment. William de Brailes was, in effect, an animator (the best) who happened to work with still images, much the way early Disney cartoonists painted their cels.

William evidently prospered; he became a property owner and in his workshop on Catte Street, the hub of the Oxford book business, probably employed a number of assistants, whom he trained up in what the scholar Claire Donovan calls his distinctive 'house style'. It was marked by de Brailes's own genius for draughtsmanship. In a mid-century Bible featuring many scenes from the Old Testament, de Brailes divides the page of the Plague of Darkness in Exodus vertically down the middle. On the left, Moses (with the usual complement of horns) and Aaron berate Pharaoh, who on the right sits in the blackness, only his golden circlet-crown gleaming, while unnumbered hordes of frightened Egyptians cringe in terror. Noah's flood is filled with stylized inundations featuring faces of the drowned and, beneath them, a mass of lost flocks and herds. On another page, an angel drives the animals two by two up a gangplank and into the ark, already so immensely crowded with little beastie faces that it seems impossible that there should be any more room: a predicament which may account for the worried look on the countenances of the Family Noah, themselves packed tight into the top deck.

Many others would follow where de Brailes led the way, but few among the Gothic illuminators of medieval England could match his punchy animation and swooping design. The exuberant talent which makes his imagery so memorable is of a piece with a personality that was not bashful about advertising his authorship. But the advertisements were first and foremost addressed to a readership of one: the

single patroness, flattered at being incorporated into the illuminations of the Book of Hours. So these first self-portraits are not in any sense a statement about the hero-artist in all his singularity, poetically apart from the world which gave him work. They are, in fact, something like the opposite: a document of a close connection with his book partners, the patrons; with the pious laymen and women who needed images to inspire their daily professions of belief, and, not least, a declaration that to be an artist-illuminator was also to be a faithful son of the Holy Mother Church.

In England, it took another three centuries, until 1554, before an artist looked into the mirror and painted what he saw there, palette and all. Gerlach Flicke, a German immigrant from Osnabrück, wears an expression of what might, at first, seem like intense self-regard. But to assume that would be anachronistic. The first edition of the great text of critical self-knowledge, Michel de Montaigne's *Essays*, would not be published until 1580, and it was not until 1603 that John Florio's translation made it available to an English-reading public. Much more likely, it was his working conditions that account for the intent peering of the artist. The mirror he was looking at would have been a small steel-and-silver disc or square which, however polished, would have been pitted and corroded and, even if relatively new, would have produced a much darker reflection than the crystal-glass, tin-and-mercury-backed modern kind invented in the mid-sixteenth century on the Venetian lagoon island of Murano, and available only at very high cost. The poor and probably distorted mirror image also accounts for the loss of focused sharpness, compared to the portrait alongside him. What was more, Gerlach Flicke, also known as Gerlin or, around where he lived in London, as Garlick, was painting on a small strip of paper, about four inches by six, which he would, at some point, attach to a rudimentary wooden panel. To make an adequate likeness, then, the painter would have needed some help from a candle or a lantern to light the room, which must have been pretty dim, since Gerlach Flicke was in prison.

In confinement with him was the other figure in the diptych: Henry

Gerlach Flicke and Henry Strangwish, by Gerlach Flicke, 1554

Strangwish, gentleman-pirate, also known as Strangways, Strangeways and, for reasons obvious from Flicke's brilliant little portrait, 'the Red Rover of the Channel'. They made an odd couple of cellmates. From the way Flicke's will was worded, we know he remained Catholic, yet not long after arriving in England, probably around 1546, he painted what has become the canonical portrait of the theological and institutional engineer of the Protestant Reformation: Thomas Cranmer. After Flicke's portrait, one of the great Anglo-Reformation icons, it is impossible to think of Cranmer in any other way than forbiddingly sombre, as befitted his steely sense of calling, not to mention the survival skills that helped him see out the reign of Henry VIII.

Flicke's own political weathervane may not have been so finely calibrated or, rather, he took commissions where he could find them, especially when they were from as grand a personage as Thomas Howard, Duke of Norfolk, who would come to grief in the reign of Elizabeth, or Sir Peter Carew, from an old Devonshire gentry dynasty. Carew was an MP but belonged to the class of gentry which lived from what the sea might offer, untroubled by whether it was strictly within what the law prescribed. His brother George was unfortunate to have been on the great Tudor flagship *Mary Rose* when it fatally keeled over in the Solent, but he survived nonetheless. Peter, painted in all his arrogant robustness by Flicke, hands on hips, doublet slashed in the hard-man-and-handsome-with-it manner of the mid-Tudors, was himself something of an adventurer.

In 1554, Carew got into serious trouble. He was supposed to be the West Country end of a triangle of rebellion against Queen Mary's proposal to marry Philip II of Spain. The revolt, led by Sir Thomas Wyatt, was also meant to raise a force in Kent and the Midlands, led by the Duke of Suffolk. Only in Kent did Wyatt himself manage to persuade a hundred and fifty poor souls to follow him, and their feeble troop scattered at the first sight of government forces. Elsewhere, including Devon, the rising was a fiasco. Wyatt, the son of the great courtier-poet, and Suffolk were both beheaded, but Carew managed to flee in time to Flanders, returning in the reign of Elizabeth to

Thomas Cranmer, by Gerlach Flicke, 1545–6

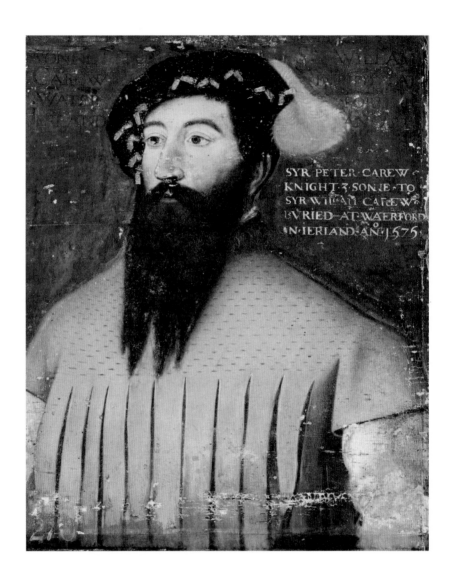

SYR·PETER·CAREW
KNIGHT·3·SONIE·TO
SYR·WIIIAM·CAREW
BVRIED·AT·WATERFORD
IN·IERLAND·AN·1575

Sir Peter Carew, by unknown English artist, after Gerlach Flicke, mid to late sixteenth century

extend his selectively tough skills to the brutal colonization of Ireland.

It may well be that Flicke was somehow incriminated by association with his patron, enough at any rate to get himself imprisoned, probably in the Tower. There he encountered Strangwish the pirate, who was very much from the same West Country world as the Carews (and Drakes), where the line between the lawful and unlawful was helpfully blurred, especially since the statute on piracy had been enacted only eighteen years before. Strangwish had been a mightily successful rover up and down the Solent and the Channel, threatening enough for the government to send two men-of-war to try to apprehend him. His primary target was Spanish shipping, which may have kept him out of jail, if not out of trouble, during the reign of Edward VI, but would have made him vulnerable when Mary came to the throne. Both parties to the diptych, then, had found themselves collateral casualties of the sudden switch from Protestant to Catholic sovereignty.

In jeopardy of their lives, the pirate and the painter must have struck up the friendship which moved Flicke to portray them together sharing the same pictorial space, the divider between them a *trompe l'œil* partition painted almost as if it were a wall separating adjoining cells. The English inscription, beautifully and carefully painted, as was the whole portrait, with much under-drawing beneath the paint layer, suggests a moment of gallows humour, albeit weighed down by some heavy punning. Flicke writes:

> *Strangwish, thus strangely, depicted is*
> *One prisoner, for thother, hath done this*
> *Gerlin, hath garnisht, for his delight*
> *This woorck whiche you se, before youre sight.*

'Garnish', as Tricia Bracher noted, was contemporary slang for what the prisoners had to shell out to their wardens for the conveniences of life, even when immured in the Tower. So it may have been that

355

Flicke (who was a man of property in Osnabrück but lived modestly in London) did the painting as his contribution to their common welfare.

And yet on the other side of the little picture, above his self-portrait, the inscription strikes a very different, elegiac tone, and is in Latin, the language of learned gravitas. There Flicke writes: 'Such was the face of Gerlach Flicke when he was a painter in the City of London. This he himself painted from a looking-glass for his dear friends. That they might have something by which to remember him after his death.'

Though the sentiment was a commonplace of the time, it sounds as though Flicke was expecting the worst. Seized by a sudden fearfulness (which proved needless, for he lived until 1558 and died at home in Cripplegate), did he change his mind about whose property the picture was and take it back? Everything turns on how we read the 'his' in the English inscription. If it was made for the pirate's delight, then Strangwish would have taken it with him; continuing his sea-roving ways under Elizabeth, this time as a licensed privateer with Martin Frobisher; eventually dying on a raid at Rouen in 1562. But if 'his' refers instead to Flicke's own 'delight', the expectation that he would not live much longer would have been paramount, and the pirate would have been relieved of his garnish so that Flicke could give the remembrance to his *amici*, his 'dear friends'.

We shall never know the answer. But even with the fate of the painting unresolved, it can nonetheless be read as a perfect expression of the two tempers of reflection: roguish and mournful, exuberant and sombre; the pirate and the painter. On any given day you never know which face will show up in your mirror.

3. *The History Painter*

Everyone knew what a real painter was like. You just took a look at the knights: Sir Peter Paul Rubens or Sir Anthony van Dyck: cavaliers with libraries. They sat high in the saddle but were also steeped in poesy ancient and modern: Virgil to Tasso and everything in between. Somehow, too, they managed to be personally nonchalant and expressively passionate all at the same time. They had Giambattista della Porta on their shelves, so they were versed in the many ways in which the *affetti*, the emotions, were written on the face. Horror and pathos, lust and guile, were their mood music. They knew how to make a Mary grieve so inconsolably you would well up at the sight of her blue gown of sorrow. Violence was second nature to them. They would sketch you a red-eyed eagle lunching on the liver of Prometheus and their workshop would fill in the details four feet high and six wide. Their silks and satins were waterfalls, the women who wore them opulently formed, hospitably spilling from their bodices. The painter-cavaliers were fastidious connoisseurs. Lodged in Rome or Naples, they would venture into dangerous alleys to seek out men with dirt-packed nails who would unwrap an oily rag to reveal a cameo of a patrician woman from the time of Diocletian, her hair piled and pinned at the back of her head. They would give the man what he wanted, take the beauty back home to Antwerp, settle her in a cabinet of inlaid rosewood and send word to friends to come and share the pleasure.

Contemporaries wrote of them as princes of the arts; familiars of popes and kings, receiving admirers at the correct hour, in houses that were like little courts. They were at ease in the company of sovereigns, trod the precarious line between informality and presumption with scrupulous precision. When Van Dyck painted his own face suffused with the reflected light of a great sunflower, understood to signify the particular favour of the King, it was no vain boast.

But who now would be to King Charles II what Van Dyck had been

to his father? Though Charles, who had spent much of the Interregnum in Holland, continued to favour foreigners – Peter Lely and Godfrey Kneller – Isaac Fuller, as home-grown as they came, saw no reason why the Serjeant Painter to the King should not be him. Though his detractors pictured him as a drunken, ham-fisted boor, he could trade Martial and Juvenal with the best of them; yes, and the schoolmen, too. Had he not served an apprenticeship with François Perrier in Paris, the artist famous for making etchings and paintings after antique busts and statuary? It is possible, in fact, that Fuller might have been in Perrier's studio at the same time as Charles Le Brun, who would go on to be the premier history painter for Louis XIV at Versailles and the author of the most influential text on the physiognomic expression of emotions since della Porta. In emulation of his teacher, Fuller himself published a book of instruction on etching after the antique style. So it was not entirely deluded for him to imagine that he had all it needed to become the first truly native history painter of England. Surely the time had arrived when the country could wean itself from those Flemings and Dutchmen, Germans and Huguenots, who had all but monopolized Britain's art?

The irony is that the Fuller who loftily condescends to us from a life-size, heroic self-portrait, his face composed into something not entirely unlike Van Dyck's Charles I, owes everything to Dutch and Flemish prototypes well known in England. The frontal pose, the figure brilliantly illuminated in the darkness, the theatrical props, the extravagant costume – red velvet pillbox cap jauntily worn to one side; the thespian striped silver scarf knotted at his throat – all evoke the Dutch followers of the Caravaggio style: above all, Gerard van Honthorst's fiddler. The *paragones*, the great exemplars marching through Fuller's ambitious vision, might have included Frans Hals, his Haarlem follower Jan de Bray and, without question, the parade master of a thousand poses in the mirror: Rembrandt van Rijn. Fuller knew that he was considered a merrymaker in the reign of the merry monarch: a decorator of taverns, a painter of stage sets. Very well, he did not deny it; a man must earn his bread, but had not the great

Rembrandt also portrayed himself as a carouser in his cups, a ruffian and a bravo, and been none the less noble an artist for all that? The Dutchman had demonstrated there was more than one way to show your learning when he set the philosopher's palm on the head of Homer; now Fuller placed his on the brow of his muse, Athena, while the other clutched a bronze figurine of her foster-father, Triton, who ploughed the seas with his trident and blew away despoilers with the trumpet of his conch. Isaac, too, was a good father to his boys, Isaac and Nicholas. One of them is here depicted looking, with a trace of anxiety as well as respect, at his father.

The heroic art-ego, prone to sink into the abyss of low spirits before ascending to the summit of inspiration, was first unveiled a century before in Giorgio Vasari's *Lives of the Artists*, especially in his account of Michelangelo, and in Benvenuto Cellini's autobiography, a threnody to the liberated, periodically homicidal demiurge. Self-portraits of the virtuosi – Dürer, Leonardo, Titian – escaped profane self-congratulation only by virtue of surrounding themselves with an aura of sacred wisdom, their bearded faces closely resembling saints' or, in Dürer's rather shocking case, that of the Saviour himself. The irascibly uncompromising Michelangelo made an unpersuasive gesture towards Christian humility by depicting himself in *The Last Judgement* as St Bartholomew, carrying his own flayed hide. In Fuller's own time, there were other artists who, like Salvator Rosa, who painted himself in an attitude of majestic loftiness, were notorious for scorning their patrons.

Like all the rest, Fuller never meant to bite the hand that fed him. But his self-portrait, painted towards the end of his life, is the epitome of a brave face, an unapologetic retort to the scoffers. The first chronicler of a specifically English art, Bainbrigge Buckeridge, writing in the early eighteenth century, marvelled at Fuller's success, given the 'rawness of Colouring', but conceded his 'great Genius for Drawing and Designing History'. Buckeridge makes it clear that Fuller was well enough respected in the 1660s to receive commissions for the decoration of at least three Oxford college chapels, at Magdalen, All Souls and Wadham, where, in a virtuoso exercise he executed a

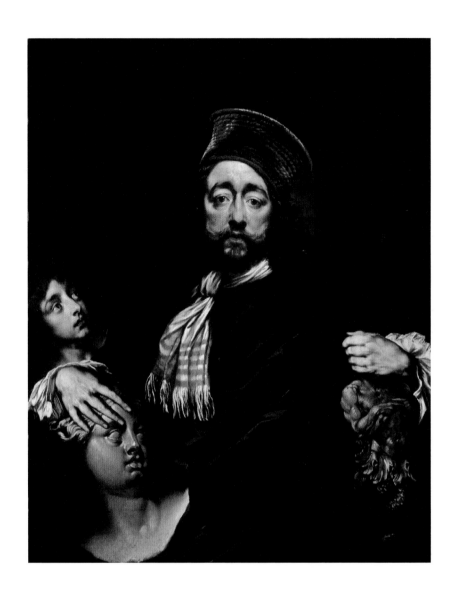

Self-portrait, by Isaac Fuller, circa 1670

painting on cloth in two colours. It seems likely that Fuller was thought of as a dependable royalist and thus a suitable candidate for the re-ornamentation of Oxford sites which, after Charles I's court had been evicted from the town, had been punitively purged of decoration. He embraced the opportunity with the hearty gusto that was his trademark. At All Souls, fragments of his *Last Judgement* survive which make Fuller's ambition to be the English Michelangelo all too glaringly obvious. He has, in fact, mastered the radical foreshortening needed for ceiling painting, so that powerful feet and hands appear to project into the space below. And there are some other details, too, which suggest that Fuller was not altogether a dud when it came to inventing a native English baroque. The head of one of his recumbent figures is a thing of wide-eyed beauty; juicy-lipped; blonde tresses blown in the wind. But the overall effect is damaged by Fuller's less secure modelling of arms and legs, which seem surgically reattached to shoulders and hips. If anything, Buckeridge was understating the effect of the massively meaty if dislocated thighs and rippling biceps when he remarked that the 'muscelling' was 'too strong and prominent'.

To later taste, at any rate, Fuller's style was too profanely heroic for sacred decoration. When John Evelyn saw the All Souls paintings he commented that the fact that there were 'too many nakeds' in the chapel meant they were unlikely to last. In reality, it was less Fuller's propensity for importing Renaissance mannerism into Oxford than his painting them in oil straight on to unprimed wooden panels which doomed the pictures. By 1677, five years after his death, they were so badly degraded that there were already plans for their replacement, eventually effected in the next century by Sir James Thornhill. But there was also the sense of Fuller's work being incongruously earthy and vernacular for a grandly dignified setting. Buckeridge commented that his designs were not executed with 'due Decency, nor after an Historical manner, for he was too much addicted to Modernize, and burlesque his Subjects'. Somehow this was to be expected from an artist who was known for his partiality to low life. The 'Extravagancies', Buckeridge sniffed, were of a piece with 'the Manners of the Man'.

Ultimately, the critics thought Fuller was better suited to painting taverns than churches. And this other line of custom was, in fact, an important part of his work. The Great Fire of London in 1666 had made work for artists when city alehouses destroyed in the conflagration were rebuilt (still in timber), incorporating indoor paintings to entertain their patrons. Dan Rawlinson's Mitre in Fenchurch Street was one of those taverns which catered to sociable men about town and in government, such as Samuel Pepys, who regularly took his friends there. Rawlinson commissioned from Fuller a spectacular display, covering his walls and ceiling with the full complement of gods and satyrs disporting themselves with brimming goblets – Silenus, Bacchus, Dionysus and the rest – as well as a comely boy riding a goat and wearing a devilish grin. At the centre of the boozy rout was an enormous mitre: the high Church surrounded by low acts.

It was this promiscuous mixing of genres that damaged Fuller's reputation with the critics of the next century – after which he was forgotten. A few surviving portraits – notably, a fine one of the political 'arithmetician' Sir William Petty – make it clear that, when he had a mind to, Fuller was perfectly capable of producing polished formal portraits. In fact, however, the folksy genre pieces which, notwithstanding those years in Paris, came more naturally to Fuller were used to demonstrate what an unapologetically English history-painting style might be.

In 1660, the lexicographer Thomas Blount (aggrieved that his dictionary had been supplanted by a Commonwealth book called *New Words* which had plagiarized many of his entries) published a popular history, *Boscobel: or, the History of His Sacred Majesties most Miraculous Preservation* . . . a History of Wonders. The epic yarn (still a good read) had everything: a loyal band of six brothers, the Penderels – servants, caretakers, a miller, and the like, devoted to saving the King; the intrepid Jane Lane, with whom Charles, going by the name of Wil Jones, one woodcutter, carrying a bill-axe, shares a horse. Moreover, the hero of the tale was famous for telling it, over and again, at the drop of a hat, not least to Samuel Pepys, aboard the ship bringing

Charles back to England from his Dutch exile. In later editions of *Boscobel*, Pepys's account was added to Blount's version of the escape narrative.

In the early years of the reign, Blount's book became Restoration scripture, and someone commissioned Isaac Fuller to make an epic cycle of paintings relating some of the 'marvels and wonders' of the story: the royal slumber in the branches of the great oak of Boscobel Wood, the donning of a woodman's disguise, the wearing, as Blount describes it, of a worn leather doublet and green breeches, stockings with the embroidered tops cut off, 'old shoos, cut and slash'd to give ease to the feet, an old grey, greasy hat without a lyning, a noggen shirt of the coursest linnen, his face and hands made of a reechy complexion by the help of the walnut tree leaves'.

The role reversal between King and commoner, complete with costume exchanges, was an ancient folk tale. The *gestes* of Robin Hood were full of it; Shakespeare's and other Jacobean comedies drew heavily on the same motif, and often with the same purpose of a fallen or exiled prince discovering the virtues of the common people, a natural nobility much to be preferred over mere accidents of birth. But if it is impossible to imagine Charles II's father rubbing his cheeks with walnut-leaf dye, that is because the whole thrust of early Stuart ideology had been to remove the monarchy as far as possible from the common sort: to translate James and Charles into 'little gods on earth' accountable to no one except the Almighty himself. For that purpose, the great baroque flying machines of ceiling gods painted by Rubens and the imperial horses of Van Dyck were perfect.

But now, after the trauma of the Interregnum, something else was needed. Charles II was probably not a whit less autocratic than his father, and the ceiling of his bedchamber at Whitehall was also painted with a densely allegorical programme of the return of the Golden Age. But the new King's common touch was not altogether a myth; and it was a staple of Restoration history that his accession answered to a deep popular yearning in the country, a romance seemingly supported by the vast, genuinely joyful crowds greeting his

return. So without altogether sacrificing the courtly iconography of divine right, it might have been timely for a painterly accompaniment to the Blount book to make the most of Charles II's closeness, whether enforced or not, with his rescuers.

Enter Isaac Fuller. Since the five paintings he made are enormous – some seven foot by eight – it seems likely that they were done at the behest of a royalist aristocrat, possibly the Earl of Falkland (as they ended up in that estate), with some sort of great hall in which to display them. They constitute a kind of fustian version of Rubens's immense cycle for Marie de' Medici, the Dowager Queen of France, who was also obliged to make a hasty escape from Paris. And Fuller's undoubted gift for roughing up royal imagery till it was part of common folklore was exactly suited to the task.

Fuller goes for it. He depicts the handsome face of the King very much as he was in 1661 rather than ten years earlier, when he was a youthful twenty-one, the better for people to identify the story with the Charles they now knew. But stripped of any semblance of royal attire, Charles and the woodman look plausibly alike. The woodman had shorn the royal locks and dirtied up the royal cheeks. And what Fuller lacks in high style he makes up with a real gift for popular storytelling. Hidden in the famous 'royal oak' of Boscobel, Charles sleeps with his head in the lap of his faithful Colonel Careless, who (especially given his name) has to take care the King doesn't fall out from the branches. Fuller paints the colonel, anxiously wide awake of course, with his arms wide, ready to catch Charles, just in case, knowing he would never have dared to hold the King directly. Fuller considers the King's varying sense of indignity, sometimes humoured; sometimes not. The mill-owner's nag he was forced to ride is plainly overdue for the knacker's yard, and Fuller gives Charles an expression of appalled mortification at the humiliating absurdity of his position. Famously, he asked Humphrey Penderel, the miller, why the 'dull jade' trotted so slowly, to which the honest man replied it was because it was carrying 'the weight of three kingdoms on his back'.

Behind the horse-jokes was, of course, the stupendous grandeur of

King Charles II and Colonel William Carlos (Careless) in the Royal Oak, by Isaac Fuller, 1660s
King Charles II on Humphrey Penderel's Mill Horse, by Isaac Fuller, 1660s

Van Dyck's equestrian portraits of Charles I. So when finally his son Charles II heads off to Bristol (still slowly, dodging Cromwellian patrols) on the back of Jane Lane's mount, Fuller gives the grey more spirit and vigour. In fact, he overcorrects, making the horse lift its front legs in the posture of the levade, almost always reserved in paintings for great generals and sovereigns, and certainly impossible to execute with two pillion riders. Jane Lane, the sister of another royalist colonel, had herself become something of a popular heroine in history lore, eventually escaping herself to Paris, where she was close enough to the young king for the predictable stories to surface.

We have no idea how Fuller's history cycle was received; but the very fact of the paintings' survival means they could not have been a complete disaster. If the Charles cycle was also a long way from what Le Brun would do for Louis XIV at Versailles, it did indeed have a distinctively English tone. In the pictures' earthiness, their closeness to popular history prints, in their twinship with literary narrative, their vernacular humour, they are an anticipation of the visual story-telling that in the much more gifted hands of Hogarth would become the English way of picturing their past.

He would never be Sir Isaac Fuller. Dutch and German artists, in their awkwardly grandiose style, would still define what histories were supposed to be. Fuller himself sank into a tank of drink in the pubs he had painted. No wonder, then, that in his flamboyant self-portrait towards the end of his career, the bravura self-promotion is shadowed by at least a touch of mournful regret.

4. 'To Self. An Unfinished Sketch' 1731

Now that he had come to what he called 'the fagg end of life', resigning himself to God's good grace as he approached that to which every man must eventually succumb, Jonathan Richardson allowed that perfectibility might not invariably be the chief business of portraiture. When he stared at his own countenance in the glass, as he did each morning, gathering the *Morning Thoughts* which he would set down in verse, he appreciated ever more Rembrandt's devotion to the unvarnished truth.

Twenty years earlier, Richardson had been of a quite different mind. His *Essay on the Theory of Painting*, the first such to be written by an Englishman, published in 1715, had insisted that the whole work of a portrayer was to 'raise his ideas above what he sees and form a model of perfection in his own mind which is not to be found in reality'. 'Common nature' was 'no more fit for a picture than plain narration is for a poem'. The ancients understood this well when they composed features of a refined grace unlikely to be encountered on the street or in the agora. How could they do otherwise with gods and heroes? Michelangelo and Raphael, too, were wont to pick and choose from diverse excellencies of face and figure and harmonize them into beauty. Was not that the very point of art? If it descended into mere transcription of what it happened to behold, where was the poetry in it? It was nothing more than common duplication. How might such low reports ennoble the human condition beyond the coarse and the brutal (of which there was no shortage in the world)? The painter ought instead to 'raise the whole species and give them all imaginable beauty, and grace, dignity and perfection; every several character, whether it be good, or bad, amiable, or detestable, must be stronger, and more perfect'.

But those sententious convictions, expressed in all sincerity, had

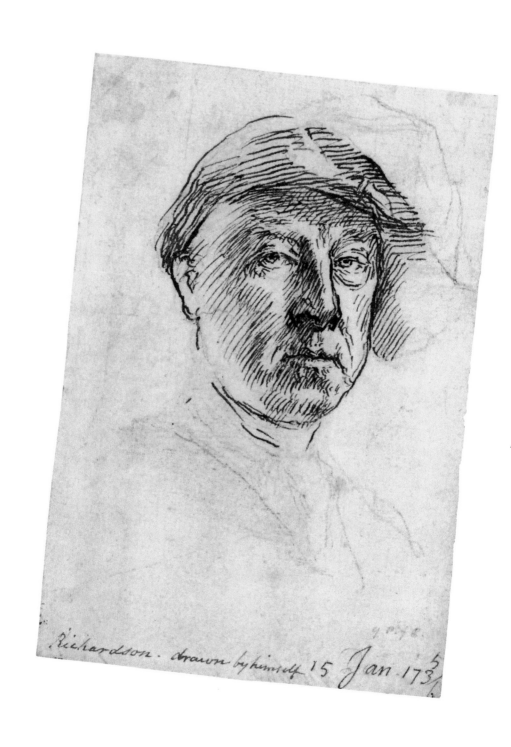

Self-portrait, by Jonathan Richardson, 1736

been set down while he had been face painter to society and then to the great talents of his age: his friend Alexander Pope, whose loftiness of mind and felicity of poetic line would never have been deduced from his physical appearance, stooped and stunted as it was. It was the former, not the latter, which had to be conveyed in any proper likeness. The *Essay* had been concerned to exalt the standing of painting amongst his countrymen, so that it would no longer be treated as a mere vehicle of minor diversion but seen rightly as what Richardson called a language, a vehicle for the communication of ideas. Seen in that light, it ought not to hang its head before the presumed superiority of poetry and prose. Literary language, after all, was available primarily to those who shared its tongue, while painting was universal. And then there was the instantaneous quality of its communication. Painting 'pours ideas into our minds; words only drop them, little by little'.

A vision of a great *English* School of Painting appeared before Jonathan Richardson's eyes: one that might hold its head high with those of the Italians and French; indeed, supplant them with countrymen who enjoyed the 'genius of freedom'. The trouble was that its practitioners were for the most part foreigners or else ignorant, even clownish journeymen. To be a true artist meant being, at the same time, historian (master of the knowledge needed to know how Greeks and Romans lived); poet (who could 'imagine his figures to think, speak, and act as a poet should do in a tragedy'); and, if he were to be a worthy draughtsman, he needed to be something of a mathematician and mechanic as well. Such virtuosi, he acknowledged, were thin on the ground at present, but all the more reason to raise standards high. What was wanted, in addition to Invention, Expression, Composition, Colouring and Handling (the several headings of his instruction) was a feeling for 'Grace and Greatness' of the kind stamped through the majestic works of a Raphael. One day there would be an English Raphael to rival the original; he was sure of it.

If George Vertue (edited and waspishly embellished by Horace Walpole) was to be believed, Richardson's grandiose prescriptions met with chuckling and shaking of heads, at least beyond his immediate

circle of friends. 'Between the laughers and the envious', his book met with as much ridicule as admiration. It did not help that Richardson himself was given to a formal manner, speaking slowly and loudly, as if every sentence were weighty with significance. A coffee-house conversation might turn into an auditorium for sonorous strictures coming from the plummy mouth of the moon-faced arbiter of painterly dignity. Nor did it escape attention, at any rate to the maliciously minded, that while some of Richardson's writing was full of 'fire and judgment, his paintings owed little to either'. There was, in fact, such stern commitment to living life according to the golden mean of temperance and moderation, avoiding both libertinism and excessive austerity, that the effort dragged the paintings down to the zone of the average, where they languished in tolerable mediocrity. Though he was 'full of . . . theory, and profound in reflections on his art, he drew nothing well below the head, and was void of imagination', wrote the uncharitable Vertue; 'his attitudes, draperies, and backgrounds are insipid and unmeaning; so ill did he apply to his own practice the sagacious Rules and hints he bestowed on others.'

Most of these stinging attacks came after Richardson's death, although his son Jonathan Junior, dedicated as he was to perpetuating his father's memory and his literary heritage, would have felt them keenly. But in the hornets' nest that was the world of London letters, the father would not have been impervious to them either. He might have dismissed them as the cavilling of the spiteful and the jealous. For by the 1720s he had made a great name for himself, above all as a portraitist, and charged much the same tariff as acknowledged masters such as Kneller. He was invited on occasions to paint for the court but grandly declined the opportunity, preferring the aristocrats of letters and the good men of the Church. He had moved from respectable quarters in Lincoln's Inn Fields to even more handsome ones in Queen Square, where he was to remain the rest of his life. He had a wife, Elizabeth, whom he loved and treasured. Ten of their eleven children had survived the perils of infancy, and most of them gave him satisfaction (though not all).

And yet. When, after Elizabeth's sudden death, following the 'mortification of the bowels' which struck her during a performance of Handel's *Rodelinda*, Richardson paused to make a reckoning of griefs and blessings, and of his own virtues and shortcomings, he could not help but wonder if he was, in fact, all that he seemed to the world which had given him a goodly portion of its blessings. Of course, he understood that, measured by all higher values, the approval (or disapproval) of the world was of little importance. What lay within was all that truly counted. 'Mind all bright if so within,' he wrote in one of his many notes to himself. So every morning through the 1730s, Richardson rose early and, by light of the dawning day, or else candle and lamp, peered at his own countenance for information on the progress or retreat of his moral condition. Horace Walpole, following *Vertue*, claimed that no day passed without him putting lead pencil to vellum or a chalk self-portrait on blue or cream paper, and that at Richardson's death in 1745 there were 'hundreds' of them. This was probably an exaggeration, but the many that do survive constitute the most compulsive and relentless self-scrutiny in all of British art.

The series began as visual autobiography. Richardson had written a poem called 'The Different Stages of My Life', intended principally for himself and his immediate circle. But when his poetry was published by his son, it attracted some mockery. Those lines he had read, Walpole commented acidly, 'excite no curiosity for more'. It is true that the verses don't exactly skip across the page; in fact, they hardly scan at all. But their ungainly amateurishness is itself somehow touching.

> *As here I sit and cast my eyes around*
> *The history of my past life is found*
> *The dear resemblances of those whose names*
> *Nourish and brighten more the purest flames.*

In the *Essay*, Richardson had written that 'in Picture, we never die, we never decay, or grow older', and when he embarked on sketching

the cast of characters populating his life he drew them at whichever stage he wished to fix them in his fond recollection. Alexander Pope, who was in advanced middle age by the 1730s, was thus drawn in the prime in which Richardson had first met him. Richardson's wife, Elizabeth, was sketched in the flower of their marriage; his oldest boy, Jonathan Junior, then approaching middle age, as a seven-year-old cherub and then again at around ten years old, plump-cheeked and fat-lipped. The occasion of drawing another of his sons, Isaac, may have been a recent tragedy. The boy is sketched as a sweet lad, but on the reverse of the vellum sheet Richardson wrote, 'Went to sea, August 9th, 1718; Cast away 10 Nov 173[illegible]'. 'The picture of an absent relation, or friend,' he had written with a characteristic balance of warm emotion and cool reason, 'helps to keep up those sentiments which frequently languish by absence and may be instrumental to maintain, and sometimes to augment friendship, and paternal, filial, and conjugal love, and duty.'

Richardson himself appears in this first series, also at different times of his life, from the earnest young man to the graver elderly critic; sometimes with a full-bottomed wig; sometimes with shaved head; at others with his soft cap on. What is striking, however, is that despite the changes in costume, the poses – and, for that matter, Richardson's expressions – are much the same: those of a man with a firm control on his passions; thoughtful, tending to sententious; neither overly familiar nor austerely remote. A middling sort of fellow with a somewhat superior mind.

As the hero of his own story in verse and picture, Richardson did perhaps exaggerate the 'oppressions' and 'sufferings' which had marked his life, the better to colour it with the sentimental hues the eighteenth-century novel would soon celebrate. 'My early steps in life, on barren ground/ Inhospitable and severe were found,' he had written, but actually his father had been a silk-weaver of Bishopsgate successful enough to leave four hundred pounds at his death, not a trifling sum for an artisan or small tradesman. But Jonathan was probably referring to the purgatory he was made to enter when his

stepfather apprenticed him to a scrivener (or notary), where he toiled for six years while his restive imagination moaned in its clerical chains. He was liberated by the portrait painter John Riley, whose pupil he became and with whom he lodged. Riley, who died prematurely in 1691, was a skilled and singular artist who painted not only kings and courtiers but, more unprecedentedly, royal servants such as the 'Necessary-Woman' Bridget Holmes, whose duties included the emptying of Charles II's chamber pot and whom Riley depicted discovered by a page behind the kind of grandiose damask curtain usually reserved for princes and nobles, wielding her broom like a musket, ready to repel invaders of the royal privy. Riley, who features in one of Richardson's most elegant drawings, was obviously an active tutor and master to his pupil, and instrumental in introducing him to his first patrons and perhaps his future wife, who may have been his niece.

Richardson himself would not prove to be quite so kindly to in-house unions. When he spoke of his subsequent life, 'muddied by domestic afflictions', he was thinking not just of one daughter who succumbed to madness, nor another who suffered a 'tedious illness', but a third, Mary, who had the temerity to elope with Richardson's pupil-assistant Thomas Hudson without so much as a by-your-leave. The aggrieved father responded by meanly depriving Mary of her marriage portion and, although he included Hudson in his drawing suite, thus presumably reconciled at some point, he never did restore what should have been her due.

Jonathan Junior, on the other hand, was the apple of his father's eye: so much the very model of virtue, discipline and filial considerateness, never marrying but preferring to care for his father as he aged, especially following a mild stroke, that Horace Walpole spoke of the two of them as 'lovers of art and of each other'. In a rare and moving double portrait, Richardson drew the two of them together, two peas in a pod, hardly distinguishable by age, both with the same slightly exophthalmic eyes (a feature of portraits of the period), mildly cleft chin and prominent nose, the father's face just a little drawn compared with the puddingy fullness of the son's.

Self-portrait, by Jonathan Richardson, 1735
Self-portrait, by or after Jonathan Richardson, 1730s

Self-portrait Wearing a Cloth Hat, by Jonathan Richardson, circa 1730–35
Self-portrait, by Jonathan Richardson, circa 1733

His paragon of a son was the only exception to the last practice Richardson left himself as he slowly retreated from professional portraiture and concentrated instead on one model alone: himself. The late chalk drawings were no longer driven by the need to survey his life as it had unfolded but rather to inspect, with unsparing intentness, the whole condition of his character as it was at that moment. It was, in effect, a pictorial version of the ancient *ars moriendi*, the preparation made by good Christians for their demise, if at all possible in a state of grace. Richardson's routine, which had never varied very much, was now as strictly repetitive as his body allowed: still the morning reflections and thoughts set down in verse; still the walks and rides which followed; the meals ever more frugal; the company select and averse to immoderate indulgence. It is easy to understand why Vertue and Walpole thought Richardson in the grip of an obsession, looking at and drawing himself every day, for there is a decided sameness to the series: the three-quarter profile to right or left; the gaze exceptionally severe and searching or, towards the end, just three years before his death in 1745, a little less strained; the cleft chin, sitting comfortably on its stock; and, remarkably, Richardson's own hair, informally brushed, its silvery hue suggested by the black and white chalk.

Richardson hoped and believed that he would be remembered more as a writer than as a painter. The self-portrait in oils he did of himself shows him with quill and paper rather than brushes and canvas, and before he died he took steps to have his books translated into French, and they did indeed enjoy a certain popularity in France, if one mixed with incredulousness that the English could write at all about art when they showed such inferior evidence they could practise it. In 1719, Richardson had followed the *Essay on the Theory of Painting* with two further works on how to be an art critic (distinguishing good from bad, originals from copies; a subject he treated more subtly than one might imagine); and *A Discourse on the Dignity, Certainty, Pleasure and Advantage of the Science of a Connoisseur*, aimed at the instruction of collectors (Richardson himself had a stupendous collection of

drawings at his death). If anyone, in any culture, can be assigned the dubious honour of having created a British 'art world', a nexus tying together artists, critics, patrons and collectors in a milieu that was not dependent on court and state but which somehow went of its own accord, it was Richardson.

This cultural miracle, the rebirth of what had once shone forth in Greece and Rome and in the Italy of Raphael and Michelangelo, was, Richardson announced, now to take place in England: 'Whatever degeneracy may have crept in ... no nation under heaven so nearly resembles the ancient Greeks, and Romans as we. There is a haughty courage, an elevation of thought, a greatness of taste, a love of liberty, a simplicity, and honesty amongst us, which we inherit from our ancestors, and which belong to us as Englishmen.' Shakespeare and Richardson's beloved Milton were but the heralds of this new empire of art; and Richardson himself would not live to see its fruition, though its germination was as yet only in its ripening time. He was confident there would be in England a great revival of art and taste, though only when 'English painters, conscious of the dignity of their country, and of their profession, resolve to do honour to both by piety, virtue, magnanimity, benevolence, and industry; and a contempt of every thing that is really unworthy of them.'

In other words, when Jonathan Richardson looked down that long Roman nose of his into the mirror for the inscription of all the high virtues of a true artist, he began to discern what the face of British art ought to be. It would, in fact, be someone rather along the lines of Sir Joshua Reynolds.

But Reynolds and Richardson would not have the argument all their own way. William Hogarth's *Analysis of Beauty*, published in 1753, was a direct attack on the equation between classical idealism and high art. Hogarth's own practice was as inclusive and catholic as Richardson's strictures were exclusive and refined. The features which Richardson disqualified from proper taste – the knobbly and the irregular; the unseemly and even the deformed, mouths wide open with mirth, madness or pain – were all to be embraced by the artist

for whom nature was indeed the only true god. In a still-later generation, eyes would stare out at the beholder, not elegantly and intelligently angled as with Richardson's own three-quarter-profile heads but locking on to the beholder directly, frontally, unnervingly, eyes which bore through those who contemplated them with the delirious address reserved for religious revelation.

5. Living Anciently at Twenty

The stare goes right through us and out the other side. We are an irrelevance to Samuel Palmer's self-observation, which is the most tightly focused in all of British art. We are admitted, almost indecently, to the force of his concentration, simultaneously exact and visionary. Despite the rabbit-pouch-cheeks, in 1826, in the twentieth-first year of his life, he is a handsome young man, but he is aware of the mind's vanity and the body's treachery. His raw lungs make him hack and wheeze alarmingly enough for Mary Ward, who had nursed him as a child, to continue to care for him, even when he moved to Shoreham in Kent.

For this moment of exhaustive self-inspection Palmer is perfectly composed, wholly absorbed in taking inventory of both his outward appearance and his innermost spirit. Every tiny hair of the stubble on his upper lip and beneath his lower one is registered with precision. The roughly cut hair, perhaps self-sheared, is more lovingly handled in black chalk than any barber could have managed and with a lot more attentiveness, too, for Palmer has found a way to draw dirt-stiffened, sweat-stuck individual hairs so that they cling greasily together, exposing glistening areas of his forehead. The buff-coloured paper on which he draws acts as a foil to the hot light falling on him, even in Surrey or Kent. A dash and a rub of his white chalk accents this numinous glow dawning on his brow; a quick stroke illuminates the bridge of his nose and the catchlight in his right eye. The shadow cast by his chin on the standing collar, the play of his loosely tied cravat, the brightly lit knot, are things of freely handled beauty which Rubens and Rembrandt would not have been ashamed to own up to. Accidental marks of romantic impulsiveness stay uncorrected on the sheet: a splat at the top of his coat lapel, an unintended smear of chalk descending, like the slash of a duelling scar, from the bottom lip. Yet, along with the assurance, Palmer's fine motor control is as precise as

Self-portrait, by Samuel Palmer, 1826

that of any calibrator of time pieces. It is as if he can draw without, for a second, taking his eyes off what he sees in the mirror, the hand automatically obedient to the sight, or perhaps the reverse: that his sense of self-description is so acutely ingrained that he seldom checks the reflection at all.

But it is, of course, the two organs of eyes and mouth, which shape the demeanour and command the face, for whatever kind of mystic Palmer will be, it will not be a silent one. He covers his sketchbooks with a mass of words: detailed instructions as to the spirit and the detail of how and where to set his hand. He diarizes, writes long, impassioned letters to friends, reports on the state of his soul. By example, waxing rapturous, his post-adolescent eye flashing, heart and head pumping hyperbole in unison, he is on a mission to heighten vision. Charm, especially what is taken for the charm of nature in his day, is the enemy. His company of 'Ancients', he thinks, should not settle for such cheaply won ingratiation. He wants the Ancients to abandon commercial picturesque, 'the pit of modern art', and seek in the art of the past the materials of a great redemption. Samuel Palmer is swollen to bursting with these words, torrents of them, as indeed were his idols, Milton and Blake, in whose poetry images and utterances, apparitions and exclamations, complex thoughts and verse song toss in gloriously profuse confusion. Looking at himself in the glass, Samuel sees that his big, boyish lips are dry and in places cracked, and he describes those stinging little creases and openings in ways that would never even occur to slighter talents. But it is, finally, the enormous coal-dark eyes, the moist lower rim of his eyelids, made with a tiny dash of white chalk, which speak of the paramountcy, at this particular moment, of his vision, which is less optical than spiritual.

For Samuel Palmer is looking through his own face, into the interior, where the only landscapes worth seeing are beginning to bud and glimmer: apple trees erupting in gouts, gobs and blobs of frothing blossom; shepherds slumbering upon the fleecy backs of their flock; umbrageous elms the shape of giant mushrooms; a night sky broken

with patches and slabs of cloud, hanging and drifting like silver rags above a low, bloated moon; imploding starbursts spangling the blackness; a setting summer sun toasting bunched sheaves of wheat into the colour of dense honey. If it occurs to you that all this anticipates that other missionary of the modern day, Vincent van Gogh, you are absolutely correct.

But where did all this manic exuberance come from (other than the distinct possibility of a bipolar personality; also the case with Van Gogh)? Straight from the soul, Palmer would have said, and did, in fact, say, 'the visions of the soul being perfect are the only true standard by which nature is to be tried.' But those visions first formed when as a boy he read the books lining the shelves of his father's shop in Newington, south of the Thames. Samuel Palmer Senior (again, like Van Gogh's father) was a Baptist convert and lay preacher, so Bunyan's *Pilgrim's Progress* was treated as a second scripture, read out loud to the asthmatic little boy growing up on the edge of Southwark, where city grime began to open up to wider, greener spaces at Blackheath, Clapham, Dulwich and Greenwich. It is hard, also, not to believe that, as spiritually inclined as they were, the Palmer parents did not speak of the medieval pilgrims of that name who had sauntered (*aller à la sainte terre*, as Thoreau recalled) through lanes and fields to the Holy Land (Sainte-Terre), golden Jerusalem fixed in the sights of their mind. Palm trees – symbols of eternity and resurrection as well as the sacred botany of the Passion – would crop up in Samuel's own landscapes even when most of the rest of them owed more to Kent than to Palestine. How different, after all, could shepherds and their flocks be? One leaf of his sketchbook of 1824 features himself as a palmer, staff in hand, wandering past a stylized palm about which are gathered flocks of virgins and sheep.

The Palmers did not have to rely exclusively on income from the bookstore to support their romantic rambles, whether on foot or in the imagination, which was just as well, since they got precious little money from it. Samuel's mother, Martha Giles, was an amateur musician and composer, and she seems to have brought a harmonizing

element to the family. The Gileses were socially and economically a cut above the Palmers. Martha's father, William, was a banker; Samuel's cousin John a stockbroker who would be an indispensable support when Samuel put together his new life at Shoreham and tried to live Anciently. A timely if modest legacy from the banking grandfather would add to this kitty of painterly independence, important when the young visionary had trouble being taken seriously at the Royal Academy, much less finding buyers. Money worries were like a black hound for the time being kicked away from Palmer's door but which would eventually come back to dog his liberty.

The money of the Gileses also allowed Samuel Senior to take the time to be his son's principal teacher when two terms at Merchant Taylors' School were all the twelve-year-old could take. Thereafter it was the father who schooled the wheezy lad in Latin and Italian poetry, Shakespeare and, especially, Spenser, Milton and Blake, whose lyrics tried to bend English verse to classical cadence and meter.

Concerned for the boy's asthma, the Palmers would try to ventilate his lungs with local pastorals in the meadows, gentle hills and slopes around Dulwich, but the antidote to the smoke and soot that clung to them even in Surrey was to go a little further into Kent. Martha sometimes took Samuel to cleanse the pipes with ozone at Margate (where one of his idols, Turner, had established himself), and it was there, when he was seven, that the boy made a tiny drawing of a beach scene, with a windmill at the back of it and a man fishing from a breakwater, which already suggested a precocious gift. He was sent first to a drawing teacher, where he learned little he didn't know already. But he came to know John Varley, a master of watercolour, and won enough of a reputation as boy prodigy for his work to be shown at the British Institution and even sold when he was at the tender age of fourteen. Two years later he made a watercolour of an approaching storm that could decently be compared with Thomas Girtin or Turner. He had decided on his path.

Samuel Palmer's life as a prodigy proceeded, as if in a modern gospel,

through a procession of personal encounters, each weighty with prophetic and apostolic meaning. The first came in 1822 with the painter John Linnell, friend to poets such as Shelley and a specialist in open-air landscapes which, beside the achievement of his protégé, seem conventional. For the seventeen-year-old Palmer, though, Linnell was the herald of revelation. 'It pleased God,' he wrote, 'to send Mr Linnell as a good angel from Heaven to pluck me from the pit of modern art.' Though the relationship between the two men – Linnell twelve years Palmer's senior and, from 1837, his father-in-law – was both to form and eventually deform Palmer's life and career, the older man ought to be credited with recognizing in Palmer something invaluably precious to the Romantics: artless art, the miraculous preservation of the innocently wide-eyed vision of the child, somehow unspoiled amidst the meretricious ways of the social world; and this notwithstanding the dandyish inclination to sport a personal style in dress. It was an article of Romantic faith that childhood was unsullied nature; adulthood all contrivance, commerce and artifice. The work of a true poet-painter was somehow to recover the former beneath the hardened carapace of the latter. Wordsworth devoted his greatest poem to exactly that enterprise. Though he was not much of an exemplar of child vision himself, Linnell took his young follower to see the European landscapes which he thought carried that sense of dewy innocence: the woodcuts of Lucas van Leyden, the prints of Albrecht Dürer, the hills and fields of what they liked to call the Flemish 'primitives'.

There were also outdoor excursions into the suburban pastoral. To persuade themselves that the deep country was the spiritual corrective to the grinding materialism of the town, the Romantics had to close their eyes to the brutal realities of the modern British countryside, where enclosures, the peremptory disappearance of common grazing, and the incoming revolution of threshing machines had liquidated small tenancies, impoverished rural labourers, ignited violent attacks on the machines, brought the militia into the villages, and sent multitudes into the rookeries of the towns and the maw of the

factories. From Palmer's own rustic idylls, you would never know that the Kent he thought approximated to a little heaven on earth was a place of chronic unrest and violence. And when he did comment on the disturbances, it was always to denounce them and to condescend to 'our fine British peasantry', led astray by mischievous radicals. During the election of 1832, the first following parliamentary reform, the twenty-seven-year-old Palmer would publish an address to the Kent electors warning that, should they not vote for the Tory candidate, they would be handing over the country to Jacobin revolution.

Politically, then, Samuel Palmer was as unlike William Blake as it was possible to be, which did not, however, make him regard the old man, at the very end of his life, as any less a revelatory prophet and patriarch. John Linnell's own work was in a completely different register from Blake's, being plain and fresh rather than mystical-extreme. But no one was a greater devotee. It was Linnell who gave Blake, then in his late sixties and ailing, a series of commissions which eased the burdens of his last years; Linnell, too, who, anxious about Blake's state of health, invited him out to his Hampstead house for some respite from his cramped lodgings at Fountain Court on the Strand. In October 1824, Linnell brought Palmer with him on a visit while Blake was working on drawings illustrating Dante's *Divine Comedy*, a task the old man took seriously enough to try to give himself a crash course in Italian before embarking on the series. Laid up with a scalded foot (or leg), Palmer found Blake 'not inactive, though sixty-seven years old, but hard-working on a bed covered with books, sat he up like one of the Antique patriarchs or a dying Michelangelo. Then and there was he making in the leaves of a great book [a folio of Chinese paper Linnell had given him] the sublimest designs from his (not superior) Dante.' Palmer then allows himself a little note of self-congratulation. 'He said he began them [the drawings] with fear and trembling. "O! I have enough of fear and trembling," I said. "Then," he said, "you'll do."' But Palmer follows it with a touching acknowledgement of how Blake's devotion to his art had become the light for

him to follow. Learning that Blake had continued to work on Linnell's Dante drawings while in pain and sickness, Palmer got up the courage to:

> show him some of my first essays in design; and the sweet encouragement he gave me (for Christ blessed little children) did not tend basely to presumption and idleness, but made me work harder and better that afternoon and night. And, after visiting him, the scene recurs to me afterwards in a kind of vision and in this most false, corrupt and genteelly stupid town my spirit sees his dwelling (the chariot of the sun) as it were an island in the midst of the sea – such a place for primitive grandeur.

Could the work Palmer dared to show Blake have been the rough drawings made in a sketchbook (which has miraculously survived his son's bonfire of many others) and which in places have a very Blakeian feel? God creating the sun and moon; stretching his form in Michelangelesque elongation above a platform of weirdly equidistant stars? The sketchbook, however, also has singularly Palmerian subjects: a fabulous quadruped, not quite mule but no horse or donkey either, a bristling camel-like little beard on its jaw, ears of monstrous size, more like a hare's, the beast standing between an orchard and a field of wheat. On another page it is Satan, not Christ, splayed backwards over a cross, his head crowned and mouth opened wide in evil rictus.

Through the next year, 1825, Palmer began to come fully into his own. He believed he was following the example of Blake's 'frescos', in which watercolour was thickened with gum arabic. But Palmer used the gum to thicken the sepia cuttlefish ink and washes he used to make the stupendous six drawings which announced his individuality. That they were, together, a self-conscious statement is apparent from the large signature, made with calligraphic care, inscribed in a flowing curve echoing the angle of the hills, his name made an integral element of the decorative composition.

The ageing of the gummy medium makes these pictures now very dark, but even at the time Palmer created them the inky depths served to make an immense drama of his favourite light effects: the light cast by a sickle, haloed moon; the irradiated gleam of dawn, backlighting an unearthly tree beneath which (if you look hard enough) you can see men and bonneted women gathered as if to greet the day with a prayer, while bright-lit at the front of the picture stands a hare, stock-still, long ears on full alert. In another, a swelling, round cumulus cloud is more brilliantly lit than the foreground, while in *The Valley Thick with Corn* a full moon has become a distended orb across which bats flit.

Anything Palmer would have seen, either at Dulwich or Shoreham, would have been no more than a springboard for his vaulting imagination. While it had become an eighteenth-century truism, especially in Britain, that the landscapist must be guided always by 'truth to nature', Palmer's work, and the writing which elaborated on it, is full of the conviction that nature and art were in fact two different realms, and the artist's role was somehow to transmute the impressions he had of the one into the 'gold' (as he put it) of the other. Already, then, in the sepia drawings, the twenty-year-old throws away pretty much everything he was supposed to have learned and to practise. The opening of deep space through perspective – the standard means of producing the vast panoramas which guaranteed a good showing at the Academy – was replaced by decorative manipulation in a shallow field. Hills are made to advance and tilt, bunch and enclose. Trees stand vast and broad at the very front of the picture space. In *The Valley Thick with Corn*, the figure of the sleeping Bunyanese pilgrim is much too big for the hummock against which he reposes; the sheaves of wheat down the hill sway like a corps de ballet; the trees in the distance are formed like balls of yarn. The entire picture seems, in fact, more woven or knitted than drawn: the reverse of a tapestry cartoon; rather, a drawing *become* tapestry or embroidery, all the forms simplified for the craftsman's patterning. The texts accompanying the images, whether from the Bible, Bunyan or Shakespeare, add another road into

the fabulous. We are in a dreamscape of poetic magic. Expect no haywain.

Palmer credited Blake for tearing aside the 'fleshly veil' to reveal deeper mysteries which had no counterpart in observed nature. Blake was largely indifferent to landscape, conventional or unconventional. And except for the literary prompts, and the mystic glimmer, the sepia drawings looked nothing like anything Blake had ever done. Palmer's scenes are empty of primordial thunderbolts and creative colossalism. They are instead profoundly down here: loamy and burgeoning; everything in a state of either maddened fecundity or drowsy fullness. Blake is grave; Palmer gravid. Blake's universe spins and whirls; Palmer's lies down to sleep amidst the ripening corn and the hanging fruit. Blake is rocket-propelled; Palmer huddles in the dell and the embowering glade. The one shoots for paradise among the wheeling stars; the other, boy though he is, seems to have found it in the piper's dreamy notes and the cradling hills. Blake is the demiurge; Palmer the child comforted by the steeple on the horizon.

In the end, they were quite different: Blake, sustained and protected by a few – Linnell, and even Sir Thomas Lawrence, at the extreme opposite to his taste and habits but nonetheless an admirer – obstinate in his originality, publishing everything he could; Palmer, on the other hand, persuaded away from his unique vision, not least by his father-in-law Linnell, to a style more acceptably 'close to nature' as the world saw it; hiding the greatest work of his genius away, sketchbooks (all but one) destroyed by his own son after his death. But in 1825 the young Palmer was so moved by the force of Blake's unbending integrity as to allow his own originality out for five or so years of uncontainable play. Much later, chained to compromise for a living, he was still thinking of that moment. Twenty-eight years after Blake's death Palmer recollected how he had seen in Blake the pure personification of how an artist should live:

In him you saw at once the Maker, the Inventor; one of the few in any age: a fitting companion for Dante. He was energy itself,

and shed around him a kindling influence; an atmosphere of life, full of the ideal . . . He was a man without a mask, his aim simple, his path straightforward and his wants few; so he was free, noble, and happy.

It's tempting to believe that by the time Palmer came to draw his own self-portrait he might have seen Blake's own haunting look in the mirror, in which the wide-set cat's eyes stare back directly, lips pursed as if challenging himself to a fight. But at some point the pose of confrontational straight-ahead directness had been established as the standard Romantic gaze. It had been the way the young Turner had pictured himself decades earlier and how the aspiring artist William Hazlitt examined himself before giving up on his chosen career, becoming instead a word-painter, an essay-duellist.

Following Blake's death on 12 August 1827, after working busily on one of the Dante watercolours, Palmer's younger friend George Richmond wrote to him that just before Blake's passing 'His Countenance became Fair – His Eyes Brighten'd and He burst out into Singing of the things he Saw in Heaven.' Linnell lent his widow, Catherine, money for the funeral at Bunhill Fields and wanted her to come and live in his Hampstead house, where he had hoped Blake would occupy a studio. Palmer had already dubbed the sainted man 'the Interpreter', as if he had led the way in unlocking revelations of heavenly places on earth. And the single experience of encountering Blake led Palmer and his friends to establish themselves as a distinctive group of artists known, in repudiation of debased modern taste, as 'the Ancients'. They included Richmond, then just fourteen years old, Edward Calvert, Welby Sherman, Frederick Tatham, Oliver French and the non-painting stockbroker cousin John Giles. It is often said that the Ancients modelled themselves on the German Nazarenes led by Johann Friedrich Overbeck, who were likewise committed to a revival of pre-Renaissance sacred art for the modern day and constituted themselves as an austere community. But there is no direct evidence that the London boys turned semi-rustic Ancients knew much about the Germans, and their art had nothing of

William Blake, replica by John Linnell, 1861
Self-portrait, by William Blake, circa 1802
The Valley Thick with Corn, by Samuel Palmer, 1825

the laborious, porcelain-smooth anachronism of Overbeck. The Ancients were, in fact, the first YBA gang: bohos among the cowsheds; rowdy for Jesus; leading (for a while) a life of exclamations and anthems.

But not quite living together as Palmer had wished. He was the only one to make a move out of London, in 1825, to the village of Shoreham, where some (not all) of the sepia drawings had been made and where he believed he could fulfil his visionary destiny. His father had first brought him to Shoreham in 1824, and in 1827 Samuel Senior sold up the failing bookshop and moved with his son and Mary Ward to the Waterhouse by the River Darent; yet another of the father–son creative cohabitations that included the Richardsons and the Turners. Two years earlier, Palmer's accommodation had been more rundown and rudimentary: the lodging he called 'Rat Hall', to which fellow Ancients tended to come for fairly short stays. Edward Calvert had a young family to support. George Richmond, the most gifted of the group, clung to Palmer, but he was too young to make a clean break. But Richmond did make two drawings of Palmer, plus an exquisite miniature of the reborn Samuel wearing a broad-brimmed palmer's hat, a long cloak and the Jesus-face of trimmed beard and shoulder-length hair. (This, the Nazarenes also affected.)

However much the Ancients might have shared common ideals, it was only Palmer who found the visual language to embody them; one which was not, like the Nazarenes (and early Pre-Raphaelite scripture painting), refreshed anachronism but something truly revolutionary; so startlingly unfamiliar in manner, so much the illumination of a dream world rather than the scenery of a Kentish pastoral, that it was doomed from the beginning to meet with rejection. Even the more tentative efforts in that direction offered to the Academy were routinely rejected; others which were seen met with brutal derision, one critic for the *European* magazine sarcastically describing them as so 'amazing' that he could not wait to be acquainted with whatever manner of man had created them and recommended that he show himself to the exhibition with a label about his neck and that way might earn a decent shilling or two.

Samuel Palmer, by George Richmond, 1829
Samuel Palmer, by George Richmond, circa 1829
Self-portrait, by George Richmond, 1830

The dismissal of the work as fantastic juvenilia hurt because Samuel Palmer paid so much attention to the technical demands of his compositions. The 1824 notebook records his determination to picture the 'mystic glimmer . . . like that which lights up our dreams' (in Dulwich, no less), but it is more remarkable as a record of constant observation and practical self-direction:

Useful to know by this if in a building with many angles against the sky one wants to neutralize the keenness of the light against one or more of them to do it by this lacework which enriches the building and makes it more solid. Also on the walls grow the most dotty things what a contrast! and they may be near large clumps of chesnut [sic] trees perhaps with leaves as long as a man's forearm, also *soft* velvet moss on a *hard* brick wall, moss *green* wall *red*. The colour of ripe corn gives to the green trees about it increased depth and transparent richness.

Sometimes, too, the stern taskmaster of material matters issues severe reprimands to himself! 'Place your memorandums in your book more neatly you dirty blackguard – then you . . . may in coming time refer to them with pleasure and see that you begin over leaf or I shall stand here a witness against you.' The habit of fierce self-criticism never left him:

Some of my faults. Feebleness of first conception through bodily weakness [he is still coughing] . . . No rich, flat body of local colours as a ground . . . Whites too raw, Greens crude, Greys cold, Shadows purple . . . Carry on the drawing till real illumination be obtained. Investigate on some simple object what are the properties of illumination and shade . . . let everything be colour and not sullied with blackness.

This last self-rebuke seems to have been dated when, notwithstanding jejune criticism from outsiders and his own fearful hesitations, Palmer

393

had nonetheless taken the leap from ink and chalk paintings to the glowing watercolour-gouaches which are the consummation of his precocious genius. They resemble nothing that had yet been seen in European art, though in their leap out of figurative representation and towards pure colour play, they anticipated by many generations much of what would eventually come. There are precious few of these stupendous watercolours, but why they have not been made central to the understanding of the turn from naturalism to a wholly different grasp of what could be done with paint is an art-historical mystery. Or again, perhaps it is not. The narrative of modern art presupposes emancipation from religious conviction rather than devotion to it. But these are, beyond anything else, intensely devotional images, though not in any formal theological sense. They marry Palmer's feverish pantheism, his anthem of joy to the natural world, to Christian reverence, until the one becomes the expression of the other. A church steeple appears in *The Magic Apple Tree*, but the eye has to hunt for it between an oncoming hillside wave of radiantly golden wheat and a vast coagulation of bunched fruit; hundreds upon hundreds of apples, thick as pomegranate seeds, hanging and drooping from a curving bough like no earthly apple crop that has ever been. Only the spire is visible, down the slope engulfed by all this fruition. While he is throwing away all and every convention of painting, Palmer has also disposed of three and a half centuries of perspective as well, so that, as with late Van Gogh and expressionist landscapes, the articulation of planes is entirely dependent on the arrangement of colour; and has parted company with any conventional reading of depth. This is what Palmer wants: a kind of sacred claustrophobia; the skyline – such as it is – pierced by trees leaning towards and interlacing their leaves to form a pointed arch, the primary unit of nature's own architecture: Gothic.

In a Shoreham Garden, a bubbling detonation of pink-and-white blossom explodes above a wraith-like female figure, scarlet-skirted at the cottage doorway. She stands perfectly still while the blossom boils madly away over the garden path, Palmer dabbing and dropping blobs and gobs of watercolour within his Indian-ink outlines. His brush is

shaking with the sheer pleasure of it, so out of control that the blobby ejaculation lifts off like soapsuds spurting into the sky, the whole crazy invention crowned by a nimbus of some sort of gold vegetation, not laburnum either but honeyed autumn in the midst of erupting spring. 'Excess is the essential vivifying spirit,' he wrote about this time in his notebook. 'We must not begin with medium but think always on excess and only use medium to make excess more abundantly excessive.'

Palmer's son, who did not know what to make of these productions, maintained that the artist himself showed them to very few, keeping them instead in a portfolio labelled 'Shoreham Curiosities'. Given A. H. Palmer's eagerness to clean up his father's record, it is a miracle they have survived at all. But they were enough to make his mentor Linnell alarmed at the direction the young Ancient was taking. On visits to Shoreham he counselled him to go more directly to nature; to observe, transcribe and pay less heed to the frantic beckonings of his inner vision. For a while, perhaps with Blake's majestic obstinacy in mind, Palmer kept faith, though even by the mid-1830s (in his own late twenties) he is painting more studiously. The Shoreham country pieces are bathed in Palmerian glow, but they no longer heave and throb or drown the beholder in the elixir of saturated colour. The shepherds are still there, but the angels have gone. This is no longer paradise; it is Kent.

Palmer had little option. The marriage with Linnell's daughter Hannah, the arrival of children, his lack of sales: all made him trim his sails in exactly the way he had promised himself he would not do. The Ancients grew older and grew up; Calvert and others chuckling at their shared youthful delusions. When Palmer went on a two-year honeymoon with Hannah to Italy, Linnell thought he was irresponsible. Tensions between the two became an open breach. Palmer lived on another half-century after his time beneath the 'glistering' (a favourite word) stars and the bat-flown harvest moons. He did Victorian eye-candy: sunsets in the purple-and-lavender light of which his early memo so disapproved; Gothic ruins above winding rivers; vast

panoramas; deep, furrowed, ancient oaks. In 1884, three years after Palmer's death, a friend, Charles West Cope, made an etching of the old boy; a pate as round and gleaming as one of his Kentish hills of old; white-bearded, hands clasped, leaning slightly forward. The face seems full of wistfulness. But a graphite drawing, surely made while Palmer was still alive, seems to have an altogether different expression: the eyes less heavy with gloom, the mouth less set and downturned. This may simply be the effect of the pose reversed. But then again, who knows? Beneath the face of the old man, the Ancient may have somehow endured.

6. The Bodies of Women

There they are, the Slade girls of 1905. They have been careful, during the strawberry picnic, not to stain their summer dresses, the costume of their graduation, and now they pose for their class photograph. There are some men there, too, but they have all been pushed to the margin of the frame, standing at the edge of the group like a wooden breakwater beside the oncoming foamy tide of New Women. Even if they don't yet have the vote, their brave and eloquent sisters are out demanding it; glowing with militant resolution. The New Women ride bicycles; they smoke; they have latch keys in their bags. They have all abandoned the bustle; many have, with a sigh of relief, ditched the tyrant corset. Some wear their hair in a chignon, the French style that's right for the Slade, which is a markedly French institution of art in the middle of Bloomsbury. If on this graduation day they sport broad-brimmed hats and nipped-in waists, it is by their own choice and to lend grace to the auspicious occasion. They no longer feel obliged to be fore and aft what they are told men want from a mate. Men will have to take them as they are, or not at all. Nor will they hold their tongues as their grandmothers were told to do if they wished to catch a husband. When they are beset with opinionated men who say nothing particularly interesting but say it very loudly, they will argue back, with confidence and clarity. And now these girls make art.

The Slade School of Fine Art opened its doors in October 1871 as an institution of University College London (which had also been the first to admit women to its classes), courtesy of the legacy of Felix Slade, lawyer and bachelor collector of glass and fine editions. Slade endowed three Chairs but also six scholarships at University College, gender blind. Not long after its establishment, the Slade School in Gower Street became identified with the mission of giving women equal access to art education with men, something previously unheard

Slade School of Fine Art, Class Photo, by unknown photographer, 1905

of in Britain. For centuries, the condition of being able to imagine a life as a professional artist had been the protection and support of men, usually within the family. Fathers, husbands, brothers might encourage a gifted female relative, though very often with the assumption that she would abandon art as a vocation once she married and became a mother. The one extraordinary exception to this convention had been the successful and fashionable seventeenth-century portraitist Mary Beale, whose husband acted as manager and dogsbody of the studio. In the eighteenth century two women, Angelica Kauffmann and Mary Moser, had been founding members of the Royal Academy but, thereafter, none would be admitted as a full Fellow until Laura Knight in 1936.

In earlier centuries, drawing (along with music) was thought of as an important, even necessary, element in the education of an accomplished woman. Watercolour landscapes and still lifes were pronounced charming by men leaning benevolently over the easel. Making a living as an independent artist, with pretentions to become a portraitist or even a history painter, was an entirely different matter, and an education towards that end was countenanced and financed only by enlightened fathers and husbands with the means to do so. One of the most successful Victorian artists, Sir Lawrence Alma-Tadema, specialist in vast Roman histories, often featuring cosmetically perfect nudes draped about indolent men in slo-mo orgies, was happy to encourage both his wife and daughter, since they were talented in their own right. But the women had modest studio space on the ground floor of their grand London house, while Alma-Tadema occupied the entirety of the first floor, where he would work on his enormous canvases in grandiose magnificence. Milly Childers, who painted a brilliant self-portrait in 1887, was likewise dependent on a benevolent papa, a Member of Parliament and Cabinet minister, for constant support and introductions to patrons. Countless gifted women found themselves a basic art education in small private schools such as the Female School of Art and (after a struggle) were allowed to attend the Royal Academy Schools. What continued to be unconscionable was the idea that women might

draw from live nude models of either sex. Instead, they were doomed to work only from plaster casts, or the occasional clothed model.

The Slade changed all this. Though its professors were of course men, and they themselves painted in very different styles – Edward Poynter enjoying himself with tremulous nudes laid out in classico-mythic contexts (a quivering Andromeda, cream-bosomed storm nymphs fingering their gold); Alphonse Legros, more attuned to history scenes; and Frederick Brown, third in line, portraits and anecdotal conversation pieces – what they shared was a hearty dislike of the Royal Academy's institutional arrogance. All three had French connections. Legros had come of age in Dijon, though without much luck in the salons of the Second Empire, despite or because of being a friend of Rodin. Poynter had studied at the Académie Julian in Paris, and Brown had the prize experience of being a fellow student, also in Paris, of James McNeill Whistler. In 1886, seven years before becoming the third Slade Professor, Brown founded the New English Art Club expressly as a place where artists disdained by the Academy could show their work and feel part of a modern, liberated wave of painting and sculpture.

Not only were women welcomed at the Slade, they were expected to take life classes, though not at the same time as the male students. Since the backbone of Slade philosophy was instructive engagement with the greatest of the old masters – especially Rembrandt, Velázquez and Titian; painting built on the mastery of draughtsmanship – those life classes assumed immense importance in the formation of the young artists. In Henry Tonks, hired to be Assistant Professor of Drawing, Fred Brown thought he had found the perfect instructor to drive that lesson home to the young women of the Slade. He had first encountered Tonks as a student at the Westminster School of Art. In 1888 the young man was taking evening classes, because he had another life and another career: medicine and, in particular, surgery. While he was studying art Tonks was also admitted to the Royal College of Surgeons, so when he spoke of anatomy as the foundation of drawing, he knew what he was talking about.

Perhaps importing some of the disciplinary severity of his medical training into the Slade, Tonks became notorious as the terror of the school, merciless in his criticisms, delivered with an acid tongue while his hooded eyes watched the progress or the calamity taking place on paper. His background lent itself to the obvious metaphors. Paul Nash, who hated him, spoke of Tonks's surgical glance. Tonksian put-downs became a legend. 'Your paper is crooked, your pencil is blunt, your donkey wobbles, you are sitting in your own light, your drawing is atrocious and now you are crying and haven't got a handkerchief' was not the worst of it.

Tonks believed he would be doing his women students no favours treating them any differently from the men. If they were to steel themselves for the arduous road ahead in an art universe still dominated by males, it was as well they should get used to trenchant criticism and, through the uncompromising excellence of their work, silent condescension. Some of the women who came his way were inspired rather than cowed by Tonks's asperity.

One of them, Gwen John from Pembrokeshire, knowing that Tonks was proud of his cartooning skills, drew a caricature of him (as well as the other professors) in the form of a strange beast: 'The Tonk: . . . a voracious bird which lives on the tears of silly girls. Its sarcasms are something awful but it generally says, "All right, go on."'

Like so many other women artists who realized their vocation, Gwen John's first enthusiast was her mother, Augusta. In Haverford West, where her husband, Edwin, was a solicitor, she encouraged two of her four children, Augustus and Gwen, to follow their gift and sketch what they found on walks, at home, anywhere. But Augusta died suddenly and inexplicably when Gwen was just eight years old. Edwin moved the family to Tenby, but he also sustained the early budding of his son and daughter. To his credit, the brother never had any doubts about his sister. 'Fifty years after my death,' Augustus John said at the height of his phenomenal fame and worldly success, 'I shall be remembered as Gwen John's brother.'

So when Augustus went off to the Slade in 1894, beginning as a

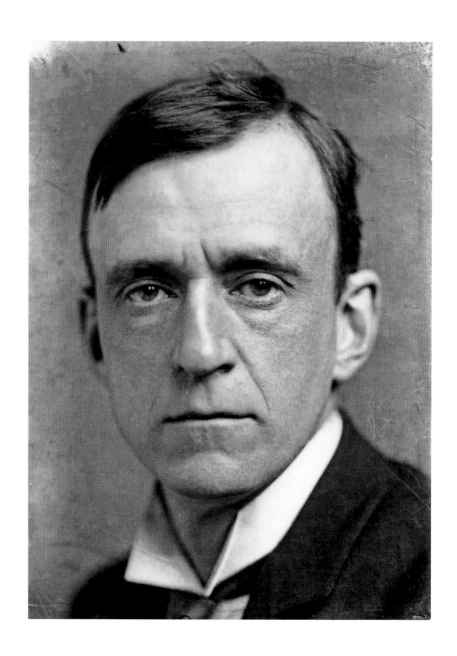

Henry Tonks, by George Charles Beresford, 1902

proper young man and almost immediately discovering how to remake himself as a roaring bohemian with the beard to match and a bottomless appetite for drink and girls, there was no question that Gwen would not join him there, too, and she duly did a year later. Slight and shy as she was, her resolution was iron and her gift unmistakable. While she was at the Slade she made at least one remarkable portrait, of her cleaning woman, Mrs Atkinson. A Tonksian decree was to ignore altogether any sort of attempt to divine on faces and figures what might be the inner character of the sitter. But from the evidence of Mrs Atkinson, this was not advice Gwen John was ever going to take. The old lady's head, emerging atop a pyramid of modest black coat, looks like a hen worrying about its immediate future. John has painted her glancing anxiously sideways, uncertain of what is wanted of her, trying to please while looking miserably uncomfortable posed against the ghastly flocked wallpaper of John's room. (Augustus, who liked to tease his sister, mocked her for preferring 'slums and dungeons'.) But the portrait is not a mockery; rather, it is as full of tender empathy as anything Gwen would have seen in the Dutch rooms of the National Gallery.

She was not willing to stop her education with a strawberry picnic at the Slade. That autumn, along with two close friends, Gwen Salmond and Ida Nettleship (who would marry her brother), she enrolled at the Académie Carmen on the boulevard Montparnasse in Paris. Its presiding teacher, who had named the place after a favourite model, was James McNeill Whistler, with only six more years to live, but to Gwen John's delight still a picture of vitality and dandyish glee; his curly hair streaked with grey and white, but his eye flashing and his wit wicked. More surprisingly perhaps, given his reputation as an ageless gadabout and Lothario, Whistler was a strong disciplinarian when it came to art. And from him Gwen learned what you would expect: the poetry of tone; the music of colour; the beauty of formal design. But just as she had ignored Tonks's disdain for expressive feeling, so she equally ignored Whistler's belief that art existed entirely within its own formal and decorative terms. Harmony was not everything.

William Orpen, Augustus John, Gwen John, Albert Rutherston, Lady Edna Clarke Hall,
Sir William Rothenstein, Lady Rothenstein and others, by unknown photographer, 1899

When she got back to London in 1899, she was evidently brimming with Whistlerian confidence. There was also another event which made a difference to her: an exhibition of Rembrandt's works at the National Gallery, and on paper at the British Museum. Her name appears on the copyist list at the Gallery, so that all these streams were flowing into her assurance. The result was a spectacularly powerful self-portrait. There had been other female self-portraits before – Mary Beale, Angelica Kauffmann, Maria Cosway, Milly Childers – but they had all chosen to represent themselves, courageously, with palette and brushes, easel and canvas; taking a moment off the work they were asking to be taken seriously. Gwen John lost all that in favour of a pose of unapologetically Rembrandtian challenge. Instead of the tools of the trade, her hands are on her hips; there is an outrageously over-size, flouncy bow at her throat (another Whistler trademark); her lips are red enough for her to have painted them with lipstick, then commercially available in paper tubes. The no-nonsense hair is tied back into the fashionably French chignon, announcing that this woman means business; the eyes are direct and the hands are the hands of a woman who works with them. It is, in fact, the great self-portrait of the turn of the century; alive with a kind of magnificent vitality and resolution.

Which is what makes what was about to happen to Gwen John so heartbreakingly sad.

Another art school, a long way and a far cry from the Slade. The thirteen-year-old Laura Johnson has been admitted as an 'artisan student' to Nottingham Art School. She is a year younger than Gwen John, but she is starting classes five years before her Welsh contemporary. She has to. Doubtless the women of the Johnson family, who are in economically straitened circumstances, are proud of their girl prodigy, but there is also an element of necessity about the choice. The Nottingham school had been originally founded as a government school of design, in a city which lived by the clothing industry – shows, textiles and lace – in which Laura's family had been involved. So the

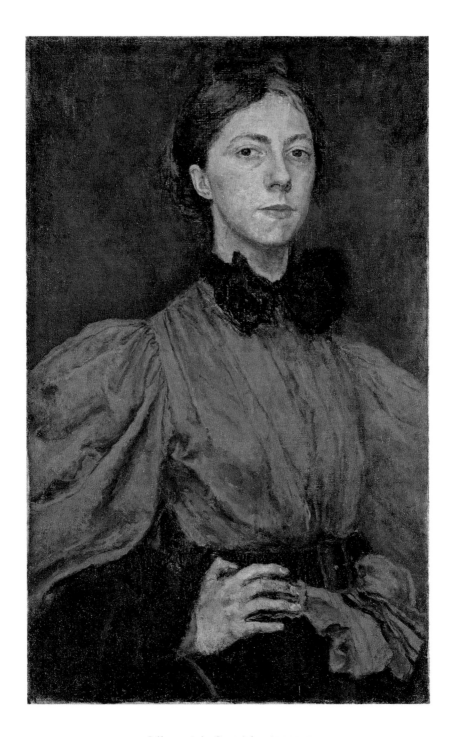

Self-portrait, by Gwen John, circa 1900

'art' education there was thought of as much in the older sense of craft and commercial application as the pursuit of painted and sculpted beauty. If those higher art values were not to be ruled out, Nottingham Art School was not about to set Whistler's 'art for art's sake' on its walls as its pedagogic motto.

Laura's grandfather on her mother Charlotte's side had owned a lace-machine factory, which, however, had been overtaken by newer processes. There was a factory making the lace itself, and tulle, in St Quentin in the north of France, run by uncles. But the Nottingham end of the business had gone bankrupt. There had been other misfortunes. Charlie Johnson, Laura's father, had imagined he was marrying up and, when he discovered the sobering truth, hit the bottle even harder than was usually his case, ending up, vocationally, as a publican, followed by an early death, probably of cirrhosis of the liver. She grew up, then, with four generations of women ('Big Grandma' plus two sisters).

Paris was in their dreams. Before she had married the feckless Charlie, her art teacher at school had singled Charlotte out as the kind of gifted girl who ought to go to Paris to study. In 1880, leaving Laura with her grandmother, Charlotte did indeed go, and – astonishing to a Midlands girl, where such things were inconceivable – she was able to attend life classes. There were times, though, when high ideals had to be brought down to earth. With the family business going downhill, Charlotte, the only adult breadwinner, had to teach art to children at the local secondary school in return for free education for her daughters. But Laura was packed off to the relatives in St Quentin, where she spent a miserable few years, cold, lonely and perpetually famished. She was rescued by the bankruptcy. Even the modest fees asked by the French school were beyond her mother's means.

Gwen John's friends and contemporaries at the Slade were nearly all well-off middle-class girls who survived Tonks to go home to Kew or Hampstead for tea and cake. Laura came of age a harder way. There she was in art school with her mother, who wanted to continue her own education after school hours, dealing with the unavoidable fact that she was better in all departments than Charlotte. After her mother

was diagnosed with cancer, the only way to make ends meet was for Laura herself to take over her mother's classes – a fifteen-year-old teaching children barely younger than herself while trying to finish her courses at art school. Bells tolled. Her older sister Nellie died of influenza; her mother; her great-grandmother; and then her feisty grandmother.

She was not quite alone. At Nottingham Art School she had become friends with Harold Knight, a social tier above her and three and a half years older. They had become teenage friends, then something closer, though not yet heart-struck lovers in the Nottingham style of D. H. Lawrence. But close enough for there to be an understanding between them that when Charlotte died Harold would more or less take care of Laura. That made them a walking-out, companionate couple.

Whether they would be true equals in art is another matter. It was Harold who went to Paris in 1896 with seventy-five pounds and a suitcase of hopes. It was also Harold who came back just ten months later, crushed by poverty, anonymity, a collapse of self-belief. A change of scene was needed to repair what was left of it: somewhere the stakes were not so high. Fishing villages were to the late nineteenth century what shepherds were to the baroque and wood-gathering peasants to the Barbizon. The pull of the tides drew painters in droves to the English sea coast, the rougher the better. The great American painter Winslow Homer went to Cullercoats on the Northumbrian coast; Harold and Laura were told to try Staithes in Yorkshire. The New English Art Club was all for *plein air* picturing: freshness and light were everything; away with Royal Academy russet, bistre and ochre. Let splashiness commence. The couple splashed, buying a pilot boat which they couldn't handle and painting the locals, which they could. More fish awaited elsewhere, in Holland, naturally, where they decamped to the artist colony at Laren; the dune-village which would bring Piet Mondrian his visions of the sea made over into marks and signs.

In 1903, Laura decided it was time they married and let Harold know her decision; she was twenty-six; he was twenty-nine. Her breezy

images of children – pictorial tonics, the palette bright and smiling – were just the ticket for the NEAC, and they began to be hung in the Academy shows as well. Harold was not unsuccessful but lacked his wife's pacey dash. Where could the sun shine on Harold Knight and his slumbrous canvases? Cornwall, where artists had established in yet more trawling and netting locales, was the answer. Without pubs with fishing nets hanging from the rafters, where would English painting have been? The Knights, as they now were, plumped for Newlyn, where they added to the bohemian quota amidst the mackerel and lobster; dressed loose, drank a lot, caroused with poetically raucous painters; brought dancers and actresses down from London to model; showed fresh-air pictures in the local galleries and shows, sent the best ones up to the Academy and the NEAC. Sex was never very far away, though when the elderly Dame Laura was brashly quizzed on it by a biographer, she retorted, 'Not my line.' Bibulous picnics where the main course was heavy flirting with someone else's wife or husband were one thing; the messy disasters that sometimes ensued quite another, as they got in the way of Laura's disciplined application. The preposterously self-conscious, dandified, opinionated Alfred Munnings, later the self-appointed scourge of modernism, arrived, flirted with the sylph Florence Carter-Wood. On their honeymoon night she took cyanide, an extreme form of second thoughts. It was not enough to kill her, but about two years later she finished the job. Another of Laura's models was shot by her jealous painter-lover.

By the time she was in her mid-thirties, Laura Knight had beaten the odds. Her paintings hung beside Vanessa Bell's in the Venice Biennale of 1910. In London, that same year, the new professor of art history at the Slade and the co-editor of the newly founded *Burlington Magazine*, Roger Fry, had mounted *Manet and the Post-Impressionists* at the Grafton Gallery, decisively redefining for the British public what art could be and do. Cézanne, Van Gogh and Gauguin, Matisse and Picasso came as thunder and lightning, blinding and illuminating at the same time. Virginia Woolf thought the show had changed humanity in one blow. Laura and Harold must have been aware of this

one-show revolution, but there is no sign in their letters or memoirs of the impact it might have had. Laura, however, was wanting to push matters further her own way. In 1909 she had had a triumph at the Royal Academy with *The Beach*: as *plein air* as you could get; children, which is to say girls, gathered at a rock pool; the smallest looking down at her reflection; her older sister (presumably) holding her by the hand to ensure she doesn't slip. Down below at the edge of the sea, everything is limpid: the grown-ups sit on the sand or stroll on the shore. The sunlight does its dappling. The mild blue water stretches away into the even milder sky. The red headscarf of the little girl (Knight is entering her scarlet time) and her dark green shift punctuate the white-blondeness of everything else. It's English impressionism: doing no harm, perfect for a railway poster or a card. Wish you were here.

But then, as if slipping a swimsuit strap down a shoulder, Laura inched towards something riskier. The little girls now turned into women sunbathing 'as nature intended', as 'naturalist' publications liked to say; topless, in Lamorna Cove, their privacy walled off by a granite cliff. The picture was painted from life. Having announced she wanted to paint outdoor nudes, London models who had stripped outdoors as happily (if not more happily) than they would have done indoors sat on the smooth rocks, dipped in the sea or walked around with the shoreline breezes playing on their bodies. The locals who witnessed the goings-on were properly scandalized and complained to the local landowner-magistrate, the young Colonel Paynter, who – this was artful Newlyn, after all – grandly brushed aside their bourgeois prudery. But the outraged ladies need not have bothered. The fiercest foe of *Daughters of the Sun*, as it was operatically titled, was the woman who had made it. An initial version was abandoned; a second was sent to the Academy and, amazingly, exhibited in the 1912 summer show, attracting little or no hostility, probably because its figurative style was not all that different to the manner used by Victorian male artists when they painted nudes disporting themselves in Roman baths or mythical grottoes. For those who wanted to look, Knight's painting did break all sorts of conventions. Its setting was

contemporary; it combined clothed and unclothed figures; it spoke of sisterhood, not least because of who had painted it. And still she was not happy with this work. She set about it with the shears. All that remains of the lovely picture is the grainy black-and-white photograph published by *The Studio* in 1912.

It would be nice had Laura not destroyed her painting, but the self-vandalizing was not an irreparable loss for the future of British art. *Daughters of the Sun* was as irreproachably wholesome as *The Beach*, except with fewer clothes. None of her biographers thinks Knight was a lesbian, but then again the criteria by which they make that judgement is often naively narrow. Amorous warmth towards her own sex did not, of course, preclude her feeling the same way about men, including her husband, nor experiencing a whole spectrum of passions from mild delight to raging lust, despite her insistence that it wasn't her 'line'. Laura may or may not have had sex with any of her close women friends, including the jeweller Ella Naper, 'admired', as the euphemism goes, by both her and Harold. There was, as far as one can tell, no happy threesome or wife-swapping by the pilchardy tides. But this doesn't mean that what Laura felt for those women's bodies was just admiration of decorative human scenery. Around the time that the perfectly cleft peach of Ella Naper's derrière appeared in Knight's masterpiece *Self-portrait* of 1913, Laura also lovingly photographed it. Ella's pose, though planted in a Cornish meadow, is that of Diego Velázquez's *Rokeby Venus*, a painting much discussed, not to say fetishized, at that time. The photograph obeys the first law of erotic invitation, which is to conceal more than is revealed, while the painting *Daughters of the Sun*, for all the care Knight took with the sunlight, cooling it down the better to make warmth reflect back off the rocks, is oddly sexless in its breezy informality. The brightness of both light and manner numbs, much as it does in the illustrations of early nudist magazines, and the bodies on the rocks are brisk poems of strapping health, never much of a turn-on.

Is it possible that Laura Knight got rid of her topless *Daughters* precisely because it did no harm? Did she regret not going further in

challenging the norms by which men monopolized the depiction of female nudes, especially when it came to patrolling the dangerous frontier between aestheticized nudes and naked indecency?

The disingenuous convenience by which painters depicted scenes of unclad women bathing, including in the narrative licentious men, young and old, thereby allowing beholders to project on to the leering figures their own voyeurism, went back almost as long as easel painting itself. The Bible and Ovid were a huge help. Patrons could order up a bathing Diana spied on by Actaeon, who, unlike the owner of the picture, would be torn to shreds by hounds for his trespass. Apocryphal Susanna, spied on by leering elders as she washed herself (and invariably showing a lot of skin as she did so), was another favourite. Only Rembrandt, both in his *Susanna* of 1634 and the *Bathsheba* of twenty years later, expressly set out to turn the tables and implicate the viewer in the voyeurism, making the paintings studies in violated modesty.

The modernist revolution began with a confrontation of this permissive tradition of the devouring male eye, producing painting after painting that forced the voyeur to admit what he was doing, usually by including a surrogate figure, either with his back to us or as a mirror image. But if the viewed bodies were no longer decorative 'nudes' but naked women stripped of idealization, the men, too, were now not classical or scriptural heroes and villains but customers. For the first time, the two kinds of money transaction involving taking your clothes off and being stared at (modelling and prostitution) and the two kinds of starers (painters and johns) were conflated. Ablutions before, and after, played a big part in all this for a generation as obsessed (with good reason) with sexual disease and its contribution to the lament of the age, 'degeneration', and they often appear in the work of artists who *did* frequent the company of working girls: Manet, Degas, Toulouse-Lautrec and, in England, the prime suspect, Walter Sickert.

It is possible, however, to see modernism's parade of frankness – the artist as less of a poetic eulogist and more of a time-sharer – as not much of an improvement on the traditional sovereignty exercised by

men over viewing rights of women's bodies. There were bathers galore in the Impressionist parade in Paris – Renoir's bosomy blooms of 1897, and then of course the piles of drooping fruit of Cézanne's late groups, massed in elaborately constructed architectural arrangements – all co-opted by the new aesthetic, which presented itself as cleansing modernist truth. (Only Vincent van Gogh, the new Rembrandt, who actually lived in The Hague with a drunken prostitute he hoped, of course, to reform, was loving enough to depict her as she really was.) As for the rest, were their radical revisions all that different, except in matters of formal representation, from the kind of seraglio-admission ticket offered in Ingres' odalisques or even the *locus classicus* of surfing tit-kitsch, Bouguereau's *Aphrodite* . . . ? To a degree which only female art historians such as Lisa Tickner and Griselda Pollock have properly understood and explained, modernist intimacy with their models' bodies, the sexual act as a *condition* of the artistic one, was at least as imperiously invasive as the ancient hypocrisies; perhaps more so, since it was now exercised in the name of the avant-garde. It is not the fact that Gauguin, Rodin, Sickert, Picasso, Lucian Freud – and so many more – all slept serially with their models that dismays; it is rather the disingenuous insistence that the power and freedom of their portrait-ure was the direct result of indispensable carnal possession, that the tactile knowledge needed to remake flesh in paint could be achieved only inside and on the body of the model, which rather gets the goat. However they finessed it (and it was beneath most of the serial copulaters, Freud especially, to bother), what they were imposing was painterly *droit de seigneur*; the sovereign right to determine just how long a model should remain imprisoned in a pose (in Freud's case, this could be a whole night) and the precise point at which she needed to break it and begin to move to a different order of obedient collaboration.

If any of this played a part in Laura Knight's decision to do some-thing without precedent and depict herself fully clothed painting a nude model whose sumptuous nakedness is doubled – in her living pose and on the easel – we will never know, for she seldom spoke of

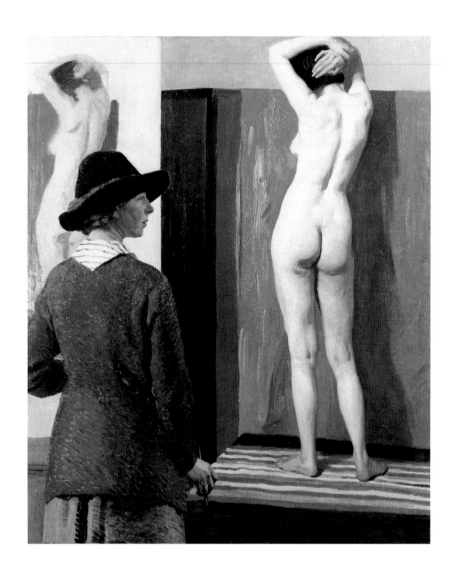

Self-portrait (with Ella Louise Naper), by Dame Laura Knight, 1913

what was, incomparably, her greatest work: all at once conceptually complex, heroically independent, formally ingenious and lovingly sensual. Though the paint handling was not in the manner the avant-garde may have wanted after seeing Cézanne and Van Gogh, where the texture of the marks brought on what Duchamp called the 'retinal shudder', there was absolutely nothing conventional about Knight's painting. It was so at odds with everything else she had done – and, for that matter, all she was to do for the next half-century, that one of the great masterpieces of British art remained unsold and in her own collection when she died in 1970.

But Knight knew exactly what she was doing with 'The Model', as it was first called. Appearing in her artist's clothes working with a nude female model whose image is doubled in the painting was a potent attack by one of the New Women on the disingenuous pose of the new art unveiled by Fry. There were three famous paintings, way stations in the modernist canon, which had combined the clothed and the nude, all of which played on the nervy borderline between reported reality and artistic phantasy. Manet's *Déjeuner sur l'herbe* included its maker only by implication. But Gustave Courbet's *Studio of the Artist* and Sickert's *The Artist's Studio* of 1906 both featured *standing* naked models, together with the imperious figure of their custodian-painter, one enthroned, the other a gatekeeper of the peep-show. Both toy with games of accessibility and denial. Courbet (who elsewhere had called his ultra-realistic hymn to the female pudenda 'The Origin of the World') has his model stand in profile, joining a gang of fans all admiring the *landscape* on his easel. Though efforts have been made to rhyme the waterfall on the canvas with the cascading drop of the model's drapery (and Courbet liked to sexualize his scenery), it is the disconnect between the subject of his work and the casually available nude that gives the huge work its power. Sickert's studio scene is characteristically a lot more worrying; a narrative, in fact, of body-ownership, our Mornington Crescent man's favourite subject.

Sickert portrays himself as a mirror image with his back to the model, who is painted as usual with Sickert's tainted cream strokes,

while he plants his arm firmly across the threshold of the door, denying us a share of his view. It's painting (as generally the case in the Camden Town pictures) as rough trade, and only the artist has the franchise to conduct it.

But the woman artist can fight back; gaming her own visibility and exposure. In contrast, say, to Matisse's *Carmenina* of 1903, where the fat-thighed model makes herself frontally available to us, the licensing image of the painter appearing in a mirror image in the background, no one in Knight's *Self-portrait* is exposed square on. She herself is rendered in profile, a shadow falling from her favourite high-crowned black fedora, head turned in absolute concentration on her subject. She is working; invisible palette in her left hand, the right by her side holding the brush, gaze steadfast on her subject. There is not a trace of ingratiation about any of this. She means business, not pleasure, though the two are not necessarily mutually exclusive.

The play here is all painterly, compositional, decorative and of the highest conceptual order imaginable. To the masters of the marks in the Grafton Gallery shows Knight answers with her own: the scarlet working jacket rendered in loose, instinctive jabs you will have seen in Van Gogh or Bonnard; the brick-red screen wall against which Ella stands is streaked and slit in a showy passage of virtuoso painting. Take Ella away and you have the slit red of Barnett Newman. All this brilliant redness, it is thought, may have been a response to Matisse's *Red Studio* of 1912, which was indeed shown in Fry's second post-Impressionist show and which was, to be sure, a one-picture revolution. But the *Red Studio* liquidates perspective and plane so that ostensible objects in it are swallowed up in the seamless, edgeless, free-floating ground. The very opposite is true of Knight's great picture, which manipulates its multiple surfaces and framing edges without ever losing the connective armature of the composition. The red–black dialogue is the key to this complicated, hypnotic dance of line, as it was with both Russian constructivism and the geometric abstractions of De Stijl, happening at the same time and in a Dutch milieu Knight knew very well. Thus the black border on which the stripy rug sits

must be read horizontally at one edge but, ambiguously, horizontally or vertically at the other. Horizontal stripes on Laura's collar rhyme those on the rug, while the verticals which hold the whole thing together – the black hinge of the screen and the edge of the canvas – are in dizzily ambiguous spatial relationship with each other. There is, in fact, no edge to the edge. It is as if Piet Mondrian, boated in from Laren, were whispering in her ear.

Except, of course, for the bodies of the women. Single-handedly, Laura Knight has taken them back from the Courbets and the Sickerts and has recovered integrity with no loss whatsoever to the complexity and grandeur of art. Consider Ella's pose. She has tried this before for one of the *Daughters of the Sun*, summoning as it does memories of classical statuary, possibly even the kind of casts Laura had been forced to copy in the drear classrooms of the Nottingham Art School, but to it she has now brought the glowing warmth of womanly life. In one of her two memoirs Knight described those constraints as 'deadening', condemning the result to dispiriting woodenness. The *Self-portrait*, by extreme contrast, is a quickening. Ella's pseudo-Greek pose, somewhat reminiscent of Aphrodite by Praxiteles, has athletic grace in the tensing of the shoulder muscles, with the indentation of the spinal ridge formed into a lovely curve. But it also has flesh: the rosy bum-blush with the merest dimple beneath the left cheek; the gentle fall of the breast. And staring us in the face is the fact of this body's doubling: the woman painter, demonstrating in the brilliance of the sketched-in version the heroic theme of the whole picture: emancipation.

For beyond Cornwall (and perhaps in it, too), women are Making Trouble. The much-discussed *Rokeby Venus* will be slashed for Votes. But Laura is not a slasher. She is a painter, and she will make a claim for equality of treatment her own way; sticking to men who assume that the nude, whether neo-Greco, or Camden Town rough stuff, is their particular province of expertise.

This, of course, does not prevent Claude Phillips, the art critic of the *Daily Telegraph*, from sneering, apropos of 'The Model', that 'Somehow, woman painting woman never infuses into her work the higher

charm of the "eternal feminine".' As it had arrived from some unknown conceptual planet, commentators on Laura Knight's masterpiece were at a loss to know what to make of it, so they resorted, as the feeblest art critics will, to smarmy condescension. Women really ought to stick to the delicate things they were naturally suited to: pastels, watercolours, still lifes, that sort of thing don't you know. In this patronizing vein, the critic of *The Times* regretted that 'Mrs Laura Knight, who sends such a good drawing to the Water-Colour Society, has produced an extremely clever picture [a damning term in the Edwardian anti-Bloomsbury lexicon] of a paintress and her model's back which, we fear, will provoke a smile not quite of admiration.'

A photograph survives of a group gathered around Laura Knight's painting, first shown at the Passmore Edwards Gallery in Newlyn, and their smiles seem perfectly admiring. But it is true that the decidedly mixed reception seems to have made Knight pause before ever attempting anything quite like that again. There was a period in the 1920s when she produced portraits of women, including a saxophonist, and the pianist Ethel Bartlett seen in profile and rendered with such ceramic coolness that it recalls Ingres or anticipates Giorgio Morandi. But our girl from Nottingham had already become a national treasure; doing her bit with home-front pictures in the First World War, as she would do female armaments workers and bomber crews in the Second. She had always been naturally gregarious and a little bit theatrical. Throwing a tantrum at the hopelessness of her art school, she had stormed off to audition for a local theatre. Now she was drawn to human colour: the circus, ballet, jazz. The entirety of the human comedy made her merry on the canvas, whether a Romany beauty or an African-American face in Maryland.

So she was co-opted. In 1922 she was elected Associate of the Royal Academy and, in 1936, a full Fellow. She would paint anyone: George Bernard Shaw, hyphenated society debs and their mothers; Indian politicians; the young Paul Scofield; Nazi prisoners at the Nuremberg trials.

She even painted the odd nude, but never again with herself, clothed

in their company, which meant, inevitably, they had frozen into innocuous Art and had entirely lost their sting.

'My master. I am not an artist. I am a model and I want to remain your model forever.' Thus wrote Gwen John to her lover Auguste Rodin, just three years after her self-portrait had proclaimed her New Womanhood to the world. For long periods during 1905 and 1906 she was as good as her word and gave up drawing and painting altogether. All she did was pose for Rodin, usually in the afternoons, and finish the day making love to him. Like some commuter, he would then pack up and return to Meudon and his companion of forty years, Rose Beuret. Gwen would go back to her little flat, first at 19 boulevard Edgar-Quinet, then in the rue St Placide, barely eat, feed her cat, and write one of the countless long letters pouring out the depths of her passion for her 'master'. A self-portrait drawing made around this time is eloquent of her ecstatic desperation. European art is full of women with letters, but none like this one. Unlike the full-length forthright-ness of her first self-portrait, this is head and shoulders alone. Her right hand is holding one of Rodin's letters, almost certainly his not hers, between her breast and her throat. John's mouth is open, as if speaking to her master: whether in sorrow, accusation or self-abasing gratitude, all of which feature in their unequal correspondence, we will never know. 'I received your card, my Master,' she writes one evening, 'and it gave me great joy. My room is calm.' (Rodin was always telling her to calm down.) 'I thought for a long time of the letter I am going to write to you, I thought that in this calmness I can easily talk to you about my passion . . . you can judge from the insufficiency of this letter that it is very difficult to write about a great love.'

The once New Woman is insecure about absolutely everything: her work; the whereabouts of her cat; her future; but most of all about the constancy of her Master, not just sexual (though she has few illusions there), but the constancy of reciprocated love or whether indeed he loved her at all. It was Rodin who had insisted that the root of every-thing worthwhile, and especially the beauty and illumination his art

Self-portrait, by Gwen John, 1905–6

was after, was sex. His friend the poet Rilke, who had also become hers, said much the same. And the slight girl from Wales and the Slade threw herself into sexual pleasure with the uninhibited energy that delighted Rodin, who was excited by the fact that little 'Mary', as he called her, so demurely Welsh to the outside world, would minister to his pleasure in this way. Once, knowing the sculptress Hilda Flodin, also a model, also a lover, enjoyed women, Rodin had asked John if they could make love with Flodin watching, and so she threw herself into that, too. She would do anything; anything not to lose him, not to have some of him, whatever was going, each and every day.

How had the New Woman come to this? *Self-portrait* in the brown blouse had been followed by a second wearing a red shirt, the tone and temper strikingly different, inward, pensive and reserved, where the first had been forthright and outgoing. Even her dress spoke a different body language: the red shirt buttoned up high on the neck, a choker with an antique cameo of a woman's head at her throat. Was the first an act, this one the real Gwen? It was, at any rate, the only one she signed.

She was, however, very much up for adventure. In 1903, along with her new friend, the dangerously beautiful Dorelia McNeill, a legal secretary who had taken courses (like Tonks) at Westminster School of Art, Gwen had decided to walk to Rome. It would be a pilgrimage and, away from Bloomsburies and bohemians, she would settle down to serious art. To the general stupefaction of their friends, Dorelia and Gwen travelled by ship to Bordeaux and then set off as planned up the winding course of the Garonne, which starts easy and then gets hard. They slept where they could: barns, fields, occasionally, when they were dog tired, just dropping by the side of the road. Beasts, usually of the bipedal kind, worried their progress, as they must have known would be the case. They sang – literally – for their supper and they would sketch portraits for their breakfast; sometimes drawing criticism from the locals. Everyone was either a critic or an artist in southern France. In an unfamiliar village, seeing a family at supper, they knocked on the door asking if they might buy a little bread, and

Self-portrait, by Gwen John, 1902

were refused. '*Sauvages!*' Gwen shouted as they trudged away. Stung, the paterfamilias ran after her, protesting that they were not and proffering a loaf, but the girls preferred to keep their scorn. There was an encounter with a wandering Belgian sculptor, Leonard, who had the cheek to criticize Gwen's drawings while falling instantly in love with Dorelia. Everyone fell instantly in love with Dorelia, including Augustus, who was by now married to their friend Ida Nettleship, as if that mattered to Augustus.

They saw the winter through in Toulouse, learning how mean the weather can be in southern France in January. When the world budded out, their will to hoof it all the way over the Alps to Italy had ebbed. Gwen remembered her happiness at the Académie Carmen, being glared at by the glinting eyes of Whistler and sitting beneath the chestnuts, excited to be counted among the company of artists, even if as a novice. The route switched north-east, to Paris. Somewhere along the way, Dorelia departed. Augustus had been affronted by the temerity of the Belgian sculptor, had stamped his foot and demanded that she return to him, even though he had no intention of leaving Ida. For her part, Ida insisted to Gus that whatever he wanted she did, too, whomever he loved she would, too, which of course suited the beneficiary of the *ménage à trois* just fine. Dorelia did what she was told, settling for a piece of Augustus John, enough so that later she would give birth, quite alone, on Dartmoor, to a baby boy she called Pyramus.

Gwen went back to Montparnasse, found that bad-smelling room on the boulevard Edgar Quinet, and a cat which she called Edgar Quinet. She drew and even painted a little, but the only way to support herself was by modelling. She enjoyed this very much. Little Gwen had a strong, limber body, which she liked to put to work in ambitious poses. Both during the years at the Slade and afterwards in Fitzrovia, the girl friends had often posed for each other, dressed and not. Now she did the same for whomever would pay: often women artists, Anglos, Americans, anyone. One afternoon she discovered at the end of the rue de l'Université the workshops of Paris sculptors; assistants hauling blocks of marble into ateliers. She

followed one almost at random and knocked on the door. Hilda Flodin, with whom she would become all too familiar, opened it. Life held its breath.

Rodin told her to undress, but, according to her, it was more a courteous invitation than an abrupt order. It was the job, after all, and she was proud of being good at it. Rodin was notorious for demanding poses, and the work he wanted Gwen for was no exception. The subject meant something to her, too, for it was an official commemoration of her old teacher Whistler, to be sculpted as his muse: hence, if one followed Rodin's drift – and what choice was there? – Gwen needed to have one knee raised up while her head was bowed, which in turn meant enough spinal flexibility to put up with this for hours on end. Rodin, the Anglomane, over-impressed with the high style of Edwardian Britain, loved his little 'Mary John', even if his grip on Welshness was uncertain. Hers was the kind of body he especially liked to work with: slender, slight-shouldered, narrow-hipped, nymph-like: the form he imagined archaic Greek sculpture had taken before it became vulgarly muscled.

For her part, Gwen flowered extravagantly, telling herself he was the Master she had been waiting for. The strong-minded, high-coloured men who had populated her life – Tonks, her brother, Whistler – all paled before Rodin and his immense, whiskery, learned, impassioned charisma. He became tutor as well as everything else, putting Schopenhauer and Wilde in her hands and expecting to have a lively discussion about them at the next sitting.

The rest was predictable. The New Woman disappeared inside hopelessly unequal love. There was the light kiss from the old boy during a sitting; then not so light, then the unstopping of restraint. Gwen felt reborn; made wholly alive. 'What gives me joy, what stays with me more or less,' she wrote in the careful French she was trying to perfect for her Master, 'are the thoughts or sentiments which come from making love to you.' Her days brimmed and spilled over with it. In the mornings she might have worked on her own art, but she didn't; the afternoons were his, the routine of the pose followed by love-making.

Sometimes he would come to her apartment to be hissed at by Edgar Quinet, and she would dissolve in unspeakable happiness.

The next chapter was predictable, too. The crazed intensity of her love letters began to have the opposite effect to what was intended. Delicately (though this was not his forte), Rodin asked her perhaps to vary them a little, and then made the suggestion that Gwen pretend she was writing to a friend rather than her lover, say a girlfriend called Julie. Amazingly, or scared of losing his closeness by even a fraction of a centimetre, she obeyed, penning chatty this and thats to 'Julie'. This only delayed what was coming. Longer intervals between sittings; reluctance to extend them into amorous embraces. Rows broke out like little brush fires, here and there. 'He likes to make me furious,' she wrote to her friend Ursula Tyrwhitt. 'I have had some scenes [but] he is always so adorable at the end. I see these scenes are necessary to him but I wish they did not make me so ill.' Everybody spoiled him; only she could scold him, and she should do it more, even though it ran off him 'like water off a duck's back'. Gwen began to suffer from the lover's illusion that only she understood him, could cater to the inner child, punish him when he was naughty. 'I adore him and it is dreadful to be angry with him. I see that I must be so, though.'

Their meetings and modelling sessions began to be more irregular. Tortured by the absences, desperate in her neediness, Gwen occasionally took the train out to Meudon and hid near Rodin's house, hoping to catch a glimpse of him. It had all become demeaning, pathetic, annihilating. 'I am nothing,' she wrote in a wail of unhinged sorrow, 'but a piece of suffering and desire.'

But some piece of what was left of the New Woman knew what to do to survive, and that was, of course, to work again, but perhaps in a different spirit and tone from the paintings of her London days. She moved once, twice, always in the same *quartier* of Montparnasse, ending up in the rue du Cherche-Midi in a room whose quiet sweetness was a balm for her emotional wound. Her vision and her drawings and then paintings moved indoors, into those rooms swimming in pale light; to

Self-portrait, by Gwen John, circa 1908

a zone of peace. While Laura was on the beach, Gwen was sitting in her chair stroking Edgar Quinet, drinking in the flickering sunshine, looking, not unhappily, at the walls, through the windowpanes and, every so often, at herself in the mirror. When she undressed and looked she saw a wraith: half there and half not; an empty line, her sex more delineated than her face, and she sketched that, too, a whole series of nude self-portraits executed with a kind of wistful tentativeness; images that seem to stir and move a little in the empty white space as if blown by a draught coming through the window.

But, little by little, Gwen John became an artist again, a portraitist in fact, of friends who came to see her from Britain. It was women she wanted for her subjects, and she painted them most often in deep stillness, conjuring up visual echoes of Vermeer and the Dutch past, though less glittering and without the crystalline radiance. Instead they were caught in a kind of daytime moonlight: a wash of poignancy, even when the models were loud with chuckling gossip. The most challenging of all was Fenella Lovell, who affected the sulky passions she thought went with being a gypsy but who drove Gwen crazy with exasperation. Out of the aggravation, however, came two astonishingly moving portraits, one clothed, the other nude: modern Majas, but without any of the erotic ingratiation with which Goya obliged his patron.

The nude Fenella, in its singular way, is as radical in the history of art as Paula Modersohn-Becker's self-portrait of her pregnancy. And what is it about this portrait which says only a woman could have painted it? Significantly, I think, John has half draped Fenella from the waist down, exactly as Rodin was posing her in the excruciating *Whistler* (which would never be finished); both to summon the ghost of classical statuary while at the same time parting company with it. For there is absolutely nothing about this portrait that panders to what is left of either classical idealism or the wave-heaving orgasmic throes rhapsodized by Rodin. Instead it moves by its portrait of womanly truth; a picture that seems to come from the interior as much as the surface of the body; from every inch of the sloping shoulders, the lightly

Nude Girl (Fenella Lovell), by Gwen John, 1909–10

drooping breasts, the long porcelain belly. The head on its long stalk of a neck carries the least apologetic face in modern art, not stylized for pleasure like the elongations of Amedeo Modigliani. Rather than eyes closed, Gwen has let Fenella look directly, challengingly, unapologetically, as she herself had done in the early self-portraits. The look burns itself into the memory; so fiercely un-English.

Onwards and inwards she went. Eventually accepting that things with Rodin could not be what they had been in the first two years of their delirium, Gwen continued to write to him, and to get letters back until 1916, the year before he died. They would see each other; even occasionally make love. In 1912 Rodin sold a batch of her drawings for her, which ought to have made her happy, but, since he did not come in person with the money, her mood collapsed into misery. 'I wanted you to come so I could have some love. That you sent your secretary turned my heart to ice.' The day before she had bought herself a new suit then waited three hours at the Gare des Invalides so that she could show it off to him, before giving up. Despite these cruelties, she could not quite shake off the longing. 'I have hurried dreadfully to meet him,' she wrote in August 1913. 'He did not come. I have a headache and long for the sea.'

Through this drawn-out saga of hopelessness, the *Whistler* which had begun it all languished, though the figure carried Gwen's unmistakable strong nose and pearl drop of a face. When the Germans marched towards Paris, Rodin escaped to England while Gwen stayed in France. She had converted to Catholicism, began to call herself 'God's little artist' and moved to Meudon (of all places); she painted absolutely beautiful portraits of nuns and friends who seemed in her hand to possess the self-contained knowledge of the cloister. She became a very great artist, though this was seen only by her brother, who admired as well as loved her, and by the single patron she had, the American John Quinn, who bought her work and sent her advances which allowed her to live as she wished, even though he himself had to develop the patience of a saint, waiting for work that seemed never to come. She had one show at the Chenil Gallery in London in the early summer of 1926.

Her friend Michel Salaman, whom she had known since the walking adventure with Dorelia, put it perfectly: 'It was indeed a chastening joy to stand there amongst those pale, quiet songs of yours – like listening to the still music of the harpsichord – only there is nothing antique or archaistic about your works they are so intensely modern in all but their peacefulness.'

7. Modelling Flesh

As he came into his own, Lucian Freud made Rodin look like a feminist. He was unapologetic. It was always and forever about him: every model an extension of his personality, existing in his work only in so far as they were a fully owned property of his imperial ego. 'All my work is autobiography,' he said, and meant it unblushingly. The Freud who appeared in the mirrored image of his self-portraits was still strategically in control of the image. In one brilliantly disconcerting work he set the mirror on the floor so that his face, distorted, looms over it, along with two of his children, whose faces are given expressions of manic glee.

There were those who fell into the category of Lucian's 'people' who were only friends, or, in two rightly celebrated instances, the Benefits Supervisor Sue Tilley and the confrontationally clownish Leigh Bowery, challenged their captivity in his studio with the mountainous immensity of their flesh. Following Walter Sickert, Freud's ambition was less to represent flesh than to re-make it in his paint, which meant abandoning the sharply linear style of his early work for density of texture, sculpturally modelled. In the best self-portrait he ever painted – of his own head and bare shoulders – he struck exactly the right balance of intuitive freedom and heavy modelling. Later, there would be naked self-portraits in which the surface was more broken into stabbing strokes, the same kind of heroic roughness which appears in the last years of Titian and Rembrandt.

But the self-regard which was at the centre of his work was always heroic; tough as the old boots he paints himself wearing, the rest of him naked in a full-length self-portrait from 1993. But he poses (and nothing Freud ever did was uncalculated) with a raised palette knife, exactly in the manner of the *Apollo Belvedere*.

Nor did he ever make any bones about the captivity he imposed on his sitters and models. Re-making flesh through paint could be a

laborious business; also nocturnal. The studio was a prison; he was the jailer; their liberation would be in realization in paint. And it was no secret that, with many of his models, the route to that realization lay through Freud's bed, just as had been the case with Rodin, Picasso and the rest.

The last of the self-portraits says it all, though not in its title, which is coyly and disingenuously given as *The Painter Surprised by a Naked Admirer*. The admirer is, in fact, his model and latest girlfriend and, from the photograph re-enacted for David Dawson's camera, we can see that the painting had made her an altogether more desperately skeletal figure than she actually was. It is as if, contemplating his own caved-in torso, forever lean and mean, Freud meant to equalize the two of them so they would be rattling together bone on bone. The flesh and the interest in it had fallen away. But the unequal relationship of the two is embodied in the model, eyes closed in an attitude of craven adoration, clinging to the great man's trouser leg as he turns back towards what really matters: the work in hand of the very same scene. The grotesque egotism of the painting is intensified by the raffish outfit Freud has given himself; the perpetual scarf and the neo-boho shirt which he did indeed wear much of the time. But such was and is Freud's justified reputation as Britain's greatest post-war portraitist that no one seems to have said anything much about the picture as an expression of the naked power exerted by the artist over the slave-model. Nor indeed has anyone noticed that there is a prototype for this drama of abasement featuring a naked woman crawling on her hands and knees in an attitude of abject humiliation, imploring attention from the omnipotent Master while he strides away in the opposite direction accompanied by the angel of his genius. The work was by Rodin's former model, lover and, in her own right, a powerful sculptress, Camille Claudel. The sculpture was made around two years before Rodin met Gwen John, and just as Gwen was to wash herself out of sturdiness, so too Claudel has made her own pathetic body diminished by its subjection. Unlike John, who, for a while at least, became liberated by the gradual undoing of her relationship with

Rodin, Claudel was driven into an abyss of depression by it, to the point where she was committed to a mental institution, where, shockingly, she spent the rest of her life. After Rodin died, though, Gwen John also wasted away, starving herself and eventually giving up painting altogether. When war broke out in 1939 she attempted to get back to England, but was too weak for the journey, dying in a Dieppe hospital.

We now live in a time when the face is the least of it. It's the rest of the body that has become the theatre of self-portraiture; and the dramas enacted on it are relentlessly replayed in the galleries. Who cares about eyes as the windows of the soul, as Palmer did, when the idea of the soul has gone missing, presumed dead? Intensity of moral self-inspection of the kind Jonathan Richardson imposed on himself has shrunk to the giggle of the selfie, or the mirror-check of the middle-aged for anything ominously untoward. Baring the soul has been replaced by baring everything else. If it was once thought the face in the mirror could deliver revelation about the essential person, the angle of vision has moved down to the site of history, usually sexual, visited on the body, and to the physical objects on which its wounded journeyings are marked, tattooed, scored and scarred. Lucian Freud may have annexed every subject he ever painted to the domain of his self, but Tracey Emin's art is nothing but the history of her body and its sexual odyssey. The material installations that made her famous – the tent sewn with the names of *Everyone I Ever Slept With*; *My Bed*, on which sundry cums lie stiffly embalmed – are the abandoned stage-sets of her erotic playground, left forlorn and crusty with post-coital gloom. The most dramatic and poignant of these works was the actual 'Here' of *The Last Thing I Said to You is Don't Leave Me Here*: a Kent beach hut (of the kind the self-nominated 'Mad Tracey from Margate' would have known well). This particular beach hut, bought by Emin and her friend and fellow historian of the body Sarah Lucas for what would now pass for a footling 30k, stands in for a place of captivity, imagined or real, in which we see her, in photos taken by

The Last Thing I Said to You is Don't Leave Me Here (I), by Tracey Emin, 2000
Two Girls (Ishbel Myerscough and Chantal Joffe), by Ishbel Myerscough, 1991

Mat Collishaw, abandoned and, like Camille Claudel, in attitudes of captive victimization, violation or punishment. Intentionally or not, the pictures are so self-consciously beautiful, reminiscent of classical statuary, her body so smooth, the gold chain around her neck so delicate, that the finesse undoes the squalor-and-misery effect, making the beach hut look more distressed than Tracey.

The self-portraiture of women's bodies does not have to be a parade of submission. Helen Chadwick has avenged the memory of Echo by switching the sex of Narcissus and making love to herself, the face of course masked by shadow but her breasts in bold highlight, one brushing against its mirrored twin. Chantal Joffe and Ishbel Myerscough pictured their friendship, in a tradition which goes back to the painter and the pirate in the Tower but somehow seems barren of comradely happiness; the expressions self-consciously grim, as if challenging the beholder to disapprove; the areolae combat-ready, if beautifully pictured.

There is, though, one kind of nude self-portraiture by women that abandons all this defensiveness and yet takes back its subject from the captivity of modelling. Paula Modersohn-Becker began it when she painted herself naked and heavily pregnant. Then she made that pose still more sweetly jubilant when, pregnant again, she rolls on the floor with her naked infant; the two of them made one flesh. In a series of big, beautiful and liquidly painted images, Chantal Joffe presented herself as doubly mother: the body from which her child emerged and the body which became the daughter's guardian playmate.

These are the new madonnas, rumbustiously celebrating the non-immaculate nature of the bodily union between mother and child. But it is only Jenny Saville who has brought together the two acts of creation, both of them physical and muscular: birth and picturing. She often acknowledges the example of Freud re-making flesh with pure painterly texture and mass, but in fact she liberated the model from its enslavement to Freud's gaze and hand by being her own sitter. The difference between the way each artist chose to represent their naked children is telling. Freud's are on the edge of pubescence, objectively

surveyed in glacial exactness by their father. The result is not so much hideous kinky as hideous creepy, the picture implicating any beholder into the way it was made and daring anyone to harbour doubts.

Exactly the opposite is true of Saville's pictures of herself with her infant children: all of them naked. For once the kids are not creatures of painterly convenience, much less end products of centuries of sentimental projection. They are, instead, furious forces of nature: raw with animal energy, a typhoon of uncontainable motion, a storm of squirming. The movements are represented, brilliantly, in what elsewhere would be called pentimenti but here is a rhythmic web of trace-lines following the thrashing and kicking and flinging this way and that. At the eye of the human storm sits the mother, Jenny, as still and majestically frontal as Dürer when he had the temerity to paint his self-portrait as Christ the Saviour. Saville is not, however, the Virgin. She, like her wildcat kids, is flesh, a body which, because it too changes, moves, resists a final shape and line, morphs in and out of different kinds of life, cannot, ultimately, be nailed by art. So hers is the most provisional of all the likenesses caught in the mirror, which is, perhaps, why it refuses to fade.

The Mothers, by Jenny Saville, 2011

V

Faces of the People

1. *Black, White and Colour*

Is it a kiss or a whisper? Either way, it's a bit of a giggle. At the same time as Charlie Phillips starts taking photographs of the Piss House pub, 1968, Enoch Powell tells Conservatives in Birmingham that, 'like the Roman', he sees 'the Tiber foaming with much blood' should an 'immigrant descended population' settle and multiply in Britain. Charlie, born in Jamaica, sees something else: moments of unguarded happiness, many of them at the Piss House on the corner of Blenheim Crescent and Portobello Road, and he catches black and white in black and white. Later that year Charlie is minding his own business when he hears what he thinks sounds like a riot coming along the street. But it's the first carnival; a glorious hullabaloo: drums, bands, calypso, ska, reggae, Red Stripe, shouty pleasure. Charlie grabs his Kodak Retinette and takes pictures of a sea of faces, plenty of white ones, too, but all young, expectant as the music rolls along. It's the answer to Powellite paranoia: no rivers of blood, just a rolling tide of happiness; bump, grind and smooch.

Charlie's world is Notting Hill and the Grove, long before the lattes and two-hundred-quid designer jeans arrived; when the words 'Notting Hill' meant the hideous race riots of 1958. Around the time Charlie was doing his paper round, I was the lanky white boy in winklepickers walking the streets my parents told me weren't safe: Rachman houses subdivided into one room for two; two rooms for four; communal kitchens on the landings ('If it weren't for him, plenty would have been out on the streets,' says Charlie); pork-pie hats; frying kingfish; working girls in purple hot pants; the Skatalites or the Clarendonians, a rocksteady beat, coming from an open window. My school was on the edge of it. After yet another detention, telling no one, not even my close pals, I hopped on a number 28 and went through the cheek-by-jowl districts of Powell's nightmares. My parents thought I was safe and studying Talmud with the limping teacher the Reverend

The Piss House Pub, by Charlie Phillips, 1969

Halpern (where I did in fact put in the odd tactical appearance), but every so often a little jolt of adventure would sit up and beg and I'd take the 28 past the salt-beef bars of Willesden, past the pubs of Irish Kilburn, across the rowdy High Road and into 'North Kensington': into the Grove, where life was on the streets; where the locals of both sexes walked differently, leaned against walls differently, did everything differently; and there was no beige, tweed or corduroy. Off the bus you caught a whiff of spliff, though I had no idea then what that was, just something parched and toasty. I followed the aroma like a Bisto boy scenting magic. What kind of coffee are they roasting *here*? I wondered. In a doorway I would lean against the flaking stucco, and cup my hand to light a Gitane or an Abdullah, anything I reckoned smelled dark and bad. The locals laughed, the dogs growled. Both were on the biggish side.

Charlie, also known as Smokey, is the portraitist of that time and place; those streets and their people; mostly gone south of the river now, like the photographer himself. He is also a visual poet; chronicler, champion, witness of a gone world, taken by the slicing destruction of the Westway and the coming of big money. The Piss House is now a multi-floor restaurant and catering venue. The hallowed shrine of grunge and punk, round the corner, Rough Trade Records, is the only rough thing left, and these days more pierced than pissed.

Charlie, however, is wonderfully unreconstructed. This afternoon, on the top floor of the sometime Piss House, he sports an oxblood-red borsalino, a buttercup-coloured scarf over an indigo shirt and a tie splashed with Jump-up eye-scalding brilliance. An array of his photos is spread out on a table – a young black man, hands on hips in front of Westbourne Park tube; a big-mama singer at the Cue Club, elbow-length white gloves, eyes tight with Soul; a father and young son at the Friday market, answering with their stare-back all the sociological pieties about disappeared dads; another Piss House kiss, this time a real plonker, white on black. But Charlie won't talk about any of them, not in the way I'm wanting to hear: Where? How? Why? Happenstance or set-up? He's never posed anyone: 'I'm just a *hunter*, in

search of my prey,' he says. But he knew personally most of the people he photographed, so he could just 'point, shoot and ask questions afterwards'. The pub, club and street moments do have unpremeditated immediacy. But there are others he must have thought about. One of them, of a young couple, his face serious, a protective arm slung around the pretty girlfriend's shoulder, has become a feel-good icon. Back when he took it, though, the Notting Hill riots were not long gone, and it was a defiantly brave act. Charlie remembers louts leaning out of cars in the Grove yelling 'Nigger lover' as they drove past. The picture is beautiful in recording how apprehension meets resolution. Charlie has seen the image become some sort of sociological Rorschach test about race attitudes. 'What do you see in it?' he asks me. 'The determination of love,' I say.

But at the same time that he's icon-resistant, Charlie does see his photos as an archive of a mixed-up Notting Hill that has been bulldozed from London's memory along with the streets demolished to make room for the Westway. One of his pictures has a heap of debris – tyres as well as odd bits and pieces of furniture – piled on the pavement while an elderly white woman walks past holding tight the hand of a little black boy. You can hear the jackhammer drills sounding their death rattle as the neighbourhood expires and locals move off down and past the Golborne Road, or south to Brixton and Mitcham, where Charlie now lives. It's a different Notting Hill now; 'I call them [the incomers] Notting Hillbillies; all they talk about at their dinner parties is property values.'

He worries that this Notting Hill will be the only one the fifth generation of Afro-Caribbeans – the young ones – will know. The memories are all verbal and soon they will be gone. So his work has to be the visual archive; the living memory. He is clearly moved as he says this, his eyes brimming under the specs. 'Sorry, sorry,' he says Britishly, 'if I'm getting emotional.' But he can't help but take it all personally; the history of black Notting Hill is also his. He was eleven when his father brought the family from Kingston in the 1950s. He gets indignant – and why not? – at what was said about immigrants

Notting Hill Couple, by Charlie Phillips, 1967

then, and now; how they were always assumed to be the destitute when in fact they had to find forty-five or seventy-five pounds to come, sell a farm or shop to 'answer the call' for labour when white Britons were leaving for Australia and Canada. In Jamaica, Britain was still cricket, fair play and the Queen. Charlie's granny took him to Kingston to see her sweep by on a day so hot she soaked a hanky and stuck it on his little head. He thought the Queen might stop and say, 'And what's your name, sonny?' But the Majesty passed by as crowds cheered and the Cubs and Brownies sang 'God Save the Queen' at the top of their voices.

Notting Hill was a rude shock; the NO COLOUREDS notices on the doors, one of which Charlie the archivist snapped. Hostility bred closeness. Mums and dads saw to it that the youngsters were back home by eight, or they got a thick ear. Still, you never knew when a brick was going to come through a window. But there was pepper-pot soup and jerk and fried plantain to get you through the bitter fogs of November. And there were the black GIs who came down from Mildenhall and the other bases, desperate for something other than steak and kidney and Watney's Red Barrel. Word of the shebeens of the Grove had reached them and they brought their own music there, along with their easy attitude and cat-like dancing. They brought records to the shebeens, and to Hammersmith Palais: Fats Domino. No one wanted to dance to Joe Loss after Fats Domino. Sometimes, remembers Charlie, the GIs got legless and woke up without the wherewithal to get back to base. One of them had his Kodak Retinette with him and sold it for fifteen bob to Charlie's dad, who handed it on to the thirteen-year-old whose only money came from a paper round fraught with the usual danger: catcalls of 'nignog' and worse. The Retinette was a treasure. Charlie went to Boots, forked out some paper-round money for a Johnson's Packet, which had all you needed to develop and print the photos. He started taking pictures of his schoolfriends; of kids, white Irish as well as black Jamaican, making faces and hooting, west London grins. One of Britain's great photo-portraitists was off and dancing.

446

While he was going around the Grove catching this and that moment, it didn't occur to Charlie that this would be his life; he had being a naval architect in mind, while his teachers at the Clarendon school said, 'Well, yes, but maybe something in *transport*, or *the post office* perhaps?' Charlie joined the Merchant Navy; saw a fair bit of the world and carried on taking pictures; through the CND years; in Paris and Rome. When he came back home in the seventies the neighbourhood was already changing; some flyover-enthusiast had drawn a big red line through 'North Kensington'; new housing legislation had seen off Peter Rachman, but property in W9, W2 and W11 was already beyond reach. The migration south was well under way.

Charlie started to take pictures of funerals: beautiful things, edged in sorrow and resignation. But it was the Grove and his Notting Hill he was mourning. Little Miss standing outside her caff at the top of Portobello Road, blackboard menu, rice with everything, went to America; another of his pals to Germany; others just passed, like the place itself. Charlie smiles and sighs a bit and does a bit more lovely Emotion before getting up for a look down his old street. Then he gathers up a sheaf of his beautiful pictures, alight with memory, some of which, finally, are in the V&A as part of an archive of black Britain. 'Photographs never lie,' he says. 'Truth is beauty.' John Keats said much the same, but it sounds better coming from Smokey.

Considering the matter of Africans and their aptness for portrayal, Joshua Reynolds insisted, in 1759, that it was absurd to question it:

> I suppose no body will doubt if one of their [African] Painters were to paint the Goddess of Beauty, but that he would represent her black, with thick lips, flat nose, and woolly hair; and, it seems to me, he would act very unnaturally if he did not: for by what criterion will anyone dispute the propriety of his idea! We indeed say that the form and colour of the European is preferable to that of the Ethiopian; but I know of no other reason for it, but that we are more accustomed to it.

South African Dancers at the Cue Club, by Charlie Phillips, 1970

Two years later, in 1761, Reynolds took pains with the figure of a black female servant handing a garland to the exceptionally white Lady Elizabeth Keppel to hang about a bust of Hymen, the goddess of marriage. The allusion was to Lady Elizabeth's role as bridesmaid at the wedding of George III and Queen Charlotte in September of that year. But what was unusual were the two independent sessions Reynolds had with the black model, both recorded in his sittings book. Images of black servants were commonplace in the eighteenth century, but they were nearly always male and seldom had the spirited vitality, hair flying, which Reynolds gave this woman. Even so we will never know who she was, since Reynolds lists her in his book merely as 'Negro'.

Like many in his circle of friends, Reynolds was an abolitionist and encouraged his friends to subscribe to memoirs of freed slaves like Ottobah Cugoano. (He may even have recommended Cugoano to the Cosways, who hired him as a servant at Schomberg House.) One of the freed slaves who found their way to London was employed as Reynolds's footman and may have been the model for a spectacularly heroic portrait, once thought to be Francis Barber, the protégé of Samuel Johnson (another fierce opponent of slavery), educated at the Doctor's expense and a beneficiary of his will. Though unfinished, Reynolds's portrait was copied by enough pupils and followers to suggest that it became an ideal of the black male. Footman or not, the Reynolds figure wears none of the customary signs of service: no livery, no turban, no pageboy breeches. Instead, he is clad indistinguishably from a free European or American: a stock wound about the neck; a collared coat. By turning his head to one side so that it catches the gentle light on brow and cheek, Reynolds has created an ideal personification of enslaved suffering: the kind that he and his friends were responding to in memoirs. The large, beautiful eyes of the African are gazing away at something distant – the plight of his people, treated like chattel goods.

The painterly romance of the freed slave had begun a generation before when Ayuba Suleiman Diallo sat for William Hoare in one of

A Young Black (?Francis Barber), in the manner of Sir Joshua Reynolds, date unknown

the little cubes of light that was a drawing-room studio in Bath. As with later heroes of the abolition movement, the intention was to use engraved versions of the portrait for the frontispiece of the African's memoirs, in this case penned by his rescuer and mentor, the lawyer Thomas Bluett. But while physical beauty and the demonstration of wisdom were the touchstones for later painters and polemicists, it was Diallo's piety – a Muslim piety, moreover – which made him a model of injured righteousness for his eulogists.

Portraits of black freedmen later in the eighteenth century dress them (as would have been the case) in European clothes, a declaration of their membership among the ranks of the enlightened. Diallo, on the other hand (almost certainly at his own request), wears the traditional costume of his West African culture, the Fulbe people of Senegambia. It was his difference which had liberated him, in particular the Muslim piety, which he wears around his neck in the form of one of the three Qu'rans he wrote out from memory both in captivity and after. But it was also his religion, which, inconveniently for his champions, allowed him to be himself an owner and a trader of men, just so long as they were pagan. It was, in fact, on one of his expeditions to trade slaves and paper that Diallo had been taken by a Mandingo raiding party and sold to a trader. The Mandingo had shaved his head so that he no longer had the appearance of a good Muslim but merely that of one of the Africans taken as traffic. It was his slaving past that offered him a hope of escaping from slavery. Diallo was known to the captain as a slave-seller, so was able to persuade him to write to his father for ransom money. But when it failed to arrive on time the captain had no compunction in treating Diallo as cargo. On the other side of the ocean, he was sold to a tobacco plantation owner on Kent Island in Maryland. But there was something too slight, too refined about his person for field work, and it was when he was sent instead to watch the cattle herds that he managed to escape. Recaptured and imprisoned, he was shown to Thomas Bluett of the Society for the Propagation of the Gospel.

Whatever the African was, it was clear to Bluett that he was no

Ayuba Suleiman Diallo (called Job ben Solomon), by William Hoare, 1733

pagan. His refusal of strong drink, his constant references to Allah and Muhammad and his zeal in praying five times a day made him enough of the personification of Muslim piety. There was, moreover, Bluett thought, a natural nobility about him which had not been crushed by his enslavement: 'By his affable carriage and the composure of his countenance we could perceive he was no common slave.' All this was enough to deliver Diallo from the brutal misery of field slavery in America, but not into liberty. An overture to the Governor of Georgia, James Oglethorpe, resulted in Diallo's being brought to London, while still remaining the property of his American master.

Once there, however, he quickly became a celebrated prodigy; not least for his Arabic, invaluable to Sir Hans Sloane, the founder of the British Museum, who asked Diallo to translate Arabic inscriptions on coins. His sudden fame and the esteem given to a literate student of English almost certainly saved him from a conspiracy which promised to return him to Africa but which Diallo himself suspected would in fact return him to the ships. More remarkably, with his story told and publicized by Thomas Bluett, a subscription was raised to buy his freedom. The Quality had to meet him; George II and Queen Caroline received him at court. Bluett's memoir went into several editions, with Hoare's portrait, and Diallo became the first great cause célèbre of the anti-slave-trade agitation which would end successfully with the Abolition Act in 1807. That he had himself been a slaver was best forgotten; and also overlooked was Diallo's plight on returning to Senegambia, where he discovered his wife had remarried and where he was briefly captured by the French.

Virtuous blacks were the first to find their way into solo portraiture, but they were followed by beautiful blacks, beautiful especially in physique. Joshua Reynolds continued a tradition inaugurated by Dürer's glorious head of his black servant Katharina. But it was black bodies, seen as supreme specimens of the human torso, which became the object of fascinated study, even by those who thought that their beauty ended at the neck. Prizing the black body, of course, was also

what slavers and auctioneers did when they wanted maximum value from their property, and the prose which described the magnificence of its musculature written by artists seems only slightly less indecent than that penned for the auctions.

But the models were free, not slaves, and many of them came as freedmen from America to Britain, where, paradoxically, they had to be translated back into Africans (sometimes with their own collaboration) to create maximum appeal. The most spectacular, and certainly the most famous, was a seaman called, simply, 'Wilson', born in Boston and arriving in London around 1810.

An injury of some kind sent him to the consulting rooms of Sir Anthony Carlisle, the chief anatomist of the Royal College of Surgeons. This presupposes that Wilson had some sort of patron, though who exactly this was remains a mystery. He was, however, about to have many more. Though not a practising artist in the Tonksian way, Anthony Carlisle had had both a medical and an art education, the latter in the Royal Academy Schools. And it was as an anatomical draughtsman as well as a physician that he found himself marvelling at the Wilsonian physique as he tended to the man's injury. What he was beholding was a living version of the classical statuary (or the casts of same) on which his whole schooling had been based but which he had never seen in the flesh. But the flesh in which the Farnese Hercules had come to life was not as white as marble but ebony black. Everything he had assumed was turned on its head. He made sure to tell his friend Sir Thomas Lawrence, the President of the Academy and Britain's most celebrated portraitist, about Wilson. Lawrence inspected the marvel, also pronounced Wilson the reincarnation of Antinous, Hadrian's incarnation of male beauty, and thought that the 'African' should model for artists so that they would see the ideal human form in something other than plaster and stone.

Wilson earned two guineas a week from sitting for the artists of London: all those who wanted to deliver the shock of black beauty to their history paintings. Noble savagery was in vogue: South Sea Islanders, Indian princes, North American chiefs brooding on the fate of

their tribe were visual exhilarations compared with the predictable tableaux of bonnets and high hats; grenadiers and rosy-cheeked infants. It was, however, possible to get overexcited by the opportunity presented by Wilson. George Dawe painted him wrestling a buffalo, and evidently winning the bout with a body lock and fall, though to judge by the buffalo's expression (more completely described than the man's), the beast was vigorously contesting the decision. Dawe seems to have got the story of the fight from Wilson himself, which just goes to show how much even the more sophisticated of London's society had to learn about America.

While Wilson was sitting in this studio and that, Benjamin Robert Haydon, burning with ambition to be the great history painter Britain had been waiting for, was jealous. Chronically broke, endlessly seeking hand-outs from friends like Turner, perennially rejected by the Royal Academy except for works he himself disdained as trivia, Haydon was desperate for a breakthrough, and Wilson was his chance. Notwithstanding the cost, he hired him for a whole month in exclusive sittings, so that either he failed to pay Wilson or else (more likely) paid up and, as usual, hoped someone else would bail him out. Agog, he looked and looked and drew and drew, this angle and that, astounded especially at Wilson's suppleness; his ability to set his foot, for example, behind his neck; a beauteous flexibility for obvious reasons missing from antique sculpture: 'His contour was undulating and nature suffered nothing to interrupt this beauty in any position.' And this led Haydon, who was having no success in making a history painting featuring the perfect black, into an experiment: making a plaster cast that would somehow freeze the very elasticity and 'undulation' he so admired. So he set about plastering Wilson, seven bushels of the stuff, covering the black with white, but so heavily and so enthusiastically that, in consternation, he realized he was asphyxiating the man under the cast. In panic, he broke it open. Wilson survived, but Haydon's project did not. Sometime in 1811 the perfect black man disappeared into London. Thirty-five years later, after failing to realize his ambitions, encumbered with debt, Haydon shot

himself. At this, too, he was incompetent, finishing himself off by cutting his throat.

Wilson's legendary torso was seen by a handful of artists and connoisseurs. But at exactly the same time – 1810–11 – tens of thousands saw another black body on display. The body belonged to the pugilist Tom Molineaux, formerly a slave in South Carolina, who had come to London in the same year as Wilson and had quickly made himself famous in an altogether different way. His promoter and trainer was another black boxer, of an older generation, the great Bill Richmond, 'the Black Terror', who also had been a slave, in Virginia. The British had offered freedom to slaves fighting on their side and it was probably in this way that Richmond ended up as batman to Lord Percy. Percy and his army lost the war, but not before he had seen the phenomenal potential in Richmond, who had already acquired a formidable reputation boxing against other former slaves. Percy brought him to England, apprenticed him to a cabinetmaker in Yorkshire and then began to hazard him in serious bouts. Richmond soon proved himself so adept that just two weeks before the Battle of Trafalgar, in 1805, he was matched against the undisputed British champion, the ferocious and apparently indestructible Tom Cribb. The fight was merciless and Richmond lost, retiring not long after to found a famous boxing academy in Leicester Fields. What he did not lose, however, was a deep urge to be revenged on Cribb; not least, one suspects, because so much racially coloured derision had been poured on his presumption.

When he met Molineaux – five foot nine (a good height for the time) and fourteen-plus stone – Richmond thought he had found the instrument of his and his people's vindication. Toughening the lad up, Richmond tried him out on Tom 'the Tough' Baker and a Bristol fighter called Burrows, chosen precisely because they were protégés of Tom Cribb, who himself had gone into victorious retirement. The complete humiliation of the white fighters at the hands of Molineaux (now called the 'Black Ajax') was meant as a goad to Cribb, and it worked. He came out of retirement to fight Richmond at Cropthorne, near East Grinstead. It was raining, of course: a thin, bleak, cold downpour. But

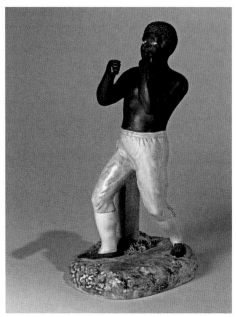

Bill Richmond, by Robert Dighton, 1810
Tom Molineaux, by unknown artist, circa 1810–15

the prospect of the black up-and-comer against the hard white champion was such a dream match that twenty thousand showed up to see it. Richmond had ensured that Molineaux was well trained; Cribb, on the other hand, was cruising on the assumption that his opponent was a soft upstart. He learned he was mistaken the hard way. Cribb took a phenomenal beating. At one point, Molineaux knocked him down entirely and he was rescued by the crowd, unsurprisingly supporting the 'Briton', invading the ring; a fracas which broke one of Molineaux's fingers. This was, remember, bare-knuckle boxing. Even then, the Black Ajax had the better of things, so much so that one of Cribb's seconds stopped the bout, accusing Molineaux of fighting with weights in his fists. The respite helped the older fighter and, gradually, he took over the contest, Molineaux conceding after hours of relentless pounding; both faces beaten to pulp.

Richmond was unhappy with the verdict, as well he might have been: feeling the result had been stolen through the weight of race prejudice loading the outcome, and doing anything to secure it. Though Cribb was initially reluctant, a return fight was organized and took place in September 1811, around the time Haydon was covering Wilson with plaster. This time, the fitness of the two boxers was reversed. Captain Barclay, an expert in cross-country training, had brought Cribb back to peak form, whereas Tom Molineaux had become the victim of his own celebrity. Richmond stood by helplessly while Molineaux became the toast of the town, dressed by Beau Brummell, patronized by the foppish *bon ton*; drunk under the table and in and out of the bagnios and stews. In all these ways, Richmond complained, his manhood was undermined. Molineaux lost to Cribb in twenty minutes and never recovered from the indignity. The Black Ajax was finished as a serious contender, and quickly became reduced to fairground and carnival acts, dying in drunken poverty at the age of thirty-four in 1819. His mortified trainer, Richmond, on the other hand, prospered in his academy and became something like an elder statesman of pugilism, as the Jewish fighter Daniel Mendoza had been before him: protector and patriarch to any young black boxers who

came to the academy, though none ever quite realized their potential like the Black Terror, or had it to squander like the Black Ajax. Richmond saw, quite clearly, the double standard operating in what white Britain wanted from black male performers. They romanticized the virility of their bodies while often reducing them to 'magnificent' physical specimens. When blacks asked to be taken seriously for their thoughtfulness, intellect and imagination, that physicality got in the way. There were a few exceptions. Thomas Gainsborough painted the portrait of Ignatius Sancho, who was certainly no prize fighter but had been adopted by the aristocratic Montagus, first as servant then, like Dr Johnson's Francis Barber, as educational project. One of the Montagus left Sancho enough money for him to set up as a grocer in Westminster, and Sancho's letters on the abominations of slavery were an important addition to the abolitionist arsenal. All the same, Sancho – his name chosen for him because his portly matter-of-factness recalled Cervantes' character – remained a grocer.

A test came in 1825 when a young black actor dared to play Othello, in the first instance at an East End theatre, and eight years later at Covent Garden. Like Richmond and Molineaux, Ira Aldridge was also an American, and this played some part in the way the British looked at him as a specimen of reckless temerity, somewhat to be admired and somewhat to be deplored for exactly that quality. Aldridge, who had played Hamlet at the age of seventeen, was the son of Daniel Aldridge, a free black cartman and straw-seller in New York. But Daniel was also an evangelical lay preacher, and it was from his preaching and his determination to give Ira a good education at the African Free School that the boy's taste for 'declamation' arose. This was exactly the period when freed slaves (and some unfree) were extending the range of their rhetorical gifts from the church to the soapbox and the theatre. The fact that in cities like New York, where there was still a large population of slaves, freedmen faced bitter racial hostility only quickened the desire to find a public voice.

To the dismay of his father, who wanted him to embark on a preaching vocation, Ira became stage-struck early, joining William Brown's

African theatre, which played farces and musical skits alongside versions of Shakespeare; especially the favourites, *Hamlet* and *Richard III*. Brown's troupe faced constant harassment and occasionally violent mob attacks, forcing it to move house. It was difficult and dangerous, then, for young Ira to place his hopes of advancement, not to mention a living wage, in the stage, so he spent some time as a steward-seaman. One of those trips was across the ocean, and on board was the actor James Wallack, who saw that Ira could be sold as a sensation – the black who acted Shakespeare tragedies – to British audiences.

In this way, 'A Gentleman of Colour' was advertised on the bill of the Royalty Theatre in the autumn of 1825. The Gentleman's name was given as 'Mr Keene', perhaps because the teenager, as Ira still was, hoped to be identified with the greatest name in Shakespearean acting and a legend in America, Edmund Kean. But the Royalty was no Covent Garden or Drury Lane. Those two theatres had the exclusive right to play the great tragedies, so the Royalty versions of *Othello* or *Hamlet* or *Macbeth* offered were usually truncated and sandwiched between light comic fare and musical acts. All the same, it was something, for the first time to see the Moor played without fake blackface. The audience – as audiences all over Britain, especially in the provinces – loved Ira, which meant, inevitably, that some of the critics did not. His Othello was especially provoking to many of them, since it was obvious he had been co-opted into the abolitionist campaign then under way to get rid of the whole institution of slavery throughout the empire. The white villain Iago bringing down the impressionable Moor became the cat's paw of the embittered debate. *The Times* was being paid for hostility to abolition, which meant that its review of Aldridge's Othello was especially vicious, sneering at the absurdity by which a black imagined he could utter the lines of the immortal Bard, given that the thickness of his lips made this impossible. Other reviewers were somewhat more generous, the *Public Ledger* confessing itself to be 'surprised to find the hero so ably portrayed'. Though, needless to say, it was Aldridge's body language which he thought did best: 'the

finest representation of bodily anguish we ever witnessed'. The same critic, however, couldn't avoid a schoolmasterly tone, recommending 'to Mr Keene a stricter attention to the text of the author'.

Aldridge was still a teenager but was shrewd about the repertoire he could work up that would give him employment and an audience: Oroonoko, the reluctantly tragic leader of a slave rebellion in Surinam, Gambia the good negro, and the like. He also slipstreamed behind some of the degrading parodies of blacks to make his own comedies, parodying the parody. The lesser theatres welcomed him; the audiences took to 'Mr Keene' and, the further away from London – especially in Ireland, where he was a sensation – the better it was. In 1826, barely a year after his debut, he was enough of a celebrity to sit for James Northcote. It was an extraordinary conjunction. Northcote had actually been a pupil of Joshua Reynolds and was now eighty years old. Aldridge was all of nineteen. Unsurprisingly, Northcote recycled Reynolds's portrait of the handsome young black, perhaps Francis Barber, perhaps not, so that Aldridge also has the noble glow; the turned head, set in a romantically airy space. The picture is in fact rather beautiful, and ended up in the Royal Manchester Institution.

Aldridge returned to London in 1833 to play Othello, at Covent Garden. It was bad timing. A lethal flu epidemic was gripping the city. Those who could had left; those who stayed were not about to frequent theatres, where the danger of contagion was among the greatest. Aldridge – who by now had taken back his real name – played to a poor house, but the audience, such as it was, rose to him, enough for him to take a curtain call. The critics, of course, with a few exceptions, repeated their derision and hostility not so much towards his particular performance but to the very idea that a black man would attempt the immortal Bard. It probably didn't help that Aldridge had married the white Margaret Gill, daughter of a Yorkshire stocking weaver, though he concocted a story about much grander origins. The sympathizers, as usual, laid stress on the physical quality of his performance: a backward death fall on the stage, head to the footlights, which became a famous hallmark and was stolen by the great American actor

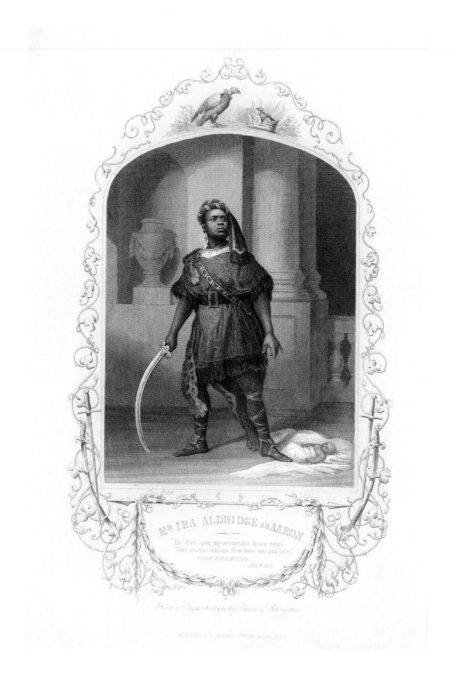

Ira Frederick Aldridge as Aaron in 'Titus Andronicus', after William Paine, circa 1850

Edwin Forrest when he played the role. Ira went on through the 1840s and '50s with much the same repertoire but trying out 'whiteface' Shakespeare roles like Richard III and Macbeth. On the European continent, in France and Germany and Russia – cultures which didn't feel so exquisitely proprietary about every word of the text – he was a genuine star, a celebrity, and he died in his fifties in Łódź, Poland. As he rose to fame, he evidently felt the need to embroider his origins in New York and developed a story somewhat like the real history of Ayuba Diallo, minus Islam. He was, he said, a Senegalese prince, victimized in a tribal war, who had taken refuge in America. This was all a bit sad. For all the knocks he had taken, Ira Aldridge was something of a great actor and, more importantly, a great man. Being himself should have been enough for his biographical portrait. But for those who have to fight for recognition it seldom is.

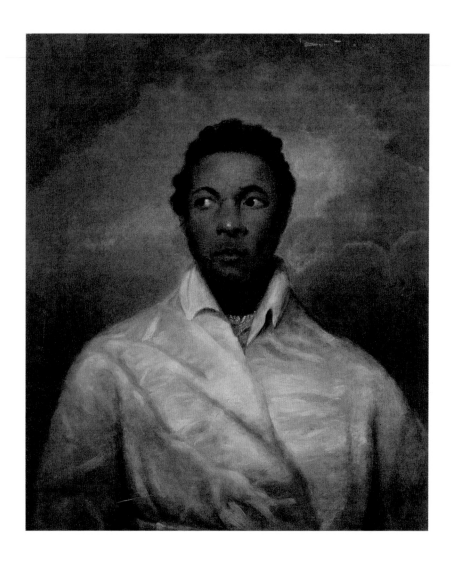

Ira Frederick Aldridge, after James Northcote, circa 1826

2. *Variety*

The title page of William Hogarth's manifesto, *The Analysis of Beauty*, began, as it meant to go on, with a shock to the system. The logogram which would normally have enshrined the Hebrew tetragrammaton, the letters of God, are replaced by Hogarth's binding principle, the serpentine line, the pagan-Egyptian snake, complete with head, which meant, at the same time, wisdom and grace. Beneath it, Hogarth planted the motto by which he had led his life and made his art: VARIETY.

Though he had sounded off every so often, in response to critics who thought his art low, chaotic and undignified, Hogarth had waited until ripe middle age (he was born in 1697) to produce not just a statement of principle, instructions for practice, but also in some wise a complete *apologia pro vita sua*, though, in truth, none was needed, for he was, at last by the 1750s, rich, esteemed and successful. But there was talk of the creation of some sort of state-authorized academy, such

as had long been established in France: not a place Hogarth believed should serve as any sort of model for British painting.

Worse, the education to be offered by that academy would be based on the practice of copying casts of classical sculpture. Thinking perhaps of Richardson's *Essay on the Theory of Painting*, with its adulation of the classical and assertion that transcription of the features of 'the common sort' was not art at all, Hogarth attacked the 'blind veneration of the antique'; the cult of the classical which had 'drawn mankind into a sort of religious esteem'. What we now call the 'art world' he hated for its herd instinct: the troops of milords on their Grand Tour, gawping at the *Laocoön* and the marbles of the Capitoline, packing a bust or two to take home to the saloon of their country house; the parasitical 'connoisseurs' (or, as we would say, 'art advisers'), also called 'quacks' by Hogarth, who preyed upon the impressionable moneyed classes. There was a sturdy strain of red-blooded Protestant patriotism in this. In 1737, in an essay signed 'Britophil', Hogarth had attacked the quacks who palmed off 'ship-loads of dead Christs, Holy Families, Madonnas, and other dismal dark subjects, neither entertaining or ornamental, on which [dealers] scrawl the terrible cramp Names of some Italian masters and fix on us poor Englishmen the character of Universal Dupes'. Hogarth invents one of these Art World persons and galleristas and calls him 'Mr Bubbleman'; he tries to sell a client a Venus which in truth was less beautiful than the average English 'cook's maid'.

Hogarth's antidote for this arid and formulaic classicism was – Modern Life. Instead of copying antique casts, he recommended drawing from immediate contemporary experience. Metaphysical notions of beauty led to a dead end; beauty based on empirical observation was forever vital, animated, *English*. Against stillness, he championed motion; against the rigidity of the straight line (including the Cross), the wavy and the undulating, since in fact every bone in our body curved and twisted. Against sparseness, he praised abundance; against regulated plainness, the endless intricacy of interconnected forms; against the stony, the burgeoning of nature; against the mechanically

regimented and the statuary yard, the pullulating swarm of the city; against silence, sound, especially that of music; against solemnity, mirth; against weight, levity; against deathly pallor, the 'tender tint' of a woman's breast, the sublimest of curves; against uniformity, the incomparable and infinite variety of human existence. In ways in which perhaps even he was unaware, the delectable salmagundi of his book exemplified its own principles, for while it is a treatise, it is chock-full of the world's multifarious matter: parsley leaves (especially their indentations); whalebones; an adult man wearing baby's clothes seen at Bartholomew Fair; the motion of a ship riding the waves (wavy); a mechanical duck; the furls, frills and helical forms of shells; anything frondy or ferny; a lock of curly hair, 'the wanton ringlet' which was, he says, the secret of sexual excitement; the wispy fumes of a smoke jack; the proportions of half-naked boxers; the variegated hues of the cutis; the endlessly serpentine moves of the minuet; the graceful motions which ought to be made by a hand passing a snuffbox or a fan to a gentleman or lady; the exercises parents should teach their children that they might neither hang their head nor yet hold it excessively erect like a mannequin. There has never been a book of art theory so pulsing with actual life; so resolved not to lose its beat in the translation to art.

The struggle between the urban zoo and classical order was the story of both Hogarths, father and son. The father, Richard, had been a schoolteacher, and had published a Latin thesaurium which brought him respect, but no money, as his son bitterly recalled, and a projector of 'academies' in which Latin alone would be the language of conversation.

Richard Hogarth was stuck in the heaving world of Smithfield Market and Bartholomew Close, where his son was born. He tried his hand at owning and running a coffee house, designed for the literati and the Latinizing, and for a time this succeeded. But when it failed in 1707, Richard was imprisoned for debt in the Fleet Prison for four years, a period of humiliation and poverty the son never forgot and which drove his own resolution never to suffer a similar fate. William

was sent first to a silver engraver and then spent some time as a designer of satirical prints directed at the follies of the time and the town, especially the South Sea Bubble. His great chance came with his marriage to Jane, the daughter of England's premier history painter, Sir James Thornhill. It got him out of the more squalid districts of London and into grander lodgings. The odd history came his way: painting enormous pictures of the Pool of Bethesda and the Good Samaritan for St Bart's Hospital, where his new connections had secured him membership of the governing body. The liveliest passages were all those where Hogarth imported a cast of characters from the Smithfield streets – the blind, the crazed, the venereally infected – into the solemn composition. He tried his hand at group portraits – of a committee of the House of Commons on prisons sitting *in* prison, a theme which, given his father's experience, would have had particular resonance. But the result was stiff. And while he accepted portrait commissions, the obligation to flatter stifled his creativity. In a memoir published after his death he remembered being condescended to for his portraits. The 'current remark', he recalled, was that:

> portraits were not my province; and I was tempted to abandon the only lucrative branch of my art, for the practice brought a whole nest of phizmongers on my back, where they buzzed like so many hornets ... my composition and engraving [are] contemptible. This so much disgusted me, that I sometimes declared I would never paint another portrait; and frequently refused when applied to; for I found by mortifying experience, that whoever would succeed in this branch, must adopt the mode recommended in one of Gay's fables, and make divinities of all who sit for him. Whether or not this childish affectation will ever be done away, is a doubtful question; none of those who have attempted to reform it have succeeded, nor, unless portrait painters in general become more honest, and their customers less vain, is there much reason to expect they ever will.

Hogarth was determined to become 'master of [his] own time' and his work took a radically new direction. While Hogarth did not give up commissions for family portraits in particular, or particular characters who were friends, personifications of good causes like the Fieldings or the benefactor of the Foundling Hospital, Captain Coram, his ambition directed itself less to individuals than to becoming the collective portraitist of the human circus, or at least that stupendous part of it on daily show in London. Powerful figures of the kind who would normally have been patrons – judges, clerics, aristocrats and gentry – were now drawn, with all their peculiarities rendered, as if characters in a graphic novel. His powers of observation turned encyclopaedic. In *Characters and Caricatures* and *The Five Orders of Periwigs*, Hogarth made visual anthologies of types, all the while insisting that he was never stooping to low cartooning, merely recording the human truth.

But exposing the human reality beneath the august mantle of authority was itself a subversive act. The majesties of Britain had wanted themselves portrayed as gods, or Caesars, or both; the currently presiding rulers, the landed aristocracy or, in London, the city patricians, all demanded dignity and civility for their public image. Hogarth's antic comedies, the exactness with which he saw and drew bloated bellies, warty noses, pinched cheeks, spindleshanks and wattles, made it that much harder to smother irreverence and command deference. This cutting down to size had, of course, been a staple of British/English drama since Shakespeare's time. But until Hogarth it had had no place in the visual arts, which for much longer had continued to project an aura of imperturbable authority. Now all those justices, swaggering gentlemen, lords and lechers were just characters in the non-stop social circus that was London.

They peopled the Modern Morality Tales – *A Harlot's Progress* and *A Rake's Progress*, with which Hogarth made his breakthrough into fame and a degree of fortune in the 1730s – comparatively late for an artist. As well as generic types – whores, rich patrons, unscrupulous lawyers, prating parsons – there were specifically recognizable

characters in these prints, but always those it was safe to revile: the 'rapemaster' Colonel Francis Charteris, who was hanged for a final, most infamous act of violence; 'Mother Needham', the most notorious brothel keeper in London; and the like.

Hogarth extended the range of sitters beyond anything hitherto imaginable. Instead of confining himself to grandees who would put their portraits on their walls, his assumption that they would be engraved for a wide public meant he took portraiture out of the lordly saloon and to the coffee-house table. So his subjects might include anyone with contemporary popular appeal: Jack Broughton the boxer, ferocious, indestructible and the codifier of the first set of rules, such as they were, governing the bloody sport of bare-knuckle fighting. More remarkably, on 5 March 1733, around the time he was inaugurating the Modern Morality Tales, Hogarth went to sketch Sarah Malcolm, the 'Irish laundress' (as she had become known), sitting in her cell in Newgate, awaiting hanging for murder two days later.

It was the sensation of the year. Malcolm was twenty-two at the time of the crime, the educated daughter of middle-class parents. When hard times came, the family moved to Ireland, then back to London. In its slippery-slope plot, the story was all too familiar: mother dies, father abandons daughter to return to Ireland; daughter works in shady tavern, falls in with a bad crowd who coax her into petty crime. Sarah then went into service with an eighty-year-old widow, Lydia Duncomb, and her sixty-year-old female companion, doing the laundry and running errands. Plot thickens; lodgings at Temple Bar scoped out. On 4 February, Sarah lets in the Alexander brothers, the baddest of the bad company, who, in the process of stealing silver and guineas, strangle the two old ladies and cut the throat of their maid in what the papers and the court called 'a savage manner'. Sarah was posted on the stairs as the lookout and claimed that it was only when the deed was done that she had any inkling of the killings. When her landlord discovered forty guineas, a silver tankard and a bloody skirt in her room, he summoned the watch. The brothers and

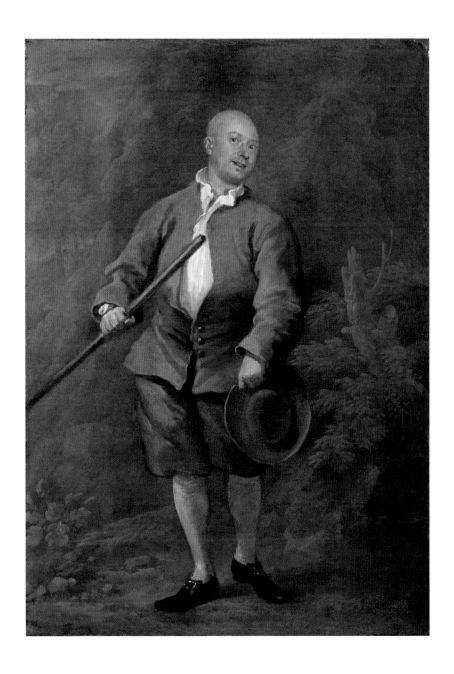

John ('Jack') Broughton, by William Hogarth, circa 1730

Sarah are imprisoned, but – surprisingly – only Sarah is tried, convicted and punished. A whole procession of earnest gentlemen, the Ordinary of Newgate and yet another chaplain failed to get her to change her story: that she had indeed been a party to the robbery but that she was innocent of murder. The bloody skirt, she said, was nothing other than menstrual flow. The shock she caused by saying so did not help; if anything, her startling frankness only confirmed the view that she was more animal than woman.

Hogarth, whose nose was acutely tuned to such things, smelled money along with the blood. His visit to the prison cell itself became collateral news, as he fully intended it should, publicity being the handmaid of profit. Sarah was flattered to the point of wearing her best red dress (a poor colour choice, in the circumstances), which Hogarth altered when he worked up the extraordinary portrait from his sketches. He knew all about prisons, of course, and made sure the cell was an especially grim one, with slatted and crossed bars at the heavy oak door. But he was also a brilliant dramatist of character. Sarah was in fact only twenty-two, but he makes her look older and stronger, exposing those meaty forearms. Since she is a Roman Catholic, a rosary is on the table; and her dress is that of any prim girl in service: the apron, the bonnet cap, the loose collar and voluminous skirt. Knowing his public, Hogarth made her scrubbed face read either as repentant or resolute in her plea of innocence to the crime of which she is accused.

And of course the painting was done in order to be engraved; not as an 'art print' either but to flood the taverns, coffee houses and print shops, pouncing on the moment for maximum and immediate exploitation. The prints, which dispensed with extraneous background – the cell; the rosary – were priced at sixpence a piece, which ensured they sold (along with the 'Confession' – still keeping to her side of the story – recited to a Mr Piddington on the eve of the hanging) like the hottest of cakes.

The Sensation market opened up a kind of portraiture no longer dependent on the sort of patron from whom Hogarth (like

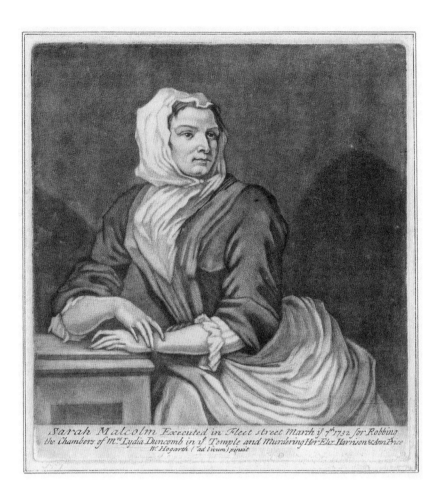

Sarah Malcolm, after William Hogarth, 1733

Gainsborough, later) felt estranged. After Sarah, who might he not portray? Highwaymen, whores, seducers, conmen: the underworld in all its carnival ripeness? But he didn't; preferring to slot the types into his graphic novels rather than specialize in solos of the Notorious. It was a matter of pride for Hogarth that, when he chose, he liked to present himself as a classical history painter, a maker of conversation pieces, caterer to the respectable as well as the infamous. Every so often he would stop the runaway horse of his storytelling to make beautiful, memorable images of the common people – Broughton the boxer, and the one everybody loves, and rightly so: the anonymous 'Shrimp Girl', straw-hatted, wide-eyed, sweet in her street-crying enthusiasm. Then, too, there were moments where he repeated the seated pose to make studies of those he thought political reprobates: the unreconstructed old Jacobite Lord Lovat and the squinting, radical idol of the common people: John Wilkes.

For the most part, though, Hogarth concentrated on pluralizing portraiture, making masterpieces of social theatre – the multitudes of the town, of Beer Street and Gin Lane; the vast crowds watching both the hanging of the Idle Apprentice, and his hideously Industrious doppelgänger making his portentous way as Lord Mayor through the throng – both as paintings and prints. Though the Dutch had produced those 'teeming pictures' of common life for a century, they had never had any purchase in British art until Hogarth.

And the great commotions and crowd scenes in *The March to Finchley, Southwark Fair, The Gate of Calais* (with himself as one of the actors, sketching before the Gate being an offence for which he was arrested as a spy); the brilliant, rowdy 'Election' series bought by David Garrick, with rival gangs of Party-thugs cudgelling each other, old codgers going over their military memories outside a pub, the elected member about to topple from his triumphal chair – all the action was held together by Hogarth's serpentine Line of Beauty. For that winding compositional ribbon was calculated to contain the swelling abundance of narrative action, wordy interpellation; the bulges and heaves of comic overspill. The line of action as well as beauty was perfectly

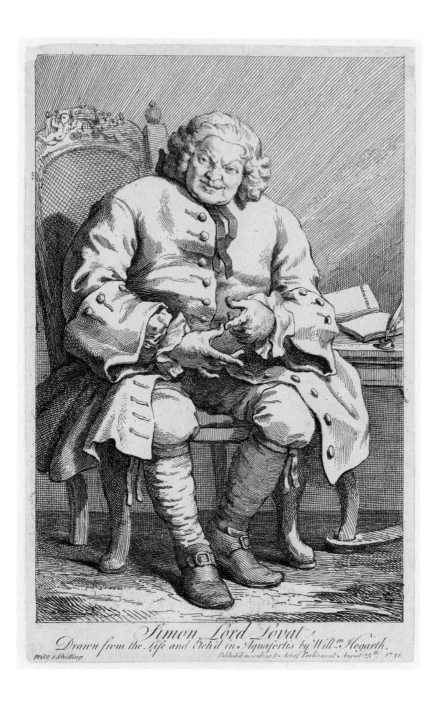

Simon Fraser, 11th Baron Lovat, by William Hogarth, 1746

executed to prevent all this riotous tumult from spinning entirely out of control into formless chaos. For Hogarth knew that chaos, as much as uniformity, was ultimately boring. So while he led the eye on the merry chase of action, liveliness, all that was also held in place by the winding arabesque, the up-and-down roller coaster of his peerless draughtsmanship.

Like all those who revolutionized British art, Hogarth was, in the end, inimitable, both in the grace of his bounding line and in the sharp intelligence of his moral imagination. Not least, even though he created the graphic novel, he belonged squarely in the company of Britain's storytellers – Fielding, Smollett and Sterne – who were themselves creating something new on the page. But he spun off a whole new generation of portrayers who occupied one of the many genres he pioneered: satirists and caricaturists like Gillray and Rowlandson, both of whom adopted the serpentine line to contain their comedies and keep them from flying away into chaos. And there were other, more obscure artists in places other than London who aspired to make a social encyclopaedia of their world, peopled with all the variety of human types Hogarth had delighted in. Thus came about, in the only British city to rival London for its social richness, a portraiture that was not only of the people but made by somebody who was very much of the people: John Kay of Edinburgh.

Hogarth had lived close enough to the street to give his dramas and portraits the unmistakable smack of authenticity. But Kay was closer still, to the street life of an Edinburgh that was changing almost unrecognizably from a population of some 50,000 in the middle of the eighteenth century to three times that by the time Kay died in 1826; and from a higgledy-piggledy assembly of ancient streets, the bastion of the castle, to the spectacularly elegant squares and crescents of New Town. Before the one Edinburgh swamped the other, Kay, in hundreds of etchings, made an incomparable portrayal of the city; a place where the educated rubbed shoulders with the ignorant; the new-fangled with the obstinately old-fashioned; the lordly with the lunatic. John

Kay had spent much of his life studying faces and heads, because the trade he had practised since his apprenticeship at thirteen was that of a wig-maker and barber. (Turner was another artist who grew up in a wig shop, run by his father.) It was one of Kay's regulars, William Nisbet of Dirleton, paying the usual four guineas a year for his services, who invited the barber to his country house, where his sketches of horses and dogs so impressed his host that he thought Kay ought to take that side of things more seriously. And so he did, compulsively, obsessively, drawing all who processed past his Royal Mile shop window, the Edinburgh passeggiata, with impish skill and wit. When Nisbet died, he neglected to follow up his encouragement with actual funds, but his heir gave Kay an annuity of twenty pounds, which allowed him to spend the rest of his life doing what he did best.

His self-portrait shows an unmistakable intelligence (along with his cat), but Kay also had a gift for picking from among the immense parade of types who made up his city at the turn of the eighteenth to the nineteenth century: soldiers and City Guards; courtesans and advocates, pastors and preachers (many of them); professors from the University; great minds like Lord Kames and James Hutton the geologist; and figures like Jamie 'the Baillie' Duff, described shortly as 'An Idiot'. On they processed in his endless Midlothian charivari: characters he knew would appeal to his public and sometimes to his subjects, though they often didn't have much say in the matter. Among them were a surprising number of centenarians, such as Mortar Willie, who had fought against the Jacobites, rose every day at four, lived to 106, and about whom it was supposed 'that but for a hurt received by a fall [he] might have lived several years longer'. Another was Andrew Donaldson, the Greek and Hebrew scholar who got it into his head that, since man had been created perfect, any 'amendment' to that creation, like shaving, was sinful and must be abandoned for ever. With the beard to match, Donaldson dressed like a Hebrew prophet in long raiment and went about the city reading from his Hebrew psalter. Alexander McKellar, 'Cock o' the Green', at least to himself, was an obsessional golfer, on the Bruntsfield Links day and night (when he

JOHN KAY
Drawn & Engraved by Himself 1786.

Self-portrait, by John Kay, 1786

played short holes by lamplight), in sunshine and freezing snow – which would have been tricky, had McKellar not been so very bad at his chosen sport, a matter of much amusement to his acquaintances. 'By the la' Harry this shall not go for nothing,' he would shout optimistically as yet another feathery flew into indeterminate space, never to be seen again. It wasn't all bunkers, though, for 'when victory chanced to crown his exertions he used to give way to joy for a second or two by dancing round the golf holes.' There was no end to the parade: Miss Burns, who was 'no better than she should be' and was chased by the wee, hooting boys as she carried her stupendous embonpoint through the Royal Mile; giants, often Irish; dwarf dandies dressed head to toe in the latest, miniaturized Brummells; the three-foot Pole Joseph Boruwłaski, who was so mortified to be teased that he would burst into tears, but not so mortified that he would not charge three shillings and six pence for private viewings, being ushered into a carriage by his friend the big advocate Neil Fergusson; one-eyed Colonel Monro, once, Kay rather cruelly observes, 'A Highland Hero', now 'turned Blue Gown Beggar' in the rags and tatters of his tartan plaid; John Wright the Accountant of Excise, profiled just as you would imagine, sallying forth beaky-nosed and bespectacled for a juicy audit; Thomas White, 'Midshipman and Homicide', seen arraigned between two beefy guards; the Turks Mahomet and Ibrahim, beaming beneath their beards; Vincent Lunardi, the intrepid aeronaut, sailing into the clouds of Caledonia in his hot-air balloon, not once not twice but five times, God bless him; and not by any means bringing up the rear, the great Domenico Angelo Malevolti Tremamondo (shortened, as the locals will, to 'Ainslie'), the first private riding master in Edinburgh, cantering about town in his finery, replete with an endless scripture of duels fought, countesses bedded, songs sung, steeds mastered. All these and many more besides: the visiting grand Mrs Siddons and Tom Paine; all available from John Kay's shop.

He never wanted for customers, even if some of them bought up loads of the prints to destroy them, such was the wound suffered to their vanity. Many of the subjects enjoyed seeing themselves in the

JAMIE DUFF, an IDIOT
COMMONLY CALLED BAILLIE DUFF
Died 1788

By the la' Harry
This shall not go for Nothing

COCK OF THE GREEN.

WILL.ᵐ WILSON, Commonly called
Mortar Willie. Aged 87.

Clockwise from top left:
Jamie Duff, by John Kay, 1812
Joseph Boruwłaski and Neil Fergusson, by John Kay, 1802
William Wilson, by John Kay, 1815
Alexander M'Kellar, by John Kay, 1803

John Rae, Charles Oman and Hamilton Bell, by John Kay, 1792

window of his shop; others, unaccountably Kay must have thought, took things entirely the wrong way: Hamilton Bell, for example. In his cups one night the grandiose Bell lad had wagered that he could win a walking race from Edinburgh to Musselburgh even with the handicap of a tavern boy on his back. And so he did! But instead of enjoying the celebrity, his great feat immortalized in print, Bell sued Kay over the indignity. It didn't do to take on John Kay. A 'retaliatory print' shows him being examined and vindicated (for he had published 'only the truth'), while Hamilton Bell and his friend sit goggle-eyed in apoplectic rage. The wager was won, which you would suppose would make Hamilton Bell perfectly happy for the great deed to be perpetuated in print. But not a bit of it. Hamilton Bell sued John Kay in a swoon of righteous indignation and lost, and good job, too.

It was a commonwealth of curiosities, to be sure, that Kay produced over his long life, his style becoming a little more formal as he aged, without losing its edge of wit. But it was also something else: an extra-ordinary collective portrait of the great city, becoming ever greater yet also about to separate itself into patrician and plebeian quarters, taverns, schools, places of work and play. Kay made no such distinctions; knew no boundary between New Town and Old. There is about his prints a thrum, a hubbub; the strut and clump; the clatter and clowning; the high minds and the low lives all jostling together before the Change unfolds and the pipes and whistles, the clamour and gossip, fade away beneath the canter of onrushing horse-trams.

3. *Cutting Edge*

What do you do when your country is defeated, four of your brothers have been killed serving the Emperor and your own military decorations seem baubles, nothing capable of earning you your daily bread? You cross the Channel from your home town of Dunkirk, to the land of the victors, and hope for the best. It was not easy for Augustin Edouart. In London, he offered his services teaching French, still a desirable accomplishment, the wars notwithstanding. But it was soon apparent that England was flooded with conjugators. So Augustin remembered a trick he had shown off when he was a small boy to much admiration, long before he had worn the shako of the Grande Armée. He would make miniature likenesses of dogs out of their own hair and then seal the result in a little wax. How the family barked its delight! When the pets died, something of them remained, a snippet of their furry bodies, so much more *of* them than any drawing could convey. In odd moments between victories and defeats Edouart had expanded this peculiar talent of hair portraits, and now it occurred to him to advertise it in the London press.

> Mr A. Edouart has the honour to inform the Nobility that he is just arrived from France with many designs in Hair, of a kind hitherto unknown, in which he is the sole Inventor. Fifteen years' study has enabled him to imitate the finest Engravings. His labor never having before been exposed to the public in any country, he begs to solicit amateurs of the Fine Arts to honour him with a visit in order that they may be able to form an idea of the delicacy and Beauty of his performances.

Should they do so, then Edouart offered not merely pet portraits but likenesses of his customers made from their own locks and tresses; also, should that please them, cunning emblems and designs, even

483

pictures of ships and whole landscapes. There was no wonder that his scissors could not perform. A few of Edouart's hair models survived into the twentieth century, including an adorable one of Tartar the Irish terrier. But an inventory also catalogues his efforts with horses and an 'old man'; another of a scene of revenue boats chasing a smuggler. It seems that in a country where the art of the 'shade' (not yet called silhouette) had hugely expanded the portrait market, to the point where anyone who could afford a minute of their time and a shilling from their purse could have their very own likeness, there was a craving for novelty. Getting your picture done in your own hair certainly fitted that bill, but Edouart's fastidiousness – he literally split hairs for fine work – meant that the process was a lot longer and the price a bit steeper for the end result.

Edouart seems, at least, to have scraped along, exhibiting his unusual art wherever he could, much like a fairground act. It was, at best, a piecemeal way of life. In 1825 his wife, Emilie, died and, while spending some time of solace with friends in Cheltenham, he was shown some shades that had been made by mechanical means, perhaps the Prosopographus, which passed a rod over the sitter's face and body and then reproduced the outline on paper. Moved to 'a moderate passion', Edouart seized a pair of scissors and, there and then, with a free hand cut through white paper, afterwards blackening the result with soot taken from a candle snuffer. The portraits were so impressive, and made with such a lightning touch, that Edouart was settled into the profiler trade, establishing a home studio in Cheltenham's Colonnade.

Edouart continued to free-cut in white paper which he then blackened, but the following year prepared black paper and card suitable for silhouettes became commercially available and his new career was suddenly and spectacularly launched. Off he went around the country, to Gloucester and Liverpool and London, but it was in Scotland that he became a widely advertised sensation. On Princes Street in Edinburgh he shared a house with a society tailor and a miniaturist who

also did some silhouette work. But it was Edouart's dazzling scissors that were the talk of the town. Sir Walter Scott (with his dog Spice sitting up and begging); members of the royal family; the exiled family and court of the deposed Bourbon King of France, Charles X; as well as clergymen, businessmen and professors – all sat for him, since, after all, this took so little of their time and the results were so pleasing. Edouart took the whole art of profiling well beyond the common run of black outlines made by the 'shade men', whose low status he deplored in a *Treatise* on his art published in 1835. Edouart could do groups, arranged like a relief or in space using perspective; he did scenes of animation and human interaction; children playing; men greeting each other on the street; genre scenes like an angry wife brandishing her fist at her coal-porter husband; classic moments of the theatre, featuring the likes of Mrs Siddons; children tormenting a dwarf; and, not least, Niccolò Paganini at a recital in Edinburgh in October 1832: 'The Signor was much pleased when I presented it to him and assured me at the same time that it was the first likeness of himself that was not caricatured.'

The most striking of Edouart's silhouettes are so animated that they resemble the cels or frames which, when flipped, become film strips. The ones he cut of Charles Simeon are tours de force of catching the changing body language of the famously histrionic preacher. There was, too, an element of missionary determination about Edouart's freehand style, set as it was against a whole welter of mechanical contrivances that were coming into play and which Edouart refused to recognize as creating art at all. His advertising boasted that, with his method, 'the Passions, and peculiarities of Character, are brought into action, in a style which has not been attempted by any other Artist', and one of his reviewers agreed that he had 'attained in pourtraying [*sic*] the features with almost microscopic minuteness and with unerring fidelity . . . while he invests every trait of the countenance with an expression in which the very mood of thought . . . of gravity or humour, deep reflection or sprightly fancy . . . are represented to the eyes'. By

Sir Walter Scott, by Augustin Edouart, 1830–31
The Beveridge Family, by Augustin Edouart, 1832
Sarah Siddons, Niccolò Paganini and Tyrone Power as Dr O'Toole in 'The Irish Tutor',
by Augustin Edouart, 1832
Charles Simeon, by Augustin Edouart, 1828

Mrs. Siddons the Celebrated Tragedian Tyrone Power Esqr. Tyrone Power Esqr.
Celebrated Irish Comedian the Irish Tutor Glasgow 18th April 1833
in the Christinal Christinal

Augst. Edouart fecit 1833.

the end of his first stay in Edinburgh, in 1832, Edouart had made forty-five thousand silhouettes! Five thousand of them were shown at Holyrood; he had received the official imprimatur of George IV, who loved this sort of thing, and he did another six thousand in Ireland later in the 1830s. An exhibition in Dublin showed off some of the more extraordinary pieces, which went well beyond his bread-and-butter portraiture: shadow plays and animated scenes; the Royal Exchange in Glasgow; a company of infantry; Jesus College, Cambridge, by moonlight; 'a Murderer'; 'a Night Mare'; his own rooms in London populated by the famous; a chess match; gatherings of Irish bishops – Dromore, Raphoe, the lot; an enticingly enigmatic picture of a beautiful woman captioned 'Do You Know Me?'

Inevitably, the country where entertainment met art called, and over the Atlantic Edouart went, setting up a studio at 114 Broadway in New York. Over ten years, he travelled the Republic from Columbus, Ohio, to Columbia, South Carolina, and everywhere in between. In 1849, perhaps not coincidentally with the creation of the second Republic, he packed up to return to France, where he hoped to spend the rest of his years. But his steamship, the *Oneida*, hit a bad storm and ran aground on the rocks of Vazon, off Guernsey. Edouart survived, but the vast majority of a hundred thousand of his silhouettes were lost in the wreckage of the ship. The twelve thousand which survived – a happy number, and the result of his rule of making duplicates – were given to the Lukis family, which looked after the physically and mentally distressed shipwrecked artist. He lived out his days in the town of Guînes in the northern department of the Pas de Calais. But from 1849 to his death in 1861, there was not another silhouette.

The art of the shade still had a good deal of life to it. It was, after all, more than any genre invented before it, the people's portraiture par excellence; knocked off in a trice, costing just a few shillings. Some of the earlier eighteenth-century practitioners, like the great pioneer John Miers, had achieved, with the 'smudging' of his last years, astonishingly delicate expressive effects in depicting hairstyles, eyelashes, frills of the collar, ribbon bows at the end of a pigtail, all of which

Henry Philip Hope, by Augustin Edouart, 1829

were genuinely painterly. Many others were admired in their day for somehow achieving eyeless images which were nonetheless, as was said of Edouart's, capable of capturing emotion. But by the time the *Oneida* foundered on the Channel Island rocks there was a new medium under way which would revolutionize the whole nature of likeness.

4. *Chummies*

1843, Edinburgh. The Old Town is hungry. The tenements growl with want. Even pease and oats and smokies cost the pennies many don't have. Men are idle all over Scotland; tens of thousands of them without work in Paisley alone. Every morning sees lines of the scrawny and the desperate; hollow-eyed men and women, bairns with legs like pipe stems, curved and brittle, queue up at the workhouse doors, frantic to be let in. Hunger lands like a flapping crow on the streets of Newcastle, York, Manchester, Leeds, Birmingham, Bristol, London, pecking at the poor. The Old Town brims with them, since the better-off sort moved to New Town. The cobbled backstreets beneath the castle and all about are full of families whose grandpas had been cleared from the highlands and islands, and who now kept body and soul together by working at looms that are stopped with the disruption in trade.

But that is not the Disruption on everyone's tongue and mind. That Disruption is an argument, become a schism, in the Church of Scotland. The cause was the right claimed by lairds and baillies, landlords and other owners of livings, to appoint ministers. That right had gone uncontested, but now brave, fierce voices spoke out against it, saying there should be no such property rights in the Church; that it was in fact an outrage against its holiness. Such was the anger of Dr Thomas Chalmers and many more who had come to be so persuaded that they would not abide any longer in a Church which countenanced such infamy. At the opening of the General Assembly, the Moderator himself read a statement to that effect, whereupon some four hundred fellow ministers rose from their benches and, like the Covenanters before (though with less hurling of chairs), broke the cowardly decorum. Out into the streets of Edinburgh they marched, three abreast, a river of black-clad righteous indignation, and down to old Tanfield Hall, where they signed a solemn 'Act of Demission': their statement of departure from their livings in the enslaved Kirk and

arrival into the new Free Church of Scotland which was to be their state of proper grace. It was no light matter that they were embarked upon. They were now cast out, along with their families, from what had sustained them in soul and, of more immediate importance, in body, too, submitting themselves to the judgement of the Lord, who, they prayed, would look with kindness on their act of self-cleansing, as He had with the prophets of Israel and the Saviour Himself.

Watching all this was the painter David Octavius Hill. His own speciality was landscapes, plain and fresh and simple; the cool light of Caledonia. But Hill, in his early forties, was profoundly stirred; so moved that he wished to capture the moment of Demission in some great painting that would in generations to come be spoken of in the same breath as *The School of Athens* or *The Night Watch*. But in the same instant that he decided the rebirth of Christian Scotland must be his life's mission, he realized how daunting was such a task: hundreds of likenesses. To pick and choose among them, moreover, was to act in express violation of the very principles of freedom and brotherhood that had motivated the dissenters in the first place. The impossibility of the work lay upon him like a millstone, even as he began to sketch the more prominent godly heroes – Dr Chalmers, above all.

An answer was at hand. One of Hill's friends was Sir David Brewster, the eminent physicist of St Salvator's College at St Andrews, to many a fearsome figure who was likely to greet even the most innocuous approach with a scowl or an entirely unprovoked tirade, to the consternation of those who had innocently inquired the time of day or some such. But speak of matters optical, and Sir David's fearsome face would glow with friendly light. Lately, he found nothing more engaging than the endeavours of his good friend Henry Fox Talbot to reproduce images from exposure to sunlight on paper treated with silver nitrate; a process he had made known to the world four years before, in 1839. This was the very same year in which a rival pioneer, Louis Daguerre, had shown his own photographic images, registered on individual copper plates, to the immense wonder of the public, and

the art world in particular. The daguerreotypes were exceptionally beautiful but could not be multiply reproduced. Fox Talbot's paper negatives could generate a wealth of prints but, beside Daguerre's beautifully fixed details, they seemed primitive and blurry. Moreover, to obtain any image at all required an unconscionable length of time, the intervals of suitable light in Britain being unpredictable. Just lately, however, to Brewster's intense fascination, his friend in Wiltshire had altered his procedure in a manner that had the potential to make paper negatives superior in every way. Instead of waiting the hours required for an image to appear on the treated paper, Fox Talbot immersed the latent, immanent image in a bath of gallic acid, from which – eureka! – a fine image was developed with astounding expeditiousness. Its quality was strong enough for the name Fox Talbot gave it – 'calotype'; 'beautiful picture' – to be no vain boast.

Ever practical, it occurred to Sir David that his friend Hill's dilemma in making his great, monumental, vastly populated history painting might itself be expedited were Hill to avail himself of photographs of the Demissioners, especially since, before long, they would all disperse to whence they came to start new livings as ministers of the Free Church. Such photographic 'sketches', which would take a trifle of the time needed for formal drawings, could then be reassembled and composed for Hill's grand picture. Moreover, Brewster suggested someone who might provide immediate practical help. One of his colleagues at St Andrews, Dr John Adamson, a fine and famed chemist, had himself become knowledgeable in the process of making calotypes. Some of striking quality had already been made of various (gloomy) buildings of St Andrews – this in the last years before its renaissance as the cradle of golf. In turn, John Adamson had introduced his younger brother Robert, also a chemist, albeit a novice, to the mysteries of this miraculous new craft or, might one say . . . art? Should Hill find the proposal agreeable, Robert might come to Edinburgh and, together, they would see if calotypes of the ministers might be achieved. And who knows what else? Other events worth fixing in silver nitrate? The building of the Scott Monument by their friend George Meikle Kemp;

the families of their heroes, Burns and Sir Walter; topographical views of the city itself with some of the more respectable of its citizens gathered beneath the walls of the castle, or on Princes Street?

Robert Adamson was just twenty-one in 1843. He had the makings of another great Scottish engineer: the impassioned curiosity in things mechanical and structural; a fine, strong, analytical mind. But what he did not have was the physical constitution for a strenuous life spent amidst fire and iron. The silent solemnities of calotypography on the other hand, the alchemical appearance of images, was Adamson's modern epiphany. When he came to Edinburgh, he and Hill immediately struck up one of the great partnerships in British history: the painterly spark and the scientific alembic; the eye for humanity and the mind to make such a picture stick. But the truth is that the Hill–Adamson partnership would not have produced the astoundingly beautiful work without each having a portion of the other's talents.

They set about their task. Church ministers posed. Chalmers himself was photographed in a classic attitude of his preaching, one arm stretched high in emphatic gesture; so high, and for all the relative speed with which the image was taken, long enough for the doctor to need his arm supported by a brace set in the wall. Pictures of animated discussions were taken. It was all working. Others sat for them: George Meikle Kemp, along with his laboriously progressing Gothic monument to Sir Walter Scott; a portrait of David Octavius Hill himself, handsome and affable; more dramatically, the blind Irish harpist Patrick Byrne, who had come to Edinburgh that summer and whose romantic performances had caused almost as much of a sensation as the Disruption itself; Hugh Miller, like Meikle a self-taught prodigy, stonemason turned geologist, author of *The Old Red Sandstone*, arguing, notwithstanding his evangelical Christianity, that the earth was of immense antiquity and had been home to innumerable now-extinct species.

Miller was photographed in the great cemetery on Calton Hill, where the unbelieving David Hume had been laid to rest, and Hill moved into Rock House, just opposite. He and Adamson together were moved by the marriage of antiquity and modernity, past and present,

Irish Harper (Patrick Byrne), by David Octavius Hill and Robert Adamson, 1843–8

which was the profound reality of their contemporary Scotland; humming with innovation and experiment, as it had been for a century, and yet so richly clad in memories both painful and glorious.

Much of what they saw in the Edinburgh of the 1840s displeased and disturbed them: the slums and rookeries of the Old Town, sweating with disease and grim destitution; children with misshapen bodies; drunks and whores, thieves and scoundrels. But they would not be like Friedrich Engels in Manchester, or Mrs Gaskell, committing their minds and their art to the graphic illustration of all this squalor and despair: the victims of the industrial maw; devoured and spat out again as the cycle of trade dictated. Instead, the two of them decided they would picture an alternative world of work; a place which carried on much as it had for centuries.

The Adamsons had in fact already made at least one calotype of the desolate-looking harbour of St Andrews, with fisherfolk near their boats. But there was somewhere much closer by, just half a mile or so from Calton Hill, that offered a much more picturesque possibility: Newhaven. Living and working where they did, Hill and Adamson could hardly have avoided the Newhaven fishwives, lugging their enormous hundredweight baskets, full of haddock, herring, cod and oysters, up the hill and down into the city every single day: an enormous feat of strength. Even from inside Rock House they would have heard the cry of 'Coller, haddie!' from the young women, dressed in their striped yellow-and-blue skirts, bulked up with so many petticoats as nearly to double the weight of their burden.

There had already been some discussion as to whether the answer to the ills of industrial cities was somehow to reinvent the village: the kind of communities from which the Clearances had banished shepherds and crofters. In those villages, had there not been broadly extended families, lending support to each other in hard times? Had there not been a strong and benevolent Church to contain and correct the iniquities which tempted the impoverished?

In 1819, Thomas Chalmers, who would become the moderator of the Free Church, had actually undertaken an experiment in social

Home from Market, by David Octavius Hill and Robert Adamson, 1843–8

reconstruction along these lines in one of the poorest districts of Glasgow. Excluding conventional poor relief and its overseers, he instituted an independent system of pastoral care run by deacons and elders who sought to recreate the microworld of neighbourly mutual support they imagined had existed before the coming of machine-age slums. In the same spirit, another friend of David Octavius Hill, Dr George Bell, went so far as to champion the restoration of urban smallhold farming on city wasteland (a programme that has re-emerged in some of the devastated districts of rustbelt America today).

With the best will in the world, though, the chances of this kind of benevolent social engineering were always going to be slim in the heartland of industrializing Scotland. But when Hill and Adamson went to look at Newhaven, they thought they had found a place miraculously spared the grinding destructions, moral and social, of the industrial world. The truth was that, while no paradise of ease, Newhaven was bound to prosper as long as the great city half a mile away went through a population boom. Edinburgh needed daily fish; a lot of it. The 'Small Line' of the shallow waters carried long nets with thousands of hooks to catch codling, haddock and whiting, while the 'Great Line' in the deeps went after cod, mackerel and the great herring shoals. To catch that last treasure, the Newhaven fleet went 200 miles north twice a year, close to Wick, many of their women going with them as gutters and smokers. There were dangers. Prolonged foul weather could play havoc with the small boats, destroy them altogether. In those bad times men would be lost and prices go up. From the changed cry they heard on Calton Hill, Hill and Adamson titled one of their pictures 'It's No Fish Ye're Buying, It's Men's Lives'. There were too many orphans in Newhaven. The photographers caught one of them, a small boy, wearing his dead father's trousers, many sizes too big for him, held up by precarious braces; an image of immense poignancy. That one they called 'His Faither's Breeks'.

When a father like Sandy Linton leans on his boat, his three bare-footed fledgling boys sitting under the bow, one of them grinning for the camera, the other two indifferent, father-and-son bravura

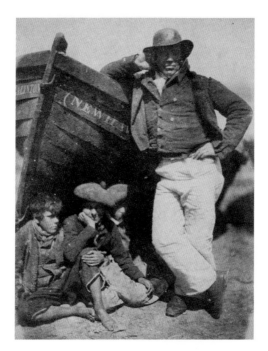

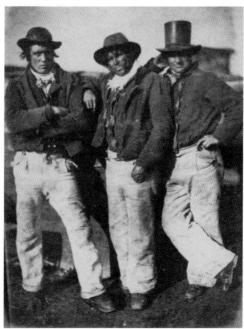

Sandy Linton, His Boat and His Bairns, by David Octavius Hill and
Robert Adamson, 1843–8
Fishermen Ashore (Alexander Rutherford, William Ramsay, John Liston),
by David Octavius Hill and Robert Adamson, 1843–8

mixes uneasily with the sense of precariousness that must have stirred every time the small boats sailed off into the rough night.

The authenticity of the pictures comes, first of all, from the strong impression that it is the fisherfolk, of both sexes and all ages, who control the poses, and with as firm a hand as they set about their livelihoods. Some of them evidently enjoyed mugging for the camera; others challenged it. John Liston, one of three fishermen leaning in a comradely way on each other, strikes an attitude of top-hatted sauciness, one dirty-trousered leg crossed over the other; while the body language of the stern Alexander Rutherford is all crossed arms and confrontational stare.

But without much of his help, preoccupied as John's brother Willie was, cleaning the line with the sharp edge of mussel shells, Hill and Adamson nonetheless turn him into one of the more romantic heroes in nineteenth-century art: the shadow from the brim of his hat falling over the brow of his handsome face; his clothes worn with a good-looking man's air of confidence – the knotted kerchief, the soft coat and waistcoat with its double row of buttons. No image – certainly no painting of the nineteenth century – turns the self-contained reserve of strength and patience of the working man into a thing of beauty as much as this single calotype.

It is not, however, the men of Newhaven who take centre stage in Hill and Adamson's calotypes. The men were gone fishing at night and, in the early hours, needed sleep when on shore, and back again they went, so many of the images caught by the photographers were cautiously sought and perhaps grudgingly allowed. Very quickly Hill and Adamson saw who were the true anchors of the community: the women. Their non-stop work, cleaning and mending nets, gutting and curing fish, hauling the catch to the city, taking care of the bairns, was unremitting. Fanny Kemble, the actress who played Edinburgh often and knew both David Octavius Hill and the fisherfolk, wrote that 'it always seemed to me that the women had about as equal a share of the labor of life as the most zealous champion of the rights of her sex could desire.' When disaster befell one of them, or merely hard

500 *Willie Liston*, by David Octavius Hill
and Robert Adamson, 1843–8

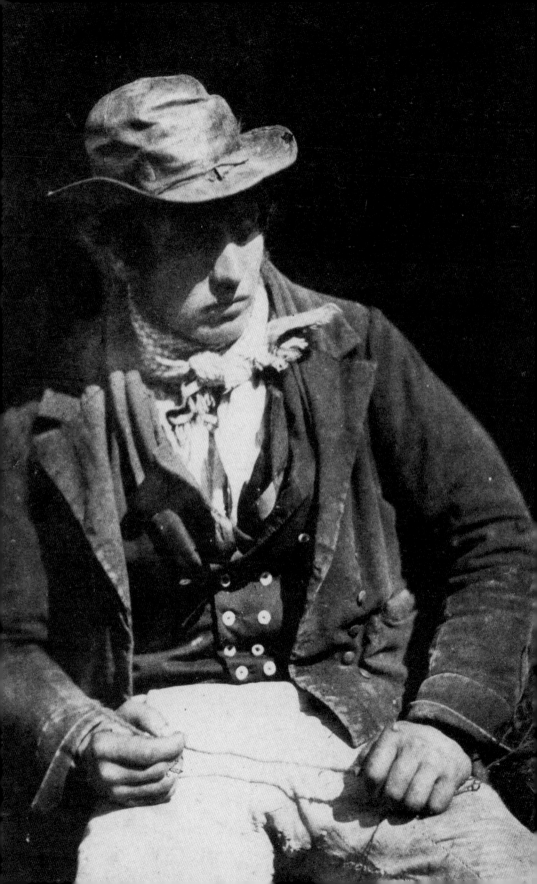

times, they could turn to one another. They called this sister-
hood – 'chummies' – a bottomless well of succour, support and gossipy
entertainment. No painter of the time caught working women in all
their rough and comely humanity with as much richness as the chemist
and the painter with their camera. Millet turned his peasant women
into clod-like monuments; Degas made his working dancers and pros-
titutes objects of the sweaty ogle; as for their British counterparts,
their women were either personifications of moral positions, theatrical
histrionics or erotic fixations.

Like the painters, Hill and Adamson train their eyes and their lens
on the young women. The occasional widow and matriarch appear,
listening to James Fairbairn, the visiting pastor, or enthroned before
a pilot's door. But it is the girls who take centre stage in so many of
the photographs: captured in the full beauty of their unconcern with
the photographers and their light box. One of them, a genuine beauty,
Jeanie Wilson, appears over and again, all the more mesmerizing
because of her absorption in her work. The two girls, Jeanie Wilson
and Annie Linton, are to be taken as they are, with their little row of
herring and oysters, entirely in each other's close company, and not
ours. Even when she was obliging Hill and Adamson with some sort
of pose, Jeanie had other things to think about. In another picture she
appears with her sleeves rolled up, leaning on her sister's shoulder,
hand on hip, not to please the men looking at her either, eyes staring
down. It's been another long day. Sometimes, too, the chummies won't
stand still for the cameramen; they stand in a lane teasingly, some
bare-footed, some not; backlit and blurred, some holding a wee bairn:
the sisterhood in its flower. Of the five girls in another chummy shot,
only one is bothering to acknowledge the camera, and she is not espe-
cially friendly towards it. In yet another heart-rending photo of a
young mother with her small child, the image is shaky, as if the mother
was rocking her wee one, or as if Hill and Adamson themselves were
unresolved about intruding indecently into her fragile life.

It was striking, too, that when *The Fishermen and Women of the Firth
of Forth* was published as an album – of the poor, but not for them,

502 *Jeanie Wilson and Annie Linton,* by David
Octavius Hill and Robert Adamson,
1843–8

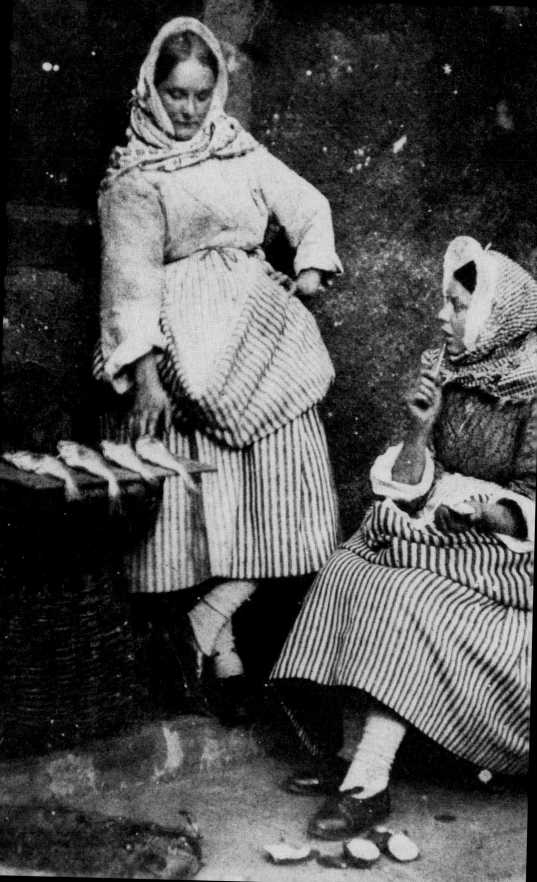

Sisters, by David Octavius Hill and Robert Adamson, 1843–8
Fisherwomen (A Lane in Newhaven), by David Octavius Hill and
Robert Adamson, 1843–8

Fisher Lassies (Grace Ramsay and Four Unknown Fisherwomen),
by David Octavius Hill and Robert Adamson, 1843–8
Fisher Lassie and Child, by David Octavius Hill and Robert Adamson, 1843–8

since the album, especially when combined with Hill and Adamson's architectural photographs, was pricey – it was the women who attracted particular attention. Dr John Brown, a friend of Hill and the reviewer for the Free Church paper, the *Witness*, praised the 'wonderful' pictures to the sky, especially 'these clean, sonsy, caller, comely substantial fishwives . . . as easy, as unconfined, as deep-bosomed and ample, as any Grecian matron'. But one of the most vocal champions of the calotypes and the women they portrayed was Elizabeth Rigby, who herself had sat for Hill and Adamson at Rock House. Rigby was English, given the German education the most ambitious parents then supplied for their gifted children, and had come to Edinburgh with her widowed mother, Anne, in 1842, a year before Robert Adamson. But she quickly became a fixture of the city's culture as essayist and critic, and would go on with her friend Anna Jameson (also photographed by Hill and Adamson) to be one of the most eloquent and influential voices in British art writing. Though she often shockingly lauded the pleasures of being unmarried, in 1849, a year after Robert Adamson's untimely death, Elizabeth did indeed marry, Charles Eastlake, a painter and critic who, with a knighthood under his belt, became President of the Royal Academy, President of the Royal Photographic Society and, in 1855, Director of the National Gallery. Two years later, Elizabeth Eastlake become immensely influential in her own right, and wrote a famous essay on photography, which, depressingly, given her earlier enthusiasm for Hill and Adamson's great work, now demoted it to the status of a visual record of fact, doing the documentary work true art ought to disdain. That was certainly not how she had felt ten years earlier in Scotland.

By this time, David Octavius Hill, bereft by the premature death of his partner Adamson, had given up photography altogether. Many followed, with ambitions to capture the social reality of Victorian towns, but never with quite the innocent eye and candid roughness the two men had brought to the fishing village on the Firth of Forth. Instead, Hill continued to toil on with the work which had started it all – the vast canvas commemorating the Disruption, which turned

Elizabeth, Lady Eastlake, by David Octavius Hill and
Robert Adamson, 1843–8
Anna Brownell Jameson, by David Octavius Hill and
Robert Adamson, 1843–8

Christina Broom, by Winifred Broom, 1910

into an ossified monster of overpopulation. But a year before Lady Eastlake produced her thoughts on the relationship between art and photography, another of their sitters at Rock House, Anna Jameson, who had become the indispensable authority on the art collections of Europe and author of the first generation of guidebooks to European museums, published her *Communion of Labour*, celebrating what she described as the union of 'love and labour' which nonetheless endured amongst women in unpromising institutions such as prisons and work-houses. Perhaps Jameson remembered the fishwives of Newhaven more sympathetically than Lady Eastlake, or at least saw that photography, when not made condescendingly, might be a friend to the cause of women, at least when it was women who were taking the pictures.

Christina Livingston was not by any means the first professional woman photographer in Britain. Julia Margaret Cameron had become justly famous for belying Elizabeth Eastlake's pessimism, taking photo-portraiture not just to the level of paintings but beyond it in imaginative expression. Clementina, Lady Hawarden, though not strictly a professional, had used herself and her daughters for a series of mesmerizing experiments in the way women saw each other and themselves, often in the mirror, sometimes in each other's eyes, games and interrogations as brave and deep as anything put on the page by Virginia Woolf.

This was not Christina's world, Christina's mind or Christina's work. But like Cameron and Clementina Hawarden, she was a pioneer none-theless, the first British woman to become a press photographer, and she did it, moreover, because she had to. She was a lowland Scot, daugh-ter of a bootmaker who had moved to Chelsea to make his name and fortune. At twenty-seven, she married Albert Broom, an ironmonger, but it was when his business collapsed in 1903 that the forty-year-old wife and mother borrowed a box camera and began another life entirely. Apart from a sharp eye for opportunity, Christina had the business head in the family, taking pictures of royal household guards with enough skill and friendliness that she became part of local life around Buckingham Palace, enough at any rate to open a stall selling

Clementina Maude, by Lady Clementina Hawarden, circa 1863–4

Mrs Albert Broom and the Oxford 1938 Boat Race Crew, by Winifred Margaret Broom, 1938
The Women's Exhibition, by Christina Broom, 1909

postcards and cheap prints of her pictures to the public. She was, in fact, the first vendor specializing in this kind of British 'tourist' photo, graduating to become the official photographer of the Oxford and Cambridge Boat Race; of the Household Division of Guards; and fashionable and ceremonious horseracing events. King Edward VII and the Queen knew about 'Mrs Albert Broom', as she called herself professionally after her husband died in 1912.

By this time Christina had developed an entirely different line of subjects: the suffragettes. In May 1909, a Women's Exhibition was held at the Prince's Skating Rink in Knightsbridge, a cavernous, 250-foot-long space. Ostensibly (and deliberately) the exhibition seemed just to be the mother of all village fetes – a showcase of all the usual work with which women were traditionally associated: baked goods and confectionery, cakes and sweets; embroidery, hats and flower-arranging. But though she was the photographer of such occasions, this would not have drawn Christina Broom to take her pictures of the show. As a news photographer, she had already taken fine shots of a suffragette march from the Embankment to the Albert Hall in June 1908, and now, a year later, Christina knew that the Women's Exhibition was a turning point in British history. The organizer of the exhibition was the Women's Social and Political Union (WSPU), and it was being held as a fund-raiser. Each of the fifty stalls had committed to provide not less than a hundred pounds' worth of goods, and in the end the show raised five thousand pounds for the cause which Emmeline Pankhurst (the subject of one of Christina's most beautiful portraits) described in her introductory brochure as 'the most wonderful movement the world has ever seen, a movement to set free that half of the human race that has always been in bondage and to give women the power to work out their own salvation in the political, social and industrial spheres'.

By the spring of 1909, both Emmeline and her daughter Christabel (also beautifully and informally photographed by Christina) had been to prison for disrupting Liberal party political meetings. All the same, it was surprising to find among the stalls selling suffragette ribbons

Emmeline Pankhurst, by Christina Broom, 1910s
Christabel Pankhurst at the Women's Exhibition, by Christina Broom, 1909

and badges in their colours (white for purity, purple for imperial dignity, green for hope) a replica of a prison cell, designed to show the discrimination and degradation to which women were subjected even when they were behind bars. Around the mock-cell were lines of Edwardian women in their flamboyant hats waiting to get their tour and talk from suffragettes who had had personal experience.

It was a tricky moment for Christina. She had a living to earn in the world of men; indeed, with the royals and the trousered powerful. But she was also obviously a whole-hearted sympathizer. In 1910, she was the photographer who captured the great march through London, culminating in a mass rally in Hyde Park. She photographed the Pankhursts and their leading comrades – Emily Wilding Davison, who would die under the hoofs of the royal horse at the 1913 Derby; Kitty Marion, the actress, who became the most dangerously militant of them all. For the last time, Christina was able to take photographs which portrayed the suffragettes as intent only on peaceful demonstrations for their cause.

After the 1910 elections, however, this changed. The Pankhursts and their sister comrades were regularly imprisoned and, when they embarked on hunger strikes, brutally force-fed. A 'Cat and Mouse' Act allowed the government to release the hunger strikers for as long as it took for them to recover physically, before re-incarcerating them. Faced with this more systematic oppression, the WSPU itself took a much more aggressive turn, which went from suicide and self-sacrificial tactics to a campaign of harm to others. Arson was the weapon of choice, but the chosen venues were extremely dangerous. In 1912, Mary Leigh, Gladys Evans, Lizzie Baker and Mabel Capper attempted to burn down the Theatre Royal in Dublin during a packed matinee performance, hiding canisters of gunpowder close to the stage and hurling petrol and lit matches at the combustibles. The principal target was the Prime Minister, Herbert Asquith, who was present and who that same morning had had a hatchet thrown at him by another suffragette. Postal incendiaries took a similarly lethal turn when phosphorus was thrown into pillar boxes with the intention of burning

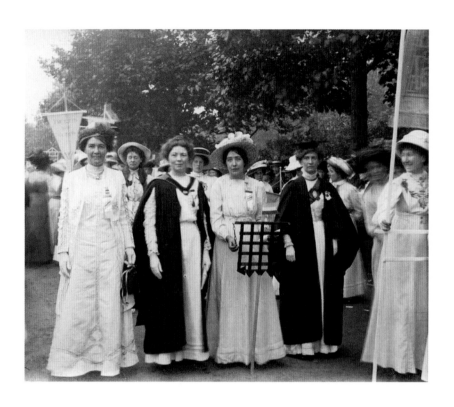

Suffragette March in Hyde Park (Emmeline Pethick-Lawrence, Christabel Pankhurst, Sylvia Pankhurst and Emily Davison), by Christina Broom, 1910

postmen picking up the mail, and in at least three cases succeeding. Any institution which the WSPU identified as speciously sacred to the official and especially male world was fair game. The tea pavilion and the tropical orchid house at Kew were bombed; another bomb was discovered in the nick of time outside the Bank of England; still another went off at the Royal Astronomical Observatory in Edinburgh. The bomb set at the Lyceum Theatre in Taunton was painted with the slogans 'VOTES FOR WOMEN', 'JUDGES BEWARE!' and 'MARTYRS OF THE LAW'.

Christina Broom stopped taking photographs of the suffragettes. But someone else was. In 1913, the Home Secretary, Reginald McKenna, purchased, for the sum of seven pounds six shillings and eleven pence, for his department an eleven-inch Ross telecentric lens, the first long-distance lens to be made in Britain, patented just a year before. A high-level joint meeting of the Metropolitan Police and the Home Office held in the spring of 1912 had decided that, since the WSPU had become a terror organization, some sort of pre-emptive surveillance was required to avert threats to the kind of public institutions they seemed to be favouring. A photo dossier, the first such security surveillance file, was to be compiled while the women were in prison and thus captive subjects. It was assumed, of course, that none of the suffragettes was likely to oblige the photographers by remaining still enough for their image to be taken. Some contorted their face in a grimace, hoping to make the picture useless as an identity record. Initial efforts to take mug shots met with similar futility. One remarkable print was doctored so that the policeman's arm gripping the recalcitrant suffragette Evelyn Manesta in a neck hold showed instead nothing more threatening than a scarf.

Hence the Ross lens. Outside Holloway Prison, the Home Office photographer hired for this secret surveillance, a Mr A. Barrett, would wait in an enclosed car until the opportunity arose for him to take pictures of women exercising in the prison yard. Little by little, this photo-surveillance file of the 'Wildcats', as the militant suffragettes were called in the code the authorities now used, grew. Copies were

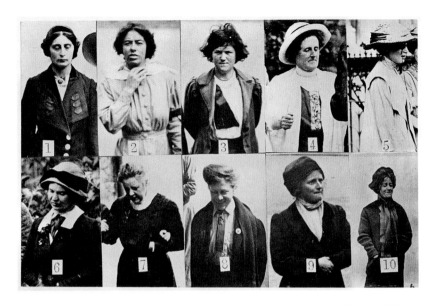

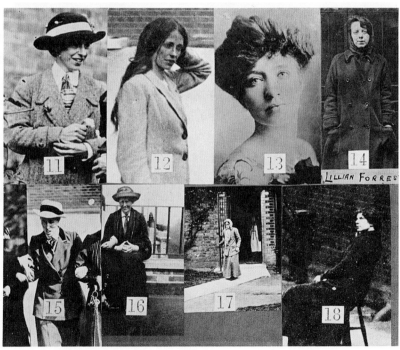

Surveillance Photographs of Militant Suffragettes (Margaret Scott, Olive Leared, Margaret McFarlane, Mary Wyan, Annie Bell, Jane Short, Gertrude Mary Ansell, Maud Brindley, Verity Oates, Evelyn Manesta), by unknown photographer, Criminal Record Office, 1914
Surveillance Photographs of Militant Suffragettes (Mary Raleigh Richardson, Lilian Lenton, Kitty Marion, Lillian Forrester, Miss Johansen, Clara Giveen, Jennie Baines, Miriam Pratt), by unknown photographer, Criminal Record Office, 1914

distributed to institutions deemed under threat, such as the Tower of London, where the Jewel House had been attacked.

Prime among the new range of targets were London's public art galleries. The fact that they were often full of nudes, which, the suffragettes reasoned, had largely been created by men for the pleasure of their own sex, and that this drooling exploitation masqueraded fraudulently under the guise of appeals to Imperishable Beauty, gave the new attacks a certain logic. Kitty Marion, who owed at least part of her success to just this kind of ogling, later wrote in her autobiography that 'I was becoming more and more disgusted with the struggle for existence on commercial terms of sex ... I gritted my teeth and determined that somehow I would fight this vile economic and sex domination over women.' That connoisseurs often seemed to consider paintings and statues of women as more precious than the actual things only added fuel to the fire. At her trial for taking an axe to Velázquez's *Rokeby Venus* in the National Gallery in March 1914, Mary Richardson justified her vandalism by saying, 'I have tried to destroy the picture of the most beautiful woman in mythological history as a protest against the Government for destroying Mrs Pankhurst, who is the most beautiful character in modern history. Justice is an element of beauty as much as colour and outline on canvas.'

The police and the Home Office had already decided at their 1912 summit that museum guards ought to be supplemented by plain-clothes police mingling with the public. But neither this tactic nor the distribution of photo files to the museums managed to prevent a rash of attacks on works of art, some of them chosen arbitrarily or, like the Giovanni Bellinis at the National Gallery and an Egyptian mummy in the British Museum, for reasons that were not articulated. Possibly, Herkomer's portrait of the Duke of Wellington in Manchester was chosen for the Iron Duke's reputation as a male hero (since much of his unstoppable womanizing was less known), but John Singer Sargent's portrait of Henry James was a more baffling pick, given the writer's well-known support for women's rights.

For a while, the threat to art was such that both the British Museum

518 *Mary Raleigh Richardson and Catherine Wilson*, by unknown photographer, Criminal Record Office, 1914

MEMORANDUM.

Special attention is drawn to the undermentioned SUFFRAGETTES, who have committed damage to public art treasures, and who may at any time again endeavour to perpetrate similar outrages.

Mary Richardson (S/168429), age 31, height 5ft. 5½in., complexion pale, hair and eyes brown.

Damaged, with a chopper, a valuable oil painting in the National Gallery and has several times been convicted of breaking valuable plate glass windows.

At the present time is out of prison, but is required to stand her trial for arson.

MARY RICHARDSON. CATHERINE WILSON.

Catherine Wilson (5753-14), age 31, height 5ft. 1in., complexion sallow, hair brown, eyes grey.

Is now out of prison, but is required to stand her trial for maliciously damaging, with a chopper, exhibits in the British Museum. Has been twice convicted of breaking plate glass windows and once for being found on enclosed premises for an unlawful purpose—found in the House of Commons in male attire with a riding whip in her coat pocket.

and the National Gallery closed their doors. This left the National Portrait Gallery, now at the bottom of St Martin's Lane, as the beneficiary of a thwarted museum-going public. Its staff had already been issued with a batch of photos of the likeliest suspects which they were supposed to consult when alerted to suspicious behaviour. On 16 July 1914, one the guards wondered about a woman who seemed unusually preoccupied with Sir John Everett Millais' portrait of Thomas Carlyle. After the event, he would say that he did wonder about this but decided the woman's close inspection of the work meant that she must be an American. When she returned the next day he changed his mind about this, since no American, he remarked, would have paid the sixpenny entrance fee two days in a row.

Quite what her attentiveness betokened, though, the guard did not stop to ask himself. He would soon find out when Margaret Gibb, calling herself by the alias of Anne Hunt, took a meat cleaver from inside her blouse, smashed through the glass covering the painting, cutting herself quite badly as she did so, and mutilated the hated face from brow to beard. She stopped only when a female art student who had been sketching in the gallery wrestled her to the ground while help was summoned. At her court appearance the next day, blood from her wound 'dripping down the side of the dock', as the *Daily Telegraph* was thrilled to report, Margaret/Anne explained very much in the Mary Richardson manner that 'life' was altogether more precious than art, since you could always get other works of art but the lives of women like Mrs Pankhurst, slowly being snuffed out in prison, could not be replaced.

Nineteen days earlier, an Austrian archduke and his wife had been shot in Sarajevo. Two weeks after Margaret/Anne's court appearance, the world was at war. The WSPU suspended their campaign for its duration, hoping that the act of loyalty would be recognized by the long-overdue granting of the vote. It was, albeit not until 1928, and then incompletely.

Now, Mrs Albert Broom had another subject. The Irish and Scots Guards she had photographed had changed their dress uniforms for

Emmeline Pankhurst's Arrest at Buckingham Palace, by unknown photographer, 1914
Edward, Prince of Wales, by Christina Broom, 1914

khaki and she pictured them as they went off to Flanders with smiles on their faces. When the Prince of Wales visited the 3rd Battalion of the Grenadier Guards at their training camp on Wimbledon Common, she was to take that picture, too. 'Goodbye-ee, goodbye-ee/ Wipe the tear, baby dear, from your eye-ee.' She went to see the ranks. One of her most heartbreaking photos is of the Bermondsey B'hoys, one of the Pals cohorts, friends and neighbours who were kept together in companies attached, in this case, to the Grenadiers. And when the wounded started to come back to Blighty and were treated to tea by the King and Queen at Buckingham Palace in March 1916, there of course was Christina, taking shots down the long tables, the men all with medals dangling from their necks, the bandages around their heads gleaming white.

Cheeeese. They are doing their best to smile for Mrs Albert Broom. But not many of them are.

Are we downhearted? NO!

Soldiers from the Household Battalion Leaving for the Front, by Christina Broom, 1916

5. *The Faceless of Britain*

Pack up your troubles in your old kit bag
And smile, smile, smile.
While you've a lucifer to light your fag,
Smile, boys, that's the style.

But how can you do that when your mouth is missing?

From under the deeply hooded eyes which gave him the appearance of an old raven, Henry Tonks, aka The Tonk, aka the Terror of the Slade, watched the disfigured brought into the Cambridge Military Hospital at Aldershot. No one there had thought the Big Push on the Somme would be easy. The hospital had been told to prepare for the worst. Special wards had been established for men suffering from wounds to the eyes, face and head. Two hundred extra beds had been wheeled in for them. But when the first batch arrived, there were two thousand, every one of them, beneath their bandages, terribly mutilated: missing ears, noses, whole jaws; gaping eye sockets; chunks of skull blown away. It was a 'chamber of horrors', Tonks wrote, his habitual sangfroid momentarily shaken. But he carried on drawing them anyway, since it was 'excellent practice'.

The year 1916 was another cruelly honeyed summer, very like the one two years before when men such as these had quick-marched out from the recruiting offices, whistling and shouting, waving to the girls, doing an oompah with their last beer belch. Now the unlucky ones had come back to Aldershot. They at least still had the legs to do a knees-up when the bloody war was over. But not the face, that was the trouble.

The hospital – Italian Revival complete with Home Counties campanile – stood on the summit of a gentle hill. From its first-floor windows, Tonks could see over Hampshire, the England of homesick dreams and railway posters: livestock decoratively distributed; the

heavy crowns of ancient oaks pushed this way and that like bulky slow dancers when the wind got up. As he walked away from the brick pile, Tonks's beaky nose would pick up cow parsley in the meadows and cow pat in the lanes, both an improvement on ether and bleach. Flanders was where landscape painting had begun: the country flat; the skies wet, the soil loamy with goodness. Now it was Golgotha, a harvest of bones. Somewhere out there were his students from the Slade, a whole regiment of Tonklings – much good his drawing classes would do them: the monstrously gifted, self-regarding Orpen, made war artist, so he had been told, even though the Irishman had shamelessly fraternized with the Fenians, what good he would be for the war effort God only knew; surly Nash, whom he knew very well, had not much liked his instruction; Christopher Nevinson, another one commissioned to make hell the size of something you could frame – what was the point of that?; Gertler, so touchy, those people, but so talented; mad Spencer – Christ help the soldiers who had to look after *him*; well, he devoutly hoped never to have to see any of them borne crying on a stretcher to this place of indescribable wretchedness, even the impossible John – he wouldn't wish that, the ridiculous, extravagant man; wheedled himself along with the Canadians, apparently permitted to keep his lecherous whiskers, the only full set in the army unless you counted the King; and his sister, the mournful nun, still in France, wasting away for the shameless old goat Rodin, who had scampered off to England as soon as the distant boom of guns disturbed his morning chocolate, then, still more absurdly, his old pate stooped in mock-piety in Rome, where he thought to fulfil his patriotic duty, as if anyone cared, by sketching the sour-faced Pope Benedict for a bust. Blessings be upon the Alpinists and the sappers, the Coldstreams and the Chasseurs. They might at any rate be of more help than art.

When the war had begun, Henry Tonks had wondered how he might help without being ridiculous or gumming up the works more than was already the case. He was in his fifties. Active service was out of the question, but there had to be some way in which his medical

experience might be put to use. It had been a long time since he had set his hand to a man's body, but these things one never forgot. So Henry Tonks summoned his other art, which, a little to his surprise, he found had never really gone away. The pencil and the lancet were closer than anyone supposed. Faced with the terror of the first stroke, both required swift dexterity and steady resolve. With the young men gone from the Slade and some of the women, too, to be nurses, Tonks found he could not in all conscience continue to talk about contour and modelling. One of his old students, Kathleen Bruce, as she had been then, told him about a hospital that was to be established in eastern France, to receive the wounded of the French 3rd Army, which had taken the brunt of the German offensive (and their own counter-push) in Champagne and the Argonne Forest. Towards the end of 1914 it had become obvious that the utter debacle of 1870, when German troops sliced through the French army to Paris, would not be repeated; but also that the price had been unimaginably high. Much had been spoken and written of a chronic shortage of hospital beds and urgent care for the wounded of that front.

Tonks knew some of those involved, including the Bromley-Martin sisters, who wanted some practical expression of a medical entente cordiale, hence the hospital. As was to be expected, both the British Red Cross and the War Office were leery of any do-gooder volunteer initiative that might interfere with those who really knew what they were doing. But the proposal had a friend in Arthur Stanley, MP for Ormskirk, one of *those* Stanleys, Barons Sheffield, Victorian prime minister, descendant of the fatally beautiful Venetia and cousin of the next fatally beautiful Venetia, who was very close indeed to the present head of government, Mr Asquith. Besides, since her Slade days, Kathleen Bruce had become the country's most famous widow, having married the doomed polar explorer Robert Falcon Scott in 1908. Between her and the Stanleys, the *hôpital temporaire* was bound to prevail over the red-tapers. And so it did.

The Hôpital Temporaire d'Arc-en-Barrois opened its doors in January 1915, and Tonks was there to attend the first appalling casualties,

along with British nurses exercising as best they could their school French. He himself was an orderly. It had been made clear that most of the civilian volunteers were to serve either as orderlies, or drivers of the few rickety motor ambulances that brought the wounded from the little railway station at Latrecey-Ormoy-sur-Aube eleven miles away, along roads and lanes everyone wished were better paved. The hospital itself was a nineteenth-century chateau built by descendants, as destiny would have it, of Nicolas de l'Hospital, Duc de Vitry, one of the marshals of Louis XIII. The chateau had been destroyed during the Revolution but had been faithfully rebuilt, complete with mansard roof and steepled gables, its windows flooding the bays with light where the mangled and torn lay crying.

'The wounds are horrible,' Tonks wrote to a friend at home, 'and I for one will be against wars in the future.' How could you even conceive of asking men to endure such suffering as was now laid before his eyes? He could bear it better were he confident that the soldiers were on the way to being healed, but most of the wounds he saw were going septic, a death sentence for the victims. Perhaps to help himself as much as anyone else, but also to put on record what was being done against the odds, Tonks reached for his box of pastels and drew one of the most moving of all the images to come from the war: *Saline Infusion: An Incident in the British Red Cross Hospital of Arc-en-Barrois, 1915.*

Drawing deep from art memory, Mantegna, Rubens, Rembrandt, the stricken poilu takes on the devotional character of a dead Christ in a modern deposition from the Cross, his torso blueish with powder burn; a lick of hair across his brow; eyes shut, while an orderly holds one hand as the physician bows his head at his work and the nursing sister stands, immobile at her bag-pole. But the patient is not dead; quite the opposite. Tonks, in a little tour de force of drawing, tenses his muscles taut with the pain and with anxiety. The slop and wash bowl in the foreground holds the whole composition together in accordance with the Tonksian rule book. But the very word 'repoussoir' would have made him gag, the minute it entered his mind.

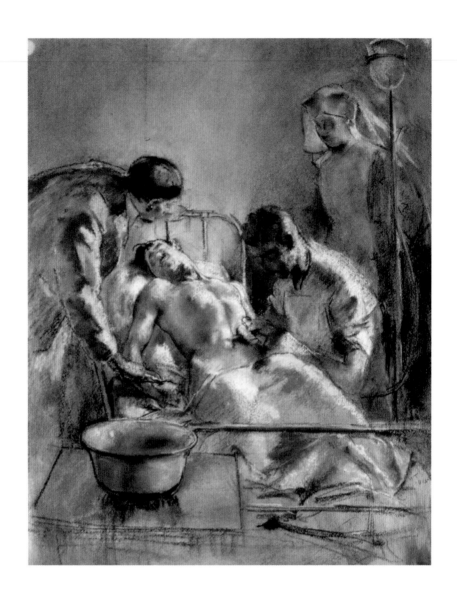

Saline Infusion: An Incident in the British Red Cross Hospital of Arc-en-Barrois, by Henry Tonks, 1915

Tonks's own faith was bad and getting worse. A sense of helplessness overtook him. It did not help that Arc-en-Barrois had become a pet project for the wordy and the arty. Poets John Masefield and Laurence Binyon were there; more on the way. Later that year, finding the conflicts battling inside his own mind insupportable, Tonks returned to England. Better, he thought, to serve in the army than with any more volunteers. After a little targeted campaigning of his own, he secured an honorary lieutenancy in the Royal Army Medical Corps which posted him to the Cambridge Hospital at Aldershot. There, in 1916, he saw things for which his own training as a surgeon, much less his anatomical drawing and instruction to medical students, had not prepared him. The nature of trench warfare, punctuated as it was by futile forays over the top, had exposed the heads of soldiers, notwithstanding their helmets, to taking fire in the face. Exit wounds were gaping. Some shells had been designed to spray shrapnel, to devastating effect. Magnesium fuses were encased within, expressly intended to catch fire when lodged in tissue, resulting in the burning away of noses, eyes, cheeks.

There were at least sixty thousand casualties of this kind during the War, and they were the worst treated of all: 'the loneliest Tommies', as the *Daily Mail* correctly observed. The victims of head wounds were simply too hideous to inflict on the public unless completely bandaged 'like mummies', and even this was thought too distressing for civilians to stomach. So, unlike those who had lost limbs and could be fitted with prosthetics, the face-wounded were not likely to be invited to tea parties at the Palace where they could be celebrated and photographed as British heroes. Harold Delf Gillies, the young New Zealander who had been made chief surgeon of these wards at Aldershot, wrote of 'men without half their faces, men burned and maimed to the condition of animals'.

Unhappy with the rough-and-ready surgery, which was mostly concerned to pre-empt infection by closing the deep wounds in any way possible, Gillies wanted to try more ambitious procedures. He had been reading what French and German surgeons had been able to achieve

with more systematic maxillofacial surgery. He may have been spurred on to this by having been in close proximity to Sir William Arbuthnot Lane, who at Great Ormond Street Hospital for Children had pioneered techniques to surgically correct cleft palates and lips, and had engineered the screws and wires needed to preserve the post-operative integrity of facial structure while the wounds healed. It helped that Lane was also a formidable absolutist when it came to medical hygiene. Like Lane and Tonks, Gillies thought as much about the long-term fate of the patient as the immediate needs of repair. When he did his rounds he considered the mental and psychological prognosis of whichever poor fellow he was examining as well as bringing them to the point where they might breathe or eat unaided. What he wanted to restore, more than just an ear, nose or mouth, was a sense that these 'broken gargoyles' could find a place again in the company of humanity.

When he discovered that Henry Tonks was already working in the Cambridge Hospital, Gillies lost no time in approaching him for help. As an accomplished amateur artist himself, one who, like Tonks, had taken drawing classes in night school, Gillies knew all about the formidable professor. He believed there might be a collaboration. His operations, he thought, would be helped, not just by preliminary diagrams of bone and muscle reconstruction, but by exact drawings of the tissue damage, as only an artist could see and transcribe. Confined to the description of surface, limited by lighting, photography was too mechanical and shallow to offer true assistance. It was, moreover, monochrome, and Gillies wanted a skilled colourist to describe the modulations of damaged tissue; to be able to penetrate depths and cavities. Tonks, with his unique and indivisibly anatomical and artistic grasp of flesh and bone, was the only person who could provide such images. Would he consider?

Tonks may have flinched at the suggestion, but it could only have been momentary. What he was being asked to do was not Art, not in the way the Slade would have understood it. It was Art not for Art's sake but for life's sake. In the light of this new task, the satisfaction

he had got from the *Saline Infusion* looked repellently precious. But he would still work in pastel, traditionally thought to be suited to decorative subjects. Pastels were soft so they might in his hands do hard things: gash and bite and stitch; rose and gold would give way to bloody scarlet and the livid rainbow of contusion. Many of the wounds were so deep that planning surgery precisely for a particular case could not be done without the surgeon manually examining the interior, finger-tracing the exact form of the cavity and its relationship to remaining bone and tissue. This was something that Henry Tonks appreciated. At the Slade, especially in life classes, he had always tried to develop his students' tactility. This was the gift possessed by the greatest masters – Leonardo, Titian, Rubens and Rembrandt – all of whom, by dint of exacting anatomical study, had been able to convey to the beholder the three-dimensional sense of finger-touching a torso, a limb or a face. Except perhaps in Rembrandt's case, those were usually beautiful heads and bodies. If art was defined by its attachment to the ideal, what he was about to practise was not art. But that, of course, was precisely why he plunged into it with utter absorption; why he had finally found a use for his talents, such as they were, which did not revolt him. By adhering, as he told himself, to austerely clinical description, and eschewing all possibility of public viewing (heaven forbid), the hostilities between aesthetics and ethics which had so distressed him in France were now suspended. Tonks clenched his teeth, steadied his nerves and his hands, looked directly into the mutilated faces of these men and created, as he supposed, anti-portraits; faces in the gerund, caught between vestige and restoration.

Modern portraitists, Lucian Freud especially, liked to insist that they were not *representing* flesh but somehow *making* it with their paint, a pardonable delusion that led them to trowel on the impasto as if, by sheer weight of pigment, this act of creation would take on life. But Henry Tonks and Harold Gillies *were* making faces; their twinned arts bringing the lost back to the world of humanity. They made something exceptionally beautiful because they were

trying their hardest not to. The world was not at peace, but Henry Tonks was.

Which was all very nice, but what did the lost and found who had no say in the matter, about either their portrait being drawn in living colour or the surgery which promised to make them men again, think of it? Gillies had banned mirrors from his wards, though undoubtedly some must have been smuggled in. Understandably, as they lay in their beds, often for months of healing before the plastic surgery could be carried out, the men were stricken by a sense of shame about their likely appearance, even if they had had no chance to take in its horror. Mothers, when they came, were known to faint at what had become of their boys. Sweethearts cried off, or were warned by their boy-friends on no account to come to Aldershot until they were told they might. Despite the best offices of the nursing sisters and Gillies him-self, many despaired of ever being treated as a normal person again, someone who could walk down the street without being hooted at by children who thought they had seen a monster.

One of those men was Private Walter Ashworth of the 18th West Yorkshire Regiment, the 'Bradford Pals'. On 1 July at the lines of the Somme, the whistles had blown and the Pals had climbed up the lad-ders, straight into a storm of German fire. Most of them failed to make it even to the front line of their own trenches. Walter was one of them, but he was not dead. Most of his mouth and jaw were gone, and it was in this condition that he arrived on Gillies's ward four days after, on 5 July. Sometime not much later, Henry Tonks drew Walter, preparing for a wash-out of his terrible wound, a kidney bowl beneath his chin. Despite the disfigurement, Tonks has preserved Walter's humanity, registered in the upward look of his blue-grey eyes, a meagre wisp of hair on his brow.

There were five operations before Walter could be discharged. In the end, Gillies decided that part of his lips would have to be sacrificed if the wound and its scarring were to close properly. This left Walter with a permanently puckish expression, which, though disconcertingly whimsical, was not, according to the surgeon, 'entirely unpleasant'.

But Walter had not that much to smile about. When he signed up with the Pals he had been engaged to a girl from Cheadle, but on hearing of his wounds she broke it off. Walter went back to his old job as a tailor in Bradford, avoiding jokes about stitches. But there, too, he was greeted with unmistakable dismay, confined to the back of the shop and to menial jobs, lest he scare the customers. The humiliation was another wound.

But it was not the end of the story. The fiancée had a friend, and the friend was sorry to hear of the broken engagement and angry at the shameful way, so she thought, it had come about. She wrote to Walter while he was still in Aldershot, and when she could, she went to see him. She didn't mind his funny little smile at all, not at all. They fell in love and married.

Missing Walter, the customers at the Bradford tailor's complained, so loudly that his employers were obliged to pay him a visit and ask him, no hard feelings you understand, if he wouldn't think of coming back, front of the shop of course. Walter didn't think so' thank you very much. Instead, he and his wife took ship across the world to Australia, where they worked as butler and cook to a rich sheep farmer upcountry in New South Wales. The sunshine suited the Ashworths, and so did Australia. There were enough poor ANZAC boys coming back worse off for people not to make funny comments, much less cross the street when they saw him approaching. There came a day when Dr Gillies, in Australia, perhaps, for his famous book on plastic surgery, ran into Walter Ashworth, or perhaps sought him out, and after the usual niceties, rather heartfelt in this case, looked his old patient over and wondered out loud if he might have another go, to improve on the job?

Walter thanked Dr Gillies but said no thanks; he and the Mrs were content, after all, and he would never forget what the doctor had done for him when he thought all hope was lost. And so it came to be. The Ashworths built up a nice little nest egg, enough to buy a tailor's shop back home in Blackpool, and this was where they ended up. Walter's granddaughter said his breathing was never quite right again; that he

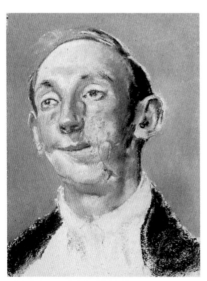

Private Walter Ashworth, by Henry Tonks, 1916–17

was bothered a bit by congestion in the pipes and there were some things he couldn't eat at all: Blackpool rock, for instance, being a very bad idea. But there they were back amongst their folk, so that when that tune was sung – 'What's the use of worrying/ It never was worth while so/ Pack up your troubles in your old kit bag/ And smile, smile, smile' – Walter could and did.

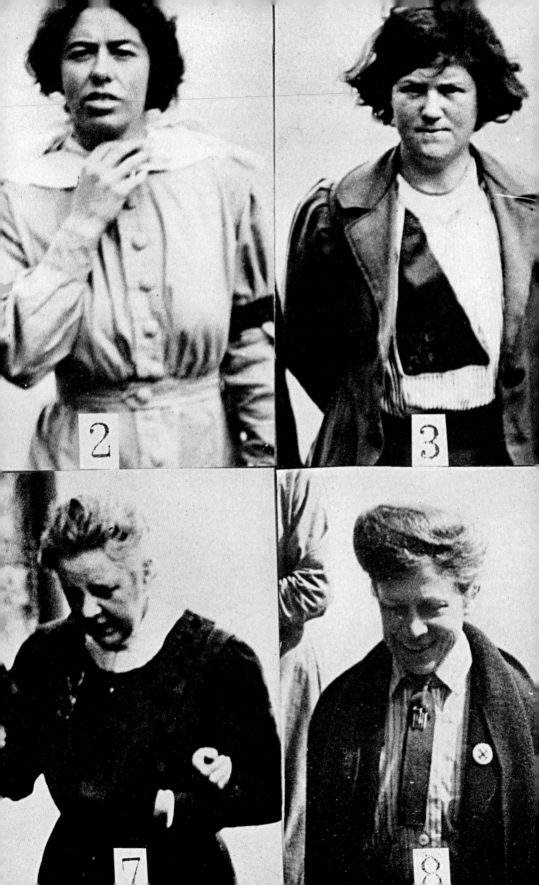

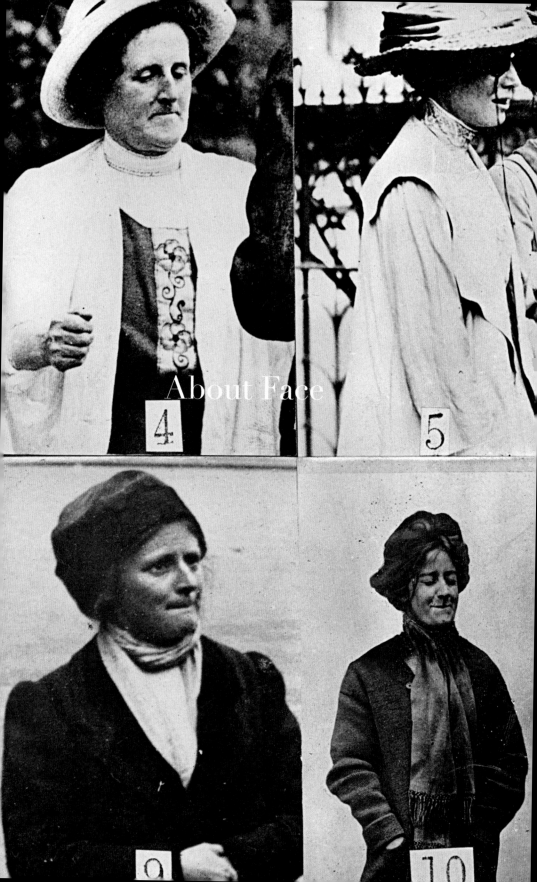

About Face

Two centuries and more before the Tinder-swipe and the Facebook like, there was the pocket Lavater. About the same size as your smartphone, the pocket Lavater was designed to help you decipher the true nature of the people you encountered in daily life. Casual first impressions of a face – 'an open countenance', and such – were no longer enough. The face was a book of moral qualities and, if read properly, with the help of Pastor Lavater's *Physiognomy* you would be able to penetrate behind any mask, however artfully worn, to the authentic individual. Whether you were assessing the qualifications of someone seeking employment in your trading company or household, the dependability of a prospective business partner or the suitability of a young man asking for your daughter's hand, the pocket Lavater would allow you to decode the phiz and make what its author insisted would be a scientific judgement.

Johann Caspar Lavater's *Physiognomy*, first published in German in 1775, was a product of a culture obsessed with transparency and sincerity and their corrupting opposites, fashion and artifice. The commonwealth of True Nature was thought to be Switzerland, and Lavater was a Swiss Zwinglian Protestant pastor, who offered a version of Jean-Jacques Rousseau's philosophy of pure nature translated into Christian anatomy. It was God who had stamped each and every individual in his creation with the facial features that declared the truth of their moral character. All that was needed to expose it was an education in the details of physiognomy.

The trouble was that Lavater's three volumes, completed in 1778, were too hefty to be hauled around on one's daily business. Memorizing or sketching a face and then repairing to the library to check its features against Lavater's text-profiles and typological illustrations carried the risk of imprecise recollection. Hence the enterprise of the pocket edition, which could be carried in a jacket and consulted

whenever and wherever a face-judgement was called for. The pocket Lavaterian merely had to excuse himself for a minute or two, flip its pages to images offering a proximate match and see what the great Physiognomist had to say. Did the applicant resemble number IV? If it was a steward or a clerk one was looking for, this seemed promising, since 'in this mouth, closely shut, and hiding the edge of the lips, are depicted application and regularity. The lower part of the face recedes a little: this is an indication of a man of discretion, modesty, gravity and reserve ... he never rises to poetic invention or overleaps the boundaries of scrupulous exactness.' Just as well; don't need a poet in the counting house. *Next!* Ah, a number X. Let's see. 'This forehead indicates both genius and folly – this, at the first glance, may appear a contradiction; but the termination of the *frontal sinus* in a point – an almost infallible mark of folly – renders the position less paradoxical. A man of such a countenance speaks quickly, talks incoherently and is often absent, or in a deep reverie.' Not what one was looking for. But at least the party wasn't number XXVIII, whose 'salient angle of the nose' and 'projection and sharpness of the chin' indicated a 'crafty character', 'a countenance we cannot regard without repugnance'!'

Though there were plenty of commendable types in the gallery – XXXI, for instance, 'a gay and sprightly man, repartee and epigram are his arms ... the mouth, with a little hollow in the middle'; or XXIX, whose 'projection of the bone of the eye' marked him with the 'impress of genius' – the overall tone of the pocket Lavater was socially defensive. When photographs replaced line engravings in works sometimes published by retired chiefs of police, the tone remained cautionary. To steer a safe path through the urban jungle, populated by plausible rogues and smiling predators, one needed to be an educated, practical physiognomist. But also, it seems, a *pathonomist*. Increasingly, it was understood that an encyclopaedia of facial features, even in countless combinations, took no account of the emotional expressions which altered the appearance of mouth, eyes; in fact, the whole countenance. It was this mobile, mutable action of the face when a person was seized by joy, terror, shame or apprehension that was the real book

of truth and, to read it, the pathonomist, the analyst of expression, needed to know in minute detail how each mood would affect facial musculature, the flow of blood to the cheeks; the lips; the movement, rapid or not, of the eyes. And this was because, however polished the social actor, the willed composure of the face would always be overcome by the involuntary motions brought on by heightened emotional states. To study those, especially the micro-expressions which passed fleetingly over a person's demeanour, was to grasp a true portrait of an individual.

At which point the pathonomists joined a long tradition of studies designed to give aspiring artists, both history painters and portraitists, a library of the emotions and the ways in which they registered themselves on the anatomy of the face. Giambattista della Porta's *De humana physiognomonia*, published in 1586, was the first attempt to make a systematic inventory of expression, and it could not have been accidental that della Porta was also a cryptographer. For seventeenth-century painters specializing in the expression of strong emotion, he was an indispensable source of reference, and the young Rembrandt's postage-stamp-size etchings of the faces he pulled in the mirror, of rage, hilarity and the rest, were certainly an effort to supplement his own library of the passions made visible. Louis XIV's court artist Charles Le Brun added to the literature but, in the nineteenth century, the scientific analysts returned to another of della Porta's preoccupations: affinities between animal and human expression. He had produced a cross-species bestiary of lion-like faces, dog-like faces, ape-like faces, and so on, and the images were so entertaining that they were often reproduced in modern works, bound in with the pocket Lavater, for example. Charles Bell's *Essays on the Anatomy and Philosophy of Expression* (1824) enlarged Lavater's compendium with the scientific rigour that came from his work as a neurologist, but it was his Christian conviction that facial expression was a mark of what distinguished man from animals that led Charles Darwin to write his own *The Expression of the Emotions in Man and Animals* (1872), to say something like the opposite. Using photographs made by Oscar

541

Rejlander and others, as well as line engravings of dogs, cats, chimpanzees and even chickens, caught in moments of fear, and territorial aggression, Darwin's wonderful book argued that emotional expression, like everything else, had resulted from an evolutionary process. Understanding the complexity of face language means understanding man as a social animal, at the advanced end of a spectrum of beasts, all of which had their own machinery of musculature which twitched or pulled according to emotions passing along their neural pathways.

All of these works, from the primitive and curious della Porta, to the sophisticated taxonomist Darwin, translated the fugitive expressions of the human face – eyes that had since St Augustine been thought to be 'windows of the soul'; lips that moistened or dried according to states of fear or desire; brows that rose, drooped or knitted depending on mood – into social and biological data. The mysteries of the passions, the stock in trade of the ambitious portraitist or poet, were made into a map of information which could be sorted, codified and analysed according to scientific principles. From demystification to purpose-driven utilization was but a short step. Search for works on facial recognition these days and you will encounter either the vast literature on the subject of cerebral wiring of neonates with which I began this book, or else something darker: a whole industry devoted to the mapping of facial features *and* their expressive variables for the benefit of the two leviathans which between them govern our contemporary world – the security state and the global corporation.

Companies like Visionics Corporation, Viisage and Miro are in the business of developing and supplying technology for the ongoing (it is always ongoing) 'securitization' of identities. That means you and me. FERET is what someone with a sense of gallows humour in the defence establishment has called this Face Recognition Technology program. Its job is to search an infinity of faces for those presenting some sort of imminent threat with techniques more sophisticated than a seated agent armed with a ballpoint pen staring briefly at a passport photo and back at a boarding pass. Eye-Dentity procedures (as they

were called in the 1990s) began by collecting images of the complex and unique patterns of blood vessels in the eye, usually supplementing them with electronic scans of finger traces. Iris-recognition technology is more advanced, but these FERET technologies depend on a match with an already existing database of prior suspects. Novices will not snag an alert. The securitization of faces is still in a Lavaterian rather than a Darwinian phase. It's been recognized that what is also required to make an instant portrait of a threat is a 'Facial Action Coding System', also known as Automated Facial Expression Analysis, which can monitor micro-expressions lasting a mere fraction of a second, in the eyes, on the mouth, in forehead lines; whatever the betraying feature is or does. As digital systems of face reading become dynamically programmed, this, too, will come about, to the point where even the most practised poker face (or *especially* a poker face) will trigger alarm bells at check-in.

In a slightly less paranoid vein, facial databases are being developed by marketeers to build communities of customers based on appearance-affinities. Creamy-complexioned redheads with a faint scatter of freckles and green eyes, or Amerindian faces with brown eyes and Inca noses, might then be automatically sorted into a pool to receive guided information as to nail-polish-colour preference, jewellery, theatre tickets, sports allegiance or choice of light or heavy reading.

Against this securitization of our faces, or, in the oxymoronic term favoured by the marketeers, 'mass individuation', it's tempting to see the traditional portrait standing (or hanging) in a last show of defiance; capable of recording the marks of humanity in ways inaccessible to even the most advanced digital scanners. But is this, in fact, just a romance of canvas and paint? In the hands of a Rembrandt or, in our own long, rich visual culture, a Gwen John or a George Romney, this is undoubtedly true. Jenny Saville's pictures of herself and her non-stop-squirming infants convey more immediately the likeness of human vitality than anything that might be captured on video. But in the age of Snapchat, where pictures self-erase after a matter of a

few minutes, and where the sheer number of selfies stored on a device militates against an emotive hierarchy, paintings or even formal videos need to be exceptionally powerful to make the case for endurance. Faces in the sense that Jonathan Richardson or Samuel Palmer would have recognized as bearing the ineradicable essence of character have become fungible. 'Work' can be done to change them, and the day may come when plastic surgery will be as habitual as a haircut. Since genetic manipulation of the embryo can already determine the coat and eye colour of mice and rats, can the day be far off when it will be possible to choose the face of a human baby from a designer catalogue?

As nailing down the 'true likeness' threatens to become in every sense a mug's game, it is possible of course that portraiture is already generating new forms which speak to the provisional quality of our appearance. Adventurous works like Tom Phillips's portrait of Susan Greenfield, which morphs images of her brain with the artist's drawings, can represent different ages, different moods and different expressions, so that the shifting, mobile shape of features constitutes something more than one moment alone taken to be somehow emblematic of a whole life.

But, actually, this is all too postmodern for me. There is an aspect of portraiture, about the *stories* of its making, that transaction between the parties, the locking of eyes, which I obstinately believe to be irreducible to bald data. And there is something else that bothers me, too, and against which the idea and the practice of portraiture might stand. We live at a paradoxical moment when an image is caught and then we look down at it, since the downward gaze has come to consume a monstrous part of daily routine. Whole micro-universes of sounds and sights are assembled in small machines as an extension of what we take to be the particular bundle of tastes that constitutes our identity. If we are not all Narcissus, we are nearly all Echo. We have never been more networked, yet we have never been more trapped by solipsism.

This would have distressed the great Jewish philosopher Emmanuel

Levinas, for whom eye contact, *face à face*, was the beginning of ethics; the indispensable condition of empathy; the capacity to experience the world through more than our own isolated persona. For Levinas, the exchange of looks, the encounter with the other, is the fundamental practice of our humanity. Conversely, what would not surprise him would be the phenomenon by which evil wears a hood before taking the life, in cold blood, of another human.

Levinas has been in my thoughts quite often during the writing of these stories of eyeballing encounters in British art and history, as have the odd scraps of memory which, for all the fallibility of their truthfulness, somehow still represent for me the visual afterburn of a moment, sometimes long ago, all the more precious as memory stumbles and mists. On a beach near the Southend Kursaal around 1948, a big, mustachioed man has hoisted a three-year-old boy on his shoulders. The square-jawed man, my grandfather Mark the kosher butcher, is (as was not his wont) beaming with mischievous warmth. The small child, a wide grin made of excitement and happy terror stretching his round moon face, is me. But it is the face missing from the picture that I remember with the utmost clarity when I look at this old snap: the expression on my father's face as he lifted it up from the flat viewfinder of the Hasselblad. It was the look of a man who knew how to be happy.

List of Illustrations

Every effort has been made to contact all copyright holders. The publishers will be happy to make good in future editions any errors of omission or commission brought to their attention.

pp. xii–xiii. *William Shakespeare*, associated with John Taylor, oil on canvas, circa 1610. © National Portrait Gallery, London (NPG 1)

p. xix. *Introduction to the General Art of Drawing*, by Willem Goeree, 1668. Heidelberg University Library

p. xxi. *Portrait of a young woman and a young man from Al Fayyum, Egypt.* Left, © DEA Picture Library/Getty Images; right, © DEA/G. degli Orti/Getty Images

pp. xxvi–xxvii. *Oliver Cromwell*, by Robert Walker, oil on canvas, circa 1649. © National Portrait Gallery, London (NPG 536)

p. 13. *Winston Churchill, Kathleen Sutherland and Graham Sutherland*, by Elsbeth R. Juda, bromide contact sheet, 17 October 1954. © National Portrait Gallery, London (NPG x136052)

p. 14. *Winston Churchill*, by Graham Sutherland, oil on canvas, 1954. © National Portrait Gallery, London (NPG 5332)

p. 19. *Winston Churchill*, by Graham Sutherland, oil on canvas, 1954. © Estate of Winston S. Churchill; photograph © Larry Burrows Collection. The portrait of Sir Winston Churchill by Graham Sutherland is reproduced by kind permission of the Churchill family.

p. 23. *Piccotts End Wall Painting*, late fifteenth century. © Oxford Film and Television Ltd, with kind permission of Karen Murphy and Alison Wright

p. 31. *King Henry VIII and King Henry VII*, by Hans Holbein the Younger, ink and watercolour, circa 1536–7. © National Portrait Gallery, London (NPG 4027)

p. 39. *Queen Elizabeth I, 'The Rainbow Portrait'*, attributed to Isaac Oliver, circa 1600. Hatfield House, Hertfordshire, UK/Bridgeman Images

p. 215. *Pomona (Portrait of Alice Liddell)*, by Julia Margaret Cameron, 1872. Royal Photographic Society/National Media Museum/SSPL

p. 218. *Jane Morris*, by John Robert Parsons, copied by Emery Walker Ltd, bromide print, 1865. © National Portrait Gallery, London (NPG x137525, NPG x137526, NPG x137527, NPG x137528)

p. 227. *Water Willow*, by Dante Gabriel Rossetti, oil on canvas, 1871. Delaware Art Museum, Wilmington, USA/Samuel and Mary R. Bancroft Memorial/Bridgeman Images

p. 230. *Francis Bacon and Muriel Belcher*, by Peter Stark, bromide print, 1975. © Peter Stark (NPG x1533)

p. 235. *Triptych – August 1972*, by Francis Bacon, 1972. © The Estate of Francis Bacon. All rights reserved. DACS 2015. Photo © Tate, London 2015

p. 237. *Yoko Ono and John Lennon*, by Annie Leibovitz, C-type colour print, 1980. © Annie Leibovitz/Contact Press Images (NPG P628)

p. 241. *Julia Stanley*, by Mark and Colleen Hayward, 1949. Redferns/Getty Images

pp. 242–3. *Emma, Lady Hamilton*, by George Romney, oil on canvas, circa 1785. © National Portrait Gallery, London (NPG 294)

p. 244. *Amy-Blue (Amy Winehouse)*, by Marlene Dumas, oil on canvas, 2011. © Marlene Dumas; courtesy of the artist and Frith Street Gallery, London (NPG 6948)

p. 254. *Sir Francis Drake*, by unknown artist, after an engraving attributed to Jodocus Hondius, oil on panel, circa 1583. © National Portrait Gallery, London (NPG 1627)

p. 256. *Sir Francis Drake*, by Nicholas Hilliard, watercolour on vellum, 1581. © National Portrait Gallery, London (NPG 4851)

p. 257. *Sir Francis Drake,* by unknown artist, oil on panel, circa 1580. © National Portrait Gallery, London (NPG 4032)

p. 259. *Sir Francis Drake*, attributed to Jodocus Hondius, completed by George Vertue, engraving, circa 1583. © National Portrait Gallery, London (NPG 3905)

p. 259. *Portrait of Sir Francis Drake*, by Thomas de Leu, after a painting by Jean Rabel, circa 1583. Wellcome Library, London

p. 306. *Kitty Fisher as Cleopatra*, by Sir Joshua Reynolds, oil on canvas, 1759. The Iveagh Bequest, Kenwood House, London, UK/© Historic England/Bridgeman Images

p. 311. *Self-portrait*, by George Romney, oil on canvas, 1784. © National Portrait Gallery, London (NPG 959)

p. 315. *Emma, Lady Hamilton*, by George Romney, oil on canvas, circa 1785. © National Portrait Gallery, London (NPG 294)

p. 315. *Emma, Lady Hamilton*, by George Romney, oil on canvas, circa 1785. © National Portrait Gallery, London (NPG 4448)

p. 317. *Horatio Nelson*, by Sir William Beechey, oil on canvas, 1800. © National Portrait Gallery, London (NPG 5798)

p. 324. *William Shakespeare*, associated with John Taylor, oil on canvas, circa 1610. © National Portrait Gallery, London (NPG 1)

p. 328. *Interior of the south wing with Sir George Scharf seated, South Kensington*, by unknown photographer, 1885

p. 331. *William Wilberforce*, by Sir Thomas Lawrence, oil on canvas, 1828. © National Portrait Gallery, London (NPG 3)

p. 334. *Charlie Chaplin*, by Alexander ('Alick') Penrose Forbes Ritchie, colour relief halftone cigarette card, 1926. © National Portrait Gallery, London (NPG D2662)

p. 334. *David Lloyd George, 1st Earl Lloyd-George*, by Alexander ('Alick') Penrose Forbes Ritchie, colour relief halftone cigarette card, 1926. © National Portrait Gallery, London (NPG D2677)

p. 334. *Sir John Berry ('Jack') Hobbs*, by Alexander ('Alick') Penrose Forbes Ritchie, colour relief halftone cigarette card, 1926. © National Portrait Gallery, London (NPG D18017)

p. 334. *George Bernard Shaw*, by Alexander ('Alick') Penrose Forbes Ritchie, colour relief halftone cigarette card, 1926. © National Portrait Gallery, London (NPG D2686)

pp. 336–7. *Self-portrait*, by Gwen John, oil on canvas, circa 1900. © National Portrait Gallery, London (NPG 4439)

p. 344. *Hotel Bedroom*, by Lucian Freud, oil on canvas, 1954. Beaverbrook Art Gallery, Fredericton, N. B., Canada/© The Lucian Freud Archive/Bridgeman Images

p. 380. *Self-portrait*, by Samuel Palmer, black chalk, heightened with white, on buff paper, 1826. © Ashmolean Museum, University of Oxford

p. 390. *William Blake*, replica by John Linnell of a portrait of 1821, water-colour, 1861. © National Portrait Gallery, London (NPG 2146)

p. 390. *Self-portrait*, by William Blake, monochrome wash drawing, circa 1802. Collection of Robert N. Essick. © William Blake Archive. Used with permission

p. 390. *The Valley Thick with Corn*, by Samuel Palmer, pen and ink with brush, 1825. Ashmolean Museum, University of Oxford, UK/Bridgeman Images

p. 392. *Samuel Palmer*, by George Richmond, watercolour and bodycolour on ivory, 1829. © National Portrait Gallery, London (NPG 2223)

p. 392. *Samuel Palmer*, by George Richmond, pencil, pen and ink, circa 1829. © National Portrait Gallery, London (NPG 2154)

p. 392. *Self-portrait*, by George Richmond, gouache on ivory, 1830. © National Portrait Gallery, London (NPG 6586)

p. 398. *Slade School of Fine Art, Class Photo*, by unknown photographer, 1905. Courtesy Slade School of Fine Art. University College London

p. 402. *Henry Tonks*, by George Charles Beresford, half-plate glass negative, August 1902. © National Portrait Gallery, London (NPG x6600)

p. 404. *William Orpen, Augustus John, Gwen John, Albert Rutherston, Lady Edna Clarke Hall, Sir William Rothenstein, Alice Mary, Lady Rothenstein and others*, by unknown photographer, vintage bromide print, April 1899. © National Portrait Gallery, London (NPG x38484)

p. 406. *Self-portrait*, by Gwen John, oil on canvas, circa 1900. © National Portrait Gallery, London (NPG 4439)

p. 414. *Self-portrait (Dame Laura Knight and Ella Louise Naper)*, by Dame Laura Knight, oil on canvas, 1913. © Reproduced with permission of The Estate of Dame Laura Knight DBE RA, 2015. All Rights Reserved (NPG 4839)

p. 420. *Self-portrait*, by Gwen John, watercolour, 1905–6. © Musée Rodin (photo: Jean de Calan)

p. 510. *Clementina Maude, 5 Princes Gardens*, by Lady Clementina Hawarden, albumen print from wet collodion negative, circa 1863–4. © Victoria and Albert Museum, London

p. 511. *Mrs Albert Broom and the Oxford 1938 Boat Race Crew*, by Winifred Margaret Broom, bromide print, 1938 (NPG x45461)

p. 511. *The Women's Exhibition*, by Christina Broom, 1909. © Museum of London

p. 513. *Emmeline Pankhurst*, by Mrs Christina Broom, bromide print, 1910s. © National Portrait Gallery, London (NPG x6194)

p. 513. *Christabel Pankhurst at the Women's Exhibition,* by Christina Broom, 1909. © Museum of London

p. 515. *Suffragette March in Hyde Park (Emmeline Pethick-Lawrence, Dame Christabel Pankhurst, Sylvia Pankhurst and Emily Davison)*, by Christina Broom, cream-toned velox print, 1910. © National Portrait Gallery, London (NPG x17396)

p. 517. *Surveillance Photographs of Militant Suffragettes (Margaret Scott, Olive Leared, Margaret McFarlane, Mary Wyan, Annie Bell, Jane Short, Gertrude Mary Ansell, Maud Brindley, Verity Oates, Evelyn Manesta)*, by unknown photographer, Criminal Record Office, silver print mounted onto identification sheet, 1914. © National Portrait Gallery, London (NPG x132846)

p. 517. *Surveillance Photographs of Militant Suffragettes (Mary Raleigh Richardson, Lilian Lenton, Kitty Marion, Lillian Forrester, Miss Johansen, Clara Giveen; Jennie Baines,* by unknown photographer, Criminal Record Office, silver print mounted onto identification sheet, 1914. © National Portrait Gallery, London (NPG x132847)

p. 519. *Mary Raleigh Richardson and Catherine Wilson*, by unknown photographer, Criminal Record Office memorandum, issued 24 April 1914. © National Portrait Gallery, London (NPG x136416)

p. 521. *Emmeline Pankhurst's arrest at Buckingham Palace*, by unknown photographer, vintage print, 21 May 1914. © National Portrait Gallery, London (NPG x137689)

p. 521. *Edward, Prince of Wales (later Duke of Windsor and King Edward VIII)*, by Christina Broom, half-plate glass negative, 1914. © National Portrait Gallery, London (NPG x277)

Select Bibliography

Portraiture

Brilliant, Richard, *Portraiture* (2001)

Cooper, Tarnya, and Sandy Nairne, *National Portrait Gallery: A Portrait of Britain* (2014)

Cumming, Laura, *A Face to the World: On Self-portraits* (2009)

Hall, James, *The Self-portrait: A Cultural History* (2014)

Lightfoot, Sara Lawrence, and Jessica Hoffmann David, *The Art and Science of Portraiture* (1997)

Piper, David, *The English Face*, Malcolm Roger (ed.) (1992)

Pointon, Marcia, *Portrayal and the Search for Identity* (2013)

West, Shearer, *Portraiture* (2004)

Woodall, Joanna, *Portraiture: Facing the Subject* (1997)

Pre-Face

Face Recognition Research

Di Giorgio, Elisa, Irene Leo, Olivier Pascalis and Francesca Simion, 'Is the Face-perception System Human-specific at Birth?', *Developmental Psychology* (vol. 48, no. 4, July 2012)

Farroni, Teresa, Mark H. Johnson, Enrica Menon, Luisa Zulian, Dino Faraguna and Gergely Csibra, 'Newborns' Preference for Face-relevant Stimuli: Effects of Contrast Polarity', *Proceedings of the National Academy of Scientists of the United States of America* (vol. 102, no. 47, Nov. 2005)

Farzin, Faraz, Chuan Hou and Anthony M. Norcia, 'Piecing It Together: Infants' Neural Responses to Face and Object Structure', *Journal of Vision* (vol. 12, no. 6, Dec. 2012)

Goren, Carolyn C., Merrill Sarty and Paul Y. K. Wu, 'Visual Following

and Pattern Discrimination of Face-like Stimuli by Newborn Infants',
Pediatrics (vol. 56, no. 4, Oct. 1975)

Grossmann, Tobias, Mark H. Johnson, Sarah Lloyd-Fox, Anna Blasi,
Fani Deligianni, Clare Elwell and Gergely Csibra, 'Early Cortical
Specialization for Face-to-face Communication in Human Infants',
Proceedings of the Royal Society B: Biological Sciences (Dec. 2008)

Kanwisher, Nancy, and Galit Yovel, 'The Fusiform Face Area: A Cortical
Region Specialized for the Perception of Faces', *Philosophical Transactions of the Royal Society B: Biological Sciences* (Dec. 2006)

Kelly, David J., Paul C. Quinn, Alan M. Slater, Kang Lee, Alan Gibson,
Michael Smith, Liezhong Ge and Olivier Pascalis, 'Three-month-olds,
but Not Newborns, Prefer Faces of the Same Race', *Developmental
Science* (vol. 8, issue 6, Nov. 2005)

Pascalis, Olivier, Michelle de Haan and Charles A. Nelson, 'Is Face
Processing Species-specific during the First Year of Life?' *Science
17* (vol. 296, no. 5571, May 2002)

Sacks, Oliver, 'Face-blind: Why are Some of us Terrible at Recognizing
Faces?', *New Yorker* (30 Aug. 2010)

Széll, Kate, 'Prosopagnosia: A Common Problem, Commonly Over-
looked', Wellcome Trust blog (Nov. 2014)

I. Power

Churchill

Berthoud, Roger, *Graham Sutherland: A Biography* (1982)

Gilbert, Martin, *Churchill: A Life* (1991)

—, *Winston S. Churchill: Vol. 8: Never Despair, 1945–1965* (2013)

Hammer, Martin, *Bacon and Sutherland* (2005)

Hayes, John, *The Art of Graham Sutherland* (1980)

Portraits by Graham Sutherland (NPG exhibition catalogue), text by John
Hayes (1977)

Purnell, Sonia, *First Lady: The Life and Wars of Clementine Churchill* (2015)

Tippett, Maria, *Portrait in Light and Shadow: The Life of Yousef Karsh* (2007)

Piccotts End and Pre-Reformation

Hamling, Tara, *Decorating the Godly Household: Religious Art in Post-Reformation Britain* (2010)

Rouse, E. Clive, 'Piccotts End: A Probable Medieval Guest House and Its Wall Paintings', *Hertfordshire Archaeology* (vol. 3, 1973)

—, 'Domestic Wall and Panel Paintings in Hertfordshire', *Archaeological Journal* (vol. 146, 1991)

Elizabeth I

— For Cecil's draft proclamation see: *Archaeologia: Or Miscellaneous Tracts Relating to Antiquity*, vol. 2

Allard, Sébastien, and Robert Rosenblum, *Citizens and Kings: Portraits in the Age of Revolution, 1760–1830* (2007)

Belsey, Andrew, and Catherine Belsey, 'Icons of Divinity: Portraits of Elizabeth I', *Renaissance Bodies*, Lucy Gent (ed.) (1990)

Cooper, Tarnya, *Elizabeth I and Her People* (NPG exhibition catalogue) (2013)

Frye, Susan, *Elizabeth I: The Competition for Representation* (1993)

Guy, John (ed.), *The Reign of Elizabeth I: Court and Culture in the Last Decade* (1995)

Hackett, Helen, *Virgin Mother, Maiden Queen: Elizabeth I and the Cult of the Virgin Mary* (1995)

Hearn, Karen, *Marcus Gheeraerts II: Elizabethan Artist*, with a technical essay by Rica Jones (2002)

Howarth, David, *Images of Rule: Art and Politics in the English Renaissance, 1485–1649* (1997)

Levin, Carol, *The Heart and Stomach of a King: Elizabeth I and the Politics of Sex and Power* (1994)

Riehl, Anna, *The Face of Queenship: Early Modern Representations of Elizabeth I* (2010)

Strong, Roy, *The English Icon: Elizabethan and Jacobean Portraiture* (1969)

Yates, Frances, 'Queen Elizabeth as Astraea', *Journal of the Warburg and Courtauld Institutes* (vol. 10, 1947)

Royal Portraits

Albinson, Cassandra, Peter Funnell and Lucy Peltz (eds.), *Thomas Lawrence: Regency Power and Brilliance* (2010)

Allard, Sébastien, and Robert Rosenblum, *Citizens and Kings: Portraits in the Age of Revolution, 1760–1830* (2007)

Ingamells, John, *Later Stuart Portraits, 1685–1714* (2009)

Moorhouse, Paul, *The Queen: Art and Image* (2011)

Scott, Jennifer, *The Royal Portrait: Image and Impact* (2010)

Charles I

Ball, R. M., 'On the Statue of King Charles at Charing Cross', *Antiquaries Journal* (67, 1987)

Brotton, Jerry, *The Sale of the Late King's Goods* (2007)

Corns, Thomas N., *The Royal Image: Representations of Charles I* (1999)

Denoon, D. G., 'The Statue of King Charles I at Charing Cross', *Transactions of the London and Middlesex Archaeological Society* (new series 6, 1933)

Esdaile, K. A., 'The Busts and Statues of Charles I', *Burlington Magazine* (vol. 91, no. 550, Jan. 1949)

Hearn, Karen, *Van Dyck and Britain* (2009)

Howarth, David, *Images of Rule: Art and Politics in the English Renaissance, 1485–1649* (1997)

Knachel, P. A. (ed.), *Eikon Basilike: The Portraiture of His Sacred Majesty in His Solitudes and Sufferings* (1966)

Lunger Knoppers, Laura, 'The Politics of Portraiture: Oliver Cromwell and Plain Style', *Renaissance Quarterly* (vol. 51, no. 4, winter 1998)

MacGregor, Arthur (ed.), *The Late King's Goods* (1989)

Madan, Francis F., *A New Bibliography of the Eikon Basilike of Charles I* (1950)

Millar, Oliver, *Van Dyck in England* (1982)

Peacock, John, 'The Visual Image of Charles I', in Thomas Corns (ed.),
 The Royal Image: Representations of Charles I (1999)
Sharpe, Kevin, *The Personal Rule of Charles I* (1992)
—, 'Van Dyck, The Royal Image and the Caroline Court', in his *Reading
 Authority and Representing Rule in Early Modern England* (2013)
Strong, Roy, *Van Dyck: Charles I on Horseback* (1972)

Eighteenth-century Aristocrats

Christie, Christopher, *The British Country House in the Eighteenth Century*
 (2000)
Perry, Gill, Kate Retford and Jordan Vibert, with Hannah Lyons (ed.),
 *Placing Faces: The Portrait and the English Country House in the Long
 Eighteenth Century* (2013)
Retford, Kate, *The Art of Domestic Life: Family Portraiture in Eighteenth-century
 England* (2006)
Spencer, Charles, *The Spencer Family* (1999)

Kit Cats

Field, Ophelia, *The Kit Cat Club: Friends Who Imagined a Nation* (2009)
Lord Killanin, *Sir Godfrey Kneller and His Times, 1646–1723: Being a Review
 of English Portraiture of the Period* (1948)
Pointon, Marcia, *Hanging the Head: Portraiture and Social Formation in
 Eighteenth-century England* (1993)
Solkin, David, *Painting for Money: The Visual Arts and the Public Sphere in
 Eighteenth-century England* (1993)
Stewart, J. Douglas, *Sir Godfrey Kneller and the English Baroque Portrait*
 (1983)

Gillray

Banerji, Christiane, and Diana Donald (ed. and trans.), *Gillray Observed:
 The Earliest Account of His Caricatures in London and Paris* (1999)

Hill, Draper, *Mr Gillray, The Caricaturist: A Biography* (1965)

Rauser, Amelia Faye, *Caricature Unmasked: Irony, Authenticity and Individualism in Eighteenth-century English Prints* (2008)

Victoria

Homans, Margaret, *Royal Representations: Queen Victoria and British Culture, 1837–1876* (1999)

Lyden, Anne M., *A Royal Passion: Queen Victoria and Photography* (2014)

Plunkett, John, *Queen Victoria: First Media Monarch* (2003)

Rappaport, Helen, *Magnificent Obsession: Victoria, Albert and the Death That Changed the Monarchy* (2011)

Taylor, Roger, 'Mr Fenton Explained Everything', in Gordon Baldwin (ed.), *All the Mighty World: Photographs of Roger Fenton* (2004)

II. Love

Maid of Corinth

Kenaan, Hagi, 'Tracing Shadows: Reflections on the Origin of Painting', in Christine B. Verzar and Gil Fischhof (eds.), *Pictorial Languages and Their Meaning* (2006)

King, Shelley, 'Amelia Opie, The Maid of Corinth and the Origins of Art', *Eighteenth-century Studies* (vol. 37, summer 2004)

Muecke, Frances, '"Taught by Love": The Origin of Painting Again', *Art Bulletin* (vol. 81, no. 2, June 1999)

Pliny the Elder, *Natural History*, Book 35, 2

Rosenblum, Robert, 'The Origin of Painting: A Problem in the Iconography of Romantic Classicism', *Art Bulletin* (vol. 39, no. 4, Dec. 1957)

Wolf, Gerhard, 'Ethnology: The Origins of Painting', *Anthropology and Aesthetics* (no. 36, autumn 1999)

Venetia and Kenelm

Aubrey, John, 'Kenelm Digby' and 'Venetia Digby', *Aubrey's Brief Lives*, Oliver Lawson Dick (ed.) (1962)

Bligh, E. W., *Sir Kenelm Digby and His Venetia* (1932)

Digby, Kenelm, 'A Discourse Concerning Vegetation of Plants', spoken by Sir Kenelme Digby, at Gresham College (23 Jan. 1660)

—, *The Closet of Sir Kenelm Digby Knight Opened*, Anne Macdonnell (ed.) (2007)

Gabriele, Vittorio (ed.), 'A New Digby Letter-book "In Praise of Venetia Digby"', *National Journal of Wales* (vol. 9, no. 2, 1955)

— (ed.), *Loose Fantasies* (1968)

Martin, Michael, 'Hallowed Ground: Literature and the Encounter with God in Post-Reformation England, *c.*1550–1704', PhD thesis, Wayne State University (2012)

Nicolas, Nicholas Harris, Sir *Private Memoirs of Sir Kenelm Digby* (1827)

Nicoll, Allardyce, 'Sir Kenelm Digby, Poet, Philosopher and Pirate of the Restoration', *Johns Hopkins Alumni Magazine* (vol. 21, 1933)

Petersson, R. T., *Sir Kenelm Digby: The Ornament of England, 1603–1665* (1965)

Sumner, Ann (ed.), *Death, Passion and Politics: Van Dyck's Portraits of Venetia Stanley and George Digby* (1995)

George and Maria

Aspinall, A. (ed.), *The Correspondence of George, Prince of Wales. volume 1: 1770–1789* (1963)

Burnell, Carol, *Divided Affections: The Extraordinary Life of Maria Cosway: Celebrity Artist and Thomas Jefferson's Impossible Love* (2008)

Grootenboer, Hanneke, 'Treasuring the Gaze: Eye Miniature Portraits and the Intimacy of Vision', *Art Bulletin* (vol. 88, no. 3, Sept. 2006)

Hadlow, Janice, *The Strangest Family* (2014)

Hall-Witt, Jennifer, *Fashionable Acts: Opera and Elite Culture in London, 1780–1880* (2007)

Kaminski, John (ed.), *Jefferson in Love: The Love Letters between Thomas Jefferson and Maria Cosway* (1999)

Langdale, Charles, *Memoirs of Mrs Fitzherbert, With an Account of Her Marriage with HRH the Prince of Wales, Afterwards King George IV* (Cambridge Library Collection: British & Irish History, 17th & 18th centuries)

Munson, James, *Maria Fitzherbert: The Secret Wife of George IV* (2001)

Plumb, J. H., *The First Four Georges* (1956)

Pointon, Marcia, '"Surrounded with Brilliants": Miniature Portraits in Eighteenth-century England', *Art Bulletin* (vol. 83, no. 1, March 2001)

Smith, E. A., *George IV* (1999)

Miniatures

Coombs, Katherine, *The Portrait Miniature in England* (1998)

Grootenboer, Hanneke, *Treasuring the Gaze: Intimate Vision in Late Eighteenth-century Eye Miniatures* (2013)

Jaffee Frank, Robin, *Love and Loss: American Portrait and Mourning Miniatures* (2000)

Lloyd, Stephen, and Kim Sloan, *The Intimate Portrait* (National Gallery of Scotland exhibition catalogue) (2008)

Portrait Miniatures (Cleveland Museum of Art catalogue) (1951)

The Cosways

Burnell, Carol, *Divided Affections: The Extraordinary Life of Maria Cosway: Celebrity Artist and Thomas Jefferson's Impossible Love* (2008)

Lloyd, Stephen, *Richard Cosway* (English Portrait Miniaturists) (2005)

Lloyd, Stephen, Roy Porter and Aileen Ribeiro, *Richard and Maria Cosway: Regency Artists of Taste and Fashion* (1995)

Sloan, Kim, and Stephen Lloyd, *The Intimate Portrait: Drawings, Miniatures and Pastels from Ramsay to Lawrence* (2008)

Gainsborough

Cormack, Malcolm, *The Paintings of Thomas Gainsborough* (1982)

Hayes, John, *Thomas Gainsborough* (1960)

—, *The Letters of Thomas Gainsborough* (2001)

Leca, Benedict, *Thomas Gainsborough and the Modern Woman* (1982)

Rosenthal, Michael, and Martin Myrone, *Thomas Gainsborough* (2003)

Charles Dodgson

Cohen, Morton, *Reflections in a Looking Glass: A Centennial Celebration of Lewis Carroll, Photographer* (1988)

Douglas-Fairhurst, Robert, *The Story of Alice: Lewis Carroll and the Secret History of Wonderland* (2014)

Higonnet, Anne, *Pictures of Innocence: The History and Crisis of Ideal Childhood* (1998)

Leach, Karoline, *In the Shadow of the Dreamchild: A New Understanding of Lewis Carroll* (1999)

Lebailly, Hugues, *Dodgson and the Victorian Cult of the Child: A Reassessment on the Hundredth Anniversary of 'Lewis Carroll''s Death* (1998)

Neumeister, Mirjam, *The Changing Face of Childhood: British Children's Portraits and Their Influence in Europe* (2007)

Pointon, Marcia, '"Charming Little Brats": Sir Thomas Lawrence's Portraits of Children', in Cassandra Albinson, Peter Funnell and Lucy Peltz (eds.), *Thomas Lawrence: Regency Power and Brilliance* (2010)

Prose, Francine, *The Lives of the Muses* (2002)

Taylor, Roger, and Edward Wakeling, *Lewis Carroll, Photographer* (2002)

Rossetti and Jane Morris

Curran, Stuart (ed.), *The Cambridge Companion to British Romanticism* (1993)

De La Sizeranne, Robert, *The Pre-Raphaelites* (2014)

Fredeman, William E., *The Correspondence of Dante Gabriel Rossetti*, vols. II–V

MacCarthy, Fiona, *William Morris: A Life for Our Time* (2010)

McGann, Jerome J., *The Complete Writings and Pictures of Dante Gabriel Rossetti* (online)

Marsh, Jan, *Jane and May Morris: A Biographical Story, 1839–1938* (1986)

—, *Dante Gabriel Rossetti: A Biography* (1999)

Marsh, Jan, and Frank C. Sharp, *The Collected Letters of Jane Morris* (2013)

Prettejohn, Elizabeth (ed.), *The Cambridge Companion to the Pre-Raphaelites* (2012)

Rodgers, David, *William Morris at Home* (1996)

Rossetti, Dante Gabriel, *The House of Life* (2014)

Thompson, E. P., *William Morris* (1955)

Tickner, Lisa, *Dante Gabriel Rossetti* (2003)

Bacon

Deleuze, Gilles, *Francis Bacon: The Logic of Sensation* (Daniel W. Smith, trans.) (2003)

Gale, Matthew, and Chris Stephens (ed.), *Francis Bacon: A Centenary Exhibition* (2008)

Peppiatt, Michael, *Francis Bacon: Anatomy of an Enigma* (2008)

Richardson, John, 'Bacon Agonistes', *New York Review of Books* (17 Dec. 2009)

Sylvester, David, *The Brutality of Fact: Interviews with Francis Bacon* (1987)

Van Alphen, Ernst, *Francis Bacon and the Loss of Self* (1992)

III. Fame

General

Braudy, Leo, *The Frenzy of Renown: Fame and Its History* (1997)

Conway, Alison Margaret, *Private Interests: Women, Portraiture and the Visual Culture of the English Novel, 1709–1791* (2001)

Cooper, Tarnya, *Searching for Shakespeare*, with essays by Marcia Pointon, James Shapiro and Stanley Wells (2006)

Crane, David, Stephen Hebron and Robert Woof, *Romantics and Revolutionaries: Regency Portraits from the National Portrait Gallery, London*, introduction by Richard Holmes (2002)

Evans, Jules, *Philosophy for Life and Other Dangerous Situations* (2012)

Garland, Robert, *Celebrity in Antiquity* (2006)

Hardie, Philip, *Rumour and Renown: Representations of Fama in Western Literature* (2012)

Inglis, Fred, *A Short History of Celebrity* (2010)

Payne, Tom, *Fame: From the Bronze Age to Britney* (2009)

Rojek, Chris, *Celebrity* (2001)

Drake

Bawlf, Samuel, *The Secret Voyage of Sir Francis Drake, 1577–1580* (2003)

Cummins, John, *Francis Drake: The Lives of a Hero* (1995)

Hakluyt, Richard, *The Principal Navigations, Voyages, Traffiques and Discoveries of the English Nation 1589 and 1598*, 8 vols. (1907)

Kelsey, Harry, *Sir Francis Drake: The Queen's Pirate* (2000)

Sugden, John, *Sir Francis Drake* (2006)

Wathen, Bruce, *Sir Francis Drake: The Construction of a Hero* (2009)

Stowe and the Temple of British Worthies

Dixon Hunt, John (ed.), 'The Gardens of Stowe' in *The English Garden* (vol. XVI, 1982)

Pope, Alexander, *An Epistle to the Earl of Burlington* (1732)

Robinson, John Martin, *Temples of Delight: Stowe Landscape Gardens* (1999)

Seeley, Benton, *A Description of the Gardens of Lord Viscount Cobham at Stow in Buckinghamshire* (1744 and subsequent editions)

Garrick, Zoffany and Siddons

Asleson, Robyn (ed.), *Notorious Muse: The Actress in British Art and Culture, 1776–1812* (1997)

Benedetti, Jean, *David Garrick and the Birth of Modern Theatre* (2001)

Bennett, Shelley, Mark Leonard, Shearer West and Robyn Asleson, *A Passion for Performance: Sarah Siddons and Her Portraitists* (1999)

Burnim, Kalman A., and Philip H. Highfill Jr., *John Bell: Parton of British Theatrical Portraitue: Catalog of the Theatrical Portraitue in His Editions of Bell's Shakespeare and Bell's British Theatre* (1997)

Kendall, Alan, *David Garrick: A Biography* (1985)

McPherson, Heather, 'Garrickomania: Art, Celebrity and the Imaging of Garrick' (http://old.folger.edu/template.cfm?cid=1465)

Perry, Gill, with Joseph Roach and Shearer West, *The First Actresses: Nell Gwyn to Sarah Siddons* (2011)

Postle, Martin, *Joshua Reynolds: The Creation of Celebrity* (2005)

— (ed.), *Johan Zoffany RA: Society Observed* (2011)

Shawe-Taylor, Desmond, *Dramatic Art: Theatrical Paintings from the Garrick Club* (1997)

—, *Every Look Speaks: Portraits of David Garrick* (2003)

Treadwell, Penelope, *Johann Zoffany, Artist and Adventurer* (2009)

West, Shearer, *The Image of the Actor: Verbal and Visual Representation in the Age of Garrick and Kemble* (1991)

Worrall, David, *Celebrity, Performance, Reception: British Georgian Theatre as Social Assemblage* (2013)

Kitty Fisher and Reynolds

Bleackley, Horace, *Ladies, Frail and Fair: Sketches of the Demi-monde during the Eighteenth Century* (1909)

Casanova, Giacomo, *History of My Life* (W. Trask, trans.) (vol. 12, 1970)

Conway, A., *Private Interests: Women, Portraiture and the Visual Culture of the English Novel, 1709–1791* (2001)

Crouch. K., 'The Public Lives of Actresses: Prostitutes or Ladies?', in E. H. Barker and E. Chalus (eds.), *Gender in Eighteenth-century England* (1977)

Hallett, Mark, *Reynolds: Portraiture in Action* (2014)

Henderson, T., *Disorderly Women: Eighteenth-century London: Prostitution and Control in the Metropolis, 1730–1830* (1999)

McCreery, Cindy, *The Satirical Gaze: Prints of Women in Late-eighteenth-century England* (2004)

Manning, David, and Martin Postle, *Joshua Reynolds: A Complete Catalogue of His Paintings* (2000)

Pointon, Marcia, 'The Lives of Kitty Fisher', *British Journal of Eighteenth-century Studies* (vol. 27, 2004)

Postle, Martin, *Sir Joshua Reynolds* (1995)

Uglow, Jenny, *Joshua Reynolds: The Invention of Celebrity* (forthcoming: 2017)

Romney and Emma Hamilton

Cross, David A., *A Striking Likeness: The Life of George Romney* (2000)

Fairburn, John, *Fairburn's 2nd Edition of the Funeral of Admiral Lord Nelson* (1806)

Fraser, Fiona, *Beloved Emma: The Life of Emma, Lady Hamilton* (2004)

Kidson, Alex, *George Romney, 1734–1802* (2002)

Williams, Kate, *England's Mistress: The Infamous Life of Emma Hamilton* (2006)

Shakespeare and Carlyle

Cooper, Tarnya, *Searching for Shakespeare,* with essays by Marcia Pointon, James Shapiro and Stanley Wells (2006)

Cigarette Cards

Ashley, Peter, *The Cigarette Papers: A Eulogy for the Cigarette Packet in Anecdote and Literature* (2012)

The Complete Catalogue of British Cigarette Cards, compiled by the London Cigarette Card Company (2015)

Cruse, A. J., *Cigarette Card Cavalcade: Including a Short History of Tobacco* (1958)

Hilton, Matthew, *Smoking in British Popular Culture, 1800–2000: Perfect Pleasures* (2000)

Tinkler, Penny, *Smoke Signals: Women, Smoking and Visual Culture in Britain* (2006)

Vaknin, Judy, *Smoke Signals: 100 Years of Tobacco Advertising* (2007)

IV. Self

General

Bakewell, Sarah, *How to Live: A Life of Montaigne in One Question and Twenty Attempts at an Answer* (2010)

Cumming, Laura, *A Face to the World: On Self-portraits* (2009)

De Girolami Cheney, Liana, Alicia Craig Faxon and Kathleen Lucey Russo, *Self-Portraits by Women Painters* (2009)

De Montaigne, Michel, *Essays* (1580)

Feather, Jessica, *Face to Face: Three Centuries of Artists' Self-portraits* (1994)

Goffman, Erving, *The Presentation of Self in Everyday Life* (1959)

Hall, James, *The Self-portrait: A Cultural History* (2014)

Rideal, Liz, *Mirror Mirror: Self-portraits by Women Artists* (2001)

Smith, Roger, 'Self-reflection and the Self', in Roy Porter (ed.), *Rewriting the Self* (1997)

William de Brailes

Camille, Michael, 'An Oxford University Textbook Illuminated by William de Brailes', *Burlington Magazine* (vol. 137, issue 1106, 1995)

De Brailes, William, *Leaves from a Psalter* (2012)

Donovan, Claire, *The De Brailes Hours: Shaping the Book of Hours in Thirteenth-century Oxford*, vol. 7 (1991)

Gerlach Flicke

Bracher, Tricia, 'Partners-in-crime: A Reading of Gerlach Flicke's 1554 Prison Diptych', in *Word and Image: A Journal of Verbal/Visual Enquiry* (vol. 23, issue 2, 2007)

Isaac Fuller

Liversidge, M. J. H., 'Prelude to the Baroque: Isaac Fuller at Oxford',
 Oxoniensia (vol. LVII, 1993)
Solkin, David H., 'Isaac Fuller's Escape of Charles II: A Restoration
 Tragicomedy', *Journal of the Warburg and Courtauld Institutes* (vol. 62, 1999)

Jonathan Richardson

Finsten, Jill, 'A Self-portrait by Jonathan Richardson', *The J. Paul Getty
 Museum Journal* (vol. 21, 1993)
Gibson-Wood, Carol, *Jonathan Richardson: Art Theorist of the Enlighten-
 ment* (2000)
—, 'Jonathan Richardson as a Draughtsman', *Master Drawings* (vol. 32:3,
 1994)
Richardson, Jonathan (Jr), *The Works of Jonathan Richardson: consisting of
 I, The Theory of Painting, II Essay on the Art of Criticism so far as it relates
 to Painting, III, The Science of a Connoisseur* (1773)

Samuel Palmer

Butlin, Martin (ed.), *Samuel Palmer's Sketchbook of 1824* (2005)
Campbell-Johnston, Rachel, *Mysterious Wisdom: The Life and Work of
 Samuel Palmer* (2011)
Harrison, Colin, *Samuel Palmer: Paintings and Drawings* (1998)
Lister, Raymond, *Samuel Palmer and the Ancients* (1983)
—, *Samuel Palmer: His Life and Art* (1987)
Palmer, Samuel, *The Parting Light: Selected Writings of Samuel Palmer*,
 Mark Abley (ed.), 1985
Vaughan, William, Elizabeth E. Barker and Colin Harrison, *Samuel
 Palmer, 1805–1881: Vision and Landscape* (2005)
Wilcox, Timothy, *Samuel Palmer* (2005)

Laura Knight

Dunbar, Janet, *Laura Knight* (1975)

Gerrish Nunn, Pamela, 'Self-portrait by Laura Knight', *British Art Journal* (22 Sept. 2007)

Knight, Laura, *Oil Paint and Grease Paint: Autobiography* (2015)

Gwen John

John, Gwen, *Letters and Notebooks*, Ceridwen Lloyd-Morgan (ed.) (2004)

Roe, Sue, *Gwen John* (2001)

Taubman, Mary, *Gwen John: The Artist and Her Work* (1985)

Lucian Freud and Tracey Emin

Dawson, David, *A Painter's Progress: A Portrait of Lucian Freud* (2014)

Debray, Cecile, et al., *Lucian Freud: The Studio* (2010)

Elliot, Patrick, and Schnabel, Julian *Tracey Emin: 20 Years* (2008)

Emin, Tracey, and Carl Freedman, *Tracey Emin: Works 1963–2006* (2006)

Feaver, William, *Lucian Freud* (2007)

Gowing, Lawrence, *Lucian Freud* (1984)

Howgate, Sarah, *Lucian Freud: Painting People* (2012)

—, *Lucian Freud: Portraits* (2012)

Hughes, Robert, *Lucian Freud: Paintings* (1988)

Jopling, Jay, *Tracey Emin* (1998)

Ruttlinger, Ines, and Eva Schmidt, *Lucian Freud und das Tier* (Kat. Museum für Gegenwartskunst Siegen) (2015)

Smee, Sebastian, and Richard Calvocoressi, *Lucian Freud on Paper* (2009)

Vaizey, Marina, and Nicholas James, *Lucian Freud: Mapping the Human* (2012)

V. People

Charlie Phillips

Gilroy, Paul, and Stuart Hall, *Black Britain: A Photographic History* (2007)

Phillips, Charlie, and Mike Phillips, *Notting Hill in the Sixties* (1991)

Phillips, Trevor, *Windrush: The Irresistible Rise of Multi-racial Britain* (2009)

Black Portraiture in Britain and Ira Aldridge

Black is Beautiful: Rubens to Dumas (exhibition catalogue, 2008)

Bluett, Thomas, *Some Memoirs of the Life of Job, the Son of Solomon, the High Priest of Boonda in Africa; Who was a Slave about Two Years in Maryland; and Afterwards being Brought to England, was Set Free, and Sent to His Native Land in the Year 1734* (1734)

Courtney, Krystyna Kujawinska, and Maria Lukowska (eds.), *Ira Aldridge, 1807–1867: The Great Shakespearean Tragedian on the Bicentennial Anniversary of His Birth* (2009)

Egan, Pierce, *Boxiana, vol. III, From the Championship of Cribb to Spring's Challenge to All England* (1829)

Haydon, Benjamin Robert, *The Diary of Benjamin Robert Haydon, vol. 1, 1808–1813*, Willard Bissell Pope (ed.) (1960–63)

Honour, Hugh, *The Image of the Black in Western Art, vol. IV, From the American Revolution to World War I, (2) Black Models and White Myths* (1989)

Lindfors, Bernth, *Ira Aldridge: The African Roscius* (2007)

—, *Ira Aldridge: The Early Years, 1807–1833* (2011)

—, *Ira Aldridge: The Vagabond Years, 1833–1852* (2011)

—, *Ira Aldridge: Performing Shakespeare in Europe, 1852–1855* (2013)

Lugo-Ortiz, Agnes, and Angela Rosenthal (eds.), *Slave Portraiture in the Atlantic World* (vol. 50, no. 2, 2015)

Hogarth

Bindman, David, *Hogarth and His Times* (1997)

Dabydeen, David, *Hogarth's Blacks* (1985)

Hogarth, William, *The Analysis of Beauty* (1753)

Paulson, Ronald, *Hogarth: Art and Politics, 1750–1764* (1993)

Uglow, Jenny, *William Hogarth: A Life and a World* (1998)

Silhouettes

Edouart, Augustin, *A Treatise on Silhouette Likenesses* (1835)

Hartley, Lucy, *Physiognomy and the Meaning of Expression in Nineteenth-century Culture* (2001)

Hickman, Peggy, *Silhouettes* (1971)

McKechnie, Sue, *British Silhouette Artists and Their Work, 1760–1860* (1979)

Pearl, Sharrona, *About Faces: Physiognomy in Nineteenth-century Britain* (2010)

Rutherford, Emma, *Silhouette: The Art of the Shadow* (2009)

John Kay

Kay, John, *Kay's Originals Vol. 1* (http://edinburghbookshelf.org.uk/volume8/)

—, *Kay's Originals Vol. 2* (http://edinburghbookshelf.org.uk/volume9/)

Szatkowski, Sheila, *Capital Caricatures: A Selection of Etchings by John Kay* (2007)

Hill and Adamson

Bruce, David, *Sun Pictures: The Hill–Adamson Calotypes* (1973)

Ford, Colin, *An Early Victorian Album: The Photographic Masterpieces (1843–1847) of David Octavius Hill and Robert Adamson* (1976)

Stevenson, Sara, *David Octavius Hill & Robert Adamson: A Catalogue of Their Calotypes in the Scottish National Portrait Gallery* (1981)

—, *Printed Light: The Scientific Art of William Henry Fox Talbot and David Octavius Hill with Robert Adamson* (1986)

—, *Hill and Adamson's 'The Fishermen and Women of the Firth of Forth'* (1991)

Suffragettes

Atkinson, Diane, *The Suffragettes in Pictures* (1996)

Davis, Mary, *Sylvia Pankhurst: A Life in Radical Politics* (1999)

Hamilton, Peter, and Roger Hargreaves, *Beautiful and the Damned: The Creation of Identity in Nineteenth-century Photography* (2001)

Marlow, Joyce (ed.), *Votes for Women: The Virago Book of Suffragettes* (2001)

Tonks and Gillies

Biernoff, Suzannah, 'Flesh Poems: Henry Tonks and the Art of Surgery', *Visual Culture in Britain* (vol. 11 (1), 2010), pp. 25–47

Chambers, Emma, *Henry Tonks: Art and Surgery* (2002)

Freeman, Julian, 'Professor Tonks: War Artist', *Burlington Magazine* (vol. 127, 1 May 1985)

Helmers, Marguerite, *Iconic Images of Wounded Soldiers by Henry Tonks* (2010)

Lennard, Debra, 'Censored Flesh: The Wounded Body as Unrepresentable in the Art of the First World War', *British Art Journal* (vol. 12, no. 2, autumn 2011)

Scotland, Thomas, and Steven Heys, *War Surgery, 1914–18* (2014)

Acknowledgements

If portraits are a three-sided relationship between sitter, artist and the viewer, *The Face of Britain* is likewise the result of a fruitful triangular collaboration between the National Portrait Gallery, Viking Penguin and Oxford Film and Television who have made the television series for BBC2. I have been lucky enough to have had indispensable help from all three sides of this creative triangle and it is a pleasure to acknowledge my gratitude to all three groups of friends and colleagues.

The project of an examination of British portraits, focusing especially on the collection of the National Portrait Gallery, was originally the idea of Will Hammond, then at Viking, and Sandy Nairne, the previous Director of the Gallery; they were exceptionally kind in encouraging me to take on both the literary and televisual side of the enterprise. At the NPG I have had guidance and stimulation – from Tarnya Cooper, Lucy Peltz, Louise Stewart and the whole team of curators and specialists in individual periods and media, many of whom were kind enough to read book chapters and offer suggestions and corrections. Rob Carr-Archer, Director of Trading, who masterminded the project at the Gallery, Lucy Peltz who co-ordinated the work on the exhibition, Pamela Jahn and Deputy Director Pim Baxter, with whom I had the exhilarating experience of judging the BP/NPG Portrait of the Year Award, were also exceptionally kind and hospitable; as were Matthew Bailey and his team, both invariably at unconscionable hours. Nicholas Cullinan, the present Director, has been warm in his enthusiasm to make the gallery exhibition as accessible and innovative as possible in fresh approaches to display and interactive engagement. My sincere thanks also go to the expert colleagues in the Gallery's conservation, collections, archive, rights, learning, digital, design, events and communications teams and the many others who have combined superbly to help make the films, exhibition and book

possible. Chris Webster at Tate Britain was exceptionally forbearing during our late evening shoots.

I should like to extend special thanks to Megan McCall and to Jacob Uecker at Christie's for their kindness and generosity in allowing us to film Lucian Freud portraits; to Jenny Saville and all at Gagosian Gallery for theirs in assisting us in discussing her works; and to Dr Andrew Bamji, who gave invaluable help on Henry Tonks, Walter Ashworth and Harold Gillies.

It has, as always, been a great joy to work with my friends and colleagues at Oxford Film and Television. No writer-presenter could imagine a more creatively generous (and forgiving) bunch of colleagues from whom I am constantly learning the art of the television documentary and who have always remained open to my own occasionally, erm, unorthodox approaches to the task in hand. Thanks in particular to Rachel Shadick and Annie Lee; genius directors Matthew Hill and Francis Hanly; sound recordists Nick Reeks and Howard Peryer; warm-hearted enthusiast and shutter-master of the shoots, Alex Hudson; our brilliant researchers Georgia Braham and Scarlet Moore. Julia Mair was as always an inspiring fount of deep research and creative ideas from start to finish, and the quality of the project owes much to her uncompromising determination to make fine television and tell powerful stories. Special thanks to the non-stop perfect Naomi Lamb, who coped heroically with the impossible presenter and began every filming day with a spray of refreshing enthusiasm.

The Face of Britain is the fourth project of an endlessly joyous collaboration with my good friends and partners in creativity at Oxford Film and Television, maestro Nicolas Kent and the peerless Charlotte Sacher, buddies and kin under the skin, and the project is as much their work as mine. Charlotte pounced on some extraordinary stories and we developed them together. And as if they had nothing better to do, they were kind enough to read chapters of the book even when its writing was doing little to help us keep to our filming schedules. I am also very grateful to Mark Bell, Commissioning Editor, Arts, at the

BBC, for his support, and as ever to Janice Hadlow, previous Controller of BBC2 and her successor, Kim Shillinglaw.

Viking have been an extraordinary delight to work with on *The Face of Britain*: patient and flexible in the face of a simultaneously testing schedule of writing and film-making; hearteningly supportive as the book came into being; inventive in its design. Daniel Crewe has been a brilliant publisher-editor, all that a writer could want, a true creative partner in the project, and Venetia Butterfield and Joanna Prior could not have been more warm-hearted in their enthusiasm. I am also deeply grateful to Keith Taylor and James Blackman for managing the editorial and production process; Sarah Day, for intensive and hawk-eyed copy-editing; the inexhaustible and ingenious Caroline Wood and Rosalind McKever for picture research; Jenny Fry and Celeste Ward-Best for their unquenchable energy and ideas for the publicity and marketing; Chris Bentham and Claire Mason for the book's beautiful design; and Dan Franklin and Roy McMillan for their skill and expertise in creating the audiobook.

As always I am deeply grateful to my agents, Rosemary Scoular on the television side of things, and Michael Sissons and Caroline Michel on the literary side, for their astounding capacity for making the impossible possible, their close attentiveness in reading long chapters of the manuscript; the wisdom of their responses and for their bottomless well of generosity, patience (a big one, that), kindness, thoughtfulness and often undeserved love.

Jennifer Sonntag has been her usual kind and enthusiastic self, helping with research in New York, and Griselda Murray Brown has been a pillar of support in London and was immensely helpful in sifting the literature on infant facial recognition. I must also thank the wonderful staff of the London Library for making that temple of literary happiness such a rewarding place in which to hammer out recalcitrant prose. My colleagues and students in Columbia University's graduate writing programme in the School of the Arts have been kind enough to help me square teaching with the exigencies of filming and writing.

ACKNOWLEDGEMENTS

My beloved family – Ginny above all, Chloe, Mike and Moses, Gabriel and Chieh – have been sweetness and light in the face of the usual disappearances on holidays to write, pace, brood, storm and generally carry on something shocking. As long as he got home cooking, none of this bothered August Sunshine T-Box who was always there; so much so that now it is hard to imagine writing anything without him.

Writing (at least for me) continues to be an act of offered connection with the reader, and the more I do of it the more I realize how much I draw on the generosity of my friends to sustain it. Laura Cumming and Hilary Fraser, who themselves have written so eloquently and perceptively about art, were kind enough to help with particular questions raised in the book. But many good friends have gone well beyond the call of duty to keep the runaway train of my notions more or less on the tracks: Chloe Aridjis, Suzannah Lipscomb and Kate Williams of the ClioTrio; Clara Sanabras, Elena Narozanski, Julia Hobsbawm; my three longtime musketeer-comrades in historical exuberance, Celina Fox, Lisa Jardine and Stella Tillyard. Alice Sherwood was generous enough to read the whole manuscript and encourage me when the climb seemed dauntingly steep. Over many decades, too many for us to want to count, Jan Dalley has been a rock of wise reassurance and sisterly good sense and this book is dedicated to her with heartfelt affection and thanks.

Index

(Page references in *italics* refer to illustrations)